Exploring Visual Design
The Elements and Principles

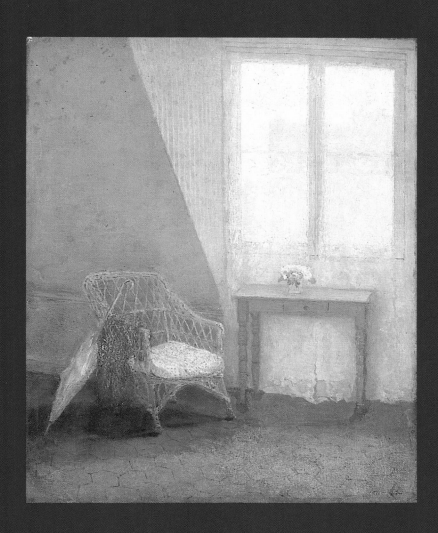

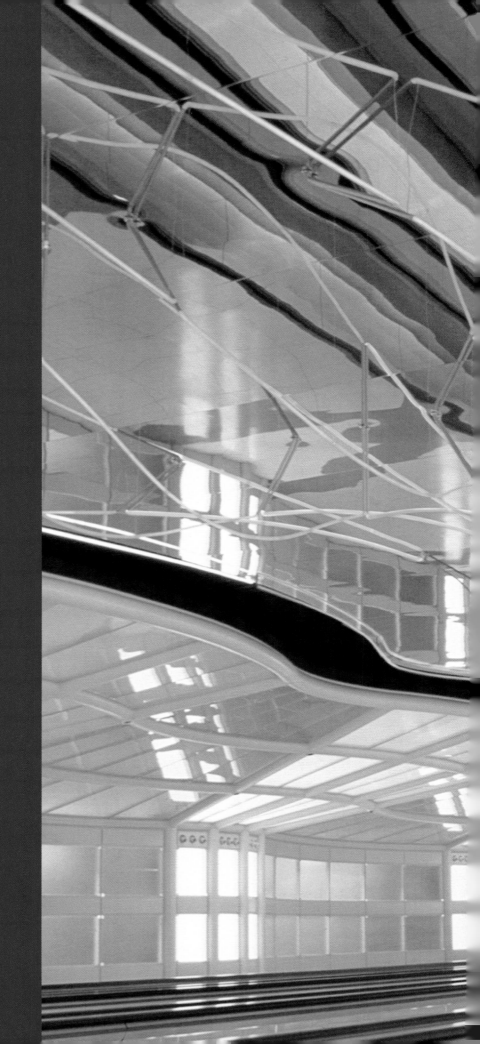

Fourth Edition

Joseph A. Gatto

Albert W. Porter

Jack Selleck

Davis Publications, Inc.
Worcester, Massachusetts

Exploring
Visual Design
The Elements and Principles

For Bryan, Jennifer, and Glenn

For Sean and Lara

Cover: Matthew Ritchie (b. 1960), *The Fast Set*, 2000, installation view, Museum of Contemporary Art, North Miami, Florida, 2000. Photo: Matthew Ritchie. Courtesy Andrea Rosen Gallery.

Page T-1: Gwen John (1876–1939), *A Corner of the Artist's Room, Paris*, 1907–09. Oil on canvas, 12 ½" x 10 ½" (31.7 x 26.7 cm). Sheffield Galleries and Museums Trust. Sheffield City Art Galleries/Bridgeman Art Library, London/New York.

Title page spread: Michael Hayden (b. 1943), *Sky's the Limit*, 1987. Neon tubes, mirrors, and computer controlled music, 744' long. United Airlines Terminals, O'Hare International Airport, Chicago. Courtesy of United Airlines.

Facing page: Juan Genovès (b. 1930), *Memorial XX*, 2001. Acrylic on canvas, 10" x 17 ¾" (25 x 45 cm). Photo ©VEGAP/Art Resource, New York. ©ARS, New York.

Copyright © 2011
Davis Publications, Inc.
Worcester, Massachusetts U.S.A.

Publisher: Wyatt Wade
Acquisitions Editor: Jane McKeag
Editorial Consultants: Claire Mowbray Golding, Robb Sandagata
Manufacturing and Production Editor: Reba Libby
Editorial Assistance: Gail Brodie, Lydia Keene-Kendrick
Design: Douglass Scott, Tyler Kemp-Benedict

Library of Congress Catalog Card Number: 2010920044
ISBN: 978-61528-022-3
10 9 8 7 6 5 4 3 2 1
Printed in the United States of America

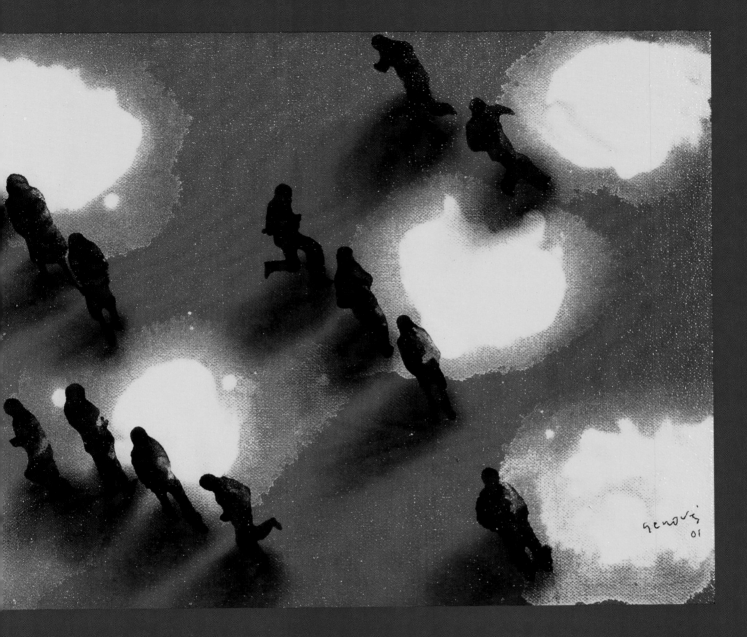

Art is a testament of the moment
and of the society in which the artist lives.
It can be positive or negative,
but meaning is always present.

Juan Genovès

Contents

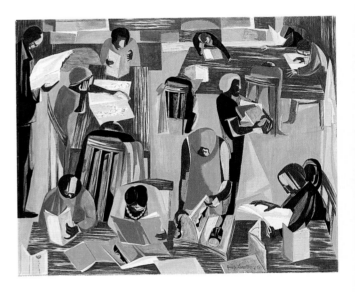

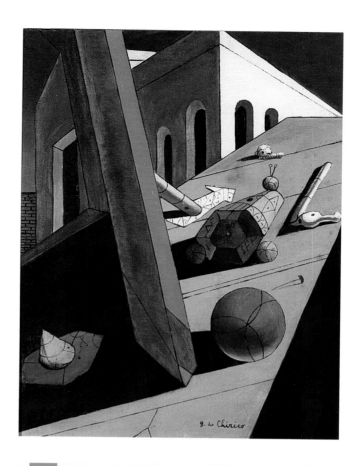

Part Two: The Principles of Design

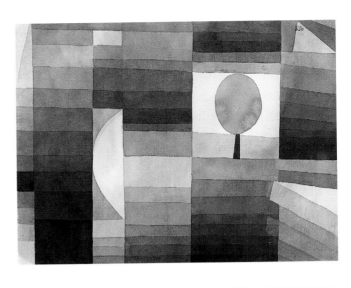

> ## "Learning to make art is like learning to write — only wetter."
> ### Jaci Hanson

Each Chapter Opener introduces an element or principle of design.

These overviews set the stage for a more in-depth exploration. Note how examples from fine art, architecture, and nature begin this exploration of unity.

Look for the Key Vocabulary.
They are listed in the order that they will appear. When a vocabulary word is introduced it will be shown in bold italic type and explained. These key terms are also defined in the Glossary.

Captions help you link the visual to the text.
These captions will challenge you to think critically as you analyze and interpret what you see.

This box highlights an opportunity for hands-on learning.
These **Discuss it**, **Note it**, and **Try it** demonstrations make abstract concepts concrete experiences.

Sub-topics are organized by spread.

Look at both pages together. See how the text, the visuals, and the captions work hand-in-hand? Here, the text verbally defines the use of color to unify an artwork, the fine art images exemplify the text, and the captions provide more information about each image.

An artist might use analogous colors to retain a strong feeling of unity. Look at the painting of the seated woman by Edgar Degas (fig.8–12), who chose to work with oranges and reds. This dominant group of colors both unifies the work and conveys a feeling of warmth and intimacy. Within the design, subordinate areas of yellow and brown provide areas of contrast.

8–14 In this painting, Rothenberg uses different tones of the same col... Identify the areas where the red is repeated as both a darker a...
Susan Rothenberg (b. 1945), *Dominos—Hot*, 2001–2002. Oil...
Courtesy Sperone Westwater, New York. ©2010 S...
New York.

Another Look at Unity

8–18 The elements of this sculpture are very similar, but they are not exactly alike. How has the artist balanced unity and variety here?
Ursula von Rydingsvard, (b. 1942) *Iwanirna II*, 1998–2001. Cedar, graphite, 72" x 264" x 48" (182.9 x 670.6 x 121.9 cm). ©Ursula von Rydingsvard. Courtesy Galerie Lelong, New York.

8–19 This twirling, dynamic composition keeps our eye moving from one part of the painting to the next. What element of design did the artist use to unify the work?
Melissa Miller (b.1951), *Salmon Run*, 1984. Oil on linen, 90" x 60" (228.6 x 152.3 cm). Shirley and Thomas J. Davis, Jr. Courtesy of the Lyons Mattis, Austin, Texas.

Note It

Start a clip file of art and graphic-art reproductions. With each reproduction, write a short statement about the unifying element, as well as the elements that create interest through variation. These could be pasted in a notebook, scrapbook, or sketchbook; filed in envelopes; or organized in page protectors in a binder.

8–20 Compare this sculpture to von Rydingsvard's (fig.8–18). Can you name at least two similar ways in which these artists unified their work?
Jacques Lipchitz (1891–1973), *A Song of the Vowels*, 1932. Bronze, 156" high (396.2 cm). Sculpture Garden, University of California, Los Angeles. Photo by A. W. Porter. ©Estate of Jacques Lipchitz/Licensed by VAGA, New York, NY/ Marlborough Gallery, New York.

8–21 How has this student achieved unity in her work?
Sharon Hess (age 16), *Paperclips*. Watercolor and felt tip, 18" x 24" (45.7 x 61 cm). Montgomery High School, Skillman, New Jersey.

Review Questions

1. Why do artists often try to create unity in their artworks?
2. List four ways to create unity in an artwork.
3. Explain what dominant and subordinate elements are in a design. Name an example of an image in this chapter that has a dominant element. Identify that element.
4. Name an image in this chapter that uses repetition of shape to create unity.
5. Select one image in this chapter that uses an overall surface texture to create unity. Describe the texture.
6. Explain what prompted Käthe Kollwitz to create her series of prints, *The Weavers' Uprising*.
7. With what two countries was Noguchi most closely associated? How did these cultures influence his work?

Key concepts are visually and verbally reviewed at the end of each chapter.

A "gallery style" review requires critical thinking as you analyze the works of master artists and other students. The review questions help you integrate and interpret what you've learned.

Note how the visuals are referenced in the text.
Follow these connections as you read and you will achieve a full understanding of the topic.

Who made the piece?
When was it made?
What is it made of?
These and other important questions are answered by the credits that accompany each visual.

When the sizes of original artworks are given, take time to imagine the art in real life. Works may be as small as a postage stamp or as large as a billboard. The size affects how you experience a piece.

Get up close and personal with artworks and artists.

What inspires you?

Which artist began his career in the basement of a New York Public Library? Which artist found inspiration in the small details of nature? Through short biographies you gain a sincere appreciation for the **diverse influences that have directed a master artist's career.** Not only does this provide new insight into the works they created, it also helps us better appreciate the importance of an artist's inner voice in making art.

Art is not made in a vacuum!

To understand the subtleties that distinguish a piece and the common threads that unite artwork across time and space it helps to take an in-depth look at **the cultural and historical influences that shape a work of art.** Consider an Aboriginal dot painting and a Muslim tomb. They are drastically different in design and scale yet they both reflect sacred beliefs and values.

Are you considering an art or design career?

A crucial part of any job search is an informational interview where you might ask:

- "What is a typical workday like?"
- "What kind of skills will I need?"
- "How do I get my foot in the door?"

Career Portfolios are **informational interviews with real working artists** in a host of art-related occupations. In addition to detailing the practical issues of a career in the arts, Career Portfolios highlight how the arts shape our world today. The entire interview from which each excerpt is drawn is provided in the *Studio Resource Binder*.

Career Portfolio
Interview with a Website Designer

While still in high school, **David Lai** learned the basics of computer design on his own. "Just for fun," he wrote and published a book on how to design computer-screen icons. Born in 1975 in Manhattan, Kansas, David now works for a firm in California that specializes in interactive design.

What do you call your occupation?

David I'm in the design profession, but we almost always talk more about solving problems. Good design does have aesthetic components, which is important, but there is also a very important functional aspect. You have to create something of utility and value. We solve real-world communication problems.

We look at computers more as a tool than a specialty. Otherwise, I'd be nothing more than an operator. You can always learn a tool, but the more difficult things to learn are conceptual—sketching your ideas out on paper before you go to the computer. Too many people these days want to go straight from whatever is in their mind—and it's usually not very clear—directly to the computer. They think they need to buy all these computer books to learn the program, but the truth is that they need to know how to conceptualize more than they need the tools, the applications.

How is balance important in website design?

David Well, there are so many different elements involved. There's content. There's visuals. There's content. There's text, the copy itself. There really has to be a synergy between all of them to get something to work. You're always balancing different spaces or different shapes.

Can anybody design a website?

David Well, theoretically, yes. Just like anyone could be a doctor, if they really put their mind to it. There's such a wide range of people in this industry because it's very easy to enter into. Anyone can pick up a book and learn some basic HTML and some basic graphic stuff. HTML is the basic programming language that you use to create web pages. It's the foundation; it's the starting point. No website can be created without knowing some of that.

How do most people learn it?

David A lot of people learn it by looking at sites they really enjoy or respect, by taking them apart and looking at how the code was done. I think that's one of the great things about the Internet—it allows people to share information quickly. That includes sharing how sites are built, in of any site and see how it was put together and learn from that.

What would you recommend to people interested in doing this for a living?

David I would recommend that they read as much as they can about the subject. There are so many good books out there on web design.

Obviously, there's a more formalized way as well. There are a lot of good art-design schools out there, especially with today's booming computer-design industry. You can take courses on web design, multimedia, interactive learning for cd-rom work, 3-D modeling for special effects for Hollywood—whatever. The important thing is that you just have to go out there and take risks.

...e of his career, David Lai has ...es for such varied businesses ... Herman Miller.

Career Portfolio
Interview with a Photojournalist

Photo ©Barbara Hakim

Capturing images from the world of possibilities around her, **Dorothy Littell Greco** works with emphasis every time she frames and shoots a photograph. Whether on assignment or pursuing her own ideas, her aim is to compose a shot that makes a statement, tells a story, or records an event. Born in 1960 in Franklin, New Jersey, Dorothy lives in Boston, Massachusetts.

How do you describe your career or your type of art?

Dorothy I make still photographs which appear in newspapers, magazines, books, and corporate publications. I work in an editorial/reportage style, which means my images are naturalistic, rather than ones that are conceived and executed in a studio.

How did you enter into this type of work?

Dorothy As a child as young as five or six, I can remember taking my Kodak camera with me on vacations. As a teenager, I began to get more serious about photography. I taught myself using my dad's old camera and took a course at night school my senior year. For two years, I worked as the high-school yearbook photographer, which influenced my decision to study photography in college. I have a B.S. degree in journalism, with my concentration in photography.

Describe what your working day is like.

Dorothy Since I am self-employed, no two days are the same. Some days, I get a phone call at noon from a newspaper asking me to do an assignment at two. I spend some days in the darkroom printing, or at my light table, editing slides. I rarely have more than one assignment per day, and generally each shoot takes me three to four hours.

If I have to make the photograph inside, I may have to take several cases of lighting equipment with me. Occasionally, I hire an assistant to help me carry my gear and set up lights. I may also be asked to fly to a location and spend several days or weeks making photographs for a client. Since the sun is so important to my work, I often get started about an hour before sunrise and continue shooting until just after dark. At midday, when the sun is at its peak, I caption my film, eat, and rest.

I have photographed presidents, princes, and refugees. I've sat courtside during the NBA Championship and shot the World Series. I've also waited for hours, sometimes even days, in a fire station, a hospital, and a courtroom for something anything—to happen so that I could make a photo. Every day brings new challenges, and I can no longer imagine having a "normal" job.

How would you describe your creative process?

Dorothy Normally I go into a shoot with some ideas about how I want to make an image. Sometimes it is very specific, and sometimes very general. When I actually arrive, the light may be poor, or my subject might inform me that I have only ten minutes to get the photo. My equipment has to be an extension of my body so I don't have to think about the mechanics. Then I just try and let the situation unfold, responding as best I can, working as quickly as possible.

Each time I have an assignment, I make an attempt to gain my s... trust and to give something ... them. When this happens, ... us know it, and it's treme... rewarding. It's also very s... artistically to enter a sit... few vague ideas, to em... later with exposed fil... see the image in the... zine a short time la...

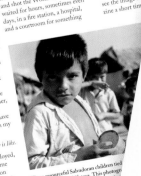
These resourceful Salvadoran children tied ... used cans as makeshift toys. This photogr... and a wide-angle lens. It was shot late in ...
Dorothy Greco, *Mesa Grande Refugee Camp,* ...

Career Portfolio
Interview with an Art Therapist

Color provides an important clue in the work of **Anna Riley-Hiscox**, who uses art as a means of communicating with her clients. Anna grew up in East Harlem, in New York City, earning scholarships that put her through college. She has a bachelor's degree in art, and a master's degree in marital and family therapy and art therapy. Anna currently works with children and adolescents at a nonprofit agency in California. Off the job, her favorite form of artistic expression is painting gourds.

What is the purpose of art therapy?

Anna I think of art therapy as a vehicle of expression. Sometimes, people have problems or concerns they want to address, but they have a difficult time sitting and talking about emotional issues. We use art as another way of communicating, to help clients learn about new ways to handle difficult situations.

Please give an example.

Anna I was working with a fourteen-year-old client. Every time he came to the office, he would chitchat, and it was pretty superficial. Even after three or four sessions, he really had a difficult time expressing why he was in counseling. One day, I decided I said, "Hey, how about doing some art with me?"

He was a little reserved; he wasn't sure whether he actually wanted to do art. He said, "Well, I don't know how to draw." I said, "That's okay." I told him that he didn't have to be perfect. I showed him how to use markers to draw a mandala, a technique that many art therapists use. A mandala drawing is organized in a circle, and is used by many Native Americans and indigenous people to express themselves.

I told my client to simply use line and color to draw, in the circle, how he was feeling. As soon as he started drawing, the room became very, very quiet. We didn't need to talk. He was really engaged in the process of artmaking.

This client had taken a wrong turn in life, which resulted in him being arrested and released on probation. Through his drawing, he was able to express how he was feeling. He talked about how he could take the right path in life or the wrong path. Although his drawing was very simple, he was able to use it to express his vision of making the right choices in the future.

Describe what your work is like.

Anna I work with a variety of clients who have problems they would like to resolve. Like other mental-health professionals, I see my clients in weekly sessions. Art therapists work in many different situations. Some are in private practice; some work for mental health institutions. Others work in schools, prisons, halfway houses, or shelters.

What aspect of your work is most important to you?

Anna Seeing the transition of the kids and the teenagers that I work with. Seeing them come in very confused, with a very chaotic life, and watching them evolve by using art. I've had several kids tell me later that the art was really good for them, and that they're still doing art.

This simple mandala was drawn by a client of Anna Riley-Hiscox (discussed in this interview). He described his artwork by saying, "This represents the paths I could take in life. The blue could be the right way, the red could be the wrong way. The green represents in the middle. I can go either way, which is why I have the diamond shape in the middle." Anna's job is to help him problem-solve so he will have the information he needs to find the right path.

It's time to make your mark.

Think with your hands!

Remember how learning to make art is like learning to write—only wetter? Well, it's time to get wet. The end of each chapter is capped off by **a comprehensive Studio Experience that helps you practice and apply what you've learned.** An example of a student's artwork lets you see how others responded to these hands-on activities.

Collaboration is key!

These three distinct features demonstrate a fundamental concept either through a hands-on activity or through a discussion. While requiring only minimal time and resources, these active learning opportunities still **encourage sharing and self-expression.**

Studio Experience
Color Harmonies with Pastels

Task: To demonstrate understanding of a color harmony by using it in a pastel painting.

Take a look. Review the following images in this chapter:
- Fig.4–15, Grant Wood, *Death on the Ridge Road*
- Fig.4–28, Aaron Douglas, *The Creation*
- Fig.4–29, Karajá, *Lori-lori*
- Fig.4–32, Lyonel Feininger, *Blue Coast*
- Fig.4–38, Jorge Pardo, *Untitled*

Think about it. Study the five artworks listed above and the diagrams of the color schemes.
- Describe the color scheme or harmony in each. List the main colors in each painting; then label the color scheme. If a painting does not quite fit into a specific category, select the closest color scheme and explain how the colors in this art vary from that scheme.
- Compare the intensity of the colors among the paintings.
- How did each artist use color to emphasize certain parts of the composition?
- How did each artist treat the background?
- Describe the mood created by the color scheme in each painting.

Do it.
1 Choose a real-life object—a plant, leaf, shoe, hand, or insect—for your subject.
2 Select pastel sticks that form analogous, complementary, split-complementary, triadic, and monochromatic color harmonies. On scrap paper, experiment with various colors of pastels and color schemes. Try blending the pastels with a tissue or tortillon to create transition tones.
3 Look again at the diagrams. Decide which color scheme you will use to set the mood that you want. Consider the mood that will be created by the colors, rather than what color your subject is in real life. Pick a color of pastel paper that goes with your color scheme.
4 On a 9" x 12" piece of pastel paper, make a sampler of the colors that you will include. Lay down several large strokes, state the type of color scheme and mood, and check your work with your teacher.
5 With a pastel close to the color of the paper, sketch the outline of your subject on an 18" x 24" sheet of pastel

paper. Draw the object twice more on this page. To fill the page, draw the objects large, overlap them near the center of the paper, and make them touch the edge of the page on at least two sides.
6 Before adding color, plan the colors for the various areas and shapes: not all need to be a flat color. You may want to vary the color in different areas, blending from one hue to another, or making the color shade from dark to light.
7 Complete your drawing with pastels.
8 Look at your pastel from a distance to evaluate it. If you wish, add more color or lighten or darken an area.
9 In a well-ventilated area, spray you pastel with fixative.

Helpful Hints
- Before you add pastels, consider background. You could divide la areas of background into shapes areas of color, as in fig.4–28.
- Thick, velvety applications of that cover the whole surface of paper are usually considered ing; lighter applications with strokes are more like a draw
- Pastels sprayed with a work fixative may smudge. Spray ed pastels with a clear acry

Check it. After you have co your pastel painting, prop i classmate, study it from a c answer the following:
- What is the mood? Is it trying to achieve?
- What is the color harm
- Would the work be in greater differences in tints between areas c
- Would the colors go if some were repeat

"What I like best abo it is a shock of blendi pastels allow for such I feel like even the b
Dhavani Badwaik (age Pastels, 18" x 24" (45 Academy, Worcester

Discuss it

Study a reproduction of a famous painting. Then discuss the answers to these questions: How does the artist lead the viewer's eye through and around the painting? Is the movement accomplished with line, color, shape, value, or some other device?

Try it

You can experience actual asymmetrical balance by placing a ruler across an outstretched forefinger, while resting your hand on a desk. Experiment by placing lighter and heavier objects on each side of the center. Move them until the ruler balances.

Note it

Explore indoor and outdoor environments to find patterns. Look for obvious, broad, large patterns, such as those on the sides of buildings. Then look more closely for smaller patterns, such as those in pavement, bicycle stands, and landscaping. Note how patterns create rich surface appearances and help us identify forms.

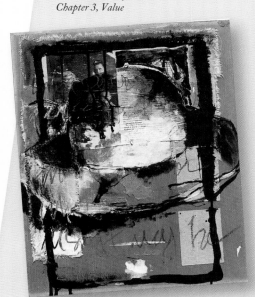

Student artwork from Chapter 9, Contrast

Student artwork from Chapter 3, Value

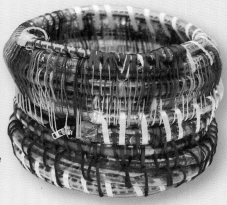

Student artwork from Chapter 6, Texture

Notable resources you don't want to miss!

The **Guide to Artists** provides clear pronunciations for the names of all of the artists in the text.

The **Glossary** defines key vocabulary and other important terms.

The **Bibliography** lists resources for both the student and the teacher.

The **Index** serves as a study aid and assists students in finding particular artists and topics.

This book will teach you about the "grammar" of art and how people from other cultures and times have used a common visual language to express their own unique perspective.

With time and practice you too will become fluent in this language.

1

Introduction

What Is Design?

The design of a work of art is its plan. Design can refer either to the way a piece is organized or to the piece itself. We might talk about the design of a fine piece of sculpture, a startling painting or photograph, an unusual building, or an interesting layout for an advertisement. When someone says, "That's a great design!" he or she is recognizing a sense of visual order—different parts brought together to make a whole.

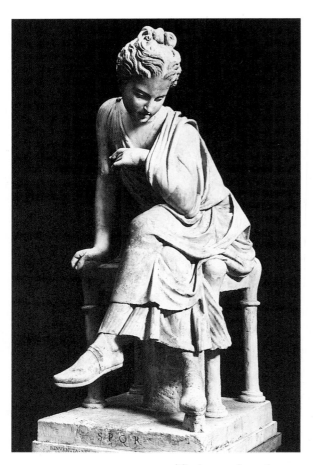

The human figure has been a favorite subject of artists since ancient times, providing an endless number of visual problems to solve. There are many challenges in designing a graceful and balanced figure such as this seated girl.

Seated Girl. Hellenistic sculpture. Palazzo dei Conservatori, Rome. Alinari/Art Resource, New York.

A work of art sometimes holds an element of surprise. This image represents the artist's mother. It recalls a simple snapshot, but the artist has manipulated the design. The space within the image and its overall shape are unexpected, and therefore attract our attention.

David Hockney (b. 1937), *Mother, Los Angeles, Dec. 1982,* 1982. Photocollage, 52 ¼" x 38 ½" (132.7 x 97.8 cm). Frederick R. Weisman Art Foundation, Los Angeles. Edition 20 ©David Hockney.

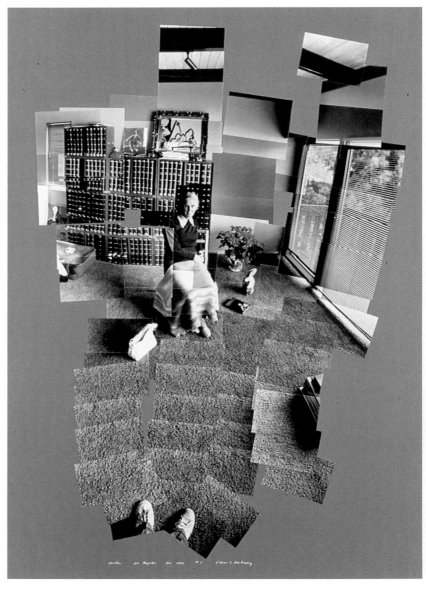

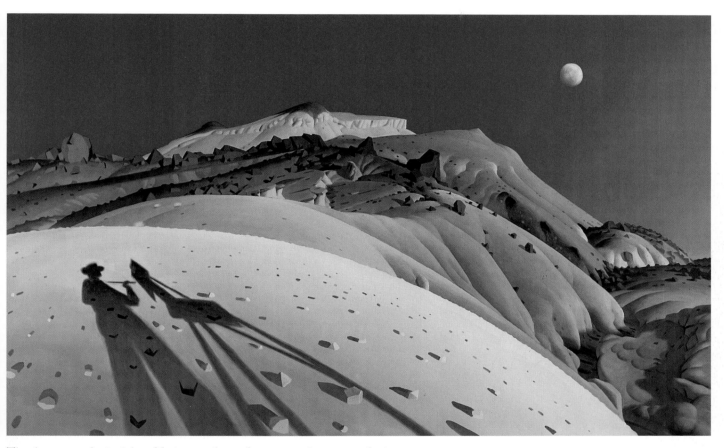

The elements and principles of design may be used to communicate or emphasize a message or a concept. Using the title as a clue, what do you think is the idea behind this work?
James Doolin (1932–2002), *Last Painter on Earth*, 1983. Oil on canvas, 72" x 120" (182.5 x 304.5 cm). Courtesy of the Koplin Gallery, Los Angeles, California.

Design surrounds us—in nature or at home, in a flower or a dinner plate. Design affects the print displays in magazines, the furniture styles in department stores, and the shapes and colors of cars and bicycles. You probably use design without even knowing it. When you buy one piece of clothing rather than another, or decorate a wall with this poster instead of that one, you are reacting to issues of design.

To know when or why one design is better or more successful than another, ask what makes it work and how it is put together. Does the design hold your interest? Is its purpose meant to entertain? To convince? To frighten? Does it achieve that goal? Also consider how the piece makes you feel and why.

Appreciating Design

Appreciating or creating a work of art takes time and effort. One way to improve your design sense and judgment is to stop and carefully look at some of the hundreds of objects that you encounter daily. Although there are no absolute rules in art, this book will help you know what to look for. It will help you understand and be able to discuss your personal reactions to design. And it should improve your ability to communicate feelings and ideas in your own creations.

With practice, we can learn to recognize elements of design in everyday objects. Consider the lines used in the design of this umbrella. There are the straight, rigid lines of the spokes and the broad, freer lines of the written characters.

Umbrella. Photo by A. W. Porter.

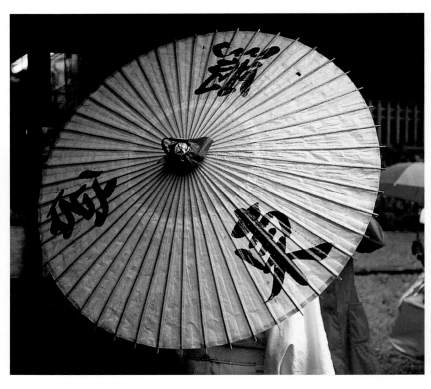

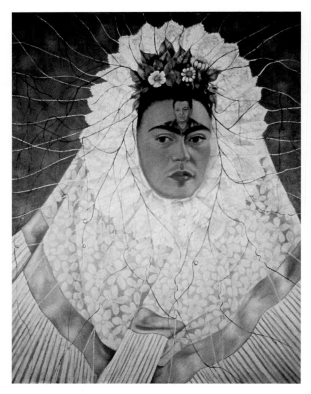

This painting is a self-portrait of the artist. Artworks can capture the very personal feelings of an artist.

Frida Kahlo (1910–54), *Autorretrato como tehuana (Diego en mi pensamiento)*, 1943. Oil on canvas, 30" x 24" (76 x 61 cm). Gelman Collection. Courtesy of the Centro Nacional de las Artes, Biblioteca de las Artes, Mexico. Reproduction authorized by the Instituto Nacional de Bellas Artes y Literatura. ©2010 Banco de México Diego Rivera Frida Kahlo Museums Trust, Mexico, D. F./Artists Rights Society (ARS).

The same elements of design used by the creator of this masterpiece over 1,200 years ago are still used to create art today.

Moche, North coast, Peru. Portrait Vessel of a Ruler, 100 BCE–500 CE. Ceramic and pigment, 14" x 9 ½" (35.6 x 24.1 cm). Kate S. Buckingham Endowment, 1955.2338, The Art Institute of Chicago. Photography ©The Art Institute of Chicago.

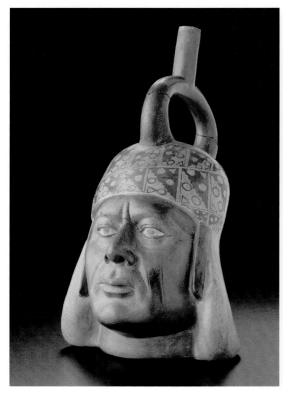

Elements and Principles of Design

This book contains two parts. The first part is devoted to the elements of design—the ingredients that artists use to create an artwork. The second part discusses the principles of design, the different ways in which artists combine the elements to achieve a desired effect or outcome. Although this book presents each element and principle separately, no one of them appears alone in a design: the elements and principles work together.

Throughout the twelve chapters are images of a variety of fine art, architecture, crafts, advertisements, and designs from nature. There are designs from different time periods and cultures. Each image is intended to help explain some idea in the text and to help you develop your looking skills. But remember: the elements and principles of design work together. Although each image is carefully placed to illustrate a particular principle or element, many of the images could illustrate a different concept in another chapter.

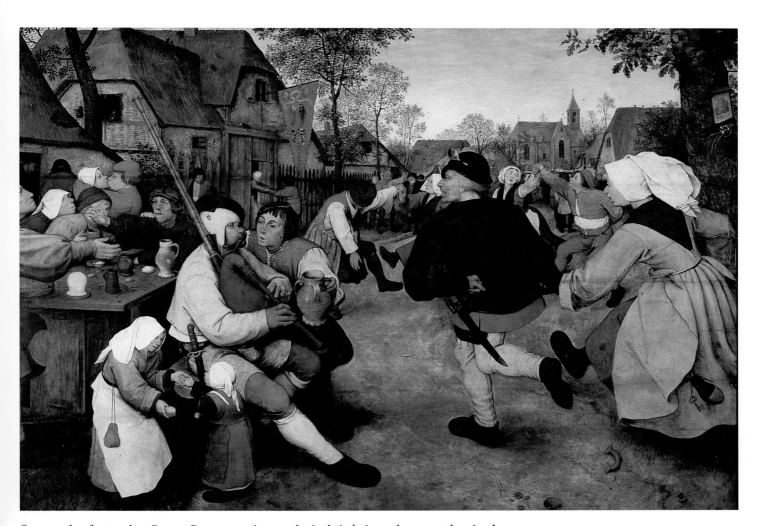

Some works of art, such as *Peasant Dance*, are quite complex in their design; others are rather simple. Each presents its own visual problems for the artist to solve.

Pieter Brueghel the Elder (c. 1525–69), *Peasant's Dance*, 1568. Oil on oakwood, 44 ⅞" x 64 ½" (114 x 164 cm). Kunsthistorisches Museum, Vienna, Austria. Photo Erich Lessing/Art Resource, New York.

Observing Design

Although the hundreds of images may also offer guidance, inspiration, and solutions to problems in creating your own artwork, be aware that they are only photographic reproductions. An image may be quite different from the real thing, and it often does not or cannot accurately reproduce a work's actual size or color. The best way to experience art is to study it in person—whether at museums and galleries, or in public parks and buildings.

Successful visual artists and designers are careful observers and collectors of ideas. Their designs reflect intimate knowledge of the world, as well as a desire to share their personal feelings and reactions with others. If you wish to achieve similar results, you must continue your exploration and study of design both in and outside the classroom.

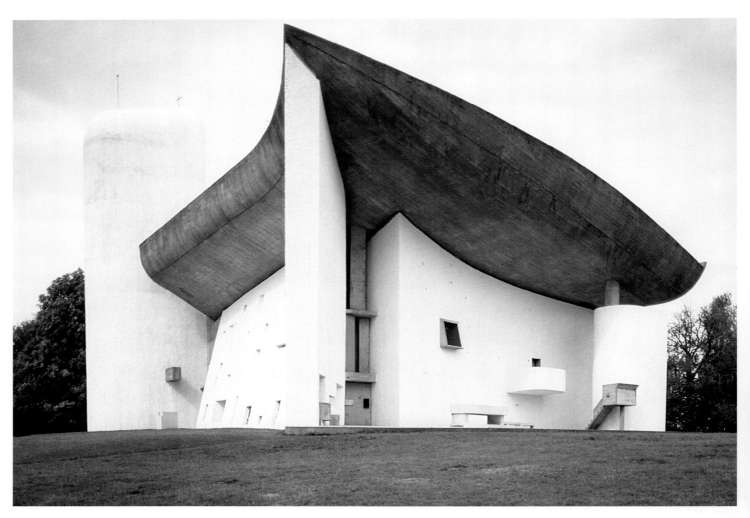

The shapes and forms that create a building's design can vary from ordinary to spectacular. How might your house, school, or church be considered a designed space?

Le Corbusier (1887–1965), Chapel of Notre Dame du Haut, 1951–53, Ronchamp, France. View from southeast. ©1987 Oliver Radford. ©2010 Artists Rights Society (ARS), New York/ADAGP, Paris/F. L. C.

A photographic reproduction of an artwork can be beautiful and inspirational, but it does not always give us an accurate view of the work. For example, note the measurements of *Howl from the Past*. In life, it is approximately five times larger than Kahlo's image shown on page 4.

Sylvia Glass (20th century), *Howl from the Past*, 1987. Acrylic and pastel on cloth, 55" x 56 ½" (140 x 144 cm). Courtesy of the artist.

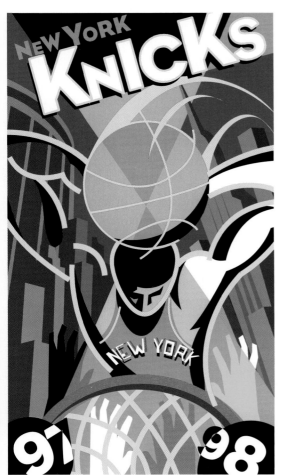

The designer of this graphic sought to convey an immediate message. Do you think the image is a successful communicator? Why or why not?

Graphic for New York Knicks 1997–98 season. Courtesy of Mecca Studios, New York.

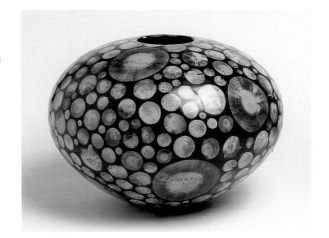

An understanding of the elements and principles of visual design will make you a more careful observer; as a result, you might more fully enjoy the pleasures of design in fine art, manufactured objects, and nature.

Philip Moulthrop (b. 1947), *White Pine Mosaic Bowl*, 1993. White pine and resin; lathe-turned, 14 ¼" x 20 ½" (36.2 x 52.1 cm). White House Collection of Contemporary Crafts. Photo by John Bigelow Taylor, New York.

Part One: The Elements of Design

Every creative process has its own tools and ingredients. Writers use paper and pen or computers to put together the ingredients of language, such as nouns and verbs. Chefs have ovens, pans, and spoons to create food by mixing assorted ingredients, such as flour, eggs, and fruit. Artists and designers might use brushes, paint, and canvas to combine the basic ingredients of art: the elements of design.

The elements of design include line, shape, form, value, color, space, and texture. You can see these elements all around you: nature offers an almost unlimited supply of them. The element of line, for example, can be seen in the thin stem of a flower, the curving ridge of a sand dune, or the intricate markings of a tropical fish. The six chapters of Part One define and provide many examples of each element.

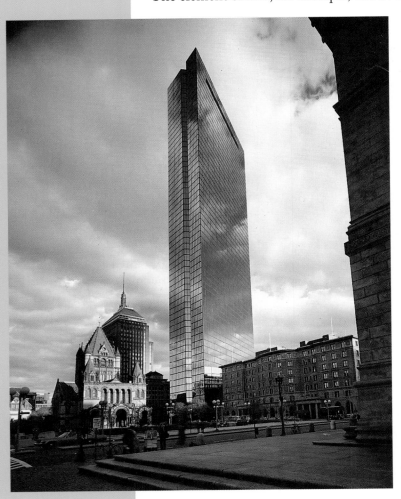

Although the elements of design are the basic parts of any work of art, there are many ways to use them. Like a writer or a chef, each artist and designer must make choices. An artist might choose to express ideas and feelings visually in pastel drawings, acrylic paintings, or sculpture. A designer might choose to express him- or herself in the design for a towering office building. In the following chapters, each element of design is isolated for study and discussion, but in both nature and art, they are rarely seen alone. Their many combinations provide a rich diversity of visual designs to explore.

Shape and form are emphasized in the design of this sky-scraper. Another essential element of its design is the shiny, reflective glass.
Henry N. Cobb (1859–1931) of Pei Cobb Freed & Partners, John Hancock Tower, Boston, Massachusetts. ©1980 Steve Rosenthal.

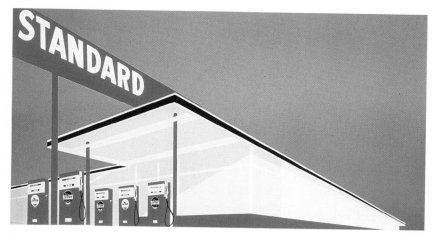

Some artworks are crisp and clear in their construction. Notice the sharp lines and simple shapes used by this artist.

Edward Ruscha (b. 1937), *Standard Station*, 1966. Silkscreen print, 25 ¾" x 40" (65.4 x 101.6 cm). Edition of 50. ©Ed Ruscha.

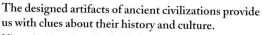

The designed artifacts of ancient civilizations provide us with clues about their history and culture.

Hieroglyphics. Photo by A. W. Porter.

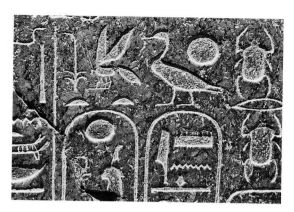

Nature often inspires artists. Dill (inset) creates abstract pieces that appear like land masses seen from a great distance. He often draws inspiration from photos released by the Jet Propulsion Laboratory. Compare the photo with Dill's artwork. What similarities do you find?

Laddie John Dill (b. 1943), *Untitled*, 1989. Cement and glass, 24" x 48" (61 x 122 cm). Courtesy of the artist.

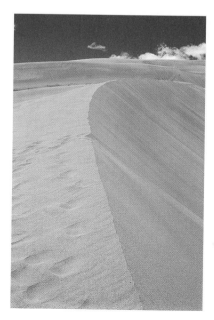

The elements of design can be found in nature. Artists often use nature as a guide or inspiration when designing.

Sand dunes. Photo by H. Ronan.

 This satellite photo of the Los Angeles area was released by the Jet Propulsion Laboratories in California. It marked the beginning of a computer animation project sponsored by NASA's Office of Space Science and Applications that would allow scientists to study the three-dimensional nature of global cloud cover.

LANDSAT satellite photo of Los Angeles area. Courtesy of the Public Information Office, Jet Propulsion Laboratory, California Institute of Technology, National Aeronautics and Space Administration, Pasadena, California.

1 Line

Key
Vocabulary

structural lines

outline

contour lines

gesture line

sketch line

calligraphy

line personality

implied line

line of sight

EXAMPLES OF LINE ARE EVERYWHERE. In nature, you see them as the stem of a flower and the stripes on a zebra. In architecture, the edge of a skyscraper and a fence surrounding a house both form lines. In art, lines may be the path made by a pencil or the stroke of a paintbrush. They are created by the wires of a mobile or the carvings in a stone sculpture. Lines are also formed when two objects meet or overlap, such as the line made by your upper and lower lips when you smile.

Lines can be thin or thick, continuous or interrupted. In general, they connect two points and are usually longer than they are wide. Whether you draw on the wet sand of a beach or write your initials on a chalkboard, you are using one of the most basic elements of design—the line.

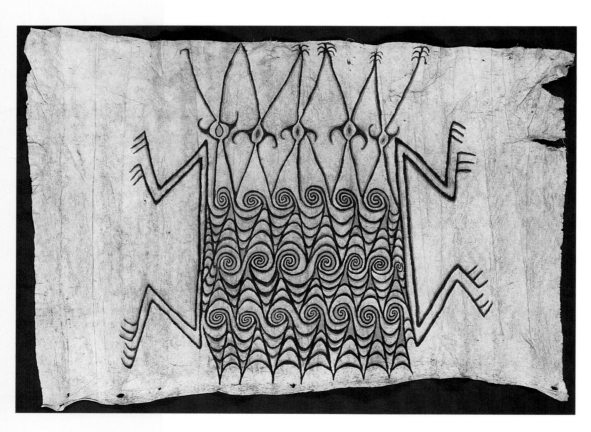

1–1 This work is from the island of New Guinea, near Australia. What words would you use to describe the creature or creatures depicted? How do the lines used by the artist help you describe the image?

New Guinea (Lake Senteni, Irian Jaya), *Barkcloth*, collected 1926. 68 ⅞" long (173 cm). Museum der Kulturen, Basel. Photo by Peter Horner.

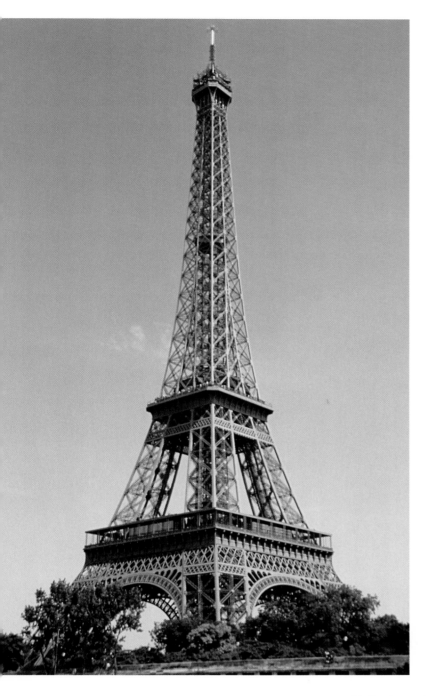

1–2 Had you ever thought of this very famous structure simply in terms of line? Its sleek profile foreshadowed modern skyscraper construction.

Alexandre-Gustave Eiffel (1832–1923), *Eiffel Tower*, 1889. Paris.

1–3 The lines, or stripes, on a zebra serve as camouflage as it roams its natural habitat. In what type of environment might these natural lines best blend?

Zebras, Ngorongoro Crater, Tanzania, 1996. Photo by David DeVore.

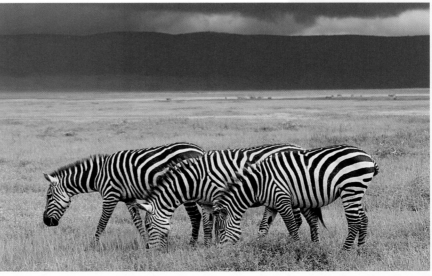

Line Types

Many types of lines are used to create art. Six of the most common are described below.

Structural Lines

Structural lines are the lines that hold a design together. Structural lines come in a variety of types with different characteristics and qualities. They can be delicate and thin like a spider's web, or thick and bold like a row of telephone poles.

Outlines

An *outline* generally refers to the outer edge of a silhouette, or the line made by the edges of an object. An outline makes an object seem flat and is usually the same thickness throughout. Tracing around an object placed on a sheet of paper is one way to create an outline.

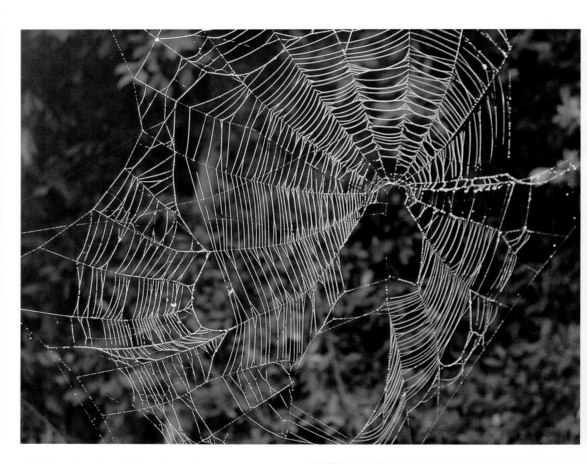

1–4 Note how these delicate lines of nature also communicate a sense of strength.

Spider Web. Photo by J. Gatto.

Try it

Choose a simple three-dimensional object, such as a chair or a shoe. Create a contour line drawing of the object. As you draw, work slowly and try not to remove your drawing tool from the paper. Keep your eyes on the object, not your paper. This is called "blind contour drawing." (It is acceptable to draw back over lines to get from one point to another.)

Contour Lines

Contour lines describe the shape of an object, and include interior detail. For example, a contour drawing of a person's face would include a line defining the shape of the head and additional lines that describe the surfaces and planes of the facial features.

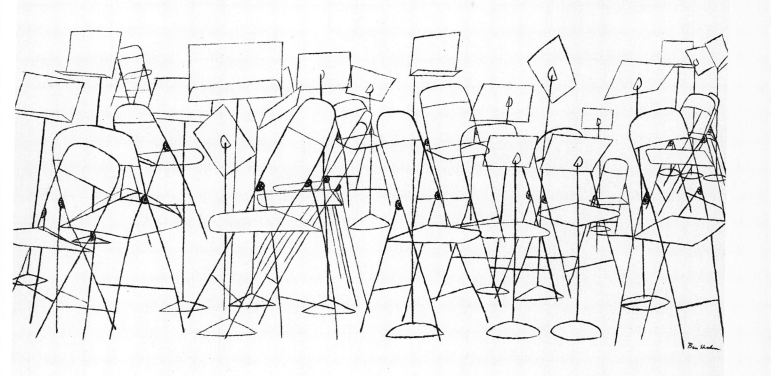

1–5 Why is an outlining technique particularly appropriate for conveying the physical characteristics of these objects?

Ben Shahn (1898–1969), *Empty Studio (Silent Music)*, 1948. India ink on paper, 26" x 40" (66 x 101.6 cm). The William S. Paley Collection. The Museum of Modern Art, New York. Digital Image ©The Museum of Modern Art, New York, ©Estate of Ben Shahn/Licensed by SCALA/ Art Resource, New York, ©VAGA, New York.

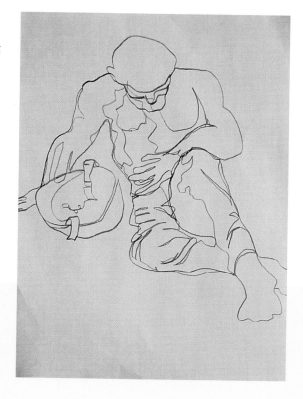

1–6 This contour drawing gives an indication of general physical features and folds in clothing.

Jeremy Mann (age 18), *Untitled Contour*, 1994. Pencil, 14" x 14" (35.6 x 35.6 cm). Plano Senior High School, Plano, Texas.

Gesture Lines

Gesture lines, sometimes called movement lines, emphasize direction and fluidity. Imagine a thin, continuous flow of line coming out of the drawing tool. By looping, twisting, and changing direction, gesture lines quickly describe a figure.

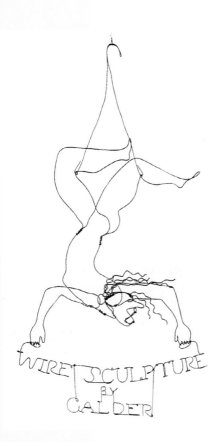

1–7 Note how the artist used irony in this work by writing out the words "wire sculpture" with the same wire he used to create the sculpture.

Alexander Calder (1898–1976), *Wire Sculpture by Calder*, 1928. Wire, 48 ¼" x 25 ⅞" x 4 ⅞" (122.6 x 65.7 x 12.4 cm). Collection of Whitney Museum of American Art, Purchased with funds from Howard and Jean Lipman, 72.168. Photo ©1998: Whitney Museum of American Art, New York. ©2010 Calder Foundation, New York/Artists Rights Society (ARS), New York.

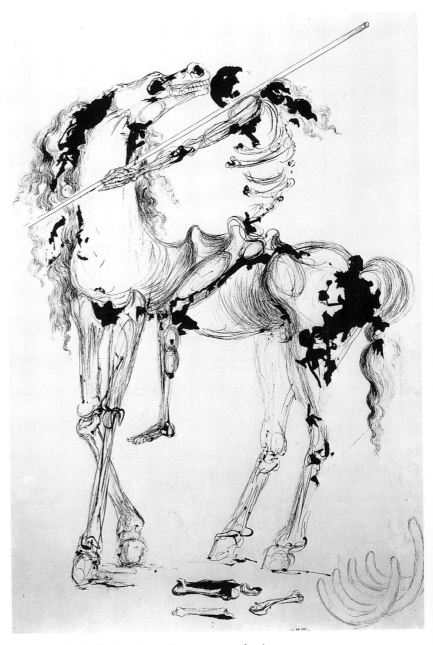

1–8 Salvador Dali often depicted strange, macabre images.

Salvador Dali (1904–89), *Cavalier of Death*, 1934. Pen and ink on paper, 38 ¾" x 28 ⅜" (98.4 x 72 cm). The Museum of Modern Art, New York. Gift of Ann C, Resor. Digital Image ©The Museum of Modern Art/Licensed by SCALA/Art Resource, New York. ©2010 Salvador Dali, Gala-Salvador Dali Foundation/Artists Rights Society (ARS), New York.

Sketch Lines

Sketch lines provide more detail than outlines, contour lines, and gesture lines. They can be drawn very quickly, but they sometimes have a finished appearance. Sketch lines often give an object the appearance of depth, or three-dimensionality. Artists use sketches for information-gathering.

Calligraphy

Calligraphy, from two Greek words meaning "beautiful writing," is precise, elegant hand-writing or lettering done by hand. The lines in calligraphy often vary between thick and thin, even within a single letter.

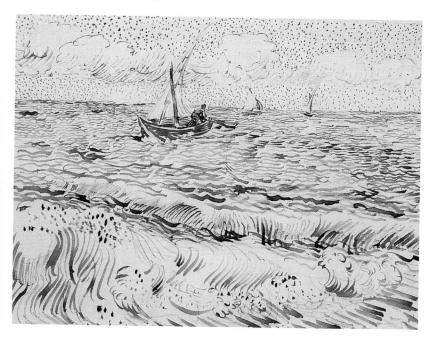

1–9 This drawing is not a nature study, but is a sketch based on one of van Gogh's own paintings. The artist was attempting to give a freer interpretation of the more precisely rendered painting.

Vincent van Gogh (1853–90), *Fishing Boats at Saintes-Maries-de-la-Mer,* 1888. Reed pen, brown ink, and graphite on wove paper, 9 ½" x 12 ½" (24.3 x 31.9 cm). Saint Louis Art Museum. Gift of Mr. and Mrs. Joseph Pulitzer, Jr. (137:1984).

1–10 The fluid motion of the lines in this emblem had to be drawn without hesitation or mistake.

Turkey (Istanbul, Ottoman period). *Tughra of Sultan Sulaiman the Magnificent,* 16th century CE. Ink, colors and gold on paper, 20 ½" x 25 ⅜" (52.1 x 64.5 cm). Rogers Fund, 1938 (38.149.1). The Metropolitan Museum of Art, New York. Image ©The Metropolitan Museum of Art/Art Resource, New York.

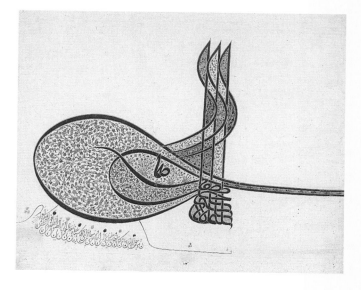

Line Personality

Artists often rely on *line personality*, or the general characteristics of a line, to convey a specific mood or feeling. You may have noticed that a thick line with sharp edges and sudden directional changes produces a feeling quite different from a thin, flowing one. The two basic characteristics of line are its direction or movement, and its quality or weight. The direction of a line may be vertical, horizontal, diagonal, or curved. You can use each of these directions to help give your artwork a different personality.

1–11 What aspects of a mountain landscape are emphasized through the use of line? Keep in mind that the black area at the top is also a part of the painting.

Sylvia Plimack Mangold (b. 1938), *Schunnemunk Mountain*, 1979. Oil on linen, 60" x 80" (152 cm x 203 cm). Courtesy of Alexander and Bonin, New York.

1–12 The artist has completely transformed the character of the bicycle parts he uses in this sculpture, even though some of the parts retain their original shape. A *chi wara* is a mythological man/antelope hybrid significant to the Bamana culture in Mali.

Willie Cole (b. 1955), *Speedster chi wara*, 2002. Bicycle parts, Overall: 46 ½" x 22 ¼" x 15" (118.1 x 56.5 x 38.1 cm). Sarah Norton Goodyear Fund, 2002. Albright Knox Art Gallery, Buffalo, New York. Photo: Albright-Knox Gallery/Art Resource, New York.

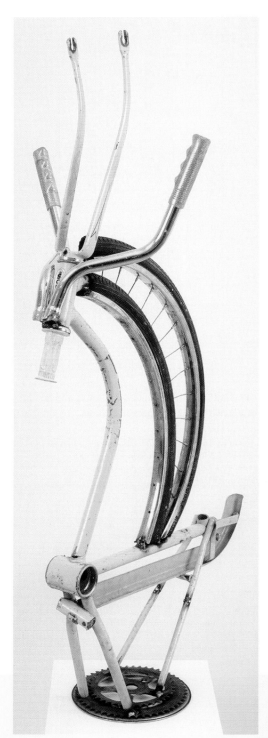

Vertical and Horizontal Lines

Vertical lines remind us of ourselves; they run straight up and down, as if they were standing. They might also bring to mind fences and forests, skyscrapers and soldiers. Artists use vertical lines to convey height, stability, and dignity.

Horizontal lines run from side to side. They call up images of the vast ocean, the horizon, or the body at rest. Artists use horizontal lines to suggest calmness, repose, and balance.

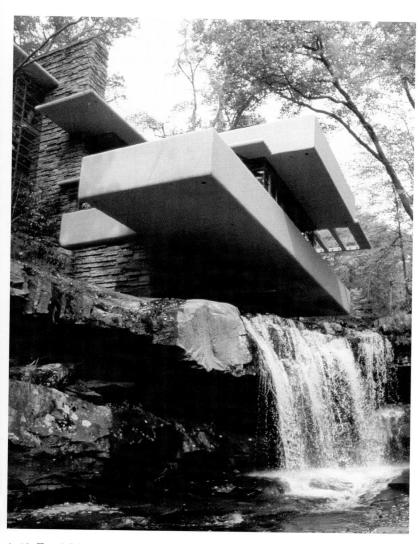

1–13 Frank Lloyd Wright was particularly interested in making his structures compatible with their environment. Note how he used construction materials that blend well with nature. How does he use line to bring together the building with its surroundings?

Frank Lloyd Wright (1867–1959), *Fallingwater (Kaufmann House),* 1936. Bear Run, Pennsylvania. The Frank Lloyd Wright Foundation, Scottsdale, Arizona ©The Frank Lloyd Wright Fund, AZ/Art Resource, New York. ©2010 Frank Lloyd Wright Foundation, Scottsdale, AZ/Artists Rights Society (ARS), New York.

1–14 Note how this student work has been tightly structured through the use of an informal grid made by horizontal and vertical lines.

Rebecca Moyer (age 15), *Rustic Wall,* 1998. Oil pastel, 18" x 24" (45.7 x 61 cm). Nashoba Regional High School, Bolton, Massachusetts.

Diagonal Lines

Diagonal lines run at an angle. They may describe a plane soaring across the sky, a tree falling down, or rays of sunlight. They can express action, movement, and tension. Diagonal lines often add a dramatic and dynamic aspect to a design.

Look at the black-and-white photograph of an agave plant (fig.1–17). The edges of the plant create sharp diagonal lines that shoot from the bottom of the image. Notice how the shadow continues the line of the plant into the upper left corner of the photograph. By using strong diagonal lines, the artist created a work of energy and action, even though her subject is a stationary plant.

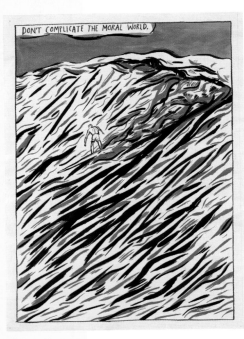

1–15 The lines in this drawing are so dynamic and powerful that they almost overwhelm the man surfing over and through them. Describe the difference in character between the black lines and the red ones.

Raymond Pettibon (b. 1957), *No Title (Don't complicate…)*, 1987. Ink and gouache on paper, 24" x 18" (60.3 x 45.7 cm). Gift of the Friends of Contemporary Drawing. (247.2000) The Museum of Modern Art, New York. Digital Image ©The Museum of Modern Art/ Licensed by SCALA/Art Resource, New York.

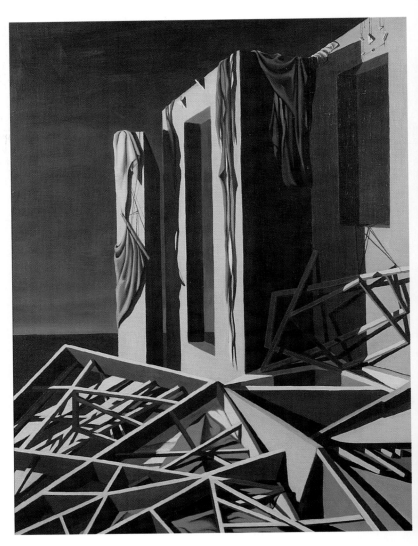

1–16 How are diagonal lines used in this composition?

Kay Sage (1898–1963), *All Soundings Are Referred to High Water*, 1947. Oil on canvas, 44" x 62" (112 x 158 cm). Davison Art Center, Wesleyan University, Middletown, Connecticut. Photo by R. J. Phil.

Imogen Cunningham

Imogen Cunningham was born in Oregon in 1883, the same year that the National Federation of Women Photographers was formed. At that time, women had little opportunity to succeed as artists; however, they were encouraged to enter the field of photography, a relatively new medium invented in the mid-1800s.

The photography bug bit Cunningham when she was in her early twenties. She pursued her interest by studying photographic chemistry, art history, and life drawing in Dresden, Germany. In the 1920s Cunningham turned her attention to photographing nature. Today, she is best remembered for her close-up studies of flowers and plants.

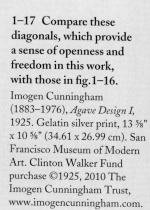

1–17 Compare these diagonals, which provide a sense of openness and freedom in this work, with those in fig.1–16.
Imogen Cunningham (1883–1976), *Agave Design I,* 1925. Gelatin silver print, 13 ⅝" x 10 ⅝" (34.61 x 26.99 cm). San Francisco Museum of Modern Art. Clinton Walker Fund purchase ©1925, 2010 The Imogen Cunningham Trust, www.imogencunningham.com.

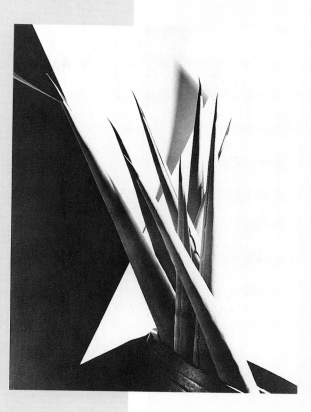

Imogen Cunningham (1883–1976), *Self-Portrait with Korona View,* 1933. ©1933, 2010 Imogen Cunningham Trust, www.imogencunningham.com.

Agave Design I (fig.1-17) is an example of the crisp, unadorned technique that led Cunningham to become a member of the famous Group f.64. This group of photographers believed that objects should be photographed in a sharp, detailed manner, without a dramatic setting, and without manipulation on the part of the photographer. *Agave Design I* clearly demonstrates this approach with its stark diagonal lines that create an image filled with strength and vitality.

Cunningham eventually shifted her attention from nature to portraiture. In the 1930s she worked for the magazine *Vanity Fair.* A popular figure in the world of twentieth-century photography, Cunningham was a special favorite among students until her death at the age of 93.

Curved Lines

Like diagonal lines, curved lines also express a sense of movement. But the motion of curved lines is fluid, not tense. They may represent rolling, turning, curling, or bending. If you've ever drawn a cumulus cloud, the rings of a tree trunk, spiraling smoke from a chimney, or the steep dips of a roller coaster, you've used curved lines.

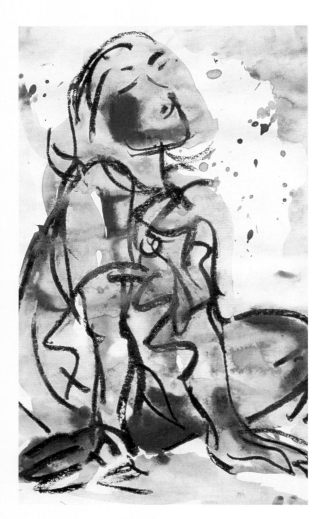

1–19 Note how line so easily communicates a mood or emotion.

Niklaus Troxler (b. 1947), *Poster for South African Jazz Night*, 1990. Silkscreen, 35 ⅝" x 50 ⅜" (90.5 x 128 cm). Courtesy of the artist. ©2010 Artists Rights Society (ARS), New York/ ProLitteris, Zürich

1–18 This figure is depicted at rest, yet the curved lines of which it is composed give it great liveliness and energy.

Aleksandra Otwinowska (age 16), *Untitled*, 1995. Mixed media, 18" x 12" (45.7 x 30.5 cm). Plano Senior High School, Plano, Texas.

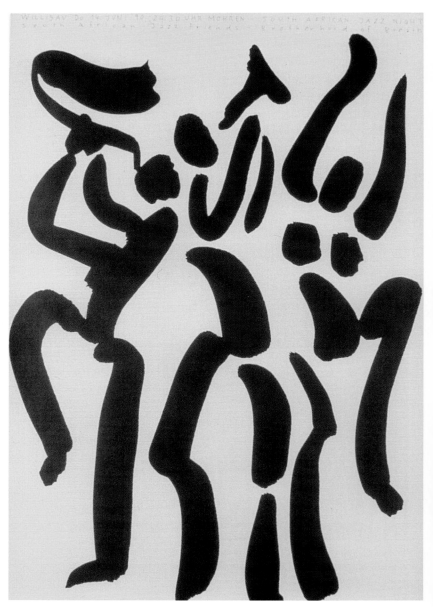

Look at the black-and-yellow poster (fig.1–19), an advertisement for a jazz concert. The curved lines provide a feeling of fun and festivity. The bold strokes capture a sense of motion in the figures. As a whole, the design conveys a sense of spontaneity and improvisation—important aspects of jazz music.

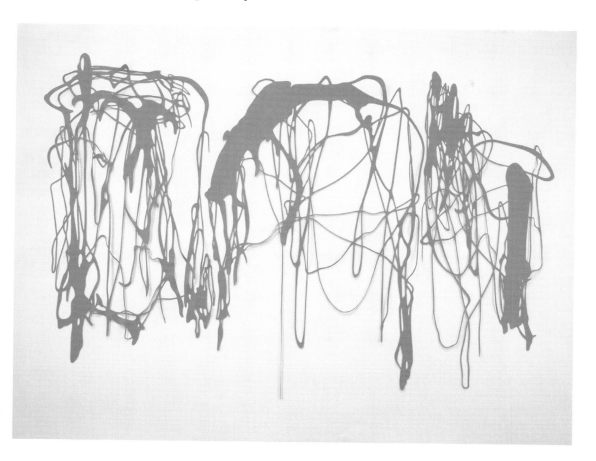

1–20 The artist projects ink drawings onto felt, which he then cuts out. What characteristics of this work make it seem liquid even though it is made of a solid material?

Arturo Herrera (b. 1959), *Before We Leave*, 2001. Wool felt, 84" x 144" (213.4 x 365.8 cm). Whitney Museum of American Art, New York; Purchase, with funds from the Contemporary Painting and Sculpture Committee and Chris Vroom and Illya Szilak, 2002.144a-c. Photograph courtesy of Brent Sikkema Gallery, New York. Courtesy of the artist and Sikkema Jenkins & Co.

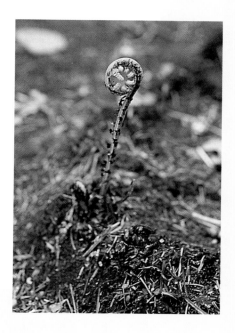

1–21 Nature contains a variety of lines. What are some other natural examples of curved line?
Fiddleheads. Photo by T. Fiorelli.

Try it

Select an interesting but common object with a curve, such as a protractor or a pair of scissors. Use thick and thin lines to draw and repeat the shape. Create a design by interweaving the images so that the curved lines and shapes break up and overlap. What kind of movement do the curved lines in your design create?

Line Quality

Line quality adds to the personality of a line. Structural lines may be thin and delicate, or thick and bold. These changes in line quality can emphasize—or contradict—what is conveyed by a line's direction. An artist may use broken or jagged lines to convey fear or irritability. Nervous, quick strokes can heighten the sense of tension or drama. Fuzzy, blurred lines might suggest a dreamy or mysterious mood. Horizontal lines usually convey calmness or rest.

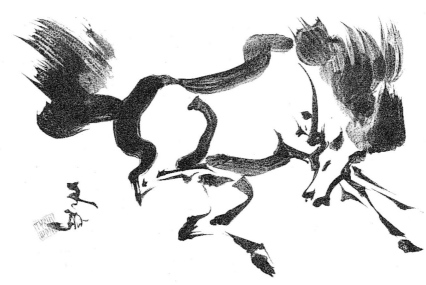

1–22 How would you describe the line quality used in this work?
Tyrus Wong (b. 1910), *Kicking Horse*, undated. Lithograph, 4" x 6" (10.2 x 15.2 cm). Collection of Shirl and Albert Porter.

1–23 Describe the type of line used to create the "nest" for the bird in this ring. What other types of line could this artist have used to create an enclosure? How would the line type change the mood?
Joseph Gatto. (b. 1934). *Nesting Bird*, 2010. Gold, ancient Roman fibula, pearls, coral, turquoise, 1 ¾" x 1 ¹¹⁄₁₆" x ⅞" (4.5 x 4.3 x 2.1 cm). Photo by Joseph Gatto.

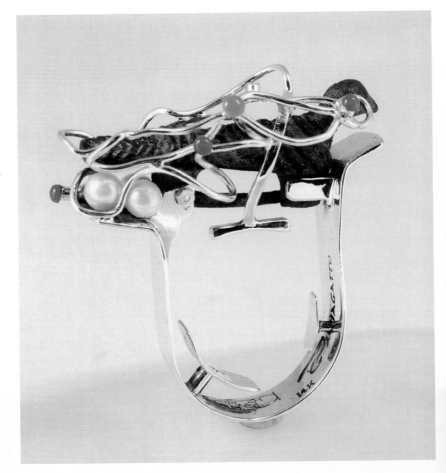

An artist's purpose or mood will determine the kind of line used. To represent an object as it actually appears, artists may choose simple, thin outlines and add many carefully drawn surface details. Cartoonists, on the other hand, may use thick outlines. They might exaggerate certain features and describe surface details with only a few well-placed lines. Other artists may use line to represent an object so that it isn't recognizable at all!

Remember: the personality of a line can suggest many different moods and feelings. This will help you view designs with more understanding. It will also help you convey meaning more effectively in your own creations.

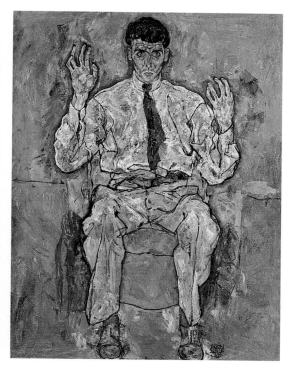

1–24 Note that this is a portrait of a painter. How do the jagged lines of the clothing convey the creative energy of the sitter?
Egon Schiele (1890–1918), *Portrait of Paris von Guetersloh*, 1918. Oil on canvas, 55 ⅛" x 43 ¾" (140 x 111 cm). ©The Minneapolis Institute of Arts. Gift of the P. D. McMillan Land Company.

1–25 Tintoretto was known for the speed with which he created his sketches and paintings. His hasty style is evident in the short, quick lines that bring this figure to life.
Tintoretto (1518–94), *Study for a Bowman in the Capture of Zara*, before 1585. Black chalk, 14 ⅜" x 8 ⅝" (36.5 x 22 cm). Gabinetto dei Disegni e Stampe, Uffizi, Florence.

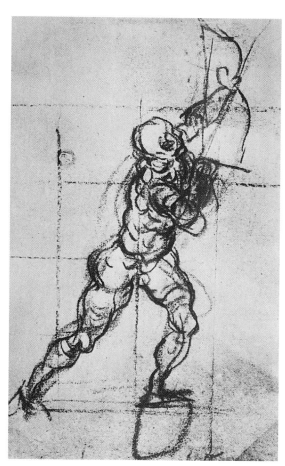

Implied Lines

Implied lines are suggested lines—lines that were not actually drawn or incorporated—in a work of art. Large objects or groups of objects may appear as lines when viewed from a distance: a winding road or river, a train speeding across the landscape, a row of tall trees. Your eyes fill in the spaces between a series of widely distanced marks or objects, thereby creating an implied line.

When objects or areas of color meet within a painting, collage, or sculpture, they also create an implied line. Where the shapes touch or overlap, they share an edge. On opposite sides of this edge may be two different textures, patterns, or colors. This shared edge may not be sharply drawn or defined, but it functions as a line within the overall design.

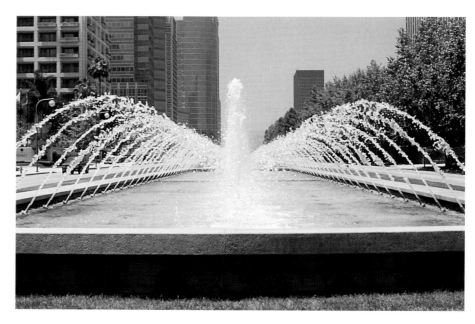

1–26 Implied lines are created in the space below the two arches of water.
Fountain, Century City, California. Photo by J. Selleck.

1–27 What implied lines can you find in this image?
Greene and Greene (Henry Mather Greene, 1870–1954; and Charles Sumner Greene, 1868–1957), *Gamble House,* 1908, detail of doorway. Located at 4 Westmore Place, Pasadena, California. Photo by H. Ronan.

Another type of implied line is a ***line of sight***, an imaginary line from a figure's eyes to a viewed object. A line of sight can help direct your attention from one part of a design to another. Look at the painting *Christina's World* (fig.1–28). The woman gazes into the distance, and the line of sight is an implied diagonal line that runs from her head to the farmhouse on the hill. What do you think the artist tried to convey with this painting? How did a line of sight help him achieve his result?

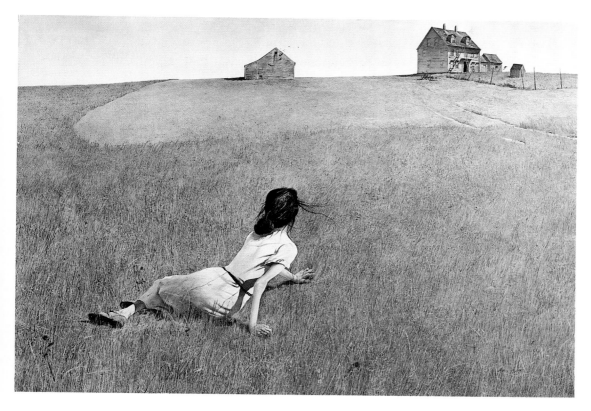

1–28 Christina Olsen, who was partially paralyzed and unable to walk, was Andrew Wyeth's neighbor when he summered in Maine near her farm. In this painting, the lines in her body and her line of sight indicate how she is straining to reach her house.

Andrew Wyeth (1917–2009), *Christina's World,* 1948. Tempera on gessoed panel, 32 ¼" x 47 ¾" (82 x 121 cm). Purchase, The Museum of Modern Art, New York. Photo ©1998 The Museum of Modern Art, New York. Digital Image ©The Museum of Modern Art/Licensed by SCALA/ Art Resource, New York.

1–29 How has this student juxtaposed shapes of different textures and patterns to create implied lines?

Ulises Kullick-Escobar (age 18), *Mexico Revisited,* 1996. Colored pencil, 14" x 17" (35.5 x 43 cm). Lake Highlands High School, Dallas, Texas.

Line as Texture and Pattern

Texture is the surface quality of an object—for example, whether it is rough, smooth, or scarred. Pattern is the repetition of a surface element; examples are the stripes on a shirt and the polka dots on a dress. Although texture and pattern are further discussed in Chapters 6 and 11, here we look at their relationship to line.

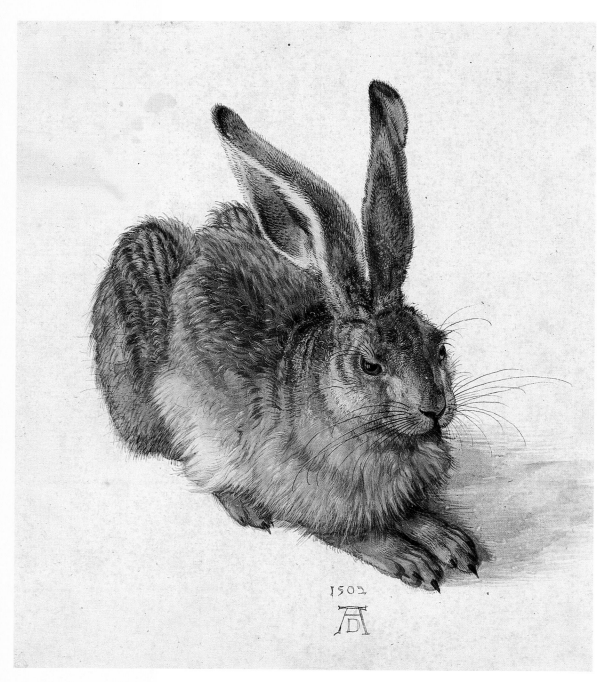

1–30 This artist was interested in science and often depicted animals and plants. Note how carefully he used line to show the familiar soft texture of a rabbit.
Albrecht Dürer (1471–1528), *Young Hare,* 1502. Watercolor with opaque white, 9 ⅞" x 9" (25 x 23 cm). Albertina, Vienna.

Artists often use a series of lines to suggest texture or pattern in their designs. In the watercolor of a hare (fig.1–30), Dürer's finely drawn lines capture the texture of soft, fluffy fur and lengthy whiskers. In the textile design (fig.1–31), the artist's short, bold lines combine to create a repetitive geometric pattern.

Sometimes, an artist achieves texture or pattern through the lines that occur in materials. A sculpture may display the grain of wood. A collage may include a piece of plaid fabric. Texture and pattern can also be increased by marking, carving, or otherwise altering the surface quality. In the Maori sculptures (fig.1–32), both straight and spiraling lines are etched into painted wood to create an intricate surface pattern.

1–31 What two types of line did the artist use to create this pattern?
Varvara Stepanova (1894–1958), *Textile design*, 1924. Gouache on paper, 12 ½" x 10 ⅞" (31.8 x 27.7 cm). ©Rodchenko and Stepanova Archive, Moscow and Estate of Varvara Stepanova/RAO, Moscow/VAGA, New York.

1–32 The Maori of New Zealand have a tradition of carving wood panels to decorate the interior and exterior of some of their buildings. Careful examination of these carvings reveals a series of stylized human forms. These figures often represent ancestors.
New Zealand, Maori. *House front panels*, 19th century. Painted wood and haliotis shell inlay, 108–132" high (274.3–335.3 cm). The Nelson Atkins Museum of Art, Kansas City, Missouri. Gift of Mr. and Mrs. W. Howard Adams and Mr. and Mrs. Julius Carlebach, F61-12/1-10.

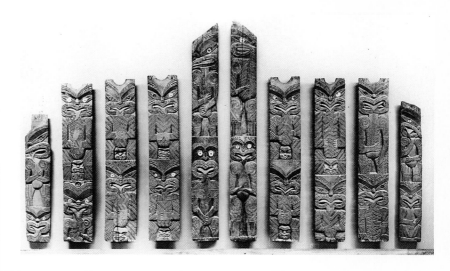

Try it

Experiment with different techniques to discover ways of using line to create texture and pattern. You might draw with twigs and ink, erase lines into a charcoal drawing, or carve lines of varying thicknesses into a plaster block. For ideas, look at natural objects in which texture and pattern are prominent: the bark of a tree, the stripes on an animal, the veins on a leaf, the walls of an eroded canyon.

Line Combinations

A line combination is a mixture of different line types and personalities. In nature, many things appear to contain a variety of lines. Think of a tree. You might depict it using thick, rough-textured lines for the trunk, thinner lines for the branches, and short, soft-edged lines to represent leaves.

In a design, artists might use line combinations to create a sense of depth. Bold lines generally appear closer to the viewer. Indistinct lines seem farther away. When combined in a single design, the mixture causes some shapes to appear to be in front of others. Artists might also use short, criss-crossed strokes called crosshatchings. These lines can suggest the edges of a rounded object or the shadows within the folds of material. Notice how the artist used crosshatchings in his illustration for the book *Alice's Adventures in Wonderland* (fig.1–34).

Line combinations can create texture and pattern. When you combine lines in a design, ask yourself if the texture or pattern you're considering has a real purpose. Will it add a needed visual interest? Will the pattern be boring? Will it compete with the structural lines or with crosshatchings? Sometimes, a design is most effective when line combinations are used sparingly.

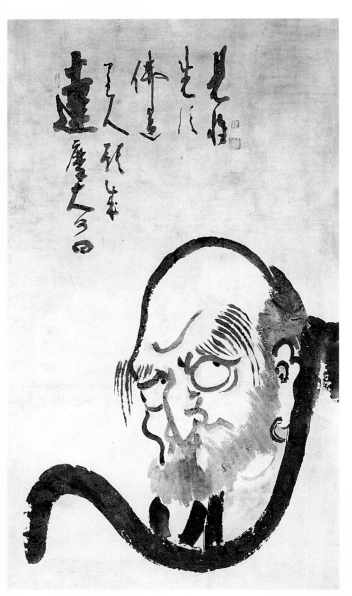

1–33 The artist used the curved line of the bald head and the curving thick line below to tightly frame the portrait.
Ekaku Hakuin (1685–1768), *Portrait of Daruma*, undated. Ink on paper, 63" x 36⅝" (160 x 93 cm). Freer Gallery of Art, Smithsonian Institution, Washington, DC. Purchase, F1973.10.

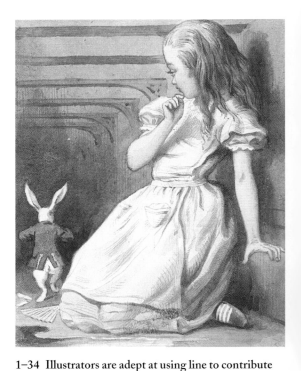

1–34 Illustrators are adept at using line to contribute to the illusion of space and rounded objects.
Sir John Tenniel (1820-1914), *Alice and the White Rabbit.* Illustration from Lewis Carroll's *Alice's Adventures in Wonderland.* ©1995 Macmillan Publishers Ltd. Reproduced by permission of Macmillan Children's Books, London.

Flying Ant Dreaming

Did you know that the oldest continuous culture in the world is the Aboriginal people of Australia? The continent has been occupied by humans for at least 40,000 years. An integral part of this culture is the idea of dreaming. This concept is very difficult to define, but it refers to Dreamtime, or several states of time and place. It reaches back to the beginning of life in Australia.

Dreaming incorporates a time when the Aboriginals believe that ancestral figures traveled the unformed earth. These beings shaped the natural landscape and created everything on the earth. Where they walked, valleys were formed and where they bled, lakes were created. The Aboriginals believe that they are descendants of these ancestral figures.

Aboriginals view Dreamtime as a state of being that encompasses both the past and the future. When they engage in certain rites, such as dancing, art making, and ceremonial walking, the Aboriginals believe that they share in Dreamtime and become one with the earth.

Dreaming forms the basis of much Aboriginal art. Dreaming designs first made their way to the modern medium of acrylic on canvas in the 1970s. Ancestral figures and natural landmarks are depicted in an abstract style. Sometimes called dot paintings, these works are composed of a series of painted dots generally arranged in curving lines. Each dream painting relates to the personal and tribal Dreamtime of the artist. The works depict sacred beings and sites. Only the initiated members of the artist's tribe can fully understand the meaning and symbolism of a dream painting.

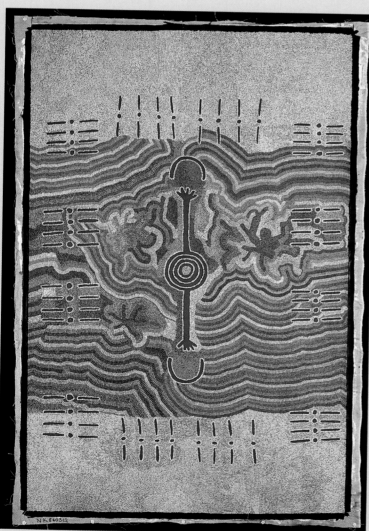

1–35 The artist used a series of evenly spaced individual dots of color to create the lines in this composition.
Norman Kelly Tjampijinpa (b. 1938), *Flying Ant Dreaming,* 20th century. Collection of Tom Raney, NY. Aboriginal Artists Agency, Sydney, Australia. Photo by Jennifer Steele/Art Resource, New York. ©2010 Artists Rights Society (ARS), New York/VISCOPY, Australia.

Another Look at Line

1–36 How many different types of lines can you find in this print, and how do they interact? The artist uses three very labor-intensive printing processes, but still makes her lines look effortlessly dynamic.

Julie Mehretu (b. 1970), *Untitled (for Parkett no. 76)*, 2006. Etching, engraving, and drypoint, plate: 15 ¾" x 19 ⅝" (40 x 49.8 cm); sheet: 23 ¼ x 28 ¼" (59 x 71.8 cm). Publisher: Parkett Publishers, Zurich-New York. Printer: Burnet Editions, New York. Edition: 60. Acquired through the generosity of Anne and John Coffin. The Museum of Modern Art, New York. Digital Image ©The Museum of Modern Art/ Licensed by SCALA/Art Resource, New York.

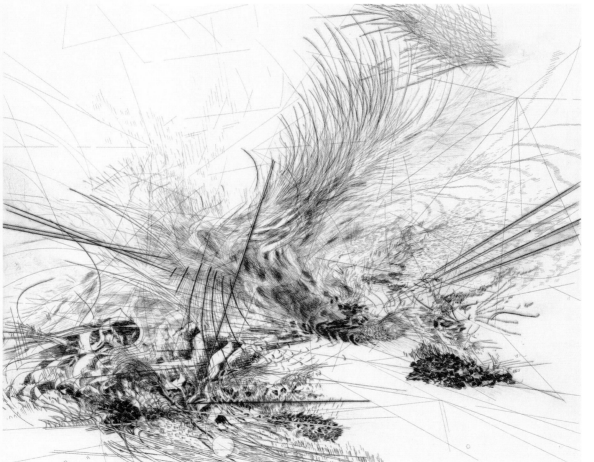

1–37 Can you tell what contradictory sensations the artist created by use of a variety of lines?

Will Rollins (age 18), *Untitled*, c. 1989–90. Welded and galvanized steel, plaster, and acrylic traces, 9' x 8 ½' (2.74 x 2.59 m). Los Angeles County High School for the Arts, Los Angeles, California.

1–38 The artist used line to emphasize the roundness of the hands. The crisp quality of the line also ensures the clarity of the image, an important aspect of instructional illustration.

Anthony Ravielli (1910–97), Illustrations for *The Modern Fundamentals of Golf*. Scratchboard, courtesy of the artist.

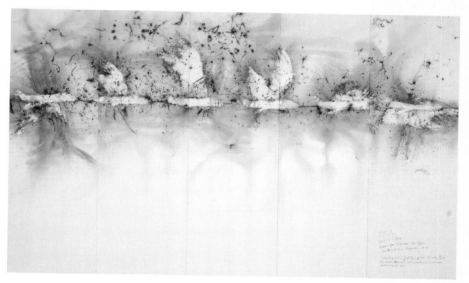

1–39 Common objects can form interesting linear compositions that we often overlook.

Wires and shadows. Photo by J. Selleck.

1–41 A petroglyph is a carving or inscription on a rock. How does the material affect the types of lines used?
Petroglyphs, Utah. Photo by H. Ronan.

1–40 Here, the artist used an unconventional medium: gunpowder. Describe the character of these lines. What do the lines reveal about how they were made?
Cai Guo-Qiang (b. 1957), *Bird of Light*, 2004. Gunpowder on paper, mounted on wood as five-panel screen, 90.55" x 146.64" (230 x 375 cm). Private collection, London. Photo courtesy Cai Studio.

Review Questions

1. What feelings and moods do horizontal, vertical, and diagonal lines usually suggest?
2. What is the difference between an outline and a contour line?
3. What are two characteristics of line that give the line personality and help convey a specific mood or feeling?
4. What are implied lines? Give an example of an artwork in this chapter that illustrates implied lines. Be prepared to point out these implied lines to other members of your class.
5. Name an artwork in this chapter in which the artist used lines to create texture.
6. For what type of artworks is Imogen Cunningham best known?
7. Describe the lines in the piece of Aboriginal art, *Flying Ant Dreaming*. On what continent do Aboriginal people live?

Career Portfolio

Interview with a Cartoonist

Cartooning is an art form with an emphasis on line. Bold outlines are the principal—often the only—element in a cartoon drawing.

Gene Mater is a free-lance artist, caricaturist, and graphic artist who has been active professionally since 1971. For seven years his cartoon strip *Gremlin Village* appeared in college newspapers, and his cartoon illustrations have appeared in numerous magazines, books, and other publications. He is best known for his good-natured cartoon portraits. Born in 1949 in San Bernardino, California, he currently lives and works in Bethlehem, Pennsylvania.

What would you call your occupation?

Gene Artist, cartoonist, or artist-entertainer, because I'm using the artwork to entertain people. I don't know anyone who does exactly what I do. There are a lot of people who call themselves caricaturists, but they're not artists who really talk to the people and find out things about them that they include in the drawings to make them a one-of-a-kind statement. Also, the drawings that I do for people are generally more cartoon portraits than caricature. A caricature, where you're really using major distortion, is a harder thing to do well, and not everyone's face or temperament do I find suited to that. Mostly what I do is cartoon portraits of people; that is to say, they are recognizable drawings/renderings of people, done in a cartoon style.

Tell us about some of your first paying jobs.

Gene My first work was political cartoons, but they didn't pay very well, even though that's what I concentrated on right out of college. I was trying to build it up enough so that I'd have a following and get good enough to show it to the syndicates [who buy and market cartoon strips nationally]. But I was moving very slowly, and I was just not confident that I was good enough.

A lot of kids know they like to draw, but don't know what to do with it.

Gene Well, sure, because there is such a breadth and width of possibilities. You can do everything from cartooning to formal oil portrait painting and everything in between. You can do fine arts, or you can do commercial arts. You can just work on paper, or you can do mixed media. There are so many different things, and that's just for drawing. I think one of the best things a person can do is to play with as many options as possible.

What would you tell teenagers about pursuing an art career?

Gene If I could get any point across to a teenager who liked art, it would be to just accept the fact that you're

going to doubt your work, that you're going to feel insecure, and that everybody else's work is going to look better, including a lot of your peers. It's not just how good an artist you are at any given point that matters. It's also how much you pursue it. I have known many, many artists who didn't have the drive and they didn't stick with it. You can always learn to be better. You can acquire skills like in any other line of pursuit.

Talk about your future goals.

Gene I would like to continue doing the kind of cartoon portrait entertainment I enjoy. Because I do enjoy people and I enjoy that instant gratification, both for them and for myself, of spending six minutes on a drawing and then having it done and having the person just sit there, look at it, and laugh. I really like it. That was one of the problems with the cartoon strips. I could never see anybody's reaction. So, sit somebody down in front of me, and let me draw him or her, and let me see those smiling faces when I'm done.

Gene Mater uses his sense of humor on the job—in this case, a cartoon portrait of himself.

Studio Experience

Wire Sculptures from Gesture Drawings

Task: To make a series of gesture drawings and create a wire sculpture that emphasizes motion.

Take a look.
- Fig.1–7, Alexander Calder, *Wire Sculpture by Calder.*
- Fig.1–8, Salvador Dali, *Cavalier of Death.*
- Fig.1–22, Tyrus Wong, *Kicking Horse.*

Think about it. Compare Tyrus Wong's drawing of a horse with that of Salvador Dali. Notice how Wong emphasizes the movement and shape of the horse with a few quick lines, whereas Dali has created rounded forms with many overlapping lines. In both drawings, note the main lines that run through the body. In Dali's gesture drawing, follow the lines that extend from the horse's head through the body and into the legs. Follow the implied line that runs through the rider's bent back. These lines suggest movement and form in the gesture drawings.

Do it.

1 Do a series of gesture drawings of figures in action poses, such as dance or sports positions. Use a black marker or a pencil on drawing paper. Draw quickly, looking for the main action lines in each pose. Select one of your sketches to turn into a wire sculpture.

2 Bend sculpture wire with your hands and pliers to create a form that emphasizes the major lines in the figure. Try to create a three-dimensional sculpture. Turn it around to view it from several different angles.

3 Staple the wire sculpture to a wood base. If color is needed, consider painting the base or the wire with acrylic paint.

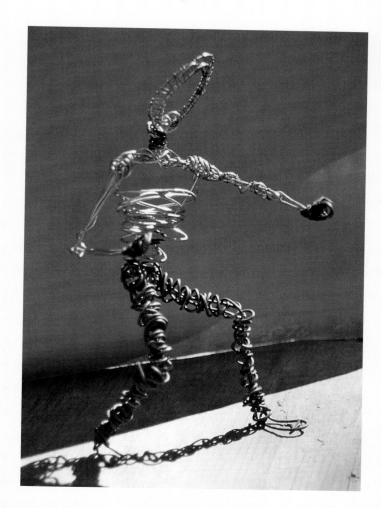

"I learned that wire has a drawing quality similar to pencil or pen. Using wire makes it possible to draw in 3-D instead of 2-D."

Max Ilizarov (age 17), *Untitled,* 1998. Wire, 8" high (20 cm). Clarkstown High School North, New City, New York.

Helpful Hints
- Use a minimum amount of wire to show just the essence of the form; use more wire for a more solid form.
- Wrap wire loosely around a pencil to form coils in some parts of the sculpture.
- If you add extra lengths of wire to the sculpture, small pieces of wire tend to dangle and not stay in place. So, cut the extra piece of wire slightly longer than what you need, and work it back into the main part of the form.
- Use two different kinds of wire to add contrast to your sculpture.
- Consider modifying your composition to include additional figures.

Check it.
- Analyze the lines in your sculpture. Can you see main action lines that run through your art? Describe these lines.
- Is your sculpture balanced so that it does not topple over?
- Can others tell what action you portrayed in your sculpture?

- If you were to make another piece of art like this, what would you do differently?
- Look at your sculpture from all angles to better determine the success of its design.

Other Studio Projects

1 Using a brush and ink or paint, draw different kinds of lines—thick, thin, straight, curved, fast, slow—without making recognizable images. What are the characteristics of each line? Describe the personality of the lines.

2 Listen to two or three kinds of music for a few minutes each. Without drawing recognizable objects, try to capture the feeling and rhythm of the music with lines only.

2 Shape and Form

Key Vocabulary

shape

form

geometric shape

organic shape

static

dynamic

WHEN A LINE CURVES AROUND and crosses itself or intersects other lines to enclose a space, it creates a shape. Similar to a silhouette or an outline, a *shape* is two-dimensional. It has height and width, but no depth. It has one boundary and a single surface. We can easily identify many objects, from guitars to light bulbs, by their shape alone.

The word *form* describes something with three dimensions: length, width, and depth. Forms usually have weight and solidity. They may have only one continuous surface, like a Ping-Pong ball. Or they may have many surfaces, like a fish tank or a pinecone.

2–2 The artist has allowed the familiar shape of an octopus to surround this jar.

Minoan (from Palaikastro). *Minoan vase decorated with an octopus,* c. 1500 BCE. 11" high (28 cm). Archaeological Museum, Herakleion, Crete, Greece. Scala/Art Resource, New York.

2–1 Consider the variety of shapes and forms that can be found on a single tree.

Trees. Photo by Joseph Gatto.

Sculptors, architects, and product designers generally work with forms. They create solid structures, which have actual volume. Cartoonists, painters, photographers, and collage artists, on the other hand, usually work in two dimensions, even when they are depicting forms. When an artist paints an apple, for example, he or she may use the apple's shape and add shading to create the illusion of three-dimensionality, or form. But the image itself has only two dimensions.

2–4 Designed for quick, efficient, and safe travel, a highway interchange creates sweeping forms in the landscape.
Freeway. Photo by J. Selleck.

2–3 The figure is created from a series of well-defined and precisely cut forms.
Pre-Columbian. (Zapotec culture, CE 250–600), *Urn in the form of Cociyo, God of Lightning and Rain.* From Monte Albán IIIa, Oaxaca, Mexico c. CE 400–500. Ceramic. 28 ½" x 21" x 18" (72.4 x 53.3 x 45.7 cm). AP 1985.09 Kimbell Art Museum, Fort Worth, TX. Photo: Kimball Art Museum, Fort Worth, Texas/Art Resource, New York.

Categories of Shapes

Artists and designers use various types of shapes and forms to create their finished products. In this chapter, you will explore these types and how they affect you as both artist and viewer. Although the following sections often refer specifically to shapes, in most cases, the information may be applied to both shapes and forms.

Geometric and Organic Shapes

Shapes fit easily into two basic categories: geometric and organic. *Geometric shapes* are precise and sharply defined. Many of them are easy to recognize, such as circles, squares, and triangles. We often see such shapes in architecture. Also, many manufactured and handmade products are based on geometric shapes. Nature shows us some geometric shapes and forms too. Honeybees make combs whose cells are in the shape of a hexagon, and an orange resembles the form of a sphere.

2–5 These rock formations have been shaped by natural forces such as wind and water.
Rock. Photo by A. W. Porter.

2–6 David Smith sculpted many similar works, which he also called *Cubi*. In all of them, he explored design problems dealing with simple geometric forms in space.
David Smith (1906–65), *Cubi, XIV*, 1963. Stainless steel, 125 ½" high (311.2 cm). Saint Louis Art Museum, Friends Fund (32:1979). Art ©Estate of David Smith/Licensed by VAGA, New York.

Although you may recognize certain geometric shapes in nature, most natural objects have **organic shapes**. Organic shapes reflect the free-flowing aspects of growth. They are often curved or rounded and appear in a variety of informal and irregular shapes. The form of a pear is organic. So too is the shape of a maple leaf.

Look at the geometric and organic shapes and forms on these pages. Do you see obvious differences and similarities? The painting by Joan Miró (fig.2–8) uses mostly organic shapes that are curved and round. The photograph of the *Bonaventure Hotel* (fig.2–7) shows that the structure is made up of geometric forms—both straight-edged rectangular forms and curving cylindrical ones.

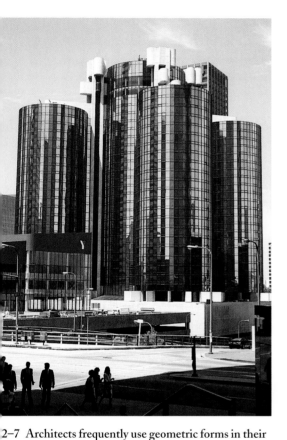

2–8 How would you describe the various shapes that Miró uses in this work?

Joan Miró (1893–1983), *Series Black and Red (Série noire et rouge)*, 1938. Drypoint printed in black and red, 6 ⅝" x 10 ¼" (16.8 x 25.8 cm). ©The Cleveland Museum of Art, 1998. Bequests of Charles T. Brooks and Grover Higgins by exchange, 1981.25. ©2010 Successió Miró/Artists Rights Society (ARS), New York/ADAGP, Paris.

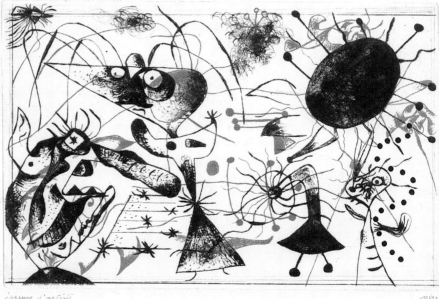

2–7 Architects frequently use geometric forms in their building designs. The cylindrical towers of glass and steel lend an air of elegance to the design of this hotel.

John Portman (b. 1924) and Associates, *Bonaventure Hotel,* 1975. Los Angeles. Photo by A. W. Porter.

Curved and Angular Shapes

Geometric and organic shapes may be either curved or angular. Shapes that are curved are graceful, and because the eye rapidly sweeps along them without interruption, they tend to imply movement.

Angular shapes, on the other hand, are straight-edged. They suggest strength and regularity. When you look at angular shapes, your eyes move along the shape and stop momentarily where one shape connects with another. These meeting or opposing shapes may add a sense of tension to a design. If an angular shape, for instance, leans to one side, it might suggest movement.

Compare the sculptures by José de Rivera (fig.2–11) and William Tucker (fig.2–12). The curved shapes of the first piece describe movement that is both fluid and predictable. The second sculpture expresses quite a different feeling. The objects leaning into one another give the piece a sense of tension. Although both sculptures convey motion, Tucker's sculpture shows opposing thrusts of horizontal, vertical, and angular forms.

2–9 The shape of the nautilus shell is more clearly defined by the bands of colors that accent the curve of the shell.
Nautilus shell. Photo by A. W. Porter.

2–10 The intertwining of these roots makes strong angular shapes.
Tree roots. Photo by A. W. Porter.

Try it

To explore the contrasting feelings of different shapes, draw two designs. Construct one with only curved shapes. Construct the other with only angular shapes. You may use rulers, compasses, french curves, and triangles to help you create the shapes.

2–11 This sculpture is made with a forged rod of stainless steel.

José de Rivera (1904–85), *Construction 8*, 1954. Stainless steel forged rod, 10" x 16" x 13" (25.4 x 40.6 x 35.5 cm) including base. The Museum of Modern Art, New York. Gift of Mrs. Heinz Schulz. Digital Image ©The Museum of Modern Art/Licensed by SCALA/Art Resource, New York.

2–12 Notice the similarities between these cylinders and the roots in fig.2–10.

William Tucker (b. 1935), *Untitled*, 1967. Steel, 80" high (203 cm). Franklin Murphy Sculpture Garden, University of California, Los Angeles. Photo by J. Selleck.

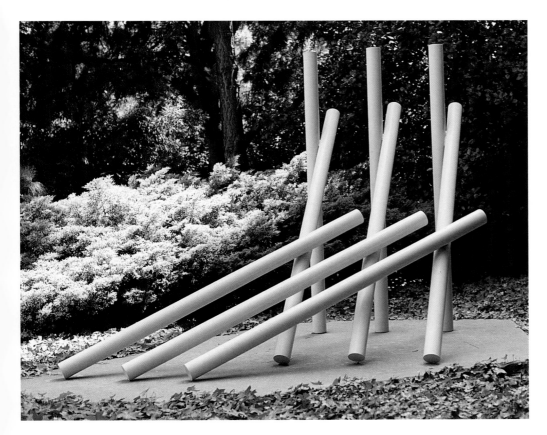

Positive and Negative Shapes

Every design—whether it is a painting, sculpture, building, or photograph—is made of positive and negative shapes. Positive shapes are the tangible, actual aspects of a design. In painting or drawing, they often represent solid forms, such as a bowl of fruit in a still life. In sculpture, the positive shapes are the solid forms of the sculpture itself.

Negative shapes are the areas that either surround the positive shapes or exist between them. In a still-life painting, they are the spaces around the bowl of fruit, between fruit forms, or in the background. In sculpture, the negative shapes are the empty spaces around and between the solid forms.

Positive and negative shapes are equally important. A successful design is one that carefully balances both. Look at the pre-Columbian *Pendant figure* (fig.2–16). Notice that the artist placed two curved openings above the figure's arms. These negative shapes echo both the curves of the figure's headdress above and those of the blade below. Together, the positive and negative shapes create a unified whole.

Sculptures and silhouettes present a strong contrast between positive and negative shapes. Sometimes, however, an artist prefers to blur the boundaries between them. Study *Plus Reversed* by Richard Anuszkiewicz (fig.2–13). Can you tell which shapes are positive and which are negative?

Create a design in which you balance positive and negative shapes. Use a sheet of white or cream-colored paper to represent the negative shapes. Cut a number of positive shapes from black paper. Arrange these into a variety of positions, and study the kinds of negative shapes you can produce. When you are satisfied with your design, glue down the black shapes.

2–13 Anuszkiewicz explores optical illusion in his art, and his work helped lead the way to the development of the 1960s art movement called Op Art.
Richard Anuszkiewicz (b. 1930), *Plus Reversed*, 1960. Oil on canvas, 74 ¾" x 58 ¼" (189.6 x 148 cm). Blanton Museum of Art, The University of Texas at Austin, Gift of Mari and James A. Michener, 1991. Photo: George Holmes Art. ©Richard Anuszkiewicz/ Licensed by VAGA, New York.

2–14 The effectiveness of this piece relies heavily on the contrast between its positive and negative shapes.
Anna Atkins (1799–1871), *Pink Lady's Slipper, Collected in Portland (Cipripedium)*, 1854. Cyanotype, 10 ³/₁₆" x 7 ¹⁵/₁₆" (25.8 x 20.2 cm). J. Paul Getty Museum, Los Angeles, 84.XP.463.3.

Jacob Lawrence

Jacob Lawrence was born in 1917 and grew up in Harlem, New York, during the Great Depression. The public library (fig.2–15) there played an important role in his life: he took his first art class in its basement, and he also spent many hours there researching African-American history. This research provided him with the ideas and information he needed to create his many series of painted images. Each series highlights an important figure (such as Harriet Tubman or Frederick Douglass) or event (such as the migration of people from the South to the North) in African-American history.

Jacob Lawrence brought a personal vision to his work that was little influenced by the upheavals within modern art. Unlike most

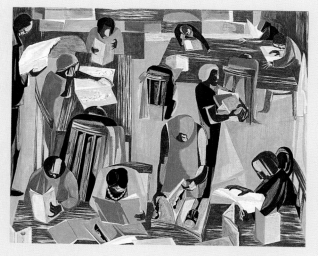

2–15 How has Jacob Lawrence unified the negative areas of this painting?

Jacob Lawrence (1917–2000), *The Library*, 1960. Tempera on fiberboard, 24" x 29 ⅞" (60.9 x 75.8 cm). Smithsonian American Art Museum, Washington, DC. Photo: Smithsonian American Art Museum, Washington, DC/Art Resource, New York. ©2010 The Jacob and Gwendolyn Lawrence Foundation, Seattle/Artists Rights Society (ARS), New York.

artists who progress through a variety of stylistic changes during their career, Lawrence's style showed little variation throughout the sixty years he painted. The subjects of his painting focused on the things he knew best: African-American history, culture, and contemporary life.

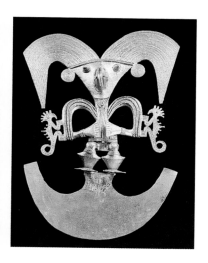

2–16 Note how the negative (empty) areas in this figure form an important part of the overall design.

Popayán (Cauca). *Pendant figure with headdress*, 1000–1600 CE. Cast and hammered gold, 6 ½" x 4 ¾" (16.5 x 12.1 cm). Museo del Oro, Banco de la República, Bogotá.

Try it

Paint or draw a still life. You may use a small cardboard frame as a viewfinder to help you search for effective positive and negative shapes. Once you've found a pleasing arrangement, begin by drawing or painting all the negative shapes. Then add the positive ones.

Qualities of Shape

Shapes and forms also have different qualities. To understand a shape's quality or appearance, you can use your senses. Your sense of sight can tell you if a shape is pleasing to look at. Use of several senses together can also give you information. Touch and sight will tell you about a form's surface and weight. Through sight, touch, taste, and even hearing its crunch, you know that an apple is hard and crisp. Being aware of appearances—such as perceived weight, surface quality, and position—will help you portray shapes and forms convincingly in your designs.

2–17 Looking at and touching the white downy head of the dandelion weed informs us of its light delicate shape. Its fine structure is designed to be set free by the wind to distribute seeds for new plants.

Dandelion (Taraxacum officinale). Photo by J. Scott.

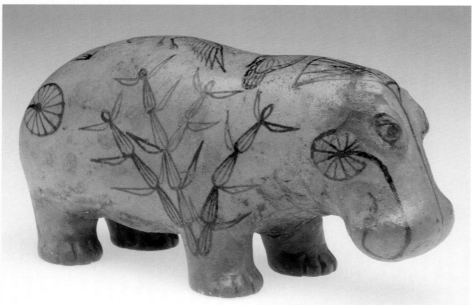

2–18 **The weighty appearance of this hippo is in contrast to its small size.**

Egyptian, Middle Kingdom to Second Intermediate Period, Dynasty 11–13, *Hippopotamus*, ca. 2040– after 1638 BCE, Faience. Height: 2 ⅝" (6.6 cm). Museum Appropriation Fund 29.119. Photo: Erik Gould, courtesy of the Museum of Art, Rhode Island School of Design, Providence.

Try it

Choose two objects that are about the same size. Draw one light and soft, and draw the other heavy and solid. Try to capture the contrast between the objects' surface qualities. Then create a small sculpture of each object. Use materials like thin wire or string to suggest airiness and delicacy. Use clay or wood to convey solidity and weight. Compare the two representations of each object to each other and to the original object.

Light and Heavy Shapes

There is a striking difference in the perceived weight of a cloud and that of a boulder. To draw or construct shapes effectively, an artist must understand how to convey qualities such as lightness and heaviness. Soft, floating clouds usually require a lighter touch, with a subtle blending or blurring of edges. Rocks and boulders, on the other hand, demand a strong, hard quality.

Look at the landscape painting by Thomas Moran (fig.2–19). Notice how Moran depicted the sky, the mountains, and the mist of falling water. Each is distinct and recognizable.

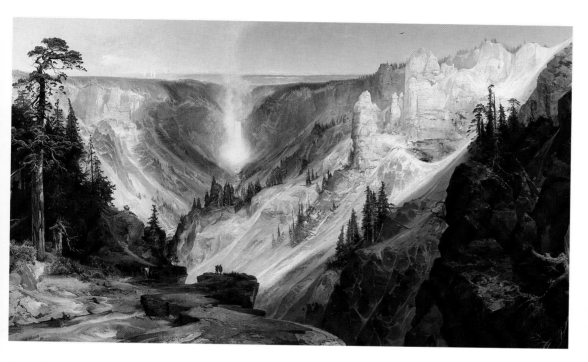

2–19 Artists and tourists continue to capture this famous area, now part of Yellowstone National Park.
Thomas Moran (1837–1926), *The Grand Canyon of the Yellowstone*, 1872. Oil on canvas, 7' x 12' (2.13 x 3.66 m), Lent by the Department of the Interior Museum. Smithsonian American Art Museum, Washington, DC. Photo: Smithsonian American Art Museum, Washington, DC/ Art Resource, New York.

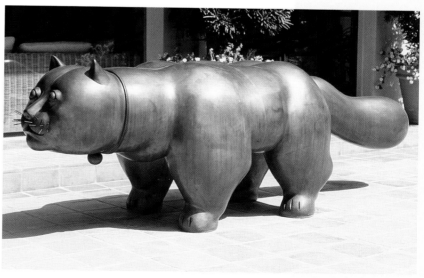

2–20 The heaviness of the forms exaggerates the weight of the cat and provides a uniquely humorous appearance.
Fernando Botero (b. 1932), *Cat*, 1984. Bronze, 39" x 128" x 42" (99 x 325.1 x 106.7 cm). Estate of Frederick R. Weisman. Photo by J. Selleck.

Smooth and Textured Shapes

Another important quality of a shape is its surface. Is the surface flat and reflective like a pane of glass? Or is it rough and pitted like tree bark? Your eyes and your fingers move easily across the smooth surfaces of glass, sanded wood, polished metal, and plastic. The speed of your observation is slowed by a textured surface, such as an intricately knitted sweater or the shell of a turtle.

Light strongly affects the surface qualities of a shape. A smooth surface reflects light easily, and the reflections can be very bright. A heavily textured surface tends to absorb light, thereby reflecting far less. Notice the difference between the smooth and textured surfaces in fig.2–23.

By emphasizing surface qualities, artists can create shapes and forms that are both interesting and lifelike. Pay attention to surface quality: doing so can help you appreciate the unique and the not-so-unique—in nature, in art, and in everyday objects.

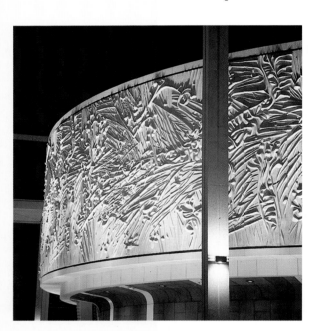

2–21 How has the night-time lighting enhanced the outer surface of this theater?
Welton Becket (1902–69) and Associates, *Mark Taper Forum*, Music Center, 1964–69. Los Angeles. Photo by A. W. Porter.

2–22 The artist uses smooth shapes to create a flowing sense in the chair's construction.
Alan Siegel (1913–78), *Torso Chair*, 1977. Wood, 28" x 17" x 29" (71.1 x 43.2 x 73.7). Frederick R. Weisman Art Foundation, Los Angeles.

Try it

Use lightweight paper and crayons or soft-leaded pencils to create rubbings. Choose a variety of surfaces: smooth, textured, and a mixture of both. Place the paper on the surface. Then rub a crayon across it until the surface texture becomes apparent. These experiments will help you create various surface textures in your own designs.

2–23 This student work demonstrates an effective combination of smooth and textured surfaces. The smooth, reflective wire and marbles stand out from the colored paper, which absorbs the light.

Josh Jones (age 19), *Wire Screen.* Wire, colored paper, marble, 12" high (31 cm). Montgomery High School, Skillman, New Jersey.

Try it

Gather items with intriguing textural surfaces, such as pieces of tree bark, grains of sand, and various seeds. Design a texture collage by gluing the items onto different areas of cardboard. You might create a design that combines geometric and organic shapes.

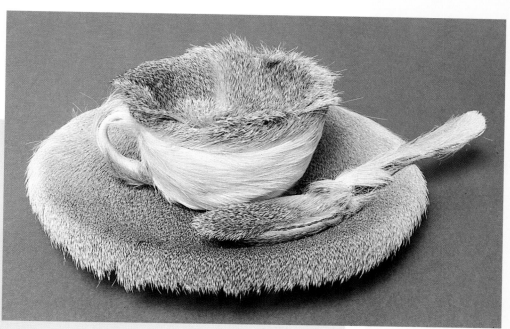

2–24 Why does this artwork make many people feel so uncomfortable?

Meret Oppenheim (1913–85), *Object (le dejeuner en fourrure)*, 1936. Fur-covered cup, saucer, and spoon; cup 4 ⅜" (10.9 cm) diameter; saucer 9 ⅜" (23.7 cm) diameter; spoon 8" (20.2 cm) long; overall height 2 ⅞" (7.3 cm). The Museum of Modern Art, New York, Purchase. The Museum of Modern Art, New York. Digital Image ©The Museum of Modern Art/Licensed by SCALA/ Art Resource, New York. ©2010 Artists Rights Society (ARS), New York/ProLitteris, Zürich.

About the Artwork

Meret Oppenheim

Object

We expect common objects to have certain recognizable surface textures. Artists, however, sometimes transform everyday items into ones that are surprisingly eerie and bizarre. Meret Oppenheim, the creator of *Object*, was a Swiss artist of Surrealism, a twentieth-century style of art in which artists combine normally unrelated objects and situations.

The idea for *Object* was born during an encounter between Oppenheim and Picasso in the Café de Flore in Paris. Picasso admired Oppenheim's bracelet, which was made from brass and covered with fur, remarking that anything might be covered with fur. The story goes that Oppenheim then requested some hot water for her tea that had grown cold. The expression in French for a warm-up is *un peu plus de fourrure* ("a little more fur")— and the seed for the concept was planted.

Continuing the train of thought begun by her conversation with Picasso, Oppenheim, after leaving the café, immediately headed for a department store to purchase a teacup and spoon. The result was her renowned fur-lined cup, which is simply called *Object*.

The first few times that *Object* was exhibited, it received both praise and anger from the public. Unusual effects, such as those in *Object*, can provoke a strong psychological reaction in the viewer—even when the original form is simple and innocent. *Object* became the symbol of Surrealism; it is almost always mentioned in any discussion of the movement.

Static and Dynamic Shapes

The position of a shape or form is important and might suggest rest and stability or a feeling of energy and movement. Shapes that are in either a vertical or a horizontal position will appear to be standing still or resting; these shapes are *static*. Leaning or diagonal shapes suggest falling, running, or climbing. The shapes appear to be active, or *dynamic*. Dynamic shapes are associated with change or movement.

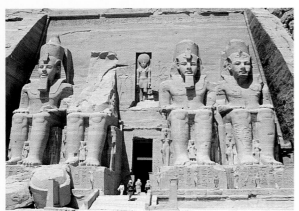

2–25 Describe how the artist achieved a sense of stability and permanence in these gigantic figures.

Ancient Egypt. *Four colossi of Ramses*, c. 1257 BCE. From the Temple of Ramses II, 59' high (18 m). Abu Simbel. Photo by Richard Putney, University of Toledo, Toledo, Ohio.

Try it

Create two small sculptures—a static arrangement and a dynamic arrangement. You may use clay, paper, or toothpicks joined with bits of clay. Note the category of shapes you use to create each sculpture: Do you rely on certain categories to make a static arrangement and others for a dynamic one?

2–26 Compare the sweeping motion of these figures with the static poses of Ramses II (fig.2–25). What words would you use to describe each?

Charles Demuth (1883–1935), *Three Acrobats*, 1916. Watercolor and graphite on paper, 12 15/16" x 7 7/8" (33 x 20.3 cm). Amon Carter Museum, Fort Worth, Texas, 1983.127.

An artist may use static shapes to produce a peaceful landscape design. For example, a combination of vertical trees and a horizontal stream can imply quiet and calm. But static shapes can also be used to convey permanence and power. Look at the monumental carvings at Abu Simbel, in Egypt (fig.2–25). The static shapes of this ancient temple display a sense of solidity and immovability; such constructions announced to all that the great pharaohs who built them were to be obeyed and respected.

To achieve a more active feeling, an artist must turn to more dynamic shapes. Notice the curved and fluid shapes in Charles Demuth's *Three Acrobats* (fig.2–26). The shapes produce an atmosphere of movement and change; the figures seem to be whirling across the paper. Soft watercolors and light pencil lines underneath add to the airiness of the design.

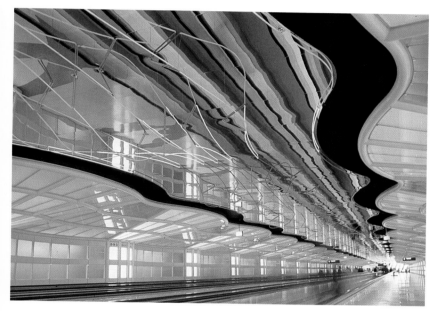

2–27 The United Airlines terminal at Chicago's O'Hare International Airport uses dynamic shapes to create an eye-catching show for travelers.
Michael Hayden (b. 1943), *Sky's the Limit*, 1987. Neon tubes, mirrors, and computer controlled music, 744' long (226.8 m). United Airlines Terminals, O'Hare International Airport, Chicago. Courtesy of United Airlines.

2–28 These robot sculptures by Nam June Paik are made of actual TVs and radios. The boxlike forms convey a sense of rigidity and awkwardness, but the lights and sounds of the TV screens and radio speakers add a dynamic quality that is not apparent in a still photograph.
Nam June Paik (1932–2006), *Family of Robot: Grandfather and Grandmother*, 1986. Video sculpture, grandmother: 80 ¾" x 50" x 19" (205 x 127 x 48 cm); grandfather: 101" x 73" x 20 ½" (256.5 x 185 x 52 cm). Courtesy of the Holly Solomon Gallery, New York.

Try it

Use only vertical and horizontal shapes to make a cityscape from cut paper. Contrast this to a work that emphasizes diagonal or other dynamic shapes. How are the works different?

Form and Light

Both artificial and natural light have an enormous effect on shapes and forms. Bright sunlight, for instance, can create dark shadows and glaring highlights. But as the sun sets or goes behind a cloud, crisp, well-defined landforms change to dark, flat shapes. A great contrast in light is also noticeable in the soft light of sunrise and the dazzling light of noon.

The angle of the light also helps define the forms we see. An overhead source of light usually creates shorter shadows and can make surface textures indistinct. A source of light from one side will lengthen and distort the shadows, calling attention to details of surface texture. (See Chapter 6 for more about the way light affects textures.)

2–29 How does the angle of the light in each of these three images define the form of the face?

Photos by T. Fiorelli.

Collect objects with varying surfaces and angles. You may wish to use something round, like a globe; something with a flat, shiny surface, like a piece of metal; and something with pleats or folds, like fabric or paper. Cast light from a floodlight or lamp onto the objects from different angles to dramatize the forms.

2–30 The powerful forms of this building are emphasized by the late-afternoon sunlight cast against the exterior walls. The contrasts of light and shadow enhance the solid structural forms.

St. Francis of Assisi, Ranchos de Taos, New Mexico. Photo by A. W. Porter.

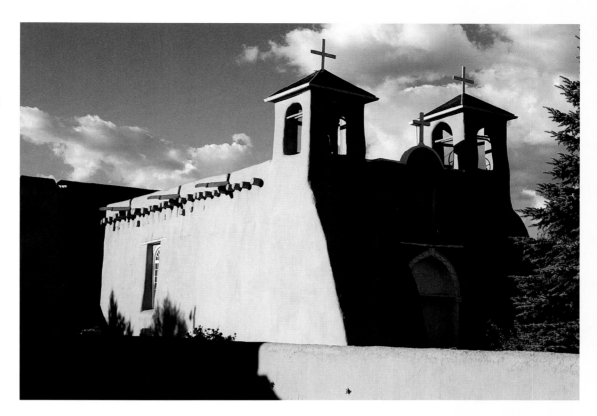

2–31 How does the artist draw the viewer's attention to this work?

Kumi Yamashita (b. 1968), *An Exclamation Mark,* 1995. Wood, light, cast shadow, 48" x 78" x 6" (121.9 x 198 x 15.2 cm). Courtesy of the artist. ©1995 Kumi Yamashita. Photo by Richard Nicol.

On round or curved forms, light creates gradual changes and shadows. Usually, the brightest and darkest areas are separated from one another by many gradations of light. On angular and sharp-edged forms, however, the changes can be sudden. The brightest highlights may appear right next to the darkest shadows. These changes from light to dark are discussed more fully in Chapter 3.

Light is a powerful part of design; it has a strong impact on both the shapes and forms you see and those you reproduce in your art. An understanding of light and shadow is critical to the mastery of form. Experiment with light and try to duplicate its numerous effects.

2–32 Impressionist Claude Monet devoted countless hours to painting outdoors. He worked at various times of day and during different seasons. Compare his two 1894 paintings of Rouen Cathedral, in France.

Claude Monet (1840–1926), *Rouen Cathedral Façade and Tour d'Albane (Morning Effect)*, 1894. Oil on canvas, 41 ¾" x 29 ⅛" (106.1 x 73.9 cm). Museum of Fine Arts, Boston Tompkins Collection—Arthur Gordon Tompkins Fund, 24.6. Photograph ©2010 Museum of Fine Arts, Boston.

2–33 How has the artist used shadows and colors to show mid-day light?

Claude Monet (1840–1926), *Rouen Cathedral Façade*, 1894. Oil on canvas, 39 ⅝" x 26" (100.6 x 66 cm). Museum of Fine Arts, Boston. Juliana Cheney Edwards Collection, 39.671. Photograph ©2010 Museum of Fine Arts, Boston.

2–34 Knapp calls this work a "lightpainting," though it also includes the sculptural elements of glass and steel. Why do you think he chose this term?
Stephen Knapp (b. 1947), *Temporal Meditations*, 2005. Light, glass, stainless steel, 107" x 354" x 10" (271.8 x 899.2 x 25.4 cm). Collection of the Flint Institute of Arts, Flint, Michigan, 2009.53. ©Stephen Knapp 2005.

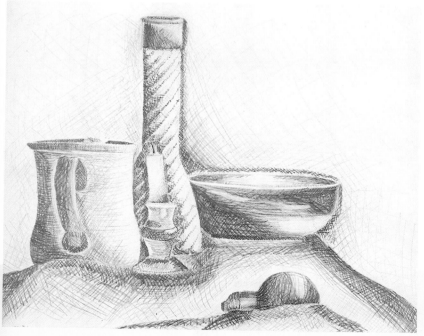

2–35 This still-life drawing explores the effect of light on curved forms.
Lauren Totero (age 15), *Still Life with Vase*, 1997. Pencil, 11" x 14" (28 x 36 cm). Clarkstown High School North, New City, New York.

Try it

In your home, school, or neighborhood, look at shadows created by artificial and by natural light. Using just black and white media, experiment with designs that capture any shadows with unusual or intriguing shapes.

Another Look at Shape and Form

2–37 Using the terms you have learned in this chapter, how would you describe these natural forms?

Cactus. Photo by A.W. Porter.

2–38 What are the positive and negative areas in this painting?

Henri Matisse (1869–1954), Les Codomas (The Acrobats), from Jazz, 1947. Pochoir Collection of the McNay Art Museum, San Antonio. Gift of Margaret Pace Willson and family. Photo by Archives Henri Matisse. ©2010 Succession H. Matisse/Artists Rights Society (ARS), New York.

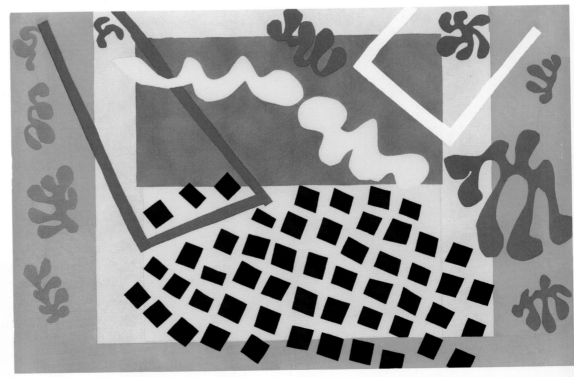

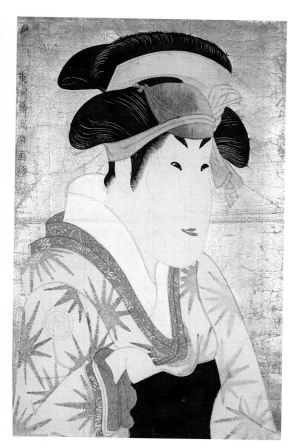

2–41 This image was so popular when it was first created, it was even made into a postage stamp. How did the artist play with the shapes and forms to make a unified and playful artwork?
Robert Indiana (b. 1928), *Love*, 1972. Polychrome aluminum, 72" x 72" x 36" (182.9 x 182.9 x 91 cm). Galerie Denise René, New York. ©2010 Robert Irwin/ Artists Rights Society (ARS), New York.

2–39 The Japanese are masters at making compositions built of shapes. Notice how flat the figure is. Can you see the area where the artist has added a sense of form?
Toshusai Sharaku (active 1794–95), *Segawa Kikunojo III as O-shizu*, 1794. Color woodcut, 14 ¹¹/₁₆" x 9 ¾" (37.3 x 24.5 cm). The Samuel S. White III, and Vera White Collection. Philadelphia Museum of Art, Philadelphia, Pennsylvania. Photo: The Philadelphia Museum of Art/ Art Resource, New York.

2–40 Analyze how this student work makes use of shapes and forms to create a dynamic composition.
Rachel Youngs (age 17), *Dance*, 1998. Watercolor, 18" x 24" (45.7 x 61 cm). Wachusett Regional High School, Holden, Massachusetts.

Review Questions

1. Define shape and form. Give an example of shape and a related form, such as a circle and a Ping-Pong ball.

2. What is the difference between a geometric and an organic shape? Give an example of each.

3. What are positive and negative shapes? Name one image in this chapter that you think shows an effective use of positive and negative shapes. Identify the main positive and negative shapes in the image.

4. List six qualities of shapes. Select one image in this chapter and use the names of these qualities to describe the design.

5. How does light influence how we see form? Name an artist who was interested in the effect of light on form.

6. What is unusual about Meret Oppenheim's *Object*? What style of art is this?

7. What subjects does Jacob Lawrence depict in his painting series? Why did he choose to depict these subjects?

Career Portfolio

Interview with a Type Designer

The letters of the printed words you read in books and magazines are called type. A type designer carefully crafted the shape of each letter. **Cyrus Highsmith** tried several different art forms and media before realizing that he wanted to be a type designer. Born in Milwaukee, Wisconsin, in 1973, he is a senior designer for a digital type foundry in Boston, Massachusetts, and teaches in the graphic design department at R.I.S.D. [RIZ-dee, Rhode Island School of Design].

How did you get interested in type?

While I was studying at R.I.S.D., I got more and more interested in typography. It seemed to me that to be a good graphic designer, you had to know about type. To create the typography I wanted, I started to draw my own letters. Drawing letters quickly became the most interesting part of the project for me. Making type was more fun than just using it. But more than that, drawing type felt to me like a very pure form of drawing. It was distilled down into just black and white, form and counterform, contour and shape.

How do you design letters?

Henri Matisse once said, "I don't paint things. I only paint the difference between things." Matisse was obviously not talking about type design—he was a painter. Nevertheless, in just a few words, he summarizes type design's critical element: the trick of getting all the letters to appear like they belong together as a group, while remaining identifiable as themselves. This is the balancing act that runs through any typeface. How do you do it? The secret is you don't draw the letters, you draw the differences between them. You draw what makes an "a" different from a "b."

Tell me about the most well-known typeface you've designed.

That's probably my series *Antenna*. Beyond the tension that is usually visible in the way I draw contours, in *Antenna* I tried to place a new emphasis on the repeat and variation of counter shapes with the spaces between characters. It comes in seven weights in four widths, with matching italics—that's 56 variations total. Lately, *Antenna* has been popular with newspapers and magazines.

I have also seen it used in the titles of some television shows.

What advice would you give to a young person who's really interested in type?

The best advice I ever got as a young person was "Quit school!" I had already dropped out by the time I got it but it was nice confirmation. If you are not into school, don't waste your time and money. My best students are often the ones who have taken some time off previously or went to the wrong school first. Then when you are ready to focus, go back to school, and go crazy with type or drawing or whatever it is you like.

Where have you seen your type being used?

All sorts of places. Newspapers, magazines, packaging, on television, in movies … I see people reading my typefaces sometimes. It is a strange experience. But I am not tempted to interrupt and introduce myself. Type design is a good medium if you are a private person like myself but also have the urge to publish.

AMIRA

LUNAR ECLIPSE PREDICTED
Missions to Mars and even beyond our galaxy
Rocket fuel
Extraterrestrials are out there
SOLAR WINDS
New worlds waiting to be discovered
Orbiting Rocks
Astronauts trained their entire lives for this
Expatriots
EXILED FROM THE EARTH
NewPlanets
SPACE SHIPS ON A FUTURISTIC QUEST
ASTRONOMY

The cross between calligraphy and sans serif is rare, inhabiting territory between Hermann Zapf's Optima, classical sans structure with a calligraphic spirit, and Warren Chapell's Lydian, classical calligraphy without serifs. Cyrus Highsmith claims adventurous new ground with Amira, a letterform that pops from the page with an angled vitality that both welcomes and surprises readers with bright new rhythms and texture.

Studio Experience
Shape Collage

Task: To create a paper collage with organic and geometric shapes that are overlapped and repeated.

Take a look.
- Fig.2–26, Charles Demuth, *Three Acrobats.*
- Fig.2–38, Henri Matisse, *Les Cadona.*

Think about it. Think about how you would answer the following questions relating to both the Matisse and the Demuth depiction of acrobats.
- Identify the geometric and organic shapes. Which shapes are angular? Which shapes are repeated?
- Which shapes are dynamic, creating a sense of movement? How has the artist positioned shapes on the page to create a sense of action? Which shapes are static?
- Identify positive and negative shapes. Are the black squares in the Matisse collage positive or negative shapes? Why do you think this?
- Which shapes overlap and which touch the edge of the picture plane? How does this overlapping and extending of shapes to the edge of the picture affect the whole composition?
- How has the artist used shape to unify the composition?

Do it.

1 Cut both organic and geometric shapes from various colors of 9" x 12" paper. For example, to develop human shapes, use either a marker or a pencil to make a series of gesture drawings of action poses. Cut out several of the poses, saving the paper from which they were cut, perhaps for use as negative shapes and a means of repeating a shape. Turn the shapes over so that the drawing does not show.

2 Arrange the cut shapes on a 12" x 18" paper of contrasting color. Cut

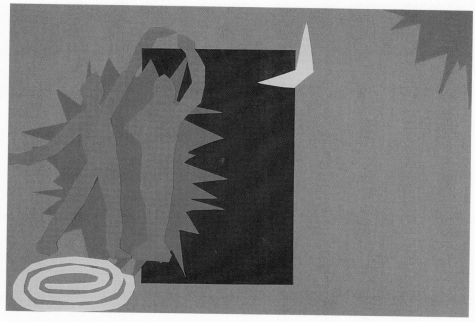

"This is a collage of two people dancing under moonlight. I used a dark background to make the other colors stand out. The 'explosive,' bright shapes were used to indicate exciting, happy movement. The yellow spiral floor was also used for this reason. The moon was used to express romance, and the reddish/purple color was chosen to show passion."
MacKenzie Lewis, (age 17), *Midnight Mambo*, 1998. 12" x 18" (30 x 46 cm). Notre Dame Academy, Worcester, Massachusetts.

out additional organic and geometric shapes from paper of another color, and add these to your collage. You might want to cut out several versions of the same shape in various sizes or colors. Use a utility knife to cut out details and small interior shapes.

3 Before gluing down the shapes, experiment with overlapping and repeating shapes, including negative shapes.

4 Use a glue stick or white glue to attach your shapes to the large piece of colored paper.

5 Near the lower edge of your composition, write the title of your collage and sign your name with a marker in small lettering.

Helpful Hints
- Sometimes, large background shapes, such as the white rectangle in Matisse's *Les Cadona*, can unify and stabilize a composition.
- By repeating shapes, you can form patterns and rhythms in your composition.

- If you use a utility knife, cut on a cutting board or cardboard to protect your work surface. Keep fingers clear of the blade.

Check it.
- Describe the shapes in your collage. Which are organic and which are geometric? Which shapes have you repeated and which have you overlapped?
- Overall, is your design effective? Does it work together as one whole composition? How do the negative and positive shapes interact?
- Consider the craftsmanship in your artwork. Are the shapes neatly and securely glued? Does the quality of the cutting, such as uneven edges, detract from or add to the design?
- What is the strongest or best part of your collage?
- What did you learn in this project?
- What might you do differently the next time you create a similar collage?

3 Value

**Key
Vocabulary**

value

high-keyed

low-keyed

value contrast

center of interest

ALL THE THINGS YOU SEE AROUND YOU ARE ILLUMINATED, or lit, by some light source. Without light, you would see nothing. No matter how bright your whitest clothes are, you cannot see them in absolute darkness. With a little light, the clothes begin to look gray. As the light increases, the white clothes look brighter.

3–1 This value chart shows a range of nine steps from white to black. Most people can distinguish about thirty to forty steps, or value gradations, between black and white.

3–2 Much of the beauty in black-and-white photography is a result of gradations in value.
Ansel Adams (1902–84), *El Capitan, Winter, Yosemite National Park,* 1948. Collection Joseph Gatto.

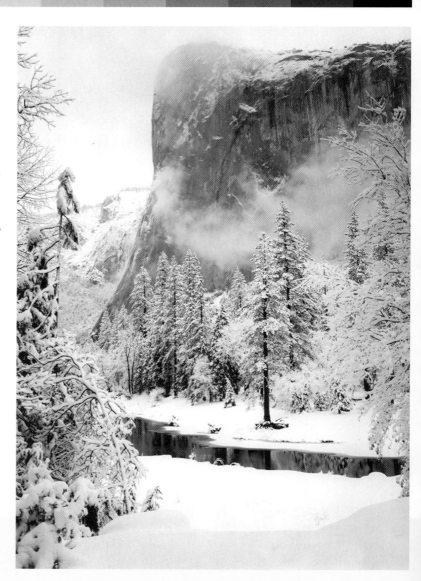

This range of light and dark is called *value*, the lightness or darkness of grays and colors. In a black-and-white photograph, you can easily see the difference between the areas of light gray and white and the areas of medium gray and black. White is the lightest value, and black is the darkest—and there are an unlimited number of values between them. In this chapter, you will explore the use of value in a design, the differences between light and dark values, and value contrast.

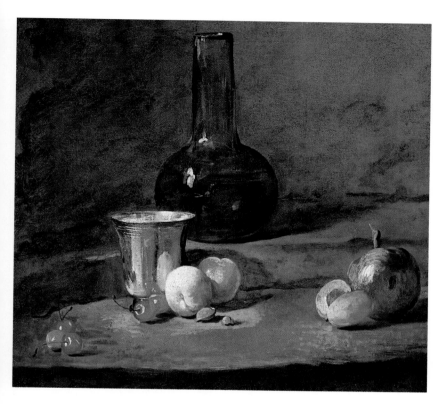

3–3 Where is your attention drawn in this image? How does the artist use value to create the center of interest?

Jean-Baptise-Siméon Chardin (1699–1779), *The Silver Goblet (Le Goblet d'Argent)*, 1728. Oil on canvas, 16 ⅞" x 19" (42.9 x 48.3 cm). Saint Louis Art Museum, Museum Purchase (55:1934).

Try it

Use pencil, charcoal, or crayon to make a value chart with only three values: light, medium, and dark. Then make a second value chart with five values, from white to black.

3–4 This self-portrait is a study in values. Think about where the source of light must have been when the artist depicted her own face.

Sun Han (age 17), *Self-portrait*, 1996. Charcoal on paper, 18" x 24" (45.7 x 61 cm). Los Angeles County High School for the Arts, Los Angeles, California.

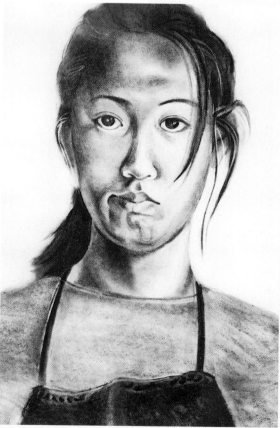

Using Value in a Design

The light in a painting or drawing may come from any single direction or from more than one direction. Areas facing a light source are lightest in value. Areas facing away from a light source are darker. Light also creates shadows. A single bright light creates shadows that are sharp and dark-valued. Multiple light sources or indirect lighting produce lighter shadows with softer edges. Shadows and varying shades of gray can create the illusion of three-dimensional space or volume.

Value may also be used to show depth. The farther away that objects are from the foreground in a landscape or cityscape, usually the lighter they are in value. Look at the image of the *Grand Canyon* (fig.3–6). In this photograph, the darkest areas are the canyon walls closest to the viewer. In the distance, the canyon becomes noticeably lighter. If an artist uses all light or all dark values, the space within his or her design may seem shallow, with little or no depth.

Artists often depict the actual effects of light, but sometimes they choose to alter or invent them. They may wish to emphasize darkness to convey a sense of mystery, or they might increase the brightness to suggest happiness or excitement. The values may not be realistic, but they can strengthen the mood to better suit the artist's intended effect.

3–5 In this image, the darkest area is farthest from the viewer. What is the effect of this?

Colleen Browning (1929–2003), *Ghost Women of Essaouira*, 1983. Oil on canvas, 40 ½" x 48 ⅜" (102.9 x 122.9 cm). Lulu H. and Kenneth Brasted, Sr. Memorial Fund, Wichita Art Museum, Wichita, Kansas.

3–6 When looking out a window, down a street, or across a field, notice how the objects farthest away from you are usually the lightest in value.

Grand Canyon. Photo by H. Ronan.

3–7 This study takes advantage of some ways value can be used to emphasize the mood of a work.

Lawrence Parks (age 17), *Self-portrait*, 1996. Graphite. Plano Senior High School, Plano, Texas.

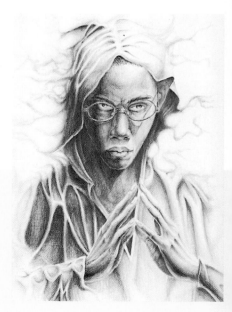

Harold Lloyd in *Safety Last*

The inspiration for *Safety Last* came to silent-film actor Harold Lloyd when he watched Bill Strothers (known as the "human fly") climb up the outside of a Los Angeles office building. Lloyd became so terrified while watching Strothers that he hid his eyes from what he was sure would end in disaster. Lloyd realized the suspenseful effect that such a scene would have on moviegoers, and incorporated similar scenes into several films over a ten-year span.

Safety Last is the story of a department-store clerk who tries to convince his visiting girlfriend that he is the store manager. In the process, the famous bespectacled character meets with some amazing obstacles. This still photo is from perhaps the best-known scene, a fast-paced, comic climb of a twelve-story building, during which Lloyd defends himself against attacking pigeons, spilled water, tilting

windows, and tangled nets. A stunt double served for much of the action.

For this shot, one of the most famous from early Hollywood, the camera placement exaggerates the distance between Lloyd and the street below. The lighting and composition of this scene, as well as the actor's expression, produce an emotional impact.

However, a sense of danger in *Safety Last* was present not only by design and acting. Lloyd reportedly dislocated his shoulder as he dangled from the clock. Also, Lloyd had one of Hollywood's best-kept secrets: because of injuries from the explosion of a faulty prop bomb, the actor had an artificial right hand. To make up for the loss, the actor worked hard to improve his athletic abilities. Despite these challenges, however, both the movie and Lloyd's life had happy endings.

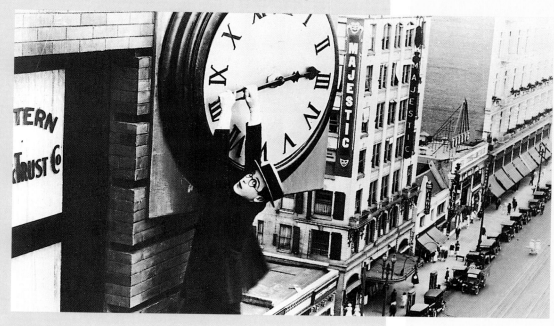

3–8 How has the cinematographer used value to increase the tension in this scene?

Harold Lloyd in *Safety Last* (1923). The Museum of Modern Art, Film Stills Archive, New York.

Discuss it

Look at various black-and-white photographs in this book. How did the photographers make objects or people contrast with their surroundings? Which works have few value changes? Which use a wide range of values? What different moods do these black-and-white images create?

Light Values

To depict happiness, warmth, or sunshine, an artist emphasizes lighter values. Think of the sun's glare at the beach or on newly fallen snow. The light is so bright that we often put on sunglasses, which darken the intensity of the light so that we can see more easily and clearly. In a work that captures the effects of such bright lighting, the shadows are often dark and clearly defined.

3–9 Light values stand out in this painting. They are high-keyed because white has been mixed with the colors.

Roberto Sebastián Matta Echaurren (1911–2002), *Years of Fear*, 1941. Oil on canvas, 44" x 56" (111.8 x 142.2 cm). Solomon R. Guggenheim Museum, New York. 72.1991. ©2010 Artists Rights Society (ARS), New York/ADAGP, Paris.

Try it

Cut 1" squares of light-gray values from magazines. Arrange them into a chart that shows value steps from white to medium gray. This chart can show you a variety of grays to use in future designs.

3–10 Describe the kind of day depicted in this watercolor.

John Singer Sargent (1856–1925), *Muddy Alligators*, 1917. Watercolor over graphite on medium, textured, off-white wove paper, 13 ⁹⁄₁₆" x 20 ⅞" (34.4 x 53 cm). 1917.86: Worcester Art Museum, Worcester, Massachusetts, sustaining membership fund.

An artwork with many light-valued colors is high-keyed. **High-keyed** colors have been mixed with white and are called pastel colors. Notice how Sargent uses light values in the watercolor of alligators (fig.3–10). The whiteness of the colors recreates the glare and heat of strong tropical sunlight.

Look at the still-life painting by Giorgio Morandi (fig.3–11), in which the artist worked with values that are close to one another. There are neither bright highlights nor dark shadows. The soft colors and subtle changes in value help emphasize a feeling of quiet and peacefulness. (See Chapter 4 for more about color and color relationships.)

3–11 Some artists choose to use only a few value changes in their work.
Georgio Morandi (1890–1964), *Still Life*, 1953. Oil on canvas, 8" x 15 ⅞" (20.3 x 39.7 cm). The Phillips Collection, Washington, DC. ©2010 Artists Rights Society (ARS), New York/SIAE, Rome.

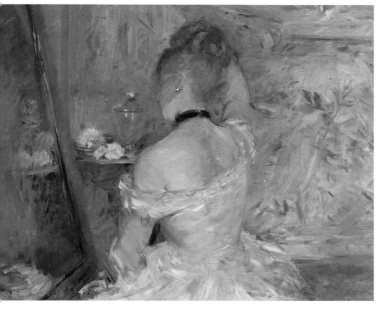

3–12 Berthe Morisot was an Impressionist. Impressionists were fascinated with the effect of light on color.
Berthe Morisot (1841–95), *Woman at her Toilette*, 1975–80. Oil on canvas, 23 ¾" x 31 ⅝" (60.3 x 80.4). Stickney Fund, 1924.127, The Art Institute of Chicago. Photography ©The Art Institute of Chicago.

Try it

Draw a single white object, such as a piece of wrinkled paper or a golf ball. Use a pencil to shade the object with many light-valued grays.

Dark Values

To suggest dark and gloomy days, nighttime, or dim lighting, an artist uses darker values. The lack of brightness tells the viewer that the source of light—whether it is the sun or artificial lighting—is weak or far away. A painting or drawing that emphasizes dark values can convey feelings of cold or sadness.

A work that uses mainly dark-valued colors is low-keyed. *Low-keyed* colors have been mixed with black or gray. The use of charcoal to draw and shade an object on light-gray paper produces a low-keyed result. All the values will be dark; the lightest value will be the gray of the paper itself.

Look at the painting *Aurora Borealis* (fig.3–13), in which the artist chose to use little value contrast. The only brightness comes from the green and red light in the sky, known as the northern lights. These multicolored flashings are visible near both of the earth's poles. The low-keyed colors perfectly capture the atmosphere of a mysterious nighttime scene.

3–14 This print's dark values and the enormous scale of the figure create an almost nightmarish feeling. How might the mood change if the values were lighter?

William Kentridge (b. 1955), *Telephone Lady*, 2000. Linoleum cut, 81 ⅜ x 39 ⁷⁄₁₆" (206.7 x 100.2 cm); sheet, 86 ⅝" x 39 ¹⁵⁄₁₆" (220 x 101.5 cm). Publisher: David Krut Fine Art, New York, London and Johannesburg. Printer: Artist Proof Studio, Johannesburg. Edition: 25. Carol and Morton H. Rapp Fund. The Museum of Modern Art, New York. Digital Image ©The Museum of Modern Art/Licensed by SCALA/Art Resource, New York.

3–13 Compare this painting to fig.3–10. These two artworks clearly show the great difference in effect between light and dark values.

Frederick Edwin Church (1826–1900), *Aurora Borealis*, 1865. Oil on canvas, 56" x 83 ½" (142 x 212 cm), Smithsonian American Art Museum, Washington, DC. Photo: Smithsonian American Art Museum, Washington, DC/ Art Resource, New York.

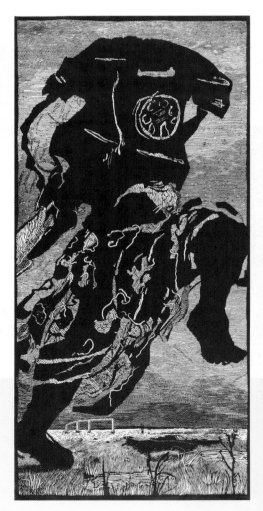

Try it

Cut 1" squares of dark-gray values from magazines. Arrange them into a chart that shows value steps from medium-gray to black. This chart can show you a variety of grays to use in future designs.

Louise Nevelson

Born in Russia in 1899, Louise Berliawsky was attracted early in life to the visual excitement of her surroundings. When she was five, she and her family moved to Rockland, Maine. Louise knew from an early age that she was going to be an artist, and she tried to improve her skills in drawing and painting by devoting considerable energy to practice and study.

She married Charles Nevelson in 1920 and moved to New York City where she pursued her interest in the fine arts. She delighted in learning about music, dance, and theater (she even had a brief career as an actress in Europe in 1931).

In 1935, Nevelson was hired as an artist and teacher under the Works Progress Administration (WPA), a federal program that, among other activities, gave work to artists during the Depression. Nevelson began sculpting in terra cotta, and at different times worked with various materials such as plaster, Plexiglas, and steel—although she is best known for her monochromatic wood

©Dan Budnik—Woodfin Camp and Associates.

sculpture, such as *Sky Cathedral* (fig.3–15). She enjoyed working with wood for what she called its quality of "livingness." To emphasize and give power to the forms, Nevelson painted her wood sculptures only black, white, or gold. Regarding her use of black, Nevelson said, "There is no color that will give you this feeling of totality. Of peace. Of greatness. Of quietness. Of excitement."

Nevelson's artwork gained important notice in the late 1950s. In 1959, a selection of her work was included in a show at the Museum of Modern Art in New York. She continued to be a fiercely independent and productive artist until her death in 1988.

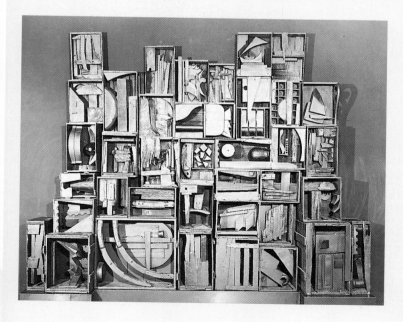

3–15 Louise Nevelson often painted her sculptures completely black or completely white.

Louise Nevelson (1899–1988), *Sky Cathedral*, 1958. Wood, painted black, overall (with base): 115" x 135" x 20" (292.1 x 342.9 x 50.8 cm); overall (without base): 102 ½" x 133 ½" (260.35 x 339.09 x 50.8 cm). George B. and Jenny R. Matthews Fund, 1970. Albright Knox Art Gallery, Buffalo, New York. Photo: Albright-Knox Gallery/ Art Resource, New York. ©2010 Estate of Louise Nevelson/Artists Rights Society (ARS), New York.

Try it

Draw a single dark object, such as an acorn squash, a black checker, a wrinkled piece of black paper, a dark backpack, or a piece of dark fabric. Use a pencil to shade the object with many dark-valued grays.

Value Contrast

Artists emphasize not only dark values or light values in their work, but also include values from all parts of the scale. Light values placed next to medium or dark values creates *value contrast*. This contrast may help viewers distinguish between different parts of a design. It also may make one area of a design stand out.

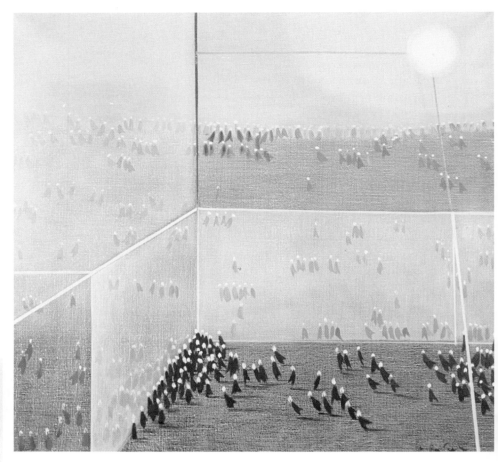

3–17 Describe how Nemesio Antúnez has used value contrast in this painting.

Nemesio Antúnez (1918–93), *New York, New York 10008*, 1967. Oil on canvas, 22" x 24" (55.9 x 61 cm). Courtesy of the Couturier Galerie, Stamford, Connecticut. Photo ©Patricia Lambert. ©2010 Artists Rights Society (ARS), New York/CREAIMAGEN, Santiago.

3–16 The stark contrast in value in this design gives the piece a sense of immediacy and simplicity.

Michelle Spinnato (age 15), *Value Study*, 1998. Construction paper, newsprint, chalk, and magazine paper, 12" x 18" (30.5 x 45.7 cm). Atlanta International School, Atlanta, Georgia.

Try it

Cut out 1" squares of dark- and light-valued grays from a magazine. Arrange them to create a collage or other design that shows strong value contrast.

The greatest possible value contrast is between black and white. A woodcut or a linoleum-block print made with black ink on white paper uses such contrast. In fig.3–16, the artist's use of black helps the bird stand out from the nearby flower.

Some artists prefer to use strong value contrast only a little, perhaps saving it for a design's *center of interest*, a special area to which the artist wishes to draw the viewer's attention. The center of interest, usually where the artist wishes the viewer to look first, may also contain a design's most important object or figure, or other important information.

3–18 Kent Twitchell drew this self-portrait with graphite. He used dark values for the background and shadows on his face; he used the lightest value for highlights and the areas closest to the viewer. The medium grays bridge the light and dark values, and provide softer details within the face.

Kent Twitchell (b. 1942), *Study for Eyes Mural*, 1991. Graphite on paper, 9 ½" x 8 ¾" (24.1 x 22.2 cm). Collection of Joseph A. Gatto, Los Angeles, California.

Note it

Look at several images in this book. Try to find the place in each image where the lightest and the darkest values come together. In which images is the center of interest created by this area of greatest value contrast? In which is the center of interest created differently? Explain.

3–18a Kent Twitchell, *Study for Eyes Mural*, detail of fig.3–18.

In a generally light-valued design, a dark shape or line will stand out. Look at *The White Girl* (fig.3–19). Notice how your eyes are quickly drawn to the top of the work, where the subject's face is composed of dark features and framed by dark hair. This is the painting's center of interest.

In a generally dark-valued design, a light shape or area will become the focus. Look at the seventeenth-century painting *Newborn Child* (fig.3–21). The entire scene is dark, with a burning candle as the only source of light. The candle itself is hidden, but it beautifully highlights the face and right arm of the young woman. The artist, Georges de La Tour, is famous for such bold, candle-lit scenes.

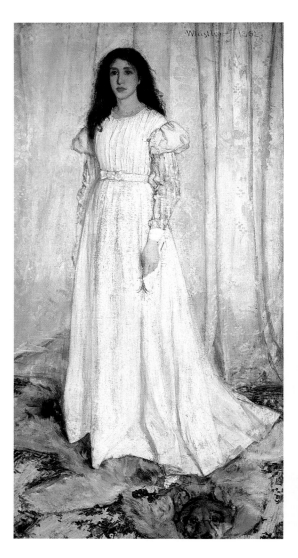

3–19 Though most know Whistler's painting of his mother best, *The White Girl* is what caused Whistler to become the first American painter after the eighteenth century to gain fame in Europe. Why do you think the artist called this painting *Symphony in White*?

James Abbott McNeill Whistler (1834–1903), *Symphony in White, No. 1: The White Girl*, 1862. Oil on canvas, 83 ⅞" x 42 ½" (213 x 107 cm). Harris Whittemore Collection ©1998 Board of Trustees, National Gallery of Art, Washington, DC.

3–20 How is value contrast used in this student work?

High school student (age 17), Los Angeles County High School for the Arts, Los Angeles, California.

Finding the contrasting values in a design is sometimes difficult. First, shut out tiny details by squinting your eyes. Then look only at the larger shapes of similar value. When you do this, the elements of dark and light will become more noticeable. You can also use this technique to balance the value contrasts in your own work more effectively.

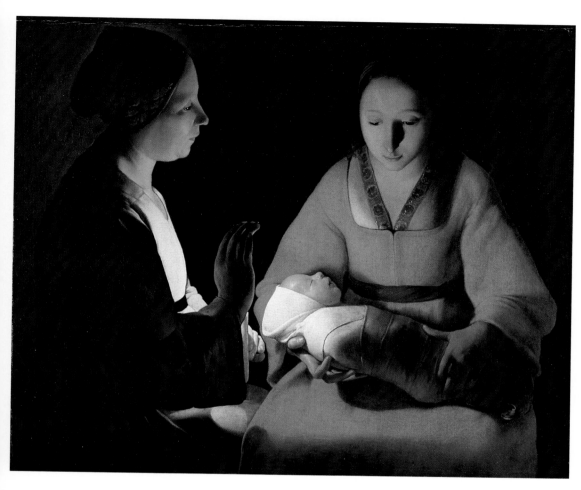

3–21 How has the artist focused the light of the candle on the child?

Georges de La Tour (1593–1652), *The Newborn (Nativity),* mid-1640s. Oil on canvas, 31 ¼" x 35 ⅞" (79 x 91 cm). Musée des Beaux-Arts, Rennes, France. Photo: Ojéda/Hubert. Réunion des Musées Nationaux/Art Resource, New York.

Try it

From a piece of medium-gray paper, cut four 1" squares. Then from white, black, and two different gray-valued papers, cut four 3" squares—one square of each value. Place the small gray shapes on the four larger shapes. What appears to happen to the value of the smaller shapes? Why do you think this occurs?

Another Look at Value

3–22 Robert Irwin used acrylic lacquer on a plastic disk form. Light directed at the disk creates repetitions of the circular form through overlapping shadows and gradual changes between dark and light.

Robert Irwin (b. 1928), *Untitled*, 1968–69. Plastic, 54" diameter (137.2 cm). San Diego Museum of Art (Gift of the Frederick R. Weisman Art Foundation). ©2010 Robert Irwin/Artists Rights Society (ARS), New York.

3–23 Here, the designer uses value to create drama. The bright light at the top of the sword is almost otherworldly, which echoes this actor's role as a superhero in the television series *Heroes*.

Wired magazine cover, May 2007. Carlos Serrao/Wired; ©Conde Nast Publications.

3–24 From a distance, the tiny pieces of color blend together to create a beautifully modeled form.

Byzantine (c. 395–1453), *Christ, Deesis*. Mosaic, mid-12th century. Hagia Sophia, Istanbul. Erich Lessing/ Art Resource, New York.

3–25 The eye of the photographer captured the profiles of these buildings in the smoke. How do the light values of the smoke give the viewer a sense of space?

Yale Joel (1919–2006), *New York, Smoke*, c. 1952. Yale Joel, *Life* Magazine ©1952 Time Inc.

Review Questions

1. To what does the art element *value* refer?
2. Explain how light affects the value of colors or gray tones.
3. In landscapes, where are the darker values usually found?
4. What type of values do high-keyed and low-keyed colors have? Give the title of an image in this chapter that has mainly high-keyed values and that of another that has mainly low-keyed values.
5. How can artists use values to create a center of interest?
6. Why did Louise Nevelson paint most of her sculptures a mono-chromatic black, white, or gold?

Career Portfolio

Interview with a Cartographer

As a cartographer (mapmaker), **Paula Lee Robbins** uses value to give relief shadings of mountain ranges a three-dimensional look. The reliefs are done by hand, then scanned into a computer, where the maps are built in layers. Paula was born in 1964 in Manitowoc, Wisconsin, and has been working with an international mapmaking company in Madison, Wisconsin for ten years.

How did you get interested in map making?

Paula When I was about nine or ten, I started drawing on my own. I liked to draw things so they looked three-dimensional. The first thing I drew was my Dad's weight-lifting set down in our basement. I couldn't believe it turned out so nice. So I started drawing a lot after that. I

would look at a black-and-white photograph and do a drawing that looked exactly like the photograph. I would use a pencil and my finger to blend the graphite to create the different values.

What was your favorite subject matter?

Paula I liked drawing landscapes and birds, sunsets, things like that. I would take my camera and go to the river and take photographs, then I would draw from them.

I also liked math and the sciences quite a bit. When I went to the University of Wisconsin Extension, in Manitowoc, I took some geology and geography courses. I also took a life drawing course [human

subjects] and really enjoyed that. I was fascinated with geology and geography. We had a short session in cartography in our geography class— maybe a week we spent on cartography and maps. I was very intrigued and I thought, well, maybe I could combine my art with geography. I had seen some relief shading and thought, hey, that looks interesting. I bet I could do that.

So, I majored in cartography. I took a lot of engineering classes. I took math classes and calculus. Advanced algebra turned out to be very useful, because you do calculations in cartography. I also took computer programming. Things just sort of fell into place.

What are your goals for the future?

Paula I would like to perfect my relief shading. I also want to learn more about Photoshop and Painter [software programs] and see how I can incorporate the computer with shaded relief. I also would like to fly, to travel more.

That's one thing that's interesting about maps; it takes you places in your mind that you may never go to—you probably *won't* ever go to. Because you can't go everywhere, physically. But mentally, it does take you places. That's what was intriguing to me also. You see that there's so many places and different people in the world. It's like expanding your mind by looking at a map. Maps are not just about the land; they're also about the people, the cultures.

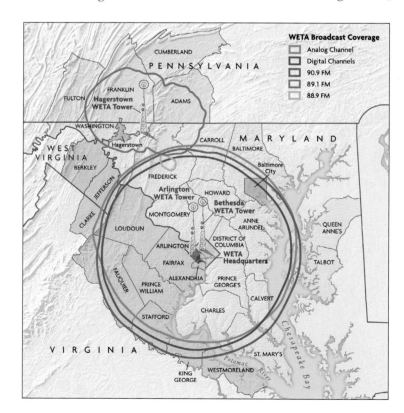

Designing a good map requires more than just a knowledge of geography. Paula Robbins uses her artistic skill to select colors that work together, devise a key, and produce relief shading for mountainous areas. She also chooses the style, size, and placement of type that organizes the names of rivers, cities, counties, and other information. This map shows the broadcast coverage of WETA (Washington Educational Television Authority) in parts of Pennsylvania, Maryland, and Virginia.

Paula Lee Robbins, *map produced for WETA through The Nature Conservancy.*

Studio Experience
Still Life Value Study

Task: To create and draw a still life using light, medium, and dark values of charcoal and white conté crayon.

Take a look. Review the following images in this chapter:

- Fig.3–3, Jean Baptiste-Siméon Chardin, *Still Life*
- Fig.3–4, Sun Han, *Self-portrait*
- Fig.3–14, William Kentridge, *Telephone Lady*
- Fig.3–18, Kent Twitchell, *Study for Eyes Mural*

Think about it. Look at the images listed above. Answer the following questions about each image:

- Where are the lightest and darkest values? The middle values? Where do the values shift slowly from dark to light? Where do light and dark contrast sharply? Where are the areas with the greatest contrast of value?
- From which direction is the light shining? What might the light source be?

Do it.

1 Before beginning this activity, collect four or five objects that you would like to draw. Store these in a bag. At least three of the objects should be clearly three-dimensional.

2 On a piece of newsprint paper, practice creating light, dark, and several medium values with both vine and compressed charcoal. Notice which charcoal erases more easily and with which you are able to create the darkest values.

3 Make a small preliminary sketch of each of your objects. Include light, dark, and several medium values in your drawings. Use a kneaded eraser to make corrections; add highlights in some darker areas by erasing some of the charcoal.

4 As you arrange your objects into a still life, illuminate them with a desk lamp or other light source. Try positioning your objects and the light in several different ways, noticing the highlights, shadows, and value contrasts that are created in each arrangement. When you find an arrangement you like, begin to draw.

5 With the vine charcoal, lightly draw the still life on a medium-toned piece of 18" x 24" pastel paper. Draw the objects large, filling your page. Then shade the objects with the charcoal, creating a wide range of values from black to light gray. Add the lightest values with white conté crayon. In some areas, blend the white with a little black charcoal to create a lighter middle value. Use tissues, tortillons, and your fingers to achieve transition tones. As you draw, occasionally step back from your work to view it from a distance—or squint your eyes.

6 When you are done drawing and have checked your artwork, spray it with workable fixative in a well-ventilated place. Protect your drawing between work sessions by covering it with a piece of newsprint paper.

Helpful Hint

If you will move your still life at the end of each class period, arrange it on a piece of paper or cardboard and mark the position of each object so that you can set these up in the same positions for the next drawing session. Also mark where your light source is.

Check it.

- Identify light, dark, and medium values in your composition. Have you effectively used a range of values?
- Where is the light source in your drawing? Can other students tell where the light source is?
- Where is the area with the greatest contrast of light and dark?
- What do you like best about this drawing?
- What might you do differently when you next create a similar drawing?
- What did you learn from this project?

Kendrick James (age 16), *Untitled*, 1998. Charcoal. Marion High School, Marion, South Carolina.

Other Studio Projects

1 In separate containers, mix three ink washes of different gray values. Use only these three values to paint a landscape, a still life, or a portrait of a student model. You may wish to add a solid black contour or outline to finish your picture.

2 Use a variety of media in black, gray, and white to create a mixed-media painting. Emphasize the variety of materials by developing texture and value contrasts. Use media such as black ink, black and white crayons, black and white tempera or acrylics, black and white markers, pencils, and black and white paper.

Key Vocabulary

spectrum

pigment

neutral

hue

primary colors

complementary colors

tint

shade

intensity

tone

color harmony

ONE OF THE MOST EXCITING AND POWERFUL ASPECTS of our environment is color. Color appeals directly to our senses and emotions. We walk along streets and shop in stores filled with color—and we often make purchases because of it. Perhaps some colors, such as school colors, cause you to cheer and feel pride. Other colors might affect your mood, making you feel happy or sad. Look around you at rusted signs, neon lights, patterned clothing, flowering plants, and other everyday objects. Color is a necessary part of our lives. Knowing where color comes from and its properties will help you learn how to use it in your artwork.

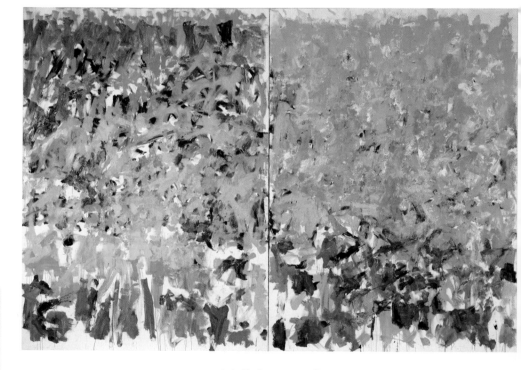

4–2 By layering and juxtaposing colors, an artist can alter how each is perceived. Study the dominant marigold yellow in this painting. Then, notice how it appears different when it is placed on top of or beside other colors.

Joan Mitchell (1926–1992), *Wood, Wind, No Tuba*, 1980. Oil on canvas, 110.24" x 157.4" (280 x 399.8 cm). Museum of Modern Art, New York. ©Estate of Joan Mitchell, Courtesy Joan Mitchell Foundation.

4–1 In some regions, fall is when we are most mindful of color in our natural surroundings.

Leaf Composition. Photo by J. Gatto.

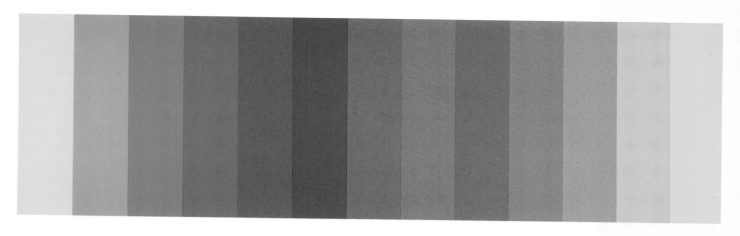

4–3 This painting can be seen as a color chart that shows the move from one color of the spectrum to the next.

Ellsworth Kelly (b. 1923), *Spectrum II*, 1966–67. Oil on canvas, 80" x 273" (203.2 x 693.6 cm). Saint Louis Art Museum, funds given by the Shoenburg Foundation, Inc. (4:1967) ©Ellsworth Kelly (EK 379).

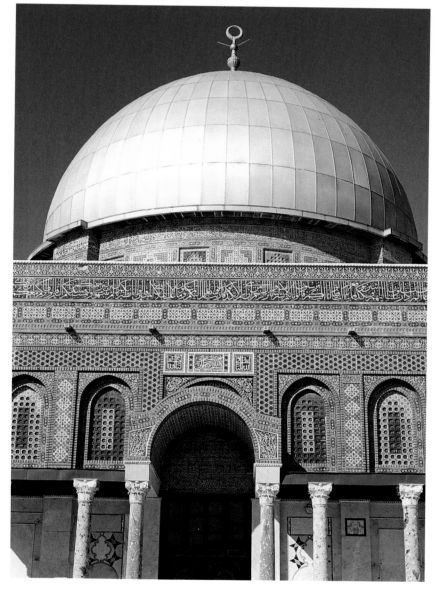

4–4 The exterior of this Islamic mosque is decorated with brightly colored ceramic tile. The tile and the dome's gold covering both take advantage of the direct, brilliant sunlight of the Middle East.

Dome of the Rock, Jerusalem, Israel, detail. Photo by L. Nelken.

The Source of Color

When studying color, it is helpful to understand some of the scientific facts and principles involved. Color comes from light, either natural or artificial. Have you ever been outside at sunrise? Or surprised by a sudden power failure at night? If so, you know that colors constantly change with the time of day and the amount of natural or artificial light. Where there is little or no light, there is little or no color. With bright light, colors are more intense.

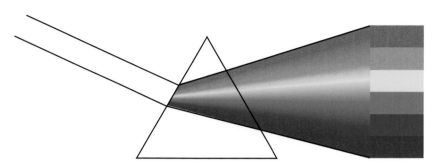

4–5 The color spectrum represents the brightest colors possible.

4–6 The artist's subject here is the light streaming through the painting. By using muted colors of similar tones she draws our attention to the patches of yellow that seem to glow.

Ellen Phelan (b. 1943), *Light in a Far Field*, 2001. Oil on linen, 5' x 7' 6" (152.4 x 228.6 cm). Gift of Agnes Gund. (162.2002) The Museum of Modern Art, New York. Digital Image ©The Museum of Modern Art/Licensed by SCALA/Art Resource, New York, ©ARS, New York. ©2010 Ellen Phelan/Artists Rights Society (ARS), New York.

Color is produced by the way our vision responds to different wavelengths of light. When a ray of white light (such as sunlight) passes through a glass prism, the ray is bent, or refracted. This ray of light then separates into individual bands of color, called the color *spectrum*. This spectrum includes red, orange, yellow, green, blue, and violet. You can see this same grouping of colors in a rainbow, in which raindrops act as the prisms.

The color spectrum represents the brightest colors possible. The coloring matter that you use in art class is neither as bright nor as pure as that in a ray of light. Artists' colors come from powdered substances called *pigments*. These natural or chemical materials are combined with other substances to make the various paints, crayons, inks, and pencils commonly used by artists.

4–8 This artist has incorporated pure pigment into his artwork. The powdered substance is generally mixed with other materials for painting or drawing.

Anish Kapoor (b. 1954), *As If to Celebrate, I Discovered a Mountain Blooming with Red Flowers*, 1981. Three drawings and sculpture with wood, cement, polystyrene, and pigment, 38 ¼" x 30" x 63" (97 x 76.2 x 160 cm) and 13" x 28 ⅛" (33 x 71.1 cm) and 32" (81.3). Tate Gallery, London. Photo: Tate Gallery, London/Art Resource, New York.

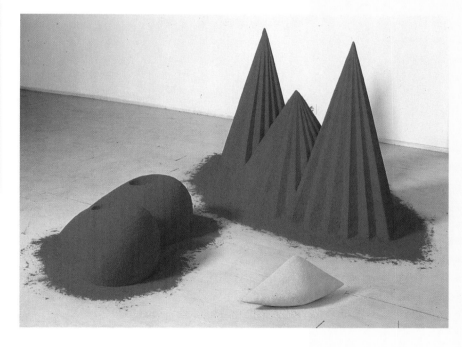

4–7 When a ray of white light falls onto a blue lamp, the entire spectrum of colors hits the lamp. All the wavelengths except blue are absorbed into the surface of the lamp. The blue wavelengths bounce off the lamp and are perceived by our eyes as the object's color. Photo by T. Fiorelli.

Neutrals

Not all objects have colors that are in the spectrum. Stars in the night sky appear white. Smoke may be gray. Ink is often black. Because we do not clearly see any one color in them, white, gray, and black are called *neutrals*. These three neutrals are created by different amounts of reflected light.

White is the sum of all colors. A white object reflects to our eyes all the wavelengths shining on it, absorbing none of them. What we see is the color of the original source of light.

Gray is created by a partial reflection. A gray object reflects part of all the wavelengths shining on it. It also absorbs part of all the wavelengths. The more light that is reflected, the lighter the gray; the more that is absorbed, the darker the gray.

Black is the total absence of reflected light. It results when an object absorbs all the wavelengths shining on it, reflecting none of them.

4–9 Pure white reflects all the wavelengths from a ray of light. Gray reflects some wavelengths and absorbs some. Pure black absorbs all the wavelengths.

4–11 How has this artist brought variety to her artwork, which uses neutral colors and similar values?

Maryrose Mendoza (b. 1969), *Twin*, 1991. Fabric, wood, foam, and plastic, 12" x 12" x 20" (30.5 x 30.5 x 50.8 cm). Staff intern, Los Angeles County High School for the Arts.

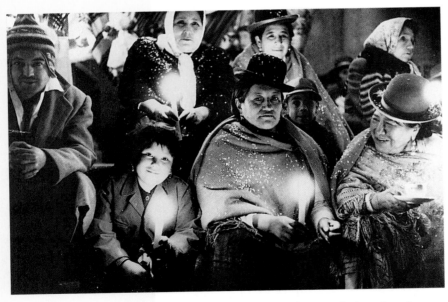

4–10 Black-and-white photography is made only of neutrals.

Emil Schulthess (1913–96), *Candlelight Meeting in Peru*, 1961. Fotostiftung Schweiz.

Georgia O'Keeffe

©Dan Budnik—
Woodfin Camp
and Associates.

Born in 1887, Georgia O'Keeffe grew up on a large farm in Wisconsin. She first drew and painted with an eye to realism, but as her skill increased, her artistic path became clear. She wisely decided to focus on being true to her own vision, rather than creating art for "everyone else." This decision was marked by her choosing to destroy nearly all of her earliest work. Eventually, by following her inner voice, she became known as one of the foremost American abstract artists. Her long and prolific career lasted until her death at ninety-nine years of age.

Flowers were a favorite early subject of O'Keeffe; she often painted large, close-up views of flowers and flower parts. Some views were even closer than that in *The White Calico Flower* (fig.4–12); the vibrating center of a flower was often the only shape on her canvas. O'Keeffe explained in 1939 that "nobody sees a flower—really—it is so small—we haven't time—and to see takes time, like to have a friend takes time." By magnifying the flowers, O'Keeffe tried to startle the viewer. She used a similar approach in depicting other forms found in nature; for example, a cornstalk or clamshell.

O'Keeffe combined her lively visual imagination with a passion for natural forms and colors; she often gained inspiration from landforms, plants, and animal bones. By depicting the stark beauty of desert scenes or bleached animal skulls in her own way, she shared the power of her compositions with countless appreciative viewers.

4–12 How has the artist used neutrals in this painting? Where is the light most reflective? How do the neutrals influence the direction that your eyes take when viewing the painting?

Georgia O'Keeffe (1887–1986), *The White Calico Flower*, 1931. Oil on canvas, 30" x 36" (76.2 x 91.4 cm). Whitney Museum of American Art, New York; Purchase 32.26 ©2010 Georgia O'Keeffe Museum/Artists Rights Society (ARS), New York.

Try it

Place a white swatch and a black swatch of fabric or paper in the sun or under a spotlight for several minutes. Then feel the two surfaces. The black one will be warmer because it has absorbed all the light rays from the sun. The white one has reflected them and absorbed none. Why do you think people often wear dark-colored clothes in winter? Why do people in warm climates often paint their houses white?

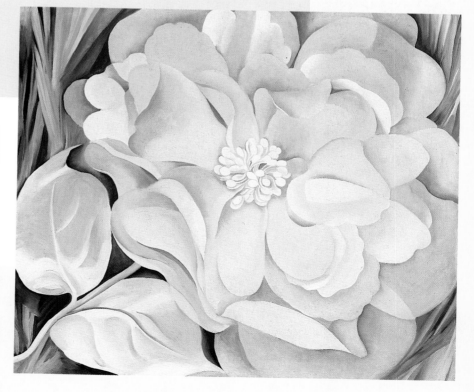

The Properties of Color

When artists discuss color, they talk about three properties that can be defined and measured: hue, value, and intensity. These properties are sometimes called qualities or characteristics of color.

Hue

Hue is the name of the color itself, such as "blue" or "red," and it refers to the color's position in the spectrum. The wavelength of blue, for example, is 19 millionths of an inch long. The wavelength of red is 30 millionths of an inch long. Each hue has a definite wavelength and position in the spectrum.

For easy study, the colors of the spectrum are usually arranged in a circle called a color wheel. Look at the color wheel in fig.4–14. Red, yellow, and blue are the three *primary colors* or hues. All other pigment hues are made by mixing different amounts of these three colors.

If you mix the pigments of any two primary colors, you will produce one of the three secondary colors or hues. From experience, you probably know that red and blue make violet, red and yellow make orange, and blue and yellow make green. These are the three *secondary colors*. Notice their location on the color wheel.

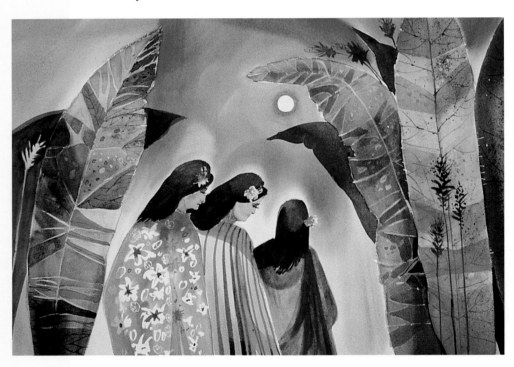

4–13 In this set of illustrations, you can see how the full-color printing process uses the three primary hues plus black to "create" all the colors of the original painting. One printing plate is produced—by digital scanning and color separation—for each color shown. The printing press contains a separate area for each ink color to be printed onto the paper. When the paper completes its pass through the press, the result is the full-color image. The neutral values of the black plate add value contrast to the primary colors.

Albert W. Porter (1923–2009), *Hawaiian Mood*, 1987. Watercolor, 15" x 22" (38.1 x 55.9 cm). Courtesy of the artist.

The color wheel also shows six *intermediate colors* or hues. You can create these by mixing a primary color with a neighboring secondary color. For example, yellow (a primary color) mixed with orange (a secondary color) creates yellow-orange (an intermediate color). Mixing the primary and secondary colors creates the six intermediate colors shown. Mixing different amounts of these colors produces an unlimited number of hues.

A color wheel also illustrates other relationships among colors. One of the most important is the pairing of complementary colors. **Complementary colors**—such as blue and orange or yellow-green and red-violet—appear opposite each other on a color wheel. These pairings show the maximum visual contrast between colors. The line where two complementary colors meet seems to vibrate. Artists sometimes place complementary colors side-by-side to produce just such an effect.

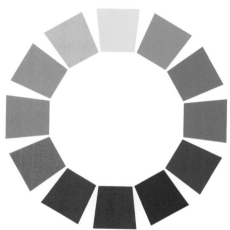

4–14 Color wheel.

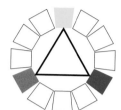

4–14a The primary colors.

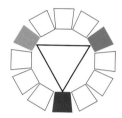

4–14b The secondary colors.

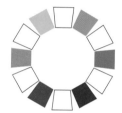

4–14c The intermediate colors.

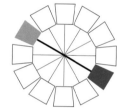

4–14d An example of complementary colors.

4–15 How has Grant Wood used complementary colors to heighten the drama of this scene?
Grant Wood (1892–1942), *Death on Ridge Road*, 1935. Oil on masonite panel, 39" x 46 ¹⁄₁₆" (99 x 117 cm). ©Figge Art Museum, successors to the Estate of Nan Wood Graham/ Licensed by VAGA, New York.

Try it

Mix tempera or watercolor paints to make your own color wheel. Start with the primary colors. Then mix the secondary and intermediate colors. Paint the colors on posterboard or heavy white paper. Are the mixtures what you expected? If not, perhaps the primary colors were not pure or clean.

Value

In Chapter 3, you learned that value is the range from white to black or light to dark. When discussing colors, value refers to the lightness and darkness of a color, or the quantity of light that a color reflects. There may be as many value steps between the lightest and darkest appearance of a color as there are between white and black.

Adding white to a hue produces a *tint*, which is a lighter version of the color. Pink, for example, is a tint of red. There are many possible tints of each color. Each tint depends on the amount of white added. The left side of fig.4–17 shows two possible tints of the original hue.

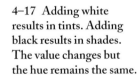

4–16 In this photograph, sunlight shines on the red surface of a motorcycle. The parts that reflect the most light are the lightest in value. Those opposite the light source, or in shadow, are darker in value.
Motorcycle. Photo by J. A. Gatto.

4–17 Adding white results in tints. Adding black results in shades. The value changes but the hue remains the same.

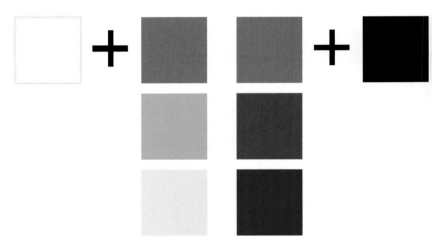

Adding black (or a darker complementary color) to a hue produces a **shade**, which is a darker version of the color. There are many possible shades of each color. Each shade depends on the amount of black added. The right side of fig. 4–17 shows two possible shades of the original hue.

In the example shown, a neutral—white or black—is added to a color (in this case, red). The value is changed, but the hue remains the same. You also can change a color by mixing it with a lighter or darker hue (such as in fig. 4–18, by adding blue to purple). In that case, both the value *and* the hue will change.

4–18 Both value and hue are changed if a lighter and darker hue are mixed.

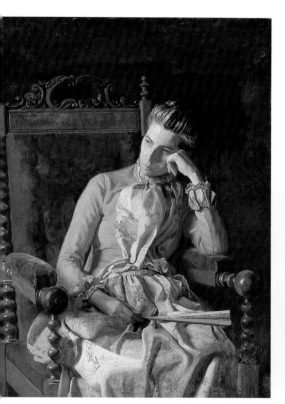

4–19 Notice how the black-and-white reproduction allows you immediately to see the range of values used by the artist. The contrast between sunlit and shadowed areas is obvious. How does the black-and-white image help you better understand and appreciate the range of values?

Thomas Eakins (1844–1916), *Miss Amelia van Buren*, 1891. Oil on canvas, 45" x 32" (114.3 x 81.28 cm), acquired 1927. The Phillips Collection, Washington, DC.

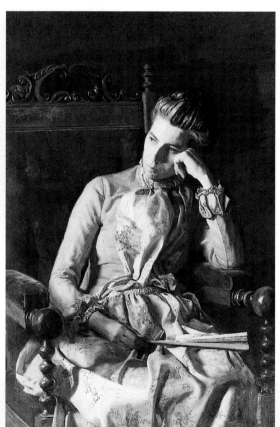

4–19a *Miss Amelia Van Buren*

Intensity

The third property of color is *intensity*. Intensity refers to the quality of light in a color. Intensity is different from value, which refers to the quantity of light that a color reflects. Intensity refers to the brighter and duller colors of the same hue. For an example, look at the two squares in fig.4–20. The top one has a higher degree of saturation, or strength. It is more intense than the one below it. Your investigations with color will show you that you cannot change value without changing intensity, even though these two properties of color are not the same.

You already know two ways to change the intensity of a color when mixing pigments: adding black to produce shades, or adding white to produce tints. After adding either of these neutrals, the resulting hue loses its intensity. The color becomes less and less intense as more black or white is added. A third way to change intensity is to mix any shade of gray with the hue. This is called a *tone.*

Mixing a color with its complementary color will also change intensity. As you mix complementary colors, bit by bit, a neutral gray is formed. This is because the complementary colors represent an equal balance of the three primary hues. In theory, the mixture should produce white, but the pigments in artists' materials are not as pure as the colors in a ray of light.

4–20 The top square has a higher degree of intensity than the bottom square.

4–21 How would you describe the intensity of the colors in this blouse?

Panama (Cuna People). *Child's blouse,* 20th century. From San Blas Island, Cuna Yala region. Private Collection, Orlando, Florida.

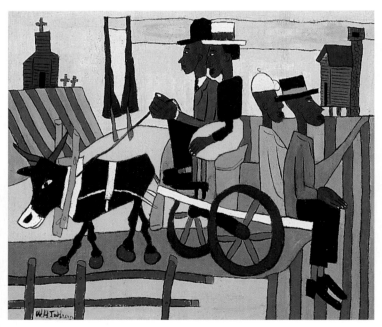

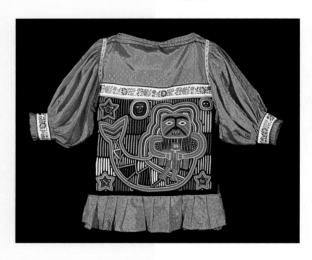

4–22 Analyze the blues in this painting. Which blue is most intense? Can you suggest what the artist did to the other blues in order to change their intensities?

William H. Johnson (1901–70), *Going to Church,* c. 1940–41. Oil on burlap, 38 ¼" x 44 ⅛" (97 x 112 cm). Smithsonian American Art Museum, Washington, DC. Photo: Smithsonian American Art Museum, Washington, DC/Art Resource, New York.

Georges Seurat

Le Pont de Courbevoie

How is it that we can know a great deal about how artists from previous centuries worked? One way is to analyze clues they might have left behind. In the case of *Le Pont de Courbevoie*, Seurat made a careful sketch of the water scene he planned to paint.

The conté crayon study for the work shows that Seurat planned the composition of *Le Pont de Courbevoie* thoughtfully. The slight tilt of the sailboat masts, the position of the bridge and shoreline, and the curved tree on the right are found in the study and the painting. Seurat added items to the composition as he painted the canvas. These include the foreground sail, the two fishermen in the distant boat, and the two isolated figures in silhouette. The angled figure on the dock adds a sense of movement to the otherwise quiet composition. Seurat probably worked on the painting both in his studio and at Courbevoie, perhaps during several visits to the riverside.

Through extensive research, scholars have also learned about Seurat's use of color. Scholars disagree about how he worked. Some say that Seurat based his decisions on a scientific color theory. Others believe that he worked instinctively, his brush creatively flowing with colors that interlock with those underneath.

Most scholars believe, however, that Seurat's palette contained an assortment of pure colors (hues), an assortment of colors mixed with white (tints), and various whites. Because Seurat could not always obtain pure pigments, he was forced to use some colors that were only close to what he wanted. Today, we do not see the painting as Seurat planned or painted it: within a few months of its completion, some of the pigments faded. We can only imagine the original effect.

4–23 Georges Seurat used a painting technique called *pointillism*, in which paint is applied to the canvas in small dots or dabs. From a distance, the eye blends these dots to make an array of colors and values. The stillness throughout this work is a result of both the painting technique and the low intensity of the colors.

Georges Pierre Seurat (1859–91) *Le Pont de Courbevoie*, 1886–87. Oil on canvas, 18" x 21" (46.4 x 55.3 cm). The Samuel Courtauld Trust, The Courtauld Gallery, London. P.1948.SC.394.

4–23a
Le Pont de Courbevoie (detail).

Mix two of the primary colors to make a secondary color. Then add a small amount of this new color to its complementary color. To study the range of intensities, continue adding a little more of the complementary color.

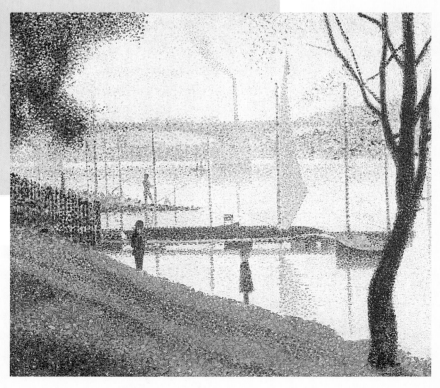

Color Harmonies

Have you ever said that certain colors "go well together"? Or that other colors "clash" when placed side by side? When designers and artists use combinations of colors to get certain results, they are using *color harmonies*. You have already read about one example of color harmony: complementary colors. Following are descriptions of other color harmonies that you might see in a design or wish to use in one of your own.

Analogous colors are next to each other on the color wheel. They have a single color in common. Because of this common color, they naturally relate well to each other. Fragonard used analogous colors in *A Young Girl Reading* (fig.4–24). The color group is yellow, yellow-orange, and orange. These analogous colors give a warm and soothing quality to the work. What additional color is shown in the color wheel in fig.4–25?

Another color harmony is *split complementary*. This is made up of a color plus the two hues on either side of that color's complement (see fig.4–27). For example, blue with yellow-orange and red-orange forms a split complementary. Such a combination forms a sharp contrast within a design. In fig.4–26, the blue urn creates a startling contrast to the yellow-orange of the ceiling and red-orange of the floor.

4–24 What are the analogous colors in this painting?
Honoré Fragonard (1732–1806), *A Young Girl Reading,* c. 1776. Oil on canvas, 32" x 25 ½" (81.1 x 64.8 cm). Gift of Mrs. Mellon Bruce in memory of her father, Andrew W. Mellon ©1998 Board of Trustees, National Gallery of Art, Washington, DC.

4–25 An example of analogous colors.

4–27 An example of split complementary colors.

4–26 Color studies such as this student work heighten our awareness of how color can help create a dynamic environment.
Iza Wojcik (age 17), *Down the Hall,* 1996. Oil on matte board, 18" x 24" (45.7 x 61 cm). Lake Highlands High School, Dallas, Texas.

Try it

How many groups of analogous colors can you discover on the color wheel? Make a painting or design using only analogous colors. You may add black, white, and gray to make shades, tints, and tones.

The Interaction of Color

Artist Josef Albers began a study of color in the 1950s called *Homage to the Square*, which he continued to develop until his death in 1976. His series showed that a color can produce unpredictable effects upon the colors in close proximity to it. For example, in this painting, Albers caused three colors to appear as two. The vertical ochre stripe, interrupted by yellow and dark blue stripes, appears to be two squares of different brown hues.

Josef Albers (1888–1976), First plate of *The Interaction of Color*, 1963. Bauhaus-Archiv Museum für Gestaltung, Berlin. ©2010 The Josef and Anni Albers Foundation/Artists Rights Society (ARS), New York.

Try it

Depending on the color next to it, any color may vary in appearance. Cut a square of bright color from a magazine, or use paint to create a 2" x 2" sample of color. Place this color swatch in different color environments: on darker and lighter solid colors, on neutrals, on patterned paper. Observe how the color appears to change when placed against different environments.

4–28 Describe the colors used in this work.
Aaron Douglas (1899–1979), *The Creation*, 1935. Oil on masonite, 48" x 36" (121.9 x 91 cm). The Gallery of Art, Howard University, Washington, DC.

Triadic harmony involves three equally spaced hues on the color wheel. The group of blue-green, red-violet, and yellow-orange is one example of a triadic harmony. Red, yellow, and blue (seen in fig. 4–29) is another. Notice that Willem de Kooning used this combination in the painting *Untitled V* (fig. 4–31). Look at the color wheel in fig. 4–14. Which other triadic harmonies can you find?

4–29 This headdress is worn by men during various rituals. The breast feathers are arranged in the shape of rosettes around a bamboo center. With the help of a color wheel, name the triadic color harmony used in this work.

Amazon. Karajá tribe (Araguaia River, Mato Grosso, Brazil). *Lori-lori,* c. 1920. Tail and breast feathers of the blue and gold macaw, bamboo, and various plant fibers. Mekler Collection. Courtesy of Houston Museum of Natural Science. Photo by E. Z. Smith, Fresno, California.

4–30 An example of triadic color harmony.

4–31 Compare this painting to the feather cap in fig. 4–29. Consider the decisions about color that each artist must have made when selecting feathers and paint.

Willem de Kooning (1904–97), *Untitled V*, 1983. Oil on canvas, 88" x 77" (223 x 195 cm). Courtesy of the Anthony d'Offay Gallery, London. ©2010 The Willem de Kooning Foundation/Artists Rights Society (ARS), New York.

An artist may sometimes use only one color or hue within a design. If a painting is made using only one hue, plus black and white, it is called *monochromatic*. In a monochromatic work, contrast is created by the use of lights and darks. Because only one hue is used, all the parts of a monochromatic design work well together.

4–32 Why might the artist have chosen blue as the principle color in this work?
Lyonel Feininger (1871–1956), *Blue Coast*, 1944. Oil on canvas, 18" x 34" (45.7 x 86.4 cm). Columbus Museum of Art, Ohio: Howald Fund Purchase 1951.013. ©2010 Artists Rights Society (ARS), New York/VG Bild-Kunst, Bonn.

Try it

Make a design with a triadic color harmony. Select the brightest hue for the smallest area of the design. Use the same triadic color harmony to create a different design in which you use the brightest hue for the largest area. Then compare the moods or feelings produced by the two designs.

Discuss it

If you were a designer (interior, industrial, graphic, or fashion), what use would you make of color harmonies? Would you always use the hues at their full intensity? What might you mix with them to lessen their intensity?

Warm and Cool Colors

Warm colors are the hues that range from yellow to red-violet. These colors are associated with warm objects or circumstances. The colors of fire, the sun, and desert sand, for example, are in the warm-color range. Look at the color wheel (fig.4–33) and the line that divides it in half. This line separates the warm colors from the cool colors. The *cool colors* are the hues that range from yellow-green to violet. What are some examples of things that have these colors?

We react in certain ways to these colors. We sense that warm colors, especially reds and oranges, seem to come forward in a painting or photograph. These colors also make shapes and forms appear larger. We sense that cool colors, especially greens and blues, seem to recede, or move backward, in a design. These colors make shapes and forms appear smaller. Notice how Chagall contrasts warm and cool colors in *The Farm, The Village* (fig.4–37).

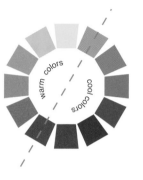

4–33 Warm and cool colors.

4–35 Raffia is a fiber product of the raffia palm of Madagascar, and is used as a textile.

Baule (Avikam or Dida), Ivory Coast. Second half of 20th century. Raffia work with plangi and tritik decorative technique, fragment, 68 ¼" x 70 ½" (173 x 179 cm). Collection Wereldmuseum, Rotterdam, The Netherlands. inv. nr. 31593 ©2010 Wereldmuseum, Rotterdam.

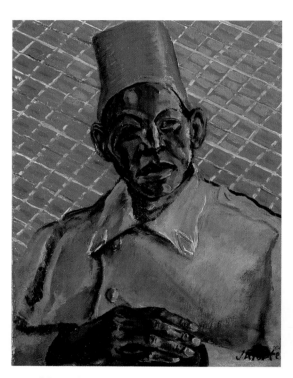

4–34 Notice how the artist picked up the warm reds, yellows, and oranges of the background and clothing, and used them to create accents on the brown skin of the figure.

James A. Porter (1905–71), *Soldado Senegales*, 1935. Oil on canvas, 38 ¼" x 30" (97.2 x 76.2 cm). Smithsonian American Art Museum, Washington, DC. Photo: Smithsonian American Art Museum, Washington, DC/Art Resource, New York.

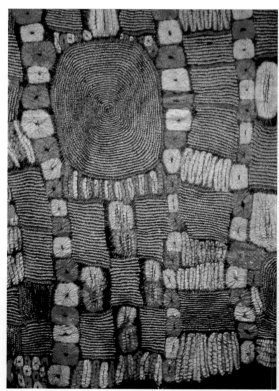

A painter's use of cool colors might emphasize the icy feeling of a wintry seascape. On the other hand, warm colors might express heat in a photograph of workers at a blast furnace. These examples are obvious, but artists and designers do use these characteristics of color to help communicate their feelings and ideas. Look at the painting *Russian Beauty in a Landscape* (fig.4–36). What do you think the artist hoped to convey by using such colors?

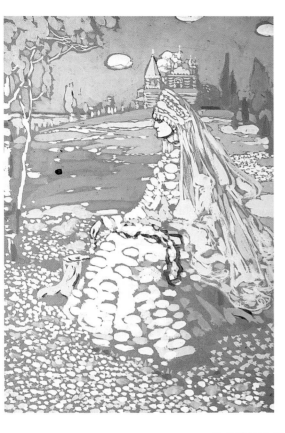

4–36 Compare and contrast this work with fig.4–34. How would you describe the individual and setting depicted in each?

Wassily Kandinsky (1866–1944), *Russian Beauty in a Landscape (Russiche Schöne),* 1904. Gouache, 16 ¾" x 10 ⅝" (42.6 x 27 cm). Städtische Galerie im Lenbachhaus, Munich. ©2010 Artists Rights Society (ARS), New York/ADAGP, Paris.

Note it

If a design has mostly cool blues except for a spot of red-orange on it, the small area of warm color will seem to float above the surface. This occurs because of the length of the lightwaves reflected from the surface and the way your mind interprets them. How do you think an artist or designer might use this knowledge? If you wanted a room to appear larger, would you paint it with warm or cool colors?

4–37 Artists sometimes combine warm and cool colors. Compare this work to the painting *Death on the Ridge Road* (fig.4–15). How did each artist use the warm color?

Marc Chagall (1887–1985), *The Farm, The Village,* 1954–62. Oil on canvas, 24" x 29" (61 x 73.7 cm). Christie's Images/ Superstock, ©2010 Artists Rights Society (ARS), New York/ADAGP, Paris.

Another Look at Color

4–39 Compare the color intensities in this sculpture with those in the pastel drawing in *The Millinery Shop* (fig.4–41).

Karel Appel (1921–2006), *The Tulip*, 1971–86. Stainless steel and enamel, 84" x 108" (213.4 x 274.3 cm). Courtesy of the Marisa del Re Gallery, New York. ©2010 Karel Appel Foundation/ Artists Rights Society (ARS), New York.

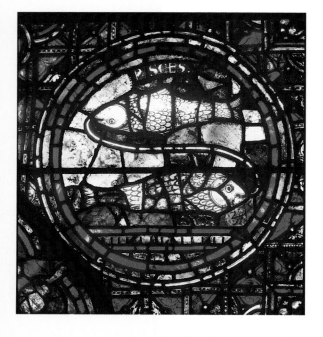

4–40 Use terms from this chapter to describe the different ways color was used in this window.

Chartres, Zodiac stained-glass window from the south ambulatory: *Labors of the months*, detail of February, Pisces, 13th century. Cathedral, Chartres, France. Bridgeman-Giraudon/Art Resource, New York.

4–41 Edgar Degas was a master of color. Consider how he used color to lead the eye through this scene. What kinds of colors did he use, and how did he arrange them in the composition?

Edgar Degas (1834–1917), *The Millinery Shop*, 1879/86. Oil on canvas, 39 ⅜" x 43 ⅜" (100 x 110 cm). Mr. and Mrs. Lewis Larned Coburn Memorial Collection, 1933.428, The Art Institute of Chicago. Photography ©The Art Institute of Chicago.

4–42 Analyze the color combinations used in this student work.

Autumn Denton (age 18), *Windows of My Life*, 1996. Oil pastels, 11" x 14" (28 x 35.5 cm). Lake Highlands High School, Dallas, Texas.

Review Questions

1. How do we perceive color?
2. What colors are not found in the light spectrum? What is the term for these colors?
3. Name the primary, secondary, and intermediate hues used in mixing pigments.
4. How are the secondary colors created?
5. To what does the term *value* refer in color mixing?
6. Explain how to lessen the intensity of a color.
7. Name five types of color harmonies. List a set of colors as an example of each harmony.
8. Why did Georgia O'Keeffe make the flowers in her paintings so large?
9. Describe how paint is applied in pointillism. Which artist is known for developing the pointillism painting technique?

Career Portfolio

Interview with an Art Therapist

Color provides an important clue in the work of **Anna Riley-Hiscox**, who uses art as a means of communicating with her clients. Anna grew up in East Harlem, in New York City, earning scholarships that put her through college. She has a bachelor's degree in art, and a master's degree in marital and family therapy and art therapy. Anna currently works with children and adolescents at a nonprofit agency in California. Off the job, her favorite form of artistic expression is painting gourds.

This simple mandala was drawn by a client of Anna Riley-Hiscox (discussed in this interview). He described his artwork by saying, "This represents the paths I could take in life. The blue could be the right way, the red could be the wrong way. The green represents in the middle. I can go either way, which is why I have the diamond shape in the middle." Anna's job is to help him problem-solve so he will have the information he needs to find the right path.

What is the purpose of art therapy?

Anna I think of art therapy as a vehicle of expression. Sometimes, people have problems or concerns they want to address, but they have a difficult time sitting and talking about emotional issues. We use art as another way of communicating, to help clients learn about new ways to handle difficult situations.

Please give an example.

Anna I was working with a fourteen-year-old client. Every time he came to the office, he would chitchat, and it was pretty superficial. Even after three or four sessions, he really had a difficult time expressing why he was in counseling. One day, I decided verbal therapy wasn't working. So, I said, "Hey, how about doing some art with me?"

He was a little reserved; he wasn't sure whether he actually wanted to do art. He said, "Well, I don't know how to draw." I said, "That's okay." I told him that he didn't have to be perfect. I showed him how to use markers to draw a mandala, a technique that many art therapists use. A mandala drawing is organized in a circle, and is used by many Native Americans and indigenous people to express themselves.

I told my client to simply use line and color to draw, in the circle, how he was feeling. As soon as he started drawing, the room became very, very quiet. We didn't need to talk. He was really engaged in the process of artmaking.

This client had taken a wrong turn in life, which resulted in him being arrested and released on probation. Through his drawing, he was able to express how he was feeling. He talked about how he could take the right path in life or the wrong path. Although his drawing was very simple, he was able to use it to express his vision of making the right choices in the future.

Describe what your work is like.

Anna I work with a variety of clients who have problems they would like to resolve. Like other mental-health professionals, I see my clients in weekly sessions. Art therapists work in many different situations. Some are in private practice; some work for mental health institutions. Others work in schools, prisons, halfway houses, or shelters.

What aspect of your work is most important to you?

Anna Seeing the transition of the kids and the teenagers that I work with. Seeing them come in very confused, with a very chaotic life, and watching them evolve by using art. I've had several kids tell me later that the art was really good for them, and that they're still doing art.

Studio Experience
Color Harmonies with Pastels

Task: To demonstrate understanding of a color harmony by using it in a pastel painting.

Take a look. Review the following images in this chapter:
- Fig.4–15, Grant Wood, *Death on the Ridge Road*
- Fig.4–28, Aaron Douglas, *The Creation*
- Fig.4–29, Karajá, *Lori-lori*
- Fig.4–32, Lyonel Feininger, *Blue Coast*
- Fig.4–38, Jorge Pardo, *Untitled*

Think about it. Study the five artworks listed above and the diagrams of the color schemes.
- Describe the color scheme or harmony in each. List the main colors in each painting; then label the color scheme. If a painting does not quite fit into a specific category, select the closest color scheme and explain how the colors in this art vary from that scheme.
- Compare the intensity of the colors among the paintings.
- How did each artist use color to emphasize certain parts of the composition?
- How did each artist treat the background?
- Describe the mood created by the color scheme in each painting.

Do it.

1 Choose a real-life object—a plant, leaf, shoe, hand, or insect—for your subject.

2 Select pastel sticks that form analogous, complementary, split-complementary, triadic, and mono-chromatic color harmonies. On scrap paper, experiment with various colors of pastels and color schemes. Try blending the pastels with a tissue or tortillon to create transition tones.

3 Look again at the diagrams. Decide which color scheme you will use to set the mood that you want. Consider the mood that will be created by the colors, rather than what color your subject is in real life. Pick a color of pastel paper that goes with your color scheme.

4 On a 9" x 12" piece of pastel paper, make a sampler of the colors that you will include. Lay down several large strokes, state the type of color scheme and mood, and check your work with your teacher.

5 With a pastel close to the color of the paper, sketch the outline of your subject on an 18" x 24" sheet of pastel

paper. Draw the object twice more on this page. To fill the page, draw the objects large, overlap them near the center of the paper, and make them touch the edge of the page on at least two sides.

6 Before adding color, plan the colors for the various areas and shapes: not all need to be a flat color. You may want to vary the color in different areas, blending from one hue to another, or making the color shade from dark to light.

7 Complete your drawing with pastels.

8 Look at your pastel from a distance to evaluate it. If you wish, add more color or lighten or darken an area.

9 In a well-ventilated area, spray your pastel with fixative.

Helpful Hints
- Before you add pastels, consider the background. You could divide large areas of background into shapes or areas of color, as in fig.4–28.
- Thick, velvety applications of pastels that cover the whole surface of the paper are usually considered a painting; lighter applications with visible strokes are more like a drawing.
- Pastels sprayed with a workable fixative may smudge. Spray completed pastels with a clear acrylic spray.

Check it. After you have completed your pastel painting, prop it up. With a classmate, study it from a distance, and answer the following:
- What is the mood? Is it what you are trying to achieve?
- What is the color harmony?
- Would the work be improved by greater differences in hue, shades, or tints between areas of color?
- Would the colors go together better if some were repeated?

"What I like best about this picture is that it is a shock of blending, ethereal blues. The pastels allow for such nice color blending, and I feel like even the bugs look beautiful."
Dhavani Badwaik (age 16), *Beatle Blues*, 1995. Pastels, 18" x 24" (45.7 x 61 cm). Notre Dame Academy, Worcester, Massachusetts.

5 Space

Key Vocabulary

positive space

negative space

picture plane

composition

vanishing point

one-point perspective

two-point perspective

perspective

linear perspective

abstract art

nonrepresentational art

SPACE—SOMETIMES CROWDED, SOMETIMES OPEN—is all around you. It may be full of trees or water, clouds or clear air. It can be contained by walls or open to the horizon. When you swim in a pool, stand on a bridge, or ride through a tunnel, you are located or moving in space. The words *above, below, around, behind, into,* and *through* all indicate position or action in space.

In art, space refers to the three-dimensionality of sculpture and architecture. It might also refer to the sense of depth in a two-dimensional artwork. In this chapter, you'll explore these aspects of space, as well as the unusual sense of space in some modern and abstract art.

5–1 An artist consciously selects the angle from which we view a scene. This Renaissance artist chose to give us a "worm's-eye view."
Andrea Mantegna (1431–1506), *St. James the Great Led to His Martyrdom,* c. 1455. Fresco, largely destroyed in 1944. Chiesa degli Eremitani, Padua, Italy. Photo: Alinari/ Art Resource, New York.

5–2 The only way to appreciate this artwork fully is to walk through the space that is an integral part of the piece.
Isamu Noguchi (1904–88), *California Scenario,* 1980–82. Costa Mesa, California. Courtesy of the South Coast Plaza Alliance, Costa Mesa, California. Photo by Stan Klimek. ©2010 The Isamu Noguchi Foundation and Garden Museum, New York/Artists Rights Society (ARS), New York.

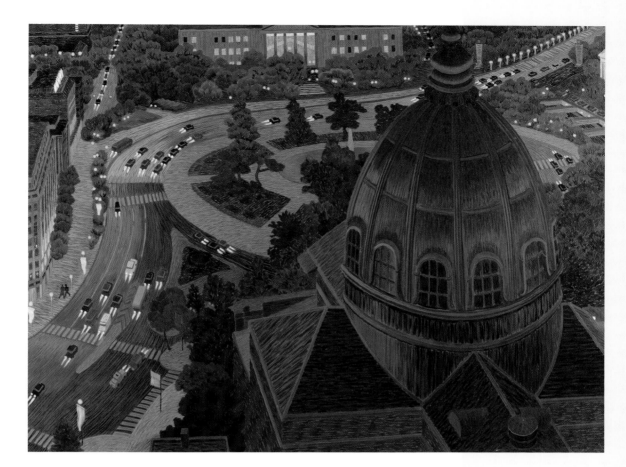

5–3 Though you cannot walk through the space in Barbara Hepworth's sculpture, as you would with Noguchi's work (fig.5–2), consider how your eye "walks" through *Pelagos*.

Dame Barbara Hepworth (1903–75), *Pelagos*, 1946. Wood and mixed media, 14 ½" x 15 ¼" x 13" (36.8 x 38.7 x 33 cm). Tate Gallery, London/Art Resource, New York. ©Bowness, Hepworth Estate.

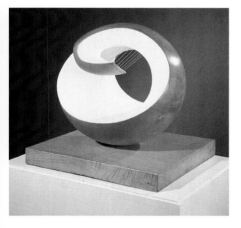

5–4 This is an unusual point of view for a cityscape. How does viewing the street from above affect our sense of the space?

Yvonne Jacquette (b. 1934), *Dark Basilica by Logan Circle*, Philadelphia, 2004. Oil on canvas, 59" x 79¼" (149.9 x 201.3 cm). Philadelphia Museum of Art, Philadelphia, Pennsylvania. Gift of the Young Friends of the Philadelphia Museum of Art, 2005 (2005-13-2). Photo ©The Philadelphia Museum of Art/Art Resource, New York.

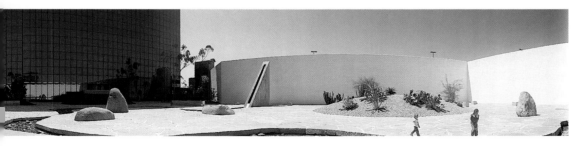

Three-Dimensional Space

An object that has three-dimensional space has height, width, and depth. In art, architects and sculptors are those most likely to work with such space. Both a cabin beside a lake and a sculpture of a horse are three-dimensional structures: they have spaces that you can walk *inside of* or *around*.

Positive and Negative Space

In today's world, you are probably more aware of space that is filled with something than of space that seems empty. City spaces are crowded with buildings and people. Roads and highways are choked with automobiles. Your living spaces are filled with furniture. And your wall spaces are likely decorated with posters and memorabilia.

When a sculptor or architect creates a three-dimensional design, he or she must be concerned with both positive and negative spaces. The ***positive space*** is the object or structure itself, such as the statue of Andrew Jackson (fig.5–6). The ***negative space*** is the area surrounding the object or structure, such as the blue sky and clouds around this statue. In a building, the negative space is also the area inside the structure.

5–5 The overcrowding of cities is often broken by empty, or negative, space in the form of plazas and spacious building entryways.
Viljo Revell (1910–64), *Ontario Civic Center* (New City Hall), 1961–65. Toronto, Canada.

5–6 What does the placement of this sculpture have to do with the idea of negative and positive space? Where are large monuments such as this generally placed?
Clark Mills (1815–83), *Andrew Jackson*, 1855. Bronze. Lafayette Park, Washington, DC.

5–7 How did the photographer use positive and negative space to balance this image?
Venice Gate, Photo by J. Gatto.

Henry Moore

Born in 1898 and raised in Castleford, England, Henry Moore was the son of a coal miner. His surroundings as a child were those of a grim industrial area; yet, his curiosity led him to explore artistic possibilities. At the age of ten, he learned about Michelangelo and decided to become a sculptor. As a teenager, Moore practiced drawing and most likely would have become a schoolteacher except that World War I caused him to join the army instead. He was fortunate: he not only survived combat (most of the men in his regiment were killed or seriously wounded) but also received a military grant to attend the Leeds School of Art.

Moore's talent became evident at Leeds: after two years, he won a scholarship to the Royal College of Art. Living in London gave him access to the British Museum, which housed sculptures from around the world. These diverse artworks inspired Moore's sculptures throughout the rest of his life. Moore also enjoyed the Museum of Natural History, where he became intrigued by the forms of natural objects such as pebbles and bones.

Sculpture was not a popular art form when Moore began practicing it seriously. In fact, there were so few sculpture students at the Royal College that he had a large studio all to himself. This situation provided Moore with a sense of freedom that he might not otherwise have felt.

Drawing remained a vital part of Moore's creative work, even as he turned his attention to sculpting. For many years, his materials of choice were stone and wood, but by 1935, he began sketching ideas for metal sculpture. Moore originally approached sculpting primarily as a carver would, chipping away pieces to "reveal" the sculpture inside. Later, though, he turned to modeling—an additive process—for its relative speed. He chose to model with plaster, however, so that he could subtract areas by cutting away the material. Eventually, he worked in bronze, even building a foundry so that he could better understand the process of casting. Many of his bronze works include "carving marks"—final touches made to the plaster just before casting—as part of the sculpture.

During World War II, Moore spent an entire year creating a powerful series of drawings of people who took refuge from air raids in the London Underground. Moore's observation of these people—the feeling of enclosed space, and the relation of bodies to the space and to one another—had an enormous impact on him. The bomb shelter drawings, which typically showed rows of sleeping people, brought him recognition as an artist, and also gave direction to his future sculpting: many of his sculptures are of reclining figures.

Henry Moore became well-known for his innovative use of negative space. In *Lincoln Center Reclining Figure* (fig.5–8), the three-dimensional form of a figure is cut by negative space. The outside space flows around and through the form. In certain sections, the negative space even takes the place of the figure, which is characteristic of much of Moore's work.

5–8 Compare the negative space in this sculpture with that in fig.5–6. How do they differ? In which one is the negative space a vital part of the artwork?
Henry Moore (1898–1986), *Lincoln Center Reclining Figure*, 1963–65. Bronze, 28' long (8.5 m). Reproduced by permission of The Henry Moore Foundation. LH 519 Photo by H. Ronan.

Flowing Space

The division between outside and inside space is not always clear. We are all aware of the different feelings created by a room that has many large windows and one that has no windows at all. Architects add windows, skylights, and other devices to buildings to help make the exterior space flow through and become part of the interior.

5–9 As in a work of art, the landscape designer plans on what plants and flowers should be used and where. Color, shape, and size contrasts are considered.

Butchart Gardens. Photo by J. Selleck.

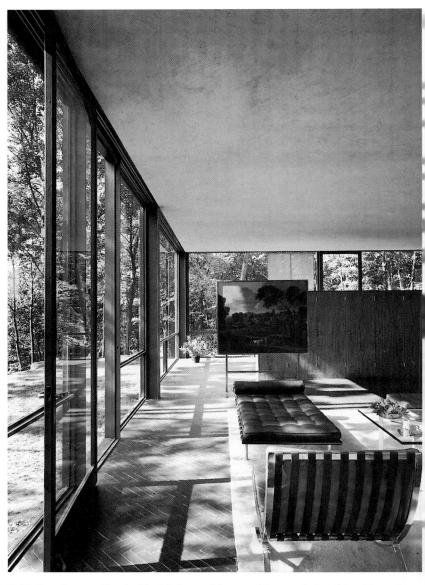

5–10 Imagine standing inside this house. How would your relationship with outdoor space differ from that which you experience in your classroom?

Philip Johnson (1906–2005), *Glass House,* 1949. New Canaan, Connecticut. Photo by Ezra Stroller, ©Esto.

Sculptures and other three-dimensional forms constructed with wire or glass or pierced with holes are other examples of flowing space. Such works tend to break the boundaries between positive and negative space. Our eyes move into, around, and through the form. Holes connect one side with another. Instead of simply surrounding a structure, air or sky might play a part in occupying or creating interior spaces.

5–11 Judy Pfaff incorporated the gallery, including the ceiling space, in her installation. Many of the materials have been recycled since the sculpture was taken apart at the close of the exhibition.

Judy Pfaff (b. 1946), *Wild Rose*, 2008. Painted and expanded foam, bent and constructed steel, rubber tubing, tree roots, grapevine, fake flowers, string, wire, black aluminum foil, a scrim made of tape; fluorescent, neon and black lights, 27' x 18' x 18' (8.2 x 5.5 x 5.5 m.), dimensions variable. Photo: Jeanne Flanagan. Courtesy of the Esther Massry Gallery, College of Saint Rose, Albany, New York. Art: ©Judy Pfaff/Licensed by VAGA, New York.

5–12 Compare and contrast the use of space here with that in fig.5–11. Notice how this artist contained the interior space of her sculpture.

Glenna Goodacre (b. 1939), *Philosopher's Rock.* Bronze, 8' high (2.43 m). Located at Barton Springs, Zilker Park, Austin, Texas. Photo by Daniel R. Anthony. Courtesy of Glenna Goodacre Ltd., Santa Fe.

Two-Dimensional Space

The *surface* of a floor, a tabletop, a sheet of cardboard, or a piece of paper can be described in terms of two dimensions: height and width. The surface has no depth.

In art, examples of two-dimensional space are a quilt design of geometric shapes and a pencil sketch of a tree. In the quilt, a red square may be sewn above a yellow one. In the drawing, the tree may be in front of a house. However, both works are physically flat.

5–13 Cartoonists often prefer not to create any sense of depth beyond the surface of the picture plane.

Stone Soup ©1998 Jan Elliot. Reprinted with permission of Universal Press Syndicate. All rights reserved.

5–14 In many of his works, the Dutch painter Vincent van Gogh created surface depth on the canvas. He used thick applications of oil paint, called *impasto*.

Vincent van Gogh (1853–90), *Roulin's Baby*, 1888. Canvas, 13 ¾" x 9 ⅜" (35 x 23.9 cm). Chester Dale Collection. ©1988 Board of Trustees, National Gallery of Art, Washington, DC.

The Picture Plane

The flat surface on which an artist works—whether it be paper, canvas, or a wall—is called the *picture plane*. Most artists do not attempt to create much physical depth on the picture plane. Some may apply oil paint thickly to a canvas to create surface depth. Collage artists might build up a flat surface with fabric, sand, or bits of wood. Other artists sometimes cut or tear the canvas or paper as part of their working method. But most drawings and paintings are basically two-dimensional.

An artist might choose to create an illusion of depth by manipulating line, color, value, and shape. The image created by painting or drawing can have a sense of depth which causes the viewer to momentarily forget that the surface is flat. Notice how in *Mystic Seaport in Fog* (fig.5–16) your eye is drawn "into" the scene and "beyond" the picture plane.

5–15 This student gives physical depth to the surface of her image by using cut paper.
Alicia Smith (age 16), *Monet in Paper*, 1998. Paper relief, 13" x 18" (33 x 46 cm). Nashoba Regional High School, Bolton, Massachusetts.

5–16 In this photograph, the fog and soft light have transformed the sky, water, and buildings into a single flat surface.
Alfred Eisenstaedt (1898–1995), *Mystic Seaport in Fog*, 1969. Photo. Alfred Eisenstaedt, *Life* magazine.

Try it

Choose a full-page photograph, such as a cityscape or landscape, from a magazine. Cut it into equal-size squares or rectangles. Rearrange the pieces until you are pleased with the design. Glue your new arrangement onto another sheet of paper. Explain what happened to the space.

Composition

Like the relationship between positive and negative spaces in a sculpture or building, there is a relationship between shapes in two-dimensional art. The organization of elements and their placement on the picture plane is called *composition*.

When you place a black square on a piece of white paper, you create a new space. The surface is still two-dimensional, but it is now divided in two. The black square has become the positive space, and the white background area is the negative space. If you add a few more black shapes, the composition will change again. You will see several black positive spaces and an encompassing white negative space.

The shapes in a two-dimensional work also have a relationship to the edges or shape of the paper or canvas. A square shape placed in the lower-right corner of a piece of white paper creates a space quite different from that made by a square shape placed at the center. Similarly, the feeling of space can be altered by changing the shape of the picture plane, whether it is paper or canvas. Although most artists create drawings and paintings within a rectangular shape, they will sometimes use a round, oval, or irregular shape.

5–17 How does the addition of black shapes change the negative space from the original composition? Does the black square also seem to change?

5–18 The fan shape is a traditional format in Chinese painting. Compare the space on the right side of the painting with that on the left. How does it differ?
Wei Zhujing (1573–1619), *The Elegant Gathering in the Western Garden*, Ming Dynasty (1368–1644). Fan painting, ink and colors on gold-surfaced paper, 6 ½" x 20" (16.9 x 51.6 cm). Museum purchase, B79D19.A-.B. ©Asian Art Museum of San Francisco. Used by permission.

Point of View

A building appears different from the street than from the roof next door because the angle or point of view determines how the structure appears in space. A car looks different on a grease rack because we are not used to looking up at the car's underside. A baseball field looks different when you are standing on the pitcher's mound than when you are looking down on the field from the stands. A mountain looks huge when you are at its base, but the valley surrounding the mountain looks smaller when you are on top of the mountain.

Look around carefully and see what happens to objects or people when you change your point of view. When you look down from a high window, for example, people walking on the street look quite different than they would if you were on the street with them. Spatial relationships change as your angle, or point of view, changes. Artists or photographers take advantage of point of view to produce dramatic spatial effects.

5–19 How would you describe the space in this scene? What is the observer's point of view?

Weegee (Arthur Fellig) (1899–1968), *Coney Island Crowd*, 1940. Gelatin silver print. Gruber Collection, Museum Ludwig, Cologne. 1977/839 Photo by Weegee (Arthur Fellig)/International Center of Photography/Getty Images.

The Illusion of Depth

Although artists may paint or draw on a flat surface, they often create the illusion or appearance of depth. To achieve this effect, they may choose from a variety of both simple and complex devices. Historically, artists from different cultures have relied more heavily on some methods than on others. Artists today often employ a combination of methods to create the illusion of depth.

You already know that shading and shadows help make a shape appear to have roundness or three-dimensionality. The techniques described in the following pages can help you create a greater sense of depth on a flat picture plane.

5–20 In this miniature, the artist worked with space in two different ways. The many patterns prevent an illusion of depth, so how is the viewer made to understand the arrangement of figures in space?
Abd Allah Musawwir (active mid-16th century), *The Meeting of the Theologians*, 1540–1550. Watercolor on paper, 11 ⅜" x 7 ½" (28.9 x 19.1 cm). The Nelson Atkins Museum of Art, Kansas City, Missouri. Purchase: William Rockhill Nelson Trust, 43-5. Photograph by E.G. Schempf.

5–21 How is a sense of depth communicated in this purely abstract painting?
Vanessa Bell (1879–1961), *Abstract Painting,* c. 1914. Gouache on canvas, 17 ⅜" x 15 ¼" (44.1 x 38.7 cm). Tate Gallery, London. Photo Tate, London/Art Resource, New York. ©Tate. ©Estate of Vanessa Bell.

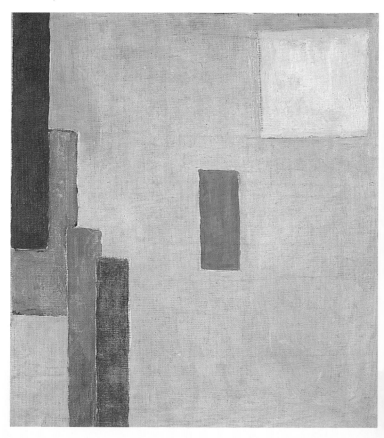

Nonlinear Methods

Position Place an object or shape higher on the page to make it seem farther away. In this diagram, the cat on the left seems closer.

Overlapping Place one shape on top of another to produce a feeling of depth. In this diagram, the apple (the top shape) appears to be in front of the orange.

Size Variation Combine similar objects of different sizes. The smaller objects will seem farther away than the larger ones. For example, trees in nature seem to become smaller as they recede into the distance.

Color Use color to create a sense of depth. A shape of bold color on a more neutral-colored background appears to move forward.

Value Use different values. Lighter values tend to recede behind darker ones. In a landscape, you might use increasingly lighter shades of blue to create the illusion of a hazy atmosphere in the distance.

Try it

Choose one object with a distinct shape—such as an apple, leaf, or butterfly—and draw the shape on colored paper seven or eight times, but in different sizes. Cut out the shapes and place them on a neutral sheet of paper. Arrange some of the shapes so that they don't touch. Place some higher and some lower. Overlap others. Notice the various three-dimensional effects that occur. When you find an arrangement that you like, glue down the shapes.

Linear Perspective

The method of depicting three-dimensional space on a two-dimensional surface is called *perspective*. When artists use lines to create depth, they are using *linear perspective*. Linear perspective is a much-used art technique, and is one of the best ways to create the illusion of depth in a drawing or painting.

One-point Outside your school or on your way home, close one eye and look up at the sides of a tall building or along the length of a street. You will notice that the sides of the building or the street appear to converge, or come together, in the distance.

During the Renaissance, Italian artists discovered that when straight lines are parallel, they seem to move away from the viewer and meet at a point in the distance. This point is called the *vanishing point*, because it is where the objects seem to disappear. When artists use linear perspective in combination with a single vanishing point, they are using *one-point perspective*.

5–22 Diagram of one-point perspective. The line drawn parallel to the top edge of the composition is called the *horizon line*. It is an imaginary line that represents your eye level when you look straight ahead. The vanishing point is located on the horizon line. Notice that the square end of the object faces the viewer directly.

5–23 This museum is a replica of an ancient Roman villa. The original architect designed this garden and surrounding structures so that when a person stood at the center of the edge of the fountain all of the architectural elements visually converged to a focal point, which is the central opening of the façade.

Main peristyle garden and façade, *Getty Villa*, Malibu, California. Photo by Julius Shulman.

5–24 As evident in the student painting, one-point perspective is an excellent device for "pulling" the viewer into a scene.

Marion Bolognesi (age 15), *Bonaire*, 1997. Oil, 12" x 16" (30.5 x 40.6 cm). Quabbin Regional High School, Barre, Massachusetts.

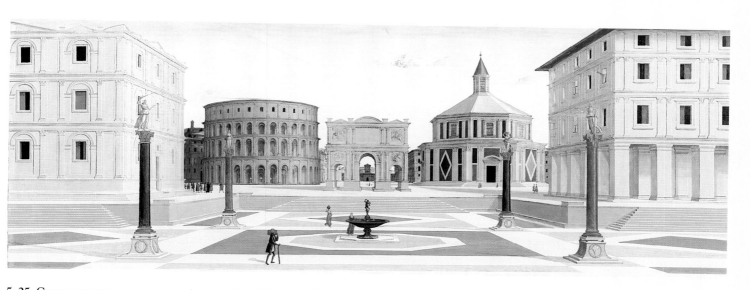

5–25 Compare your eye movement when viewing this image and fig.5–20.

Fra Carnevale (1420/25–84), *The Ideal City*, c. 1480–84. Oil on panel, painted surface: 30 ½" x 86 ⅝" (77.4 x 220 cm); panel: 31 ⅝" x 86 ⅝" x 1 ¼" (80.3 x 220 x 3.2 cm). Walters Art Gallery, Baltimore 37.677. Photo ©The Walters Art Museum, Baltimore.

Two-point One-point perspective uses lines that lead to a single vanishing point. To create the appearance of three-dimensionality for objects placed at an angle to the viewer's line of sight, you must use two-point perspective. *Two-point perspective* uses parallel lines that seem to lead to two different vanishing points set far apart.

The different ways of depicting space and depth can be quite complicated—especially when artists combine several in one artwork. When you paint or draw, notice how edges and lines slant as they get farther away—and don't forget the simple methods of overlapping and size variation! Careful observation and use of these cues will help you create the illusion of three-dimensional space.

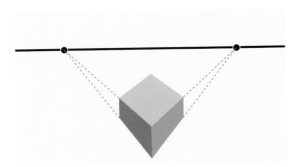

5–26 Books, boxes, and buildings that are at an angle to your line of sight can be shown by using two-point perspective. Notice that none of the three surfaces shown faces the viewer directly. The two vanishing points are on the horizon line.

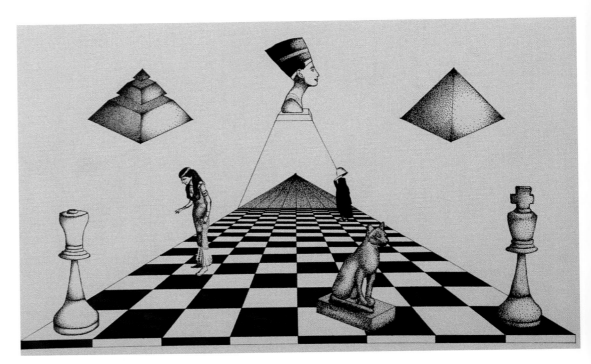

5–27 How has this student used one-point and two-point perspective to make this surrealist composition more effective?
Jeffrey T. Metter (age 17), *Egypt*. Pen and ink, 18" x 12" (45.7 x 30.5 cm). Palisades High School, Kintnersville, Pennsylvania.

Try it

Choose a magazine photograph or graphic design that depicts objects in deep space. Draw in the vanishing point where you think it belongs. Then use a ruler and a marker to draw converging lines from any objects back to the vanishing point.

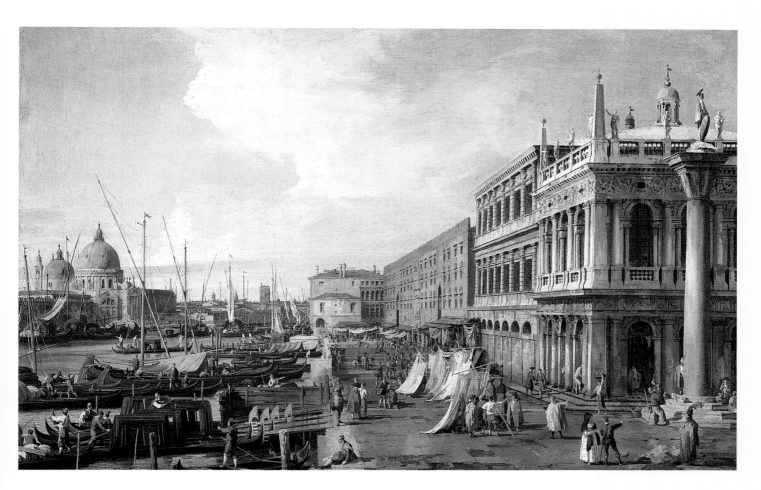

5–28 Allow your eye to follow the two imaginary perspective lines that begin at the corner of the building at the right. The line that moves to the right is quickly stopped by the edge of the painting. The line that extends to the left goes deeper into space, but is stopped by the building in the distance whose façade is parallel to the picture plane. Why do you think Canaletto used these devices? Where did he want you to focus your attention?

Giovanni Antonio Canaletto (1697–1786), *The Molo, Venice,* c. 1735. Oil on canvas, 24 ½" x 39 ⅞" (62.3 x 101.3 cm). AP 1969.22 Kimball Art Museum, Fort Worth, Texas. Photo: Kimball Art Museum, Fort Worth, Texas/Art Resource, New York.

5–29 Douglass Crockwell used two-point perspective to depict a number of the objects in this painting. Can you name at least three?

Douglass Crockwell (1904–68), *Paperworkers,* 1934. Oil on canvas, 48 ¼" x 36 ⅛" (91.7 x 122.4 cm). WPA Work. Smithsonian American Art Museum, Washington, DC. Photo: Smithsonian American Art Museum, Washington, DC/Art Resource, New York.

Subjective Space

A device like linear perspective helps artists depict scenes and objects as they appear in nature or in photographs. The subjects seem accurate and realistic to us. But artists are often interested in altering the world that we see with our eyes. Using their imagination and emotions, they manipulate and transform space and reality, creating subjective spaces that bear little resemblance to the real world.

5–30 For many centuries, artists have been fascinated with the depiction of reflected space. Here, the photographer momentarily confuses us because he captured both real and reflected space, and we must work hard to solve the puzzle of their relationship to each other.
André Kertész (1894–1985), *Untitled*, 1929. Gelatin silver print, 9 ⅜" x 7 ⅛" (23.81 x 18.1 cm). Promised gift of Paul Sack to the Sack Photographic Trust ©The Estate of André Kertész.

5–31 Compare this painting with the logical way that Canaletto constructed space in *The Molo, Venice* (fig.5–28). Use this comparison to help you see how Giorgio de Chirico created a space that makes the viewer very uneasy.
Giorgio de Chirico (1888–1978), *The Evil Genius of a King*, 1914–15. Oil on canvas, 24" x 19 ¾" (61 x 50.2 cm). The Museum of Modern Art, New York. Purchase (112.1936). The Museum of Modern Art, New York. Digital Image ©The Museum of Modern Art/Licensed by SCALA/Art Resource, New York. ©2010 Artists Rights Society (ARS), New York/SIAE, Rome.

Space That Deceives

Look carefully at reflections in mirrors, water, and glass and metal surfaces. How are spaces distorted and deceptive? Artists today and in the past have used unusual spaces to confuse, surprise, and educate their viewers. Their works may cause you to question whether the space depicted is flat or three-dimensional, or whether the composition could actually occur in space and time as we know it. Sometimes, such optical illusions are purely entertaining. At other times, they can be the basis of serious art.

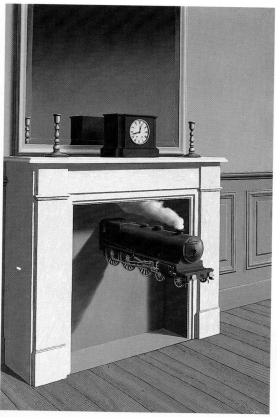

5–32 In this fresco, the early Renaissance artist Masaccio showed a series of three events happening at the same time. Other artists throughout history have made similar adjustments, seeming to go beyond the limits of the traditional concepts of space and time.
Masaccio Maso di San Giovanni (1401–1428), *The Tribute Money*, c. 1427. Fresco. Brancacci Chapel, Santa Maria del Carmine, Florence. Photo: Scala/Art Resource, New York.

5–33 Surrealist artists attempt to create a deep space in which their personal dreamlike worlds exist. At first glance, their works may appear to imitate nature. But often—after careful examination—you'll notice that they bear little relationship to reality. In this fantastic creation, as in others by René Magritte, objects are combined in impossible ways.
René Magritte (1898–1967), *Time Transfixed*, 1938. Oil on canvas, 57 ⅞" x 38 ⅞" (147 x 98.7 cm). Joseph Winterbotham Collection, 1970.426, The Art Institute of Chicago. Photography ©The Art Institute of Chicago. ©2010 C. Herscovici, London/Artists Rights Society (ARS), New York.

Cubism

One group of subjective artists, called Cubists, depicted space in a new way. In their works, objects and figures might be recognizable, but their shapes and the spaces they inhabit do not resemble those in the real world.

The Cubists flattened space, fractured forms, experimented with color, and added lines where none really exist. Because the objects they depicted usually resembled squares, or cubes, their method of working came to be called *Cubism*. In many Cubist works, objects seem both to stand straight up *and* to slant toward the viewer. Such treatment of space is contrary to nature and the camera lens, but it allows an artist to share his or her imagination and creative energy.

5–34 Do you think Juan Gris was working from a traditional still-life arrangement when he created this piece? If so, describe or sketch what it might have looked like.

Juan Gris (1887–1927), *Coffee Grinder and Glass*, 1915. Oil on paperboard, 15 ⅛" x 11 ½" (38.5 x 29.2 cm). The Nelson Atkins Museum of Art, Kansas City, Missouri. Gift of Earl Grant in Memory of Gerald T. Parker, 71-22. Photograph by Robert Newcombe.

5–35 Review the description of Cubism in the text. In what ways does this painting fit that description?

Georges Braque (1882–1963), *Still Life with Grapes and Clarinet*, 1927. Oil on canvas, 24 ¼" x 28 ¾" (54 x 73 cm). The Phillips Collection, Washington, DC. ©2010 Artists Rights Society (ARS), New York/ADAGP, Paris.

Try it

Choose a simple object, such as a chair, a desk, or a lamp. Create three drawings of the object from different angles: perhaps a view from the side, from the top, and from below. Then combine parts of the three drawings into one to create your own Cubist composition.

Pablo Picasso
Guitar

Sometimes, a single work of art will cause long-held ideas to collapse. The twentieth century saw a steady stream of important artworks that changed the way we think about time, space, and form.

Working collaboratively in the spring of 1912, both the Spanish artist Pablo Picasso and the Frenchman Georges Braque experimented with breaking the boundaries of traditional ideas about space and form. Their creative minds challenged the age-old concept that art must consist of paint on canvas.

Picasso and Braque introduced real items to their canvases, items such as newspaper clippings, known as *papiers collés* ("glued-on papers"). This new art form was the beginning of collage as we know it. At the same time, both artists carried their Cubist ideas into three dimensions. Braque made paper reliefs, whereas Picasso used wood, sheet metal, and wire. Picasso's more durable materials survived, but Braque's studies did not. Picasso began to transform his Cubist still lifes from the canvas plane into the sculptural realm.

At first, Picasso used cardboard and string to construct *Guitar* (the restored maquette, or model, is also in the MOMA collection). He made his final version of more permanent sheet metal and wire, and this became the first sculpture that had been created neither by carving nor modeling. This new art form was called *constructed sculpture*.

New ideas, however, are not always seen as successes in the beginning. In 1913, an art magazine called *Les Soirées de Paris* published four photographs of Picasso's Cubist constructions, similar in style to *Guitar*. Thirty-nine of the journal's forty subscribers so strongly disapproved of Picasso's sculptures that they canceled their subscription. The subscribers did not realize that constructed sculpture would become a widely accepted art form.

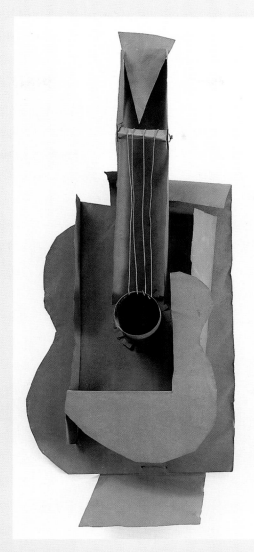

5–36 In this early Cubist sculpture, a projecting cylinder indicates the sound hole. Pablo Picasso, Georges Braque, and Juan Gris were the leading supporters of the Cubist style.

Pablo Picasso (1881–1973), *Guitar,* after March 1914. Sheet metal and wire, 30 ½" x 13 ¾" x 7 ⅝" (77.5 x 35 x 19.3 cm). The Museum of Modern Art, New York. Gift of the artist. (94.1971) Digital Image ©The Museum of Modern Art/Licensed by SCALA/Art Resource, New York. ©2010 Estate of Pablo Picasso/Artists Rights Society (ARS), New York.

Try it

To achieve a flattening effect of the picture plane, draw some simple still-life objects. With a pencil, draw the outside edges of each object, allowing the lines to overlap the other objects and continue off the page. Notice the unity and flatness of the objects and background that result. Compare your drawing with Gris's *Coffee Grinder and Glass* (fig.5–34).

Abstract and Nonrepresentational Art

Beginning with Cubism in the early years of the twentieth century, artists began to alter their depictions of space. Objects and figures, if depicted at all, were difficult to recognize in their paintings, drawings, sculptures, and other creations—works that are generally called *abstract art*. Works in which no objects or figures appear are referred to as *nonrepresentational art*.

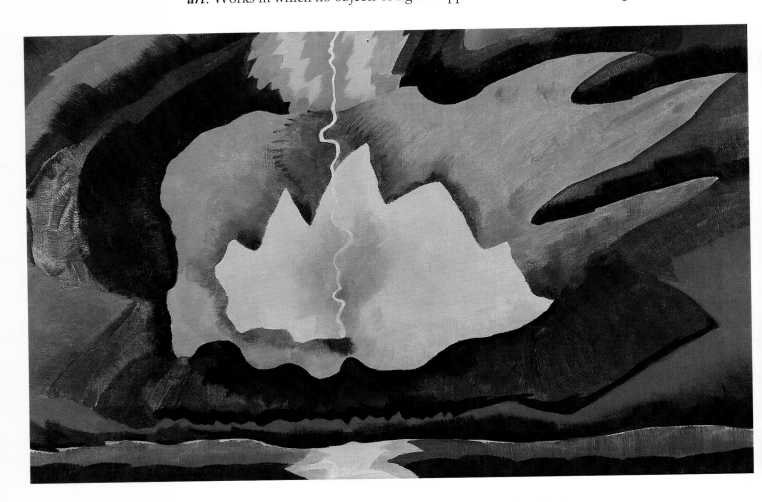

5–37 A composition of contrasting lights and darks will appear to have depth. Warmer and brighter colors also seem to come forward. In this painting, the blue shapes recede; the red and yellow shapes move forward.

Arthur Dove (1880–1946), *Thunder Shower*, 1939–40. Oil and wax emulsion on canvas, 20 ¼" x 32" (51.2 81.3 cm). Amon Carter Museum, Fort Worth, Texas 1967.190.

Try it

Choose three sheets of paper whose colors are closely related. Cut out similar shapes, perhaps squares or rectangles, from each color. Paste the shapes on another surface, completely covering it. Notice that the related colors make the picture seem relatively flat. Now choose a contrasting color. Cut out a few similar shapes. Place those on top of your design. What happened to the sense of space?

Although an abstract work may not depict anything recognizable, it still may have depth. Principles about position, overlapping, size, color, value, and linear perspective also apply to abstraction. Just as in more realistic art, these principles may be combined to create space that appears flat, shallow, or deep.

5–38 Notice how the top section of this work seems caved in, whereas the lower section seems to bulge forward.

Victor Vasarely (1908–97), *Sir-Ris*, 1952–62. Oil on canvas, 6' 6" x 3' 3" (198 x 99 cm). Reproduced with permission by the Janus Pannonius Múzeum, Pécs, Hungary. ©2010 Artists Rights Society (ARS), New York/ADAGP, Paris.

5–39 How is an illusion of depth created in this abstract painting?

John Ferren (1905–1970), *Orange, Blue, Green*, 1969. Acrylic on canvas, 45 ⅛" x 50" (115 x 127 cm). Jack S. Blanton Museum of Art, The University of Texas at Austin. Purchased through the generosity of Mari and James A. Michener, 1970. Photo by Rick Hall.

Another Look at Space

5–40 Early medieval artists were masters of surface decoration and purposely did little to give the illusion of deep space.

St. Matthew, from the Lindisfarne Gospels, before CE 698. 13 ½" x 9 ¾" (34.3 x 24.8 cm). British Library, London. ©The British Library Board. All Rights Reserved.

5–41 Describe the relationship between positive and negative space in this object.

Torii Ippo (b. 1930), *Lightning God,* 2001. Woven madake bamboo, rattan, 20" x 13 ½" (50.8 x 34.3 cm). Mint Museum of Art, Charlotte, North Carolina. Museum Purchase: Funds provided by Mattye and Marc Silverman, Emily and Fred Gurtman, Patty and Bill Gorelick, and Ethel and Jim Montag. 2002.15

5–42 Many artists use space to create an element of surprise in their work. What makes our eyes do a double take here?

M. C. Escher (1898–1972), *House of Stairs,* 1951. Lithograph, 18 ⅝ x 9 ⅜" (47 x 23.9 cm). ©2010 The M. C. Escher Company-Holland. All rights reserved. www.mcescher.com.

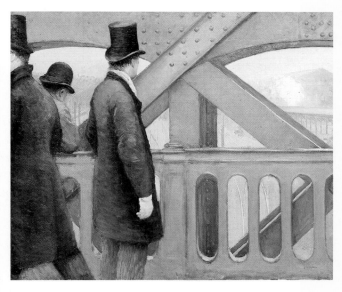

5–44 In reality, the view from this bridge must extend quite far. How does Caillebotte's use of color prevent the illusion of deep space?

Gustave Caillebotte (1848–94), *On the Europe Bridge (On the Pont de Europe),* c. 1876–77. Oil on canvas, 41 ⅝" x 51 ½" (105.3 x 129.9 cm). AP 1982.01 Kimbell Art Museum, Fort Worth, Texas. Photo: Kimbell Art Museum, Fort Worth, Texas/Art Resource, New York.

5–43 Analyze the use of flowing space in this student work.

Lonnie Nimke (age 13), *Do-do Bird,* 1994. Metal and found object welding, 36" x 24" (91.4 x 61 cm). Manson Northwest Webster Community School, Barnum, Iowa.

5–45 How does the Mayan sculptor of this ceramic piece contain the space and focus our attention?

Mayan, *Model of a Ballgame.* Ceramic, 6 ½" x 14 ½" x 10 ⅝" (16.5 x 36.8 x 27 cm). 1947.25 Worcester Art Museum, Worcester, Massachusetts. Gift of Mr. and Mrs. Aldus Chapin Higgins.

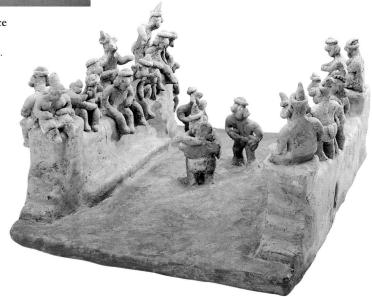

Review Questions

1. Define the art element *space.*
2. List five means that artists use to create an illusion of depth on a flat surface.
3. In a linear-perspective drawing, what happens at the vanishing point? What does the horizon line represent?
4. Select a Cubist image from this chapter and describe how the artist abstracted space and forms.
5. Select an abstract or nonrepresentational image from this chapter and explain how the artist indicated depth.
6. What is innovative in Henry Moore's sculptures?
7. Which two artists worked together in developing the art of collage?

Career Portfolio
Interview with an Architect

Space is a major consideration for architects, both in and around the buildings they design. Planning must include streets, sidewalks, and parks as part of the greater picture. Born in Seoul, South Korea, **Susie Kim** has degrees in architecture and urban design. She has worked on several large-scale projects in London, Boston, Beirut, Vietnam, and China.

Please describe what you do.

Susie We do architecture and urban design—designing cities.

When you design a city, is the city already there?

Susie Sometimes and sometimes not. Planning a new piece of a city within the old city is like an orchestration. Maybe you already have a violin section and a cello section, but you don't have the flute section or the woodwind section.

What makes a good city?

Susie It depends on the culture and some of the drawbacks of the culture. Generally, a good city with good pieces benefits other pieces, benefits the whole. Let's pull an example: Manhattan, Central Park. Can you imagine anyone putting in Central Park? Most developers would say that's stupid. But what that did was to bring value, which was a benefit to

the city and its people. My partner and I don't believe in single-use cities. People need different experiences in a city.

When did it click for you that architecture was a possibility?

Susie I wanted to go into a profession which was, at that time, not necessarily right for girls. I wanted to be either an architect or a pilot. Don't ask me why a pilot, other than I figured there weren't a lot of women in this profession. In a song in *The Fantasticks* [a long-running play in New York City], a girl says, "Oh, please God, don't make me normal." That was one of my images.

Are there different kinds of architects?

Susie There are a lot of different things you can do with an architecture degree. One is practice: residential, commercial, institutional, a mixture, urban design. I also have a lot of friends who are teaching, which is incredibly valuable. You can also go into aspects of setting up public policy; policy-making jobs are more administrative and political.

What advice would you give to young people who are interested in architecture?

Susie A project in this profession is a very long process. To put up a building or to make a city takes a tremendous amount of patience. Tremendous. If you can count on your fingers ten important projects, that's probably five more than Michelangelo did. Think about it. How many buildings can you put up that are of a certain quality? It's a long process. It's not a profession for people who want instant gratification.

What is your role in a project?

Susie I'm a medium for creating something much larger than myself. That is the most rewarding thing about a project or a building, when it really has a life of its own that goes beyond yourself. But it's always amazing to me how much of a stranger it can seem. After five, ten years, you go back and look at it, and the building has its own life. That's when you know it's successful. It's no longer yours. It's somebody else's; it's part of the city, part of the fabric.

The Osher Map Library and Smith Center for Cartographic Education is a three-story building that marks the gateway to the University of Southern Maine Campus. Aluminum panels clad the upper levels, more than 100 of which are part of a 156-foot etching of The Dymaxion Map. Susie Kim, *Osher Map Library, University of Southern Maine.*

Studio Experience
An Event in Clay

Task: To create a clay sculpture of an event, such as a ceremony or game.

Take a look. Review the following images in this chapter:

- Fig.5–2, Isamu Noguchi, *California Scenario*
- Fig.5–11, Judy Pfaff, *Wild Rose*
- Fig.5–12, Glenna Goodacre, *Philosopher's Rock*
- Fig.5–41, Torii Ippo, *Lightning God*
- Fig.5–45, Mayan, *Model of a Ballgame*

Think about it.

- In each sculpture, notice how the figures or objects relate to one another. In which sculptures do the major elements seem to overlap? In which are they separate? How has each artist united the figures and objects to create a unified whole?
- Imagine that you are the same size as the elements in these sculptures. If you were moving through them, in which would you have to weave in and out between the figures and objects? In which could you stroll through the space?
- Point out the negative space in each sculpture.
- Find contrasts of shape, space, and form in each sculpture.

Do it.

1 To plan your sculpture of an event, make pencil drawings of some of the figures that you will include. Consider how the people are dressed and where they are in relation to one another. Include any objects—such as sports equipment, furniture, animals, plants, or architectural elements—that would be important to the scene.

2 Wedge the clay a few times to eliminate air bubbles.

Alexandra Gehl (age 17), *Neck and Neck,* 2009. Low fire glaze clay, 5" x 3" x 4"each (12.7 x 7.6 x 10.2 cm). New Smyrna Beach High School, New Smyrna Beach, Florida.

3 On a foil-covered board, create an island of clay, which will be the sculpture base: either flatten a ball of clay with your hands or use a rolling pin.

4 Create figures by pulling and shaping another piece of clay. Attach these clay figures securely to the base by scoring both the surface of the figure and the base where they are to join, applying slip, and then pressing the two pieces together. Pieces of clay must be securely joined together because clay shrinks as it dries.

5 As you build your sculpture, turn it around and work on it from different sides so that all viewpoints will be effective. Study it from various angles and from above. Create negative and positive spaces between the figures. Try arranging and bending the figures to enclose space. You might want to add texture to your sculpture.

6 After the figure is dry and has been fired, either apply ceramic glaze and refire it, or paint it with acrylic paints.

Helpful Hints

- Simplify the scene by showing just a few people.
- The sculpture base should be at least ¼" thick. If the base is too thin or too narrow, the sculpture may break easily or be unstable, tending to tip over.

Check it.

- What event did you depict in your sculpture? What main figures are in your sculpture?
- Describe the space in your sculpture. How have you incorporated negative space into your design?
- What other artworks influenced your creation?
- Consider the craftsmanship in your artwork. Did your piece stay together, even after it was fired? Describe the quality of the surface—the texture, glazing, or painting. Is it as you had envisioned it?
- What might you do differently the next time you create a similar work?

6 Texture

Key Vocabulary

texture

real texture

implied texture

IMAGINE A LIFE IN WHICH EVERYTHING had the same surface look and feel. Fortunately, our world is full of a rich variety of surfaces that provide us with both information and visual pleasure.

One of the features of surface quality is **texture**, the physical surface structure of a material. Woven fabrics, for instance, have particular textural surfaces. They range from the closely knit fibers of silk to the heavy weave of burlap. We can often readily identify a material by its texture: glass is smooth and slick; sand is gritty and fine.

6–1 Polyester and fiberglass—the materials used to create this sculpture—help make it look so realistic that from a short distance, an observer can be fooled into thinking it is a real person.

Duane Hanson (1926–96), *Old Man Dozing*, 1976. Polyvinyl, polychromed in oil, mixed media with accessories, 48 ½" x 25 ½" x 38" (123.2 x 64.8 x 96.5 cm). Frederick R. Weisman Art Foundation, Los Angeles Art. ©Estate of Duane Hanson/ Licensed by VAGA, New York, NY.

6–2 Some artists delight in depicting textures as realistically as possible. Here, a remarkable number of different textures are represented.

Attributed to Anna Alma-Tadema (1865–1943), *Interior of Gold Room*, Townsend House, 1883. Watercolor with scraping over graphite on paper, 20 ⅞" x 14 ⅛" (53 x 35.9 cm). The Nelson Atkins Museum of Art, Kansas City, Missouri. Bequest of Milton McGreevy, 81-30/86. Photograph by Mel McLean.

Texture might create diverse effects in a design. Just as some artists or craftspeople may focus on line, shape, or color, others concentrate on texture to capture a particular look or feel. In this chapter, you'll explore a wide range of textures, their effects on the viewer, and various methods of incorporating them into your own art.

6–3 Designers sometimes use an unexpected texture to add an element of surprise to their work.
Shiro Kuramata (1934–1991), *How High the Moon* armchair, 1986. Nickel-plated steel mesh, 28 ¼" x 37 ⅜" x 32" (71.8 x 94.9 x 81.3 cm). Manufactured by Vitra AG, Basel. Gift of Vitra Inc. Basel, Switzerland, 1988 (1988.186) The Metropolitan Museum of Art, New York. Image ©The Metropolitan Museum of Art/ Art Resource, New York.

6–4 How would you describe the texture of this flower?
Pinwheel/Protea. Photo by J. Scott.

6–5 Often, the forces of nature can change the texture of an object. These river rocks have been made smooth by the force of flowing water. What other natural or manufactured objects undergo such a change?
River rocks. Photo by N. W. Bedau.

Note it

The outdoors presents many different natural textures. Some are obvious, such as the bark of a tree. Others are more subtle, such as fine spider webs or frost on a window pane. Write brief descriptions of outdoor textures that interest you. Make a small sketch next to each description. Try to capture the feeling of the texture in the marks you make.

Surface Qualities

Whether you are the viewer or the artist, you experience two kinds of textures: real and implied. ***Real textures*** are those that can actually be touched, such as the smooth surface of a bronze sculpture or the spiky surface of a cactus. ***Implied textures*** are those that are simulated, or invented. They include the roughness of a rock seen in a photograph and the fluffiness of a cloud depicted in an oil painting. Real textures offer both look and feel; implied ones provide only the appearance of texture.

Real Textures

Real textures are important because they provide clues about an animal's or object's nature and, to a large degree, about its function. The rugged texture of an elephant's skin seems quite logical for survival in the rough terrain and heat of Africa and Asia; the slick, smooth skin of a snake helps it maneuver swiftly in water and over the earth.

6–6 We often describe animals in terms of their texture. What words would you use to describe the texture of cat fur, snake skin, and porcupine quills?

Sleeping Roger, 1997. Photo by R. Banas.

6–7 This tree displays several textures. How many can you see?

Tree trunk and branches. Photo by J. Selleck.

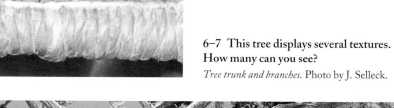

Try it

Explore textures by touch only. With your eyes closed, let your hands identify objects and surfaces by the sensations delivered through your fingertips. Group together a number of objects that have different textures. Then study what creates these textures.

122

Many textures have a protective purpose. Fur provides warmth. Prickly plants and spiny animals give fair warning that their surfaces are unpleasant to touch—or eat; therefore, humans and other animals usually avoid them. Other textures attract. We enjoy the softness of cat fur, the smoothness of silk, and the reflective surface of polished wood.

Actual textures in artworks often provide visual interest—even when they cannot be touched. But for texture to be appealing, the artist must control its use. Too much texture or an inappropriate type can disturb the appearance of a surface. For instance, raised, bumpy, pebbly, or craggy textures are visually active; whereas smooth, woven, and finely textured surfaces are more restful. Artists sometimes include areas of refined or minimal texture as a visual rest from highly textured areas.

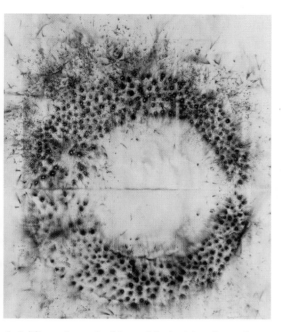

6–8 The artist made this work by igniting fireworks that he had placed between two sheets of paper. The explosions resulted in tiny holes and burn marks that create both real and implied texture.

Cai Guo-Qiang (b. 1957), *Drawing for "Transient Rainbow"*, 2003. Gunpowder on two sheets of paper, 179" x 159 ½" (454.7 x 405.1 cm) (overall). Fractional and promised gift of Clarissa Alcock Bronfman. (508.2004) The Museum of Modern Art, New York. Digital Image ©The Museum of Modern Art/ Licensed by SCALA/Art Resource, New York.

6–9 Architects are highly selective in choosing textures to enrich the appearance of a building. Combinations of glass, wood, brick, stucco, stone, and metal offer textural variety and contrast. In this detail from a building at Ellis Island, notice how well the stone and brick surfaces work together.

Ellis Island, *Main building,* by Boring and Tilton, 1898. Detail of cornice, arch, and carving. Photo by H. Ronan.

Implied Textures

All our experiences with real textures build memories that we experience again when we see similar implied textures. These memories also help us make judgments when we encounter unusual or unfamiliar textures. When an artist uses implied textures, he or she is "fooling our eyes" in a sense. We are seeing an impression, or something that is not really there, because in our imagination we can feel the texture portrayed.

Naturally, implied texture plays an important role in photography. Texture is essential in paintings and drawings that portray objects realistically. Artists also use familiar and invented textures to enhance their abstract or nonrepresentational art. In such works, textures can suggest certain feelings and moods, or even remain purposely ambiguous. Textures and textural contrasts can also function as organizational devices: they may unify an area or create patterns and movement within a composition. In any successful work of art, the artist has paid careful attention to texture and its effects.

6–10 The music style called "jazz" is very versatile. Here the artist seems to be emphasizing the smooth sound that characterizes some jazz. How does the texture of the painting help create that impression?
Man Ray (1890–1976), *Jazz*, 1919. Tempera and ink (aerograph) on paper, 28" x 22" (71.1 x 55.9 cm). Columbus Museum of Art, Ohio. Gift of Ferdinand Howald 1931.253. ©2010 Man Ray Trust/Artists Rights Society (ARS), New York/ADAGP, Paris.

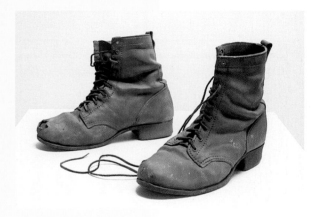

6–11 Notice the lifelike appearance of this sculpture and of Hanson's *Old Man Dozing* (fig.6–1). Why might an artist want to represent reality so precisely?
Marilyn Ann Levine (1935–2005), *Work Boots*, 1983. Ceramic, right boot: 8 ½" x 11 ¾" x 5 ¾" (21.6 x 29.9 x 14.6 cm); left boot: 9" x 11 ½" x 4 ½" (22.9 x 29.4 x 11.4 cm). O.K. Harris Works of Art, New York.

6–12 Brushstrokes themselves create texture. Here, the artist used broad sweeping strokes. What kind of strokes do you think Vermeer used in *Street in Delft* (fig.6–13)?
Clyfford Still (1904–80), *Untitled R No. 2*, 1947. Oil on canvas, 105" x 92" (266.7 x 233.7 cm). Private collection.

Try it

Cut out a number of implied textures from magazines or newspapers and fit them together to construct a landscape.

Jan Vermeer

Why are most people so fascinated when viewing a painting by Jan Vermeer? Vermeer's talent lay in his ability to transform an ordinary scene—he often painted people doing an everyday task, such as writing a letter—into a poetic and lasting impression. We are drawn into these scenes, often without realizing exactly why they hold such interest.

This sense of mystery is often heightened by visual devices: figures placed behind an object such as a table or chair, or seen through a doorway. Vermeer brings us into the mood of the scene with his great sensitivity to color and light, his skill in using (and subtly altering) perspective to create depth, and his amazing ability to render textures.

Vermeer rarely dated his paintings, but art historians have determined that he mastered the ability to portray textures by the time he was in his thirties. Highly skilled in painting surface appearances, he used a combination of impasto (thickly applied paint) and thin glazes. Whether depicting the sheen of a pearl or the roughness of bricks, he carefully recorded each material's unique texture. The exactness of these implied textures gives an air of great realism to his work.

6–13 **Compare and contrast the many textures that are depicted in this scene.**
Jan Vermeer (van Delft) (1632–1675), *A street in Delft,* 1658–1660. 21 ⅜" x 17 ⅜" (54.3 x 44 cm). Rijksmuseum, Amsterdam, The Netherlands. Photo: Erich Lessing/Art Resource, New York.

Son of art dealer, weaver, and innkeeper Reynier Jansz, Jan Vermeer was born in Delft, Holland, in 1632 and lived there until his death, in 1675. Nothing is known of his artistic training, and only thirty-eight paintings are firmly attributed to him. When he signed his paintings, Vermeer often used different signatures, or marks, making the art historians' task—to verify certain works as his—more challenging. Nothing is known of his personality. However, he is considered one of the most accomplished painters in art history. We can only guess at the kind of legacy he would have left had he lived longer.

The documents that outline Vermeer's life are those that relate to the history of Delft. Historians know that when he was twenty-one Vermeer registered as a professional with a painters' guild. He was then also starting out in business with the art dealership he inherited from his father. Although Vermeer was considered a master painter, no records indicate that he took students. During his lifetime and for almost the next two centuries, his works were not widely known. Then, in the eighteenth century, English painter Sir Joshua Reynolds "discovered" a Vermeer painting in Holland. Reynolds's praise for the work led to worldwide recognition of Vermeer's achievements.

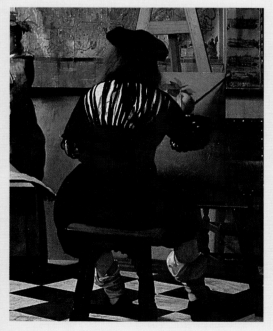

Jan Vermeer (1632–75), *The Painter (Vermeer's self-portrait) and His Model as Klio,* 1665–66. Oil on canvas, 47 ¼" x 39 ⅜" (120 x 100 cm). Detail, Kunst-historisches Museum, Vienna. Erich Lessing/Art Resource, New York.

Texture and Light

Because texture is mainly a surface quality, the way that light falls on an object has a definite effect on the readability of the surface: when light hits an object, it strongly defines the texture of the object. If that same object is in shadow or dim light, the surface texture may be reduced or become imperceptible. When the light is right—that is, when it is bright enough and in the best position—the texture becomes active and dominant.

Even in bright light, however, the surface appearance of an object may change, depending on whether the light hits it from above or from an angle. If a rounded surface is lit from above, its texture may be smoothed out on top, strongly evident on the sides, and lost in the shadows below. The late afternoon sun, ideal light for dramatic outdoor photographs, emphasizes the texture of an object and causes the casting of strong shadows.

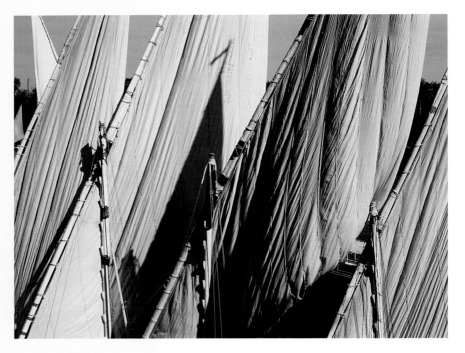

6–14 Brilliant sunlight and deep shadows often combine to create a heightened sense of texture.

Egyptian Sailboats on the Nile River, Egypt. Photo by A. W. Porter.

6–15 How does the light accent the texture of this wood?

Wood Grain Erosion, from *Driftwood Series.* Photo by J. Scott.

6–16 Here, the artist represented the textures of this engine as they would appear in direct, stark light. We are still able to distinguish the textures, though they are somewhat flatter than they would be if the light were altered by shadow.

Alexander J. Guthrie (b. 1920), *Happy Wanderer,* 1983. Watercolor, 25" x 30" (63.5 x 76 cm). Courtesy of the artist.

An artist might find that bright light is too strong for a highly polished surface: the light bounces off the surface and creates a glare. For surfaces that are smooth or finely textured, an artist might use indirect lighting to bring out their definition and character.

Because light is such a significant element in creating texture, artists sometimes test how materials look in various lighting situations. Before creating an outdoor sculpture, for instance, an artist might explore how shifting natural light will affect the final work. For artwork that will be displayed indoors, an artist might experiment with placement of light sources, which can enhance surface effects and highlight even the finest textures. This kind of critical analysis helps artists achieve the desired results from their designs.

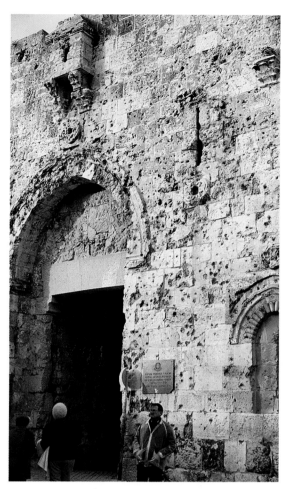

6–17 The late afternoon sun emphasizes the surface detail of this building in historic Jerusalem.
Building in Jerusalem. Photo by L. Nelken.

6–18 Note how the lighting in this student work emphasizes the subtleties in its texture.
Lauren DiColli (age 18), *Chinese Platter*, 1997. Handmade paper pulp and found plant materials, 17" x 24" (43.2 x 61 cm). Haverford High School, Havertown, Pennsylvania.

Discuss it

Experiment with light sources to alter the surface appearance of objects with different textures. What happens when a bumpy object is lit from the side, from behind, and from above? What happens to a smooth object or a transparent one? How can you create different textural effects by varying light and shadows?

Artists and the Use of Texture

Think about all the materials that artists can use to express their ideas: paint, clay, cloth, wood, ink, glass, metal, and stone. Each of these has a unique textural surface. Artists can use these materials and others—alone or in combination—to convey a variety of messages and emotions.

Three-Dimensional Art

When artists create three-dimensional works, they usually turn to materials that have real textures. Potters, for instance, commonly use clay. Sculptors and installation artists may explore the uses of plastic, marble, and found objects—including broken plates, driftwood, and used car parts!

6–19 Examine the range of textures in this object. What other elements and principles did this artist use to make the texture prominent?

Stephanie Skaggs (age 18), *Up Surge,* 2008. Red earthenware, multiple firings, layered and textured glazes, 10" x 10" x 8" (25.4 x 25.4 x 20.3 cm). New Smyrna Beach High School, New Smyrna Beach, Florida.

6–20 Compare the texture of this ceramic pot with that of the clay container in fig.6–19. How are they similar? How are they different?

Qing (18th century), *Incense Burner in bronze form,* approx. 1700–1800. Ge ware porcelain with off crackled glaze, 3 ¼" x 4 ⅝" (8.3 x 11.8 cm). The Avery Brundage Collection, B60P1453. ©Asian Art Museum of San Francisco. Used by permission.

Pottery and Ceramics Pottery that has been *thrown*, or made on a wheel, usually has a uniform, smooth surface. But potters also use various tools and procedures to create pronounced textures. They may incise lines or draw into a piece. Before they *fire*, or bake, the clay, they might add glazes to produce a specific finish—smooth or rough, transparent or opaque, marbled or crackled. Some potters deliberately throw salt into the kiln during firing to pit the surface of the pottery and produce a texture similar to that of volcanic rock.

Sculpture Sculptors achieve textural qualities by selecting and combining materials with certain surface attributes. They also use tools to alter those surfaces. They might carve, gouge, sand, or polish the surface of wood. They might alter a metal surface by cutting, welding, rusting, or polishing. For centuries, artists have sculpted marble to simulate the soft folds of fabric and the appearance of human skin and hair. Italian sculptor Desiderio da Settignano, for instance, perfectly captured the smooth flesh of a young child's face (fig.6–21).

Today sculptors explore the potential of plastic and synthetic materials using processes such as vacuum forming and epoxy laminations.

6–21 The soft textures of the child's hair and skin belie the cold, hard qualities of marble.
Desiderio da Settignano (1429/30–64), *A Little Boy*, 1455/60. Marble, 10 ⅜" x 9 ¾" x 5 ⅞" (263 x 247 x 150 cm). Andrew W. Mellon Collection. ©1988 Board of Trustees, National Gallery of Art, Washington, DC.

6–22 The familiar woven texture of basketry is used here to create a lively, tactile sculpture.
Carol Eckert (b. 1945), *Spell of the Green Lizard*, 1995. Cotton and wire, 11 ½" x 7" x 3 ½" (29 x 17.8 x 8.9 cm). Courtesy of the Connell Gallery/Great American Gallery, Atlanta.

Two-Dimensional Art

Most two-dimensional art relies heavily on implied textures, which may be drawn, depicted in paint, or achieved by means of a print process. Textiles, however, may incorporate both implied and real textures.

Drawing and Printmaking In drawings, skillful artists can portray an array of textures—from wrinkles in a face to ripples in a pond. Artists might use charcoal, ink, colored pencils, or pastels to achieve different surface qualities; or they might choose to work on paper that has a smooth or a coarse texture of its own.

Printmaking—which involves transferring an image from a carved or etched surface onto paper—creates additional opportunities for artists. To create implied textures, printmakers might use the grain of a woodcut; the sharp, etched lines of a zinc plate; or the uneven textures of a linoleum block.

DVD
PBS Art:21 Season 2
Vija Celmins

6–23 Using only charcoal on paper, Celmins creates an image with nuanced texture and astonishing detail.
Vija Celmins (b. 1939), *Night Sky No. 22*, 2001. Charcoal on paper, 18 ¾" x 22" (47.6 x 55.9 cm). The Museum of Modern Art, New York. Digital Image ©The Museum of Modern Art/Licensed by SCALA / Art Resource, New York.

6–23a *Night Sky No. 22*, detail.

6–24 In this print, the marks from the linoleum cutting process remain visible, adding another layer of texture to the print. What other examples of texture do you see?
Nomathemba Tana (b. 1953), *You will indeed be clever to come through fire with water (Uyob' yuakwaz' ukuphuma nomlil')*, 2000. Linoleum cut, Image: 39 ⅜" x 27 ⁹⁄₁₆" (100 x 70 cm). Katsko Suzuki Memorial Fund. The Museum of Modern Art, New York. Digital Image ©The Museum of Modern Art/Licensed by SCALA/Art Resource, New York.

Painting Like drawings, some painted images rely heavily on implied textures and the skill of the artist to reproduce them accurately. But painters also achieve textural effects with their materials. Painters might apply the medium thinly or thickly, or they might mix it with wax and other substances. Thick, textured applications of paint create highly energetic forms that almost seem to leave the surface of the canvas. Artists might apply paint with brushes, sponges, or palette knives, or by spraying or dripping. The surface on which they record images may range from finely textured canvas (fig.6–25) to rough burlap to smooth glass or wood.

Textiles Throughout the centuries, artisans and weavers have produced fibers and fabrics with rich textures. Early Egyptian fabrics are still unparalleled and are treasured for their finely woven materials. Museums around the world preserve examples of European tapestries made during the Middle Ages and Renaissance. The striking beauty of woven materials from the South Seas, the Andes, and Guatemala—as well as those crafted by Native Americans—also reflect great skill and inventiveness.

6–25 Here, Helen Frankenthaler used such a thin layer of paint that the texture of the very finely woven canvas she chose to use shows through and becomes an important part of the painting.
Helen Frankenthaler (b. 1928), *Small's Paradise,* 1964. Acrylic on canvas, 100" x 93 ¾" (254 x 238 cm). Smithsonian American Art Museum, Washington, DC. Photo: Smithsonian American Art Museum, Washington, DC/Art Resource, New York. ©2010 Helen Frankenthaler/Artists Rights Society (ARS), New York.

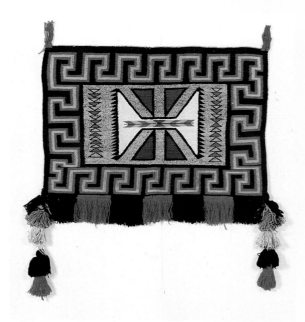

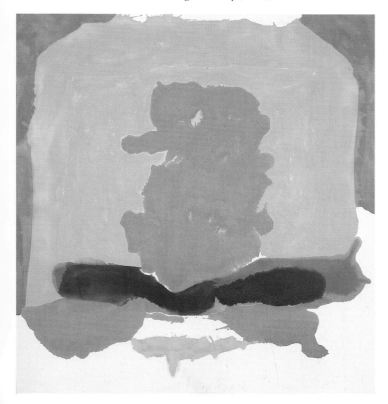

6–26 The tight, heavily textured weave of this Navajo saddle blanket contrasts with the looser texture of its fringe and tassles.
Navajo saddle blanket, late 19th century. Germantown yarn, 46" x 37 ½" (116.8 95.3 cm). Smithsonian Institution, Washington, DC. National Museum of the American Indian, Matthew M. Cushing Collection. Presented by Mrs. Nellie I. F. Cushing in his memory. Photo by Katherine Fogden.

Texture in Your Environment

Each day, you encounter texture, as well as lines, shapes, forms, colors, values, and space. These elements of design are unavoidable aspects of your environment and essential parts of everyday life. They are crucial to interior design and exterior landscaping. And they are significant in the clothes you wear and in the advertisements that sell them.

City planners introduce textures in parks and squares, outdoor sculptures and fountains, and even the surfaces upon which we walk. Sidewalks and parking lots do not have to be great expanses of uninterrupted cement: they might contain textured bricks or other stonework, benches, and lighting fixtures. Even the simple addition of plants, grasses, and trees can provide relief, enjoyment, and visual interest.

Museums, hotels, churches, and temples all integrate texture into their design. Houses and apartment buildings offer many textural opportunities: materials used in carpeting, draperies, furniture, and wall coverings both provide textural variety and enhance our surroundings. Look around and study your environment. You'll discover that textures—and all the other elements of design—are essential aspects of seeing.

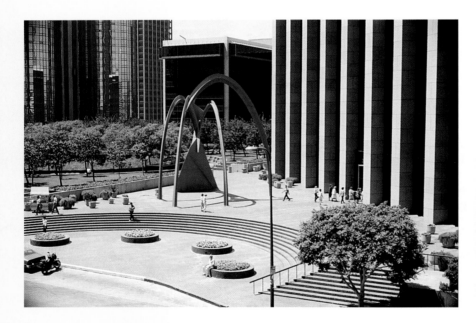

6–27 During the course of a day, we encounter so many textures that we usually do not notice them. How many common textures can you see in this image?
Overview of downtown Los Angeles plaza, Los Angeles, California. Photo by J. Selleck.

6–28 A walk outside often lets us appreciate the textures in the natural environment.
Lichen pattern on rock. Rust and yellow. Photo by J. Scott.

Antonio Gaudí
Güell Park

How might it feel to own a home in the midst of a city-garden fantasyland? Would you like to live surrounded by the wildly creative shapes, colors, and textures of Gaudí's creation? The plan for this park included sixty houses, a market, a medical center, schools, a chapel, and other facilities. Work began in 1900, and although never completed, Güell Park is one of the best-loved destinations in Barcelona. Under the imaginative direction of architect Antonio Gaudí, enough work was accomplished to provide a magical space in which to dream and play.

There are fountains made of colorful mosaics, a walkway with an arcade of angled trees, fanciful gatehouses, pathways lined with leaning columns, and a monumental staircase flanked by ceramic walls leading to the *Sala de les Cent Columnes*—eighty-six Doric columns supporting a mosaic-tile area decorated with dogs' heads. A giant mosaic dragon is close to the famous bench: its mosaic pieces suggest the dragon's scales. The mosaic bench surrounds the park's "central square" with a series of glistening ceramic curves. From this area is a panoramic view of the city below.

The concept for the bench—believed to be the longest one in the world—was Gaudí's, yet much of the detailed work was executed by artist Josep Jujol. To achieve mosaic tiling of the curved surfaces, traditionally-made flat tiles were broken and organically rejoined. This technique was also used by Gaudí in other artworks. The bench design was so innovative that some art historians see it as a forerunner of the abstract and Surrealist movements. In fact, the park was known to be an inspiration for Surrealist Salvador Dalí.

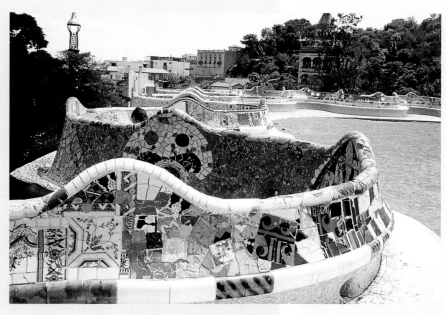

6–29 How would the rich texture of these benches strike you in the midst of a park's greenery?
Antonio Gaudí (1852–1926), *Güell Park benches,* 1900–14, Barcelona, Spain. Photo ©1991 Benedikt Taschen Verlag GmbH, Köln, Germany. Photo by François René Roland.

Güell Park was funded as an urban-development project by the financier and Barcelona art lover Eusebio Güell. Nearly fifty acres were acquired in a city area that needed renewal, and the site was intended to be a place where architecture was integrated into the natural surroundings. For the job, Güell commissioned Gaudí, who had a liking for nature and was known as an eccentric genius and religious mystic.

When Güell died, which brought a halt to the funding and the work, only two houses had been built. One of them was built as a model to encourage others to build and live there. The house was designed by Gaudí's colleague, Francesc Berenguer, and Gaudí himself lived there from 1906 until shortly before his death in 1926. Gaudí completed his work there by 1914; in 1922, the project was given to Barcelona by Güell's family, for use as city parkland.

Another Look at Texture

6–30 Using terms from this chapter, describe the texture of this belt.

Guatemala, *Woven belt,* 1972. Cotton, 83 ⅞" long (213 cm). Photo by Allan Koss.

6–31 Imagine running your fingers along this fly whisk from one end to the other. Write a description of the textural journey your fingers would take.

Tubuai, Austral Islands, *Fly whisk.* Wood, plant fiber, feathers, and mother-of-pearl, 35" high (89 cm). Courtesy of the Division of Anthropology, Yale Peabody Museum. ©1998 Peabody Museum of Natural History, Yale University, New Haven, Connecticut.

6–32 How has this student communicated the texture of a sunflower?

Rachel Shuman (age 17), *Flower of the Sun,* 1998. Acrylic, 15 ½" x 6 ½" (39.4 x 16.5 cm). Holliston High School, Holliston, Massachusetts.

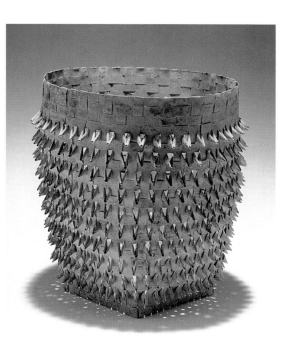

6–33 Note that this piece is made of metal, not fiber. How does your impression of the piece change when you realize it is not a typical basket? What other contrasts in texture does the artist use?

Ken Carlson (b. 1945), *Porcupine Basket*, 1993. Copper, woven and oxidized, 10" x 9 ½" (25.4 x 24.1 cm). White House Collection of American Crafts. ©1995 Harry N. Abrams, Inc. Photo by John Bigelow Taylor, New York.

6–34 This image is one of a series of prints of the birds of North America. Why is texture a vital element in a depiction such as this?

John James Audubon (1785–1851), *Common Merganser (Goosander)*, 1832–1833. Watercolor and graphite on paper with mat, 39" x 53" (99.1 x 134.6 cm). Hand-colored engraving from *Birds of America*. ©Abbeville Press Publishers, New York. Collection of the New York Historical Society. Accession no. 186317.331.

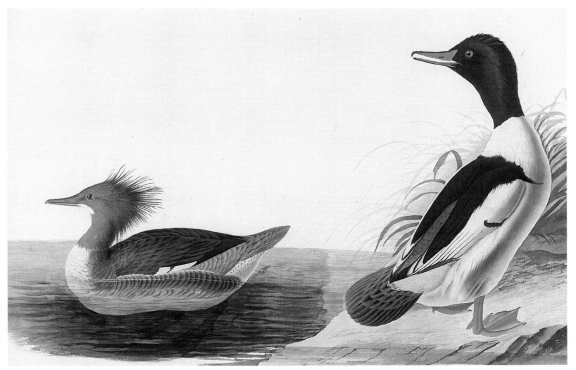

Review Questions

1. To what does the art element *texture* refer?
2. What is the difference between real and implied texture?
3. Explain why light is important to how people see texture.
4. What are some methods that artists use to create real textures?
5. Identify and describe three different textures in your environment.
6. Describe an example of implied texture from the images in this chapter.
7. What type of subjects did Vermeer often paint? How did he add a sense of mystery or intrigue to his subjects?
8. What material did Gaudí use to create a colorful texture on the bench in Güell Park, Barcelona?

Career Portfolio
Interview with a Weaver

Drawing from her Native American (Tlingit) heritage, **Clarissa Rizal** makes one-of-a-kind ceremonial robes. Some are traditional Chilkat woven robes like the one on page 150. Some, such as the robe on this page, are hand-stitched. Like other artwork meant to be worn and touched, texture is an important consideration in these robes. During the spring and summer, Clarissa lives in Juneau, Alaska, where she was born. For the rest of the year Clarissa lives in Santa Fe, New Mexico.

Tell me about the "Eagle" robe.

Clarissa In the 1800s, when the first navy ships came to Alaska, the native people saw the wool navy blankets, and they traded furs for those. They saw how they could use them for ceremony, for some of their robes. They also saw the mother-of-pearl buttons that were on the clothing of the men on these navy ships. The buttons were mother-of-pearl with steel shanks—steel loops that came down off the back of the buttons. The shanks were pushed through the thick wool, and leather strips were used to hold the robe in place. You can always tell the very old robes—that were done in the

The eagle design in this robe is made entirely of mother-of-pearl buttons—about 800 of them! The edging is appliquéd work, cut-out wool that has been sewn to the main body.

Clarissa Rizal, *Eagle Robe*, 1988. 100% woven blanket-weight wool, two nickel metal faces (in the eyes), mother-of-pearl buttons, 5' x 6' (1.5 x 2 m). Now part of the Native art collection of the Tlingit and Haida Central Council in Juneau, Alaska.

1800s—because they had those steel shanks. You cannot buy these steel-shank buttons through a retail store any more, but sometimes you may come across them at an antique store or through a trader. I use mother-of-pearl buttons, that I get from a button company in Iowa.

How long does it take to make a robe?

Clarissa The appliquéd ones take about a month. The Chilkat woven robes take at least a year, a year to two years. Traditionally, they were made from thin strips of cedar bark and mountain goat wool. We now use New Zealand's merino wool because it is the closest thing, and the only thing that will work with the cedar bark. The bark is collected at a certain time of year and broken down into very thin little strips. When you soak it, it becomes very silky. As in knitting or crocheting, there is a specific fingering. We don't use a shuttle; it's all two-strand twining of two warp threads at a time. That's why a whole robe will take a year to make.

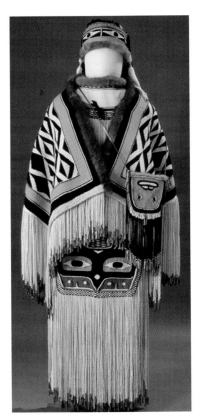

The woman who taught me how to weave had made fifty robes and about twenty-five tunics. Her name was Jennie Thlunaut. She made seventy-five major garments in her lifetime, which was ninety-six years. Her speed, accuracy, and tension were superb and graceful because of her fingering. In watching Jennie weave, I was inspired by her grace and compelled to weave. She entrusted me with her knowledge and her skills, entrusted me to carry on the tradition. I apprenticed with her for a couple of months in 1986, and then she passed away about a month later.

Given the work that goes into them, the robes must be very expensive.

Clarissa For the appliquéd, button-blanket robes: I sold one for $350, and the most I have sold one for is $6,000. The woven ones—the Chilkat or raven's-tail robes that take a year or two to make—those go anywhere from $15,000 to $30,000.

Do you use traditional designs?

Clarissa Yes and no. My robes are usually based in personal experiences, visions, and dreams, interpretations of humankind; this is where the robe designs are not traditional. But, they have the look of traditional design because I stick to the form line art, the traditional art form. Traditionally, what you put on a robe is your clan crest—eagle clan, raven clan, killer whale clan—or an image of a story or clan history.

Studio Experience
Coiled Baskets

Task: To create a basket using the coiling technique.

Take a look. Look at the contemporary coiled sculptures of Carol Eckert, an example of which is shown in fig.6–22. You may also want to research Native American baskets. Can you tell how each kind of art was made?

Think about it.

- Texture can range from smooth to rough, flat to nubby. Think of various materials and the textures you could create from them.
- What did Native Americans do to create textural qualities in their baskets?
- What found objects could you use to decorate a basket?

Do it.

1 Read through steps 2–8, below, for how to make a coiled basket of rope and yarn. Then make a small practice sample. Try to enclose one or more found objects in your sample. When you feel that you understand the process, think about the textural look and shape you want for your actual basket. Decide on what found objects you will use to create texture.

2 Cut your core material (the rope) about 2–3' long. Taper one end by making a diagonal cut. 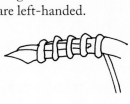 To start the base of the basket, overlap the ends of the rope core and wrapping material (the yarn). If you are right-handed, hold the rope with your left hand and wrap with your right hand. Do the reverse if you are left-handed.

3 Wrap the rope core for about 1 ½", spacing the yarn wraps about ¼" apart.

4 Fold the tapered end of the rope core back on itself, making the smallest hole possible. 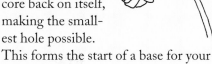 This forms the start of a base for your basket.

5 Now thread the yarn into a large, blunt needle. Again fold the rope core back on itself and join the core to the base with a wrapping stitch. To do this, wrap the new core twice, then bring the needle around the wrapped core and through the hole two times. Pull the yarn tight enough to hold the coils close together. Continue wrapping the core twice and then connecting it to the previous coil until the diameter of the base measures 5" or whatever other dimension you choose.

6 To start making the sides of the basket, hold the core on top of the previous row. Use the wrapping stitch to attach the first side row to the base. As you attach the core row upon row, the sides gradually take shape. To make the opening narrower, place the new core inward, toward the center of the base; to make the opening larger, place the core outward, toward the outside of the base. If you wish, thread through beads, buttons, or other objects to attach them to your basket as you wrap.

7 If your length of core is about to run out, work until 1" remains. Then cut the core on a diagonal. Hold together the tapered end of the core with the tapered end of the new core. Lightly tape around both; then wrap as usual. If your yarn is about to run out, leave 6" remaining. Lay the end of the new wrap along the core. Make a stitch or two around the core over the new wrap to secure it. Thread the needle with the new wrap. Wrap over the remaining old yarn and the core while making the next stitch.

8 To finish your basket, work the last row until you are within 2" or 3" of the place where you first started shaping the sides. Taper the end of the core, as in step 2. Continue to wrap and attach the core to the previous row, stitching a bit beyond where the tapered core ends. Take the needle and weave it through the wrap to bury the thread. You may have to change to a smaller needle if the wrap is tight. Cut off the remaining wrap.

Check it.

- What part of your basket concept was original and creative?
- How did you use found objects? Do they effectively create more texture?
- What might you do differently the next time you create a basket?

"I learned that incorporating many different materials with contrasting properties can create very interesting and appealing textures."
Brooke Erin Goldstein (age 16), *Invention Basket*, 1997. Bungie cord, plastic tubing (stuffed with batteries, beads, nuts, and bolts), yarn, ribbon, and embroidery thread, 5 ½" high (14 cm); 8" diameter (20.3 cm). Clarkstown High School North, New City, New York.

Part Two: The Principles of Design

To help them combine the elements of design effectively, artists and designers follow certain guidelines, or principles. The principles of design are balance, unity, contrast, emphasis, pattern, movement, and rhythm. When used properly, these principles organize the parts of a design so that an artwork clearly communicates an artist's message or intention. They are used in all media—from painting to architecture to clothing design.

These principles are not binding but are there to help you make choices: you may study, modify, or juggle them as you wish. You might think of them as recipes that have worked for a long time for many people. Like the elements of design, these principles are rarely used separately. Although one of them may be more obvious in a particular design, it usually will be supported by others. There are many ways to combine the principles; artists sometimes even deliberately ignore or distort them.

The six chapters of Part Two define the principles separately and contain images to explain each one. (As in Part One, the images are from both nature and the arts.) Balance, for example, might involve pairing an extended arm and an outstretched leg in a sculpture of the human figure. Or it may mean contrasting certain colors in a painting. Once you understand these principles, you will likely begin to notice them in your environment—and your increased understanding of how artworks are put together will help you become a more sensitive viewer and a more skillful designer.

Lê cuts photographs into strips and weaves them together to create multilayered works. Smaller photographs coalesce to create a larger overall image.

Dinh Q. Lê (b. 1968), *Untitled (Movie grid)*, 2003. Cut-and-woven chromogenic color prints and linen tape, 33 ¼" x 67" (84.5 x 170.2 cm). Purchased with funds provided by The Buddy Taub Foundation, Dennis A. Roach, Director. (3.2004) The Museum of Modern Art, New York. Digital Image ©The Museum of Modern Art/Licensed by SCALA/Art Resource, New York.

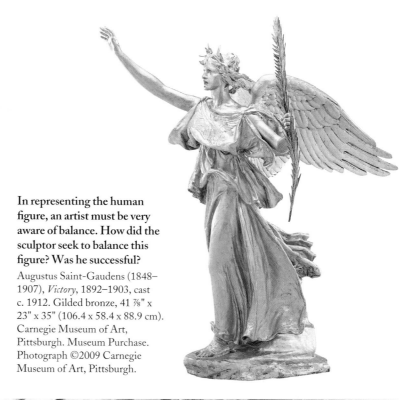

In representing the human figure, an artist must be very aware of balance. How did the sculptor seek to balance this figure? Was he successful?

Augustus Saint-Gaudens (1848–1907), *Victory*, 1892–1903, cast c. 1912. Gilded bronze, 41 ⅞" x 23" x 35" (106.4 x 58.4 x 88.9 cm). Carnegie Museum of Art, Pittsburgh. Museum Purchase. Photograph ©2009 Carnegie Museum of Art, Pittsburgh.

Use your knowledge of color to analyze how Green created contrast in this painting.

Jonathan Green (20th century), *Family Fishing*, 1989. Acrylic on canvas, 48" x 36" (121.9 x 91.4 cm). Collection of John and Barbara Langston. Photo by Tim Stamm.

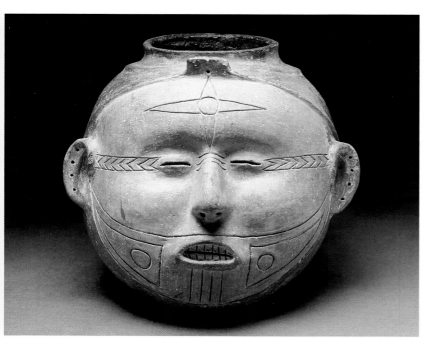

Notice how Biggers used white both to unify this painting and to move our eye through the composition.

John Biggers (1924–2001), *Jubilee: Ghana Harvest Festival*, 1959–63. Tempera and acrylic on canvas, 38 ⅜" x 98" (97.5 x 248.9 cm). The Museum of Fine Arts, Houston; Gift of Duke Energy 85.3 ©John T. Biggers Estate/Licensed by VAGA, New York.

Artists sometimes use simplicity of design to emphasize a certain aspect of an artwork. What did the artist want to emphasize in this piece?

Human head effigy bottle, 1400–1650 (Late Mississippian culture/Nodena). Earthenware (Carson red on buff), 6 ⅛" x 7 ¼" (15.6 x 18.5 cm). National Museum of the American Indian, Smithsonian Institution, Washington, DC. Photo by Bernard Palais.

7 Balance

Key Vocabulary

symmetrical balance

approximate symmetry

asymmetrical balance

radial balance

DO YOU REMEMBER WHEN YOU FIRST LEARNED TO SKATE, ride a bike, surf, or dance? As long as you didn't lose your balance, you felt fine. But when you did, you probably became nervous for a moment. Staying in balance is one of our most important needs. But from the time we're born, we are at odds with the forces of gravity. Our earliest struggles to maintain balance occur when we learn to stand and walk. Later, we strive for other kinds of physical balance, as well as mental and emotional balance.

Artists strive for visual balance. Visual balance is the way that the different parts of a composition relate to one another. When dealing with issues of design and organization, artists always consider visual balance because it is so basic to art. Artists use the elements of design—such as shape, color, and texture—to create balance within a composition. The four most important types of visual balance are symmetrical balance, approximate symmetry, asymmetrical balance, and radial balance.

7–1 This is a portrait of Close's friend, the artist Lucas Samaras. Generally, an artist tries to convey certain characteristics about a person when creating a portrait. What traits do you think Chuck Close was trying to capture in this portrait? How does Close communicate these characteristics?
Chuck Close (b. 1940), *Lucas Woodcut,* detail, 1992–93. Color woodcut with pochoir, 46 ¼" x 36" (116.8 x 91.4 cm). Edition of 50. Published by Pace Prints.

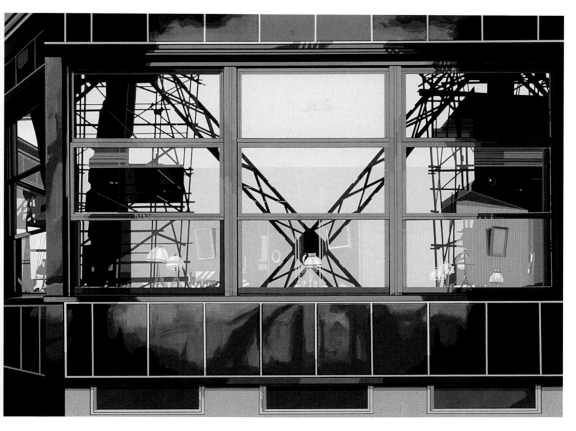

7–2 In this work, what does the artist do to create balance?
Richard Estes (b. 1932), *Eiffel Tower Restaurant*, from *Urban Landscapes III*, 1981. Screenprint, 19 ¾" x 27 ½" (50 x 69.9 cm). ©Richard Estes/Licensed by VAGA, New York/Marlborough Gallery, New York.

7–3 Artists and architects sometimes purposely avoid an obvious sense of balance in their works.
Frank O. Gehry (b. 1929) and Associates, Inc., *Nationale Nederlanden Building*, Prague, Czech Republic. Model. Photo by Joshua White.

Symmetrical Balance

Stand with your feet side by side and both arms extended outward to your sides. You are now in symmetrical balance. What happens if you drop or raise one arm? You become unbalanced and might even begin to lean to one side. When a design displays *symmetrical balance*, it is exactly the same on both sides. If you drew a line through the center of the design, one side would be the mirror image of the other. Symmetrical balance is sometimes known as bilateral, two-sided, or formal balance.

A well-shaped fir tree is symmetrically balanced, as is a well-formed apple. Compositions that display symmetry tend to be stable, dignified, and calm. In design, symmetrical balance is often evident in architecture. Notice, for example, the peacefulness achieved by the perfect symmetry of the famed Taj Mahal (fig.7–8).

Symmetry refers not only to a single object or figure with identical halves. Symmetrical balance is also produced by the same shapes or forms on opposite sides of a composition. Look at fig.7–4. The shapes and colors on one half of the composition repeat precisely on the other half.

7–4 Variety of color and strong diagonal lines enliven this symmetrical composition.
Cory Longhauser (age 14), *Colorful Geometric Shapes*, 1997–98. Acrylic and tempera, 12" x 18" (30.5 x 45.7 cm). Manson Northwest Webster Community School, Barnum, Iowa.

7–5 Why do you think that most architecture is generally symmetrical? Can you think of some practical advantages?
Michael Graves (b. 1934), *Portland Public Services Building*, 1980–82. Portland, Oregon. Photo by J. Selleck.

7–6 Ceremonial objects often display symmetry. The static, formal quality suggested by symmetry adds significance to the ceremony or ritual.
Mask, Senufo or Baule, Cote d'Ivoire. Wood, 12" x 9" (30.5 x 22.9 cm). Collection of Joseph A. Gatto, Los Angeles, California.

Try it

Choose two small pieces of paper equal in size, color, value, and shape. Place them on a larger piece of white paper. Move the two shapes away from an imaginary center line, observing the balance that occurs. What happens when you move the shapes toward the edges? What happens when you move them close to the center? After you've experimented with various locations, glue the shapes down to form a symmetrically balanced design.

Taj Mahal

What kind of monument comes to mind when you think about a well-loved person's tomb? For a Mughal emperor in the seventeenth century, the Taj Mahal is such a monument. Its design and construction was ordered by Shah Jahan (ruled 1628–58) in memory of his beloved wife Mumtaz Mahal, who died unexpectedly in 1630.

Built from 1632–38 on the bank of the Yamuna River at Agra, this architectural treasure is one of the most famous landmarks in the world. Twenty thousand workers participated in the creation of the structure, which is surrounded by four minarets (slender towers from which Muslims are called to prayer). Each minaret has three divisions, echoing the levels of the tomb.

The octagonal tomb and its supporting platform are built from gleaming white marble. On each side, the building has a large central *iwan* (a vaulted opening with an arched portal) flanked by two stories of smaller *iwans*. These openings make the building seem weightless: it appears to float magically above the reflecting pool. The surrounding garden (1,000' x 1,900'), divided by water channels, is laid out in total symmetrical balance. Trees and flowers are planted along broad walkways with inlaid stones in geometric patterns. Originally, fountains were a part of this outdoor environment.

In the tradition of Islam, the style of the building is entirely symmetrical, with panels of carved inscriptions and flowering plants for simple decoration. Two smaller buildings, mirror images of each other, are set behind the tomb. One is a mosque, and the other a resting hall. They share a base with the mausoleum's marble platform, but are constructed primarily from a contrasting red sandstone.

The Taj Mahal is the crowning achievement of Islamic architectural design. It represents, by its form and location, a description found in the Koran: "the Throne of God above the gardens of paradise on the Day of Judgment." For the power of its presence, the Taj Mahal might be compared to the pyramids in Egypt.

7–8 The plan of this famous building and its grounds are perfectly symmetrical.
India (Agra). *Taj Mahal*, 1632–38. Photo by David Gyscek.

7–7 Can you think of other examples of symmetrical balance in the insect world?
Butterfly. Photo by Sparrel Wood.

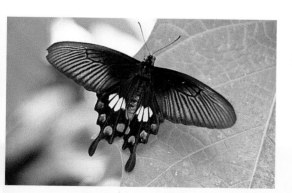

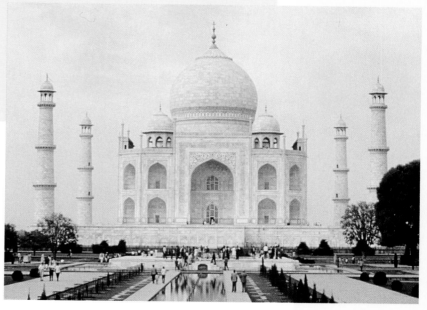

Approximate Symmetry

Although symmetry is the simplest way to achieve balance in a design, it can be monotonous and may fail to hold a viewer's interest for long. Because one side repeats the other, the effect is usually static. An artist may actually wish to establish such a feeling of monotony, but most artists and designers prefer to use a less severe form of symmetry.

Look in a mirror. Most likely, you'll notice that your face is *almost* symmetrically balanced. One eyebrow may be a little higher than the other. Your nose may not be perfectly straight. Or you may have more freckles on the left side of your face than on the right. These slight differences between the two sides make you more interesting to look at.

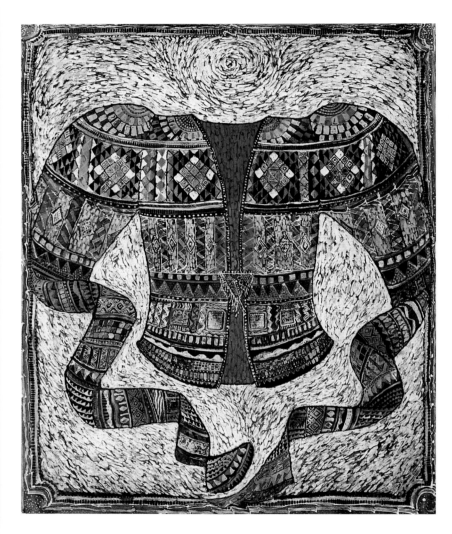

7–9 What variations in this piece make its symmetry approximate? Consider color as well as shape.

Dorte Christjansen (b. 1943), *Borderjacket*, 1992. Batik on silk (satin), 32" x 36" (81.3 x 91.3 cm). Commission/Kremen.

Note it

Look at images of paintings and sculpture throughout this book to see how artists and designers have achieved approximate symmetry in their work.

In a design, artists can break the severe monotony of pure symmetry by using *approximate symmetry*. With approximate symmetry, the two sides of a composition are varied. They offer enough differences to hold the viewer's attention, but the halves are similar enough to provide a sense of balance.

Study the photograph of the woman with her cats (fig.7–10). What variations do you see? You probably notice that the cats are different colors. But did you observe that the cats' paws are crossed? The photographer also allowed one tail to hang over the edge. These minor variations give the composition greater visual interest.

7–10 As you consider the approximate symmetry shown in this photograph, look also at the background of the composition. What might have been the artist's reason for including a generous amount of space above the subjects? How does this affect the artwork's sense of symmetry?

Paul Tanqueray (1905–91), *Elinor Glyn*, 1931. Bromide print, 9 ⅛" x 5 ½" (23.2 x 14.1 cm). Courtesy of the National Portrait Gallery, London. Reprinted with permission by Marc Bryan-Brown.

7–11 Several items cause the symmetry of this work to be approximate rather than perfect. Can you spot two?

Alexander J. Katz (b. 1927), *Ada in Aqua*, 1963. Oil on canvas, 50 ¼" x 80" (127.6 x 203 cm). New Orleans Museum of Art, gift of the Frederick R. Weisman Foundation. ©Alex Katz/Licensed by VAGA, New York.

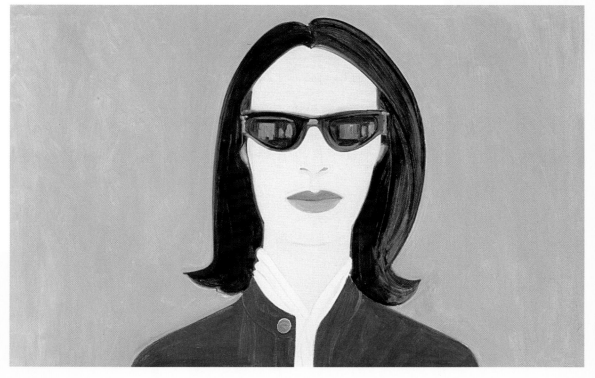

Asymmetrical Balance

Asymmetrical balance (also called informal balance) is more complex than symmetrical balance. It often contrasts elements that at first glance may not seem to be balanced. For example, an artist may place a large shape on one side of a design and a group of smaller shapes on the other. Or, he or she may balance a small area of color with a larger, colorless space; or a small, bright area of color with a large, dull one. In each of these examples, the two sides will appear to have the same "visual weight."

Asymmetry can provide balance in a design and also produce a sense of excitement and interest. Look at *Igor Stravinsky* (fig.7–12). In this unusual portrait, Arnold Newman placed the composer's face in a corner of the composition. To his right, the black shape of a piano lid takes up most of the space. Even though the face is very small, our attention is naturally drawn to it. The fact that it is close to the edge also adds enough "weight" to balance the much larger black shape.

Asymmetrical balance offers many possibilities and combinations to an artist, who might balance light against dark, large against small, or rough against smooth. But asymmetrical balance is more difficult to achieve than symmetrical, or formal, balance. Informal balance is something that the viewer senses in a composition; it cannot be measured. There is no center line or pairing of mirror images. As you manipulate the visual elements in a design, you'll learn to judge when opposing elements are in balance.

7–13 Mobiles display a continuously changing asymmetry. It is this characteristic that makes them so fascinating to the eye.

Alexander Calder (1898–1976), *Lobster Trap and Fish Tail*, 1939. Hanging mobile, painted steel wire and sheet aluminum, 8' 6" x 9' 6" (2.6 x 2.9 m). Commissioned by the Advisory Committee for the stairwell of the Museum. The Museum of Modern Art, New York. Digital image ©The Museum of Modern Art/Licensed by SCALA/Art Resource, New York. ©2010 Calder Foundation, New York/Artists Rights Society (ARS), New York.

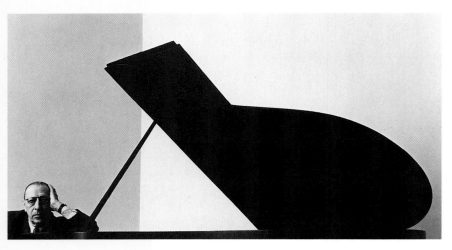

7–12 The composer and the piano become one in this image. Note the serious expression on Stravinsky's face. Why do you think the photographer chose this composition? What impression does the image give you about the composer and his music?

Arnold Newman (1918–2006), *Igor Stravinsky*, 1946. Print. ©Arnold Newman.

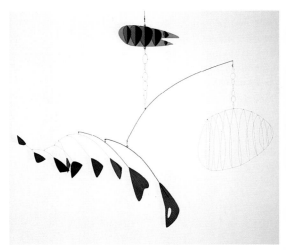

Try it

Study fig.7–13 and other mobiles by Alexander Calder. Then make a mobile of your own. Try to balance your work visually by contrasting large and small forms. To achieve equal visual and physical weight, use color and size variation.

Piet Mondrian

If you want a challenge, try to find an artist whose search for harmony and balance in his work produced more unique artwork than Piet Mondrian. Considered by art historians to be one of the most influential pioneers of abstract art, his paintings are in the collections of most museums worldwide.

Piet Mondrian was born in the Netherlands in 1872. He studied drawing and later painting at the Royal Academy in Amsterdam,

supporting himself by giving private lessons, copying museum works, doing scientific drawings, and occasionally selling a painting.

Mondrian painted traditional Dutch landscapes: trees, windmills, farms, and the Gein river, as well as later experimenting with Impressionism and Post Impressionism. Theosophy with its spiritual principle of universal harmony became a major influence on his work. He lived in Paris from 1912 to 1914 painting Cubist works.

Piet Mondrian (1872–1944), *Self-Portrait*, c.1900. Oil on canvas mounted on masonite, 19 ⅞" x 15 ½" (55 x 39 cm). The Phillips Collection, Washington, DC. ©2010 Mondrian/Holtzman Trust c/o HCR International, Virginia.

Mondrian spent World War I in the Netherlands. His paintings from this period show a new simplicity of line and color. In 1917, Mondrian co-founded the journal *De Stijl* (the style), where he published essays explaining his artistic theories, which influenced generations of Dutch artists.

When the war ended, Mondrian returned to Paris, where his work showed a radical

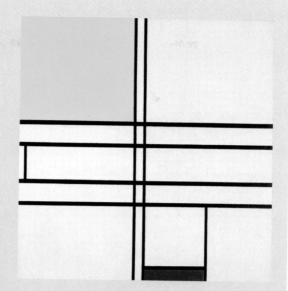

7–14 Keep in mind that though a work might be asymmetrical, it can still have a strong sense of balance. Can you analyze how Piet Mondrian maintained balance in this painting?

Piet Mondrian (1872–1944), *Composition in White, Blue and Yellow: C*,1936. Oil on canvas, 28 ⅜" x 27 ¼" (72 x 69 cm). ©2010 Mondrian/Holtzman Trust c/o HCR International, Virginia.

transformation. His paintings were often asymmetrical, with a dynamic balance with blocks of primary colors on planes of white and gray divided black lines. It was an art of pure abstraction, which he defined as Neoplasticism and developed for the rest of his life.

Mondrian's paintings were shown in Europe and America. With the threat of World War II, Mondrian made his way to New York, where he was still making dramatic changes to his style. He died in 1944, leaving a creative legacy that affects the way we view art today.

Try it

You can experience actual asymmetrical balance by placing a ruler across an outstretched forefinger, while resting your hand on a desk. Experiment by placing lighter and heavier objects on each side of the center. Move them until the ruler balances.

Radial Balance

If the parts of a design turn around a central point, the design has *radial balance*. A bicycle wheel is an example of radial balance: the wheel has a central point from which the spokes radiate outward. The blossoms of sunflowers and daisies are other examples.

Designs based on radial balance are somewhat similar to those that use symmetrical balance: they are generally orderly and repetitious, and one side may be much like the other. But because the various elements in radial designs form a circular pattern, they often convey a greater sense of movement or energy. Look at the plate (fig.7–17) created by Maria Martinez. The design uses radial balance, and its circular repetition of feathers suggests a feeling of turning or spinning.

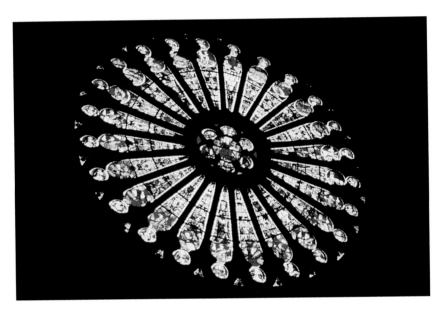

7–15 Rose windows are excellent examples of radial balance in architecture. This window is from the Cathedral of Angers, in France, which was completed during the 1200s. Rose windows such as this one were most often placed on the end walls of medieval churches to allow a burst of light to flood the interior.

Cathedral of St. Maurice, c. 1150–13th century, Angers, France. South transept of rose window.

7–16 We usually think of a daisy as a simple form, but if we look at it in terms of radial balance, it becomes a much more complex creation.

Daisy. Photo by N. W. Bedau.

Note it

Look for simple and complex radial designs in manufactured objects. You might notice buttons, plates, fountains, or hubcaps. Make sketches to use as ideas for later artworks.

As they do with symmetrical balance, artists often modify radial balance to add greater visual interest or tension. They may vary the number, direction, or arrangement of the design's parts. One example of this is the so-called rose window commonly found in a church or cathedral (see fig.7–15). The "spokes" of this stained-glass architectural feature often depict a variety of scenes or figures, and, unlike the plate, the rose window would not look the same if it were turned upside down. Even with modifications, however, most radial designs tend to create an overall decorative effect.

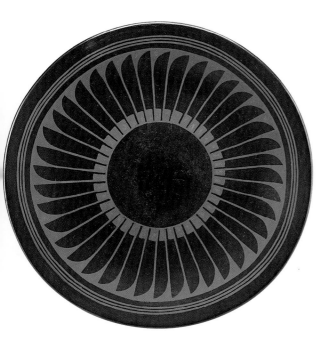

7–17 Over her long lifetime, Pueblo artist Maria Martinez created many exquisite works, including this earthenware black-on-black plate. The ideas for this style came from prehistoric pottery discovered by archaeologists near her home in New Mexico.

Maria Poveka Martinez (1886–1980), *Plate*, c. 1943–56. Polished clay, 14 ½" diameter (36.8 cm). Saint Louis Art Museum, Gift of Mr. and Mrs. Charles Shucart (526:1982).

7–18 How has this artist used radial balance in her work?

Jessica Genelli (age 17), *In Good Times and Bad*, 1996. Oil pastel and watercolor. West Boylston Middle/High School, West Boylston, Massachusetts.

Another Look at Balance

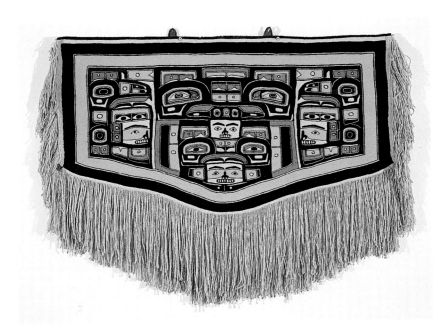

7–21 Describe how balance is achieved in this three-dimensional work.

Erin Freeland (age 14), *Untitled*, 1998. Papier-mâché, 25" high (63.5 cm). Wachusett Regional High School, Holden, Massachusetts.

7–20 Though this building has many disparate elements, the architect uses balance to achieve a sense of unity. Which types of balance are employed here?

Walter Gropius (1883–1969), *66 Old Church Street, façade*, 1936. Multiple story house, International Style, London.

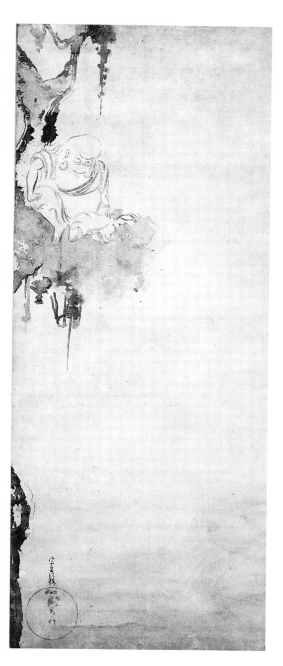

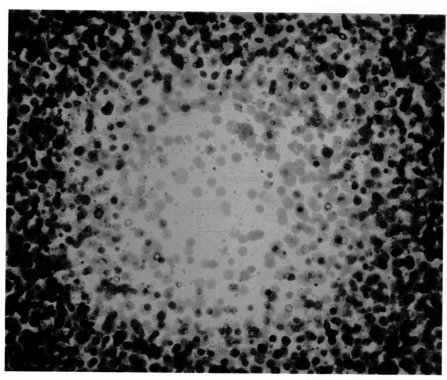

7–22 Empty space, or a void, is often used by Asian artists in a masterful manner. What effect does the emptiness here have on the viewer?

Nonomura Sotatsu (1576–1643), *The Zen Priest Choka*, Edo period. Hanging scroll, ink on paper, 37 ¾" x 14 ¾" (95.8 x 37.5 cm). ©The Cleveland Museum of Art, 1998, Norman O. and Ella S. Stone Memorial Fund, 1958.289.

7–23 Wilson made this print by letting drops of acid fall directly onto the metal plate. Because he introduced an element of chance into the work, the symmetry is approximate.

Fred Wilson (b. 1954), *Convocation*, 2004. Etching on paper, 30 ½" x 34" (77.5 x 86.4 cm). Edition 25, ©Fred Wilson, Courtesy PaceWildenstein, New York.

Review Questions

1. What is visual balance?
2. What are four types of visual balance? List an example of each from this book.
3. How do the two halves of a bilateral, or symmetrical, composition relate to each other?
4. How does approximate symmetry differ from bilateral symmetry?
5. Why might an artist wish to create an approximately symmetrical or asymmetrical design instead of a symmetrical one?

6. What type of balance does the design of the Taj Mahal display? Where is the Taj Mahal located? Why was it built? What is an iwan? Locate iwans in this structure.
7. Experiments in what art style led Mondrian to focus on a new style called De Stijl? Describe the restrictions that he placed on himself as he painted in the nonrepresentational De Stijl style.

Career Portfolio
Interview with a Website Designer

While still in high school, **David Lai** learned the basics of computer design on his own. "Just for fun," he wrote and published a book on how to design computer-screen icons. Born in 1975 in Manhattan, Kansas, David now works for a firm in California that specializes in interactive design.

What do you call your occupation?

David I'm in the design profession, but we almost always talk more about solving problems. Good design does have aesthetic components, which is important, but there is also a very important functional aspect. You have to create something of utility and value. We solve real-world communication problems.

We look at computers more as a tool than a specialty. Otherwise, I'd be nothing more than an operator. You can always learn a tool, but the more difficult things to learn are conceptual—sketching your ideas out on paper before you go to the computer. Too many people these days want to go straight from whatever is in their mind—and it's usually not very clear—directly to the computer. They think they need to buy all these computer books to learn the program, but the truth is that they need to know how to conceptualize more than they need the tools, the applications.

How is balance important in website design?

David Well, there are so many different elements involved. There's content. There's visuals. There's audio. There's text, the copy itself. There really has to be a synergy between all of them to get something to work. You're always balancing different spaces or different shapes.

Can anybody design a website?

David Well, theoretically, yes. Just like anyone could be a doctor, if they really put their mind to it. There's such a wide range of people in this industry because it's very easy to enter into. Anyone can pick up a book and learn some basic HTML and some basic graphic stuff. HTML is the basic programming language that you use to create web pages. It's the foundation; it's the starting point. No website can be created without knowing some of that.

How do most people learn it?

David A lot of people learn it by looking at sites they really enjoy or respect, by taking them apart and looking at how the code was done. I think that's one of the great things about the Internet—it allows people to share information quickly. That includes sharing how sites are built, in that I can download the source code of any site and see how it was put together and learn from that.

What would you recommend to people interested in doing this for a living?

David I would recommend that they read as much as they can about the subject. There are so many good books out there on web design.

Obviously, there's a more formalized way as well. There are a lot of good art-design schools out there, especially with today's booming computer-design industry. You can take courses on web design, multimedia, interactive learning for cd-rom work, 3-D modeling for special effects for Hollywood—whatever. The important thing is that you just have to go out there and take risks.

Over the course of his career, David Lai has designed websites for such varied businesses as Nintendo and Herman Miller.

Studio Experience
Balance in Nature

Task: To create a painting—with either symmetrical or asymmetrical balance—of a small symmetrical natural object.

Take a look. Review the following images:
- Fig. 7–1, Chuck Close, *Lucas Woodcut*
- Fig. 7–6, *Mask*
- Fig. 7–7, butterfly
- Fig. 7–13, Alexander Calder, *Lobster Trap and Fish Tail*
- Fig. 7–15, *Cathedral rose window*

Think about it.
- Notice the symmetrical balance in most of the images listed above. Imagine a vertical line drawn through the middle of each image. Each half of the image would be about the same. Point out the symmetrical details on each half of the images. Which image has radial symmetry?
- Compare the mood or stability of the symmetrical images to that in an asymmetrical composition, such as *Lobster Trap and Fish Tail* (fig.7–13).

Do it.

1 Select a small nature object with symmetrical balance. Study its details with a magnifying glass or loupe.

2 Fold an 8 ½" x 11" piece of bond paper in half.

3 With a soft pencil, draw one half of the object, arranging your drawing so that the center line of your subject is on the fold.

4 Refold the paper, and rub over the outside with a smooth, hard object like the back of a spoon, transferring the image to the other half of the paper.

5 Redraw any lines that did not transfer. You now have a symmetrical drawing.

6 To design a composition from your sketch, move a viewfinder made of two paper Ls over your sketch. Place the viewfinder so that you have a symmetrical composition. Change the size of the viewfinder opening; then consider some asymmetrical compositions by moving the viewfinder so that the center of the subject is not in the center of the opening. You may wish to use only a portion of your drawing, with the subject extending out of the picture plane.

7 Draw a line around the edge of your chosen composition.

8 Enlarge your composition to fill an 18" x 24" sheet of drawing paper. To do this, very lightly draw with a pencil and ruler a grid of 1" squares over your drawing. Then, very lightly draw a grid of 2" squares on the large paper. Copy each square from your small drawing onto the large paper.

9 Paint your drawing with black, white, and two colors of tempera paint. Consider which colors will suggest a mood for your subject. For some areas, you may want to mix your selected colors.

Helpful Hints
- Make dark pencil lines in your first drawing so that they will transfer to the other half of the paper.
- If you do not want to draw the grid on your small drawing, draw it on a sheet of tracing paper or acetate, and tape it over your drawing.
- Make light pencil lines on the grid so that they will not show in your finished painting.
- Periodically view your artwork from a distance. Check the contrast to determine if details that you want to stand out do so. Would your composition benefit from any changes, such as the addition of lines or a variation in color?

Check it.
- Is the balance in your completed artwork symmetrical, asymmetrical, or radial? Why is the composition pleasing or not pleasing to you?
- Is the color scheme appropriate for the composition?
- Is the drawing technique appropriate? What would you do to improve the painting technique?

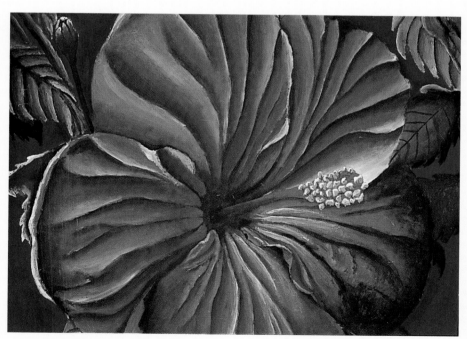

"I learned that when you work with tempera paint, you must work quickly, and if you want the colors to blend together, then you need to make sure you use a lot of paint."
Aileen Delgado (age 17), *Hybiscus*, 1998. Tempera, 18" x 24" (45.7 x 61 cm). West Springfield High School, Springfield, Virginia.

8 Unity

YOU'VE PROBABLY HEARD A COACH or the school principal talk about teamwork or school spirit. He or she knows that a group can produce a much better result when all members work toward a common goal or purpose. When parts combine to create a sense of oneness, they display *unity*. Examples of unity are all around you. An aquarium might hold a number of fish that vary in color, texture, form, and size. However, what unifies these differences is the fact that all the creatures are fish. A successful dogsled team or tug-of-war players also display unity. Without unity, the dogs would run in different directions, and the tug-of-war players would not all pull at the same time.

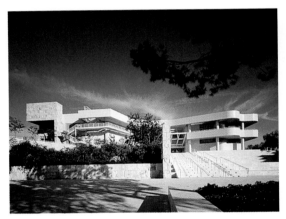

8–1 Architects often work on a grand scale, so it is essential that they incorporate design elements that serve to unify the whole.

Richard Meier (b. 1934) & Partners, *J. Paul Getty Museum*, 1997. The museum's entrance façade, seen from the tram arrival plaza at the Getty Center. Photo by Tom Bonner.

8–2 This pitcher is an example of the sleek, smooth style that dominated American art in the 1930s. The continuous lines of the piece and its unadorned surface make its unity both simple and perfect.

Peter Müller-Munk (1904–67), *Normandie*, designed 1935, manufactured 1935–1941. Chrome-plated brass, 12" x 9 ½" x 2 ¾" (30.5 x 24.1 x 7.0 cm). Toledo Museum of Art (Toledo, Ohio), purchased with funds from the Florence Scott Libbey bequest in memory of her father, Maurice A. Scott. 1991.86

Artists are concerned with unity. They want their work to have a feeling of wholeness or harmony, and they achieve this when all the parts of a design work together. For example, an architect wants the windows, doors, roof, and walls of a building to look as if they belong together. If the parts don't work together, the result will be chaos and disorder. An artist can achieve a single, harmonious design in many ways, including the use of color, texture, and repetition of shapes or forms.

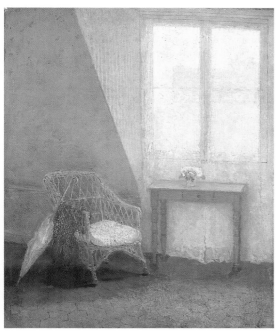

8–3 What design element helps unify this painting?
Gwen John (1876–1939), *A Corner of the Artist's Room, Paris*, 1907–09. Oil on canvas, 12 ½" x 10 ½" (31.7 x 26.7 cm). Sheffield Galleries and Museums Trust. Sheffield City Art Galleries/Bridgeman Art Library, London/New York.

8–4 At first glance, determining how an artwork is unified can be difficult. Careful examination allows the viewer to understand the way a design holds together.
Charles Rennie Mackintosh (1868–1928), *The Scottish Musical Review*, 1896. Lithograph, printed in color, 97" x 39" (246.3 x 99 cm). Glasgow Museums: Art Gallery & Museum, Kelvingrove, Scotland.

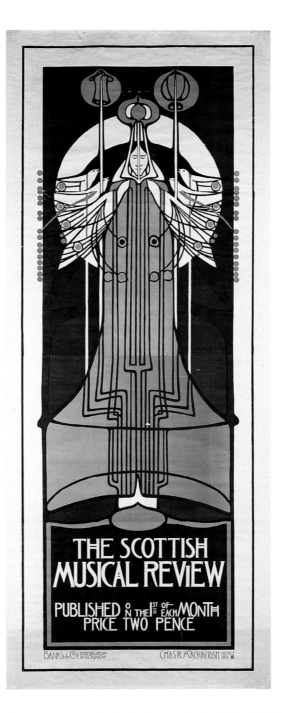

Dominance

One way to achieve unity in a design is to make a single visual element play a major part. This element is then said to have *dominance* within the design. For example, an artist might create a sculpture from a single material that dominates and unifies the surface, or a painter might create a work with one color that occurs throughout most of the composition, creating a certain mood and unifying the parts.

Because a design sometimes needs variety, an artist may add other materials to a sculpture or more colors to a painting. These lesser parts are said to be *subordinate*, or secondary: they can both support the dominant subject and add variety to the design.

Look at Ellsworth Kelly's *Blue on White* (fig.8–6), which is clearly a single unit. The artist used one major shape and a single color that dominates and provides a sense of wholeness. The unusual shape of the painting creates an exciting relationship between the positive and negative spaces, and supplies the design with the necessary variety and interest.

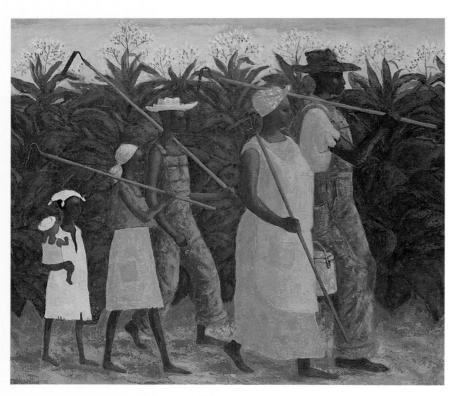

8–6 Some works of modern art are called minimal because they make use of very simple shapes, forms, and color combinations. These works rely on the principle of dominance for their effect.

Ellsworth Kelly (b. 1923), *Blue White*, 1961. Oil on canvas, 85 ½" x 67 ½" (217.2 x 171.5 cm). Gift of S. C. Johnson & Son, Inc. EK 272. Smithsonian American Art Museum, Washington, DC. Photo: Smithsonian American Art Museum, Washington, DC/Art Resource, New York.

8–5 **Which elements in this painting would you call subordinate?**

Ellis Wilson (1899–1977), *Field Workers*. Oil on fiberboard: masonite, 29 ¾" x 34 ⅞" (75.6 x 88.6 cm). Smithsonian American Art Museum, Washington, DC. Photo: Smithsonian American Art Museum, Washington, DC/Art Resource, New York.

Discuss it

Look through magazines to find several car advertisements that show one car in a dominant location in the composition. Discuss how all other features are subordinate to the dominant form and color.

Käthe Kollwitz
Attack

Have you ever had strong feelings after seeing a movie or a play? Perhaps you later wrote about your feelings or created an artwork based on what you saw and felt.

One person who often worked with ideas based on what she observed firsthand was the German artist Käthe Kollwitz (1867–1945). One of her greatest works, a series of prints (etchings and lithographs) called *The Weavers' Uprising*, was based on a play she had seen.

The play, *The Weavers*, written by Gerhart Hauptmann, was about the 1844 revolt of weavers who lived near the German-Polish border in Silesia and worked, in traditional style, on hand looms. Because of the Industrial Revolution, they were no longer an essential link in the economic chain, and their lives had become filled with hardship and suffering.

Although the play was banned from public performance in Berlin, it was performed in secret, beginning in 1893. Kollwitz may have attended the controversial play more than once. She made a thorough study of all available information about the revolt as she sketched ideas for her six-part series. Kollwitz created many preliminary studies and etchings before completing the work. Not content with all the etchings, she remade the first three images as lithographs, in a very unusual combination of techniques within a single series.

The first print, *Poverty*, shows a grieving mother attending her starving child, who is bedridden in a tiny room. The second is *Death*, which portrays parents and child with a skull-faced figure in the background, signifying death's presence; a single candle illuminates the cramped space. In *Deliberation* (also known as *Conspiracy*), the third print, Kollwitz expresses the urgency of a small group meeting to decide what must be done about the crisis their lives had become. The fourth print in the series, *Weavers on the March*, shows anger and determination as the

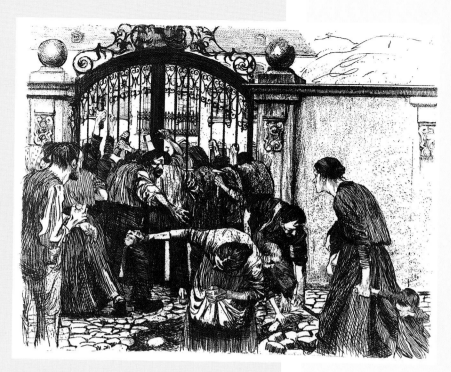

8–7 This print is part of a series that tells the story of an 1844 uprising of linen weavers in the German province of Silesia. How does Käthe Kollwitz use dominance to communicate the tension and emotion of the protest?

Käthe Kollwitz (1867–1945), *Attack (Sturm)*, from T*he Weavers' Uprising (Weavers' Riot)*, 1897. Etching. Reproduced from the collections of The Library of Congress Prints and Photographs Division, [FP XIX K81 A33]. ©2010 Artists Rights Society (ARS), New York/VG Bild-Kunst, Bonn.

community of weavers heads toward the source of their oppression with a few farm tools as weapons. *Attack,* the fifth print, pictures the weavers storming the gate of the factory owner's villa. Women bend to dislodge stones from the roadway, handing them to the men to throw. Their weak attack is unsuccessful. In the final print, *The End*, a soldier's bullet has killed another of the impoverished weavers, whose body lies on his cabin floor.

Kollwitz presented the prints to her father on his seventieth birthday. He died shortly thereafter, and she was upset that he would not be able to see them at a public exhibition. She postponed public debut of *The Weavers' Uprising* for over a year until 1898, when the epic work caused a sensation at the Berlin Art Exhibition.

Repetition of Visual Units

Have you ever noticed that buildings within certain neighborhoods go well together? Or that one structure seems more unified than other buildings nearby? If so, you were responding to the repetition of visual units. For example, a high-rise structure may have rectangles and squares repeated over its surface, or the houses in a neighborhood might have similar shapes or be made of the same materials.

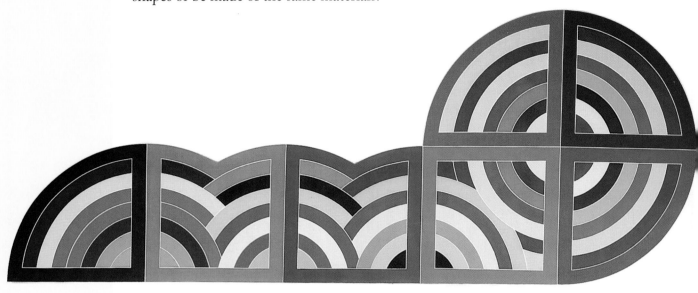

8–8 Analysis of this work will reveal a variety of repeating shapes. Can you find a shape that does not repeat?

Frank Stella (b. 1936), *Raqqa II*, 1970. Synthetic polymer and graphite on canvas, 120" x 300" (304.8 x 762 cm). North Carolina Museum of Art, Raleigh, Gift of Mr. and Mrs. Gordon Hanes. ©2010 Frank Stella/Artists Rights Society (ARS), New York.

8–9 Some buildings have more repeating visual units than others. Is there any repetition of architectural elements on your school building?

Richard Rogers (b. 1933), *Façade of Lloyd's Bank*, London, detail, 1994. ©Oliver Radford.

Artists use repetition of visual units to develop a feeling of unity within a design. For example, an artist might repeat certain shapes in a textile design, or a photographer might frame a composition so that similar shapes or values are repeated. However, artists are aware that too much repetition of a single feature can produce monotony. Therefore, to add some variety, an artist might repeat a shape but give each a slightly different color or size, or he or she might repeat a color within a slightly different shape. If used carefully, such variations will increase interest but not disturb the unity of a composition.

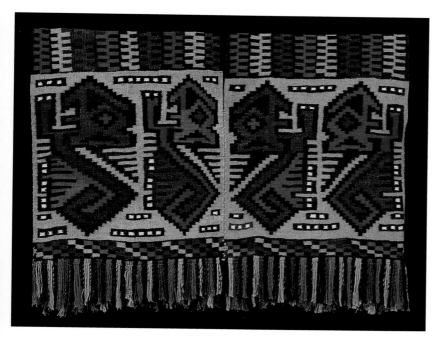

8–10 The Nasca were an Andean people whose culture flourished from 100 to 700 CE in what is modern-day Peru. Repetition was an important part of their textile, as well as their ceramic, designs.

Tunic with animal motif, 600–700 CE, Nasca, Peru. Camelid fiber, dovetail tapestry weave, 22 ½" x 30 ¼" (56 x 77 cm). Dallas Museum of Art, 1970.20. MCD. The Eugene and Margaret McDermott Fund.

8–11 In this aerial photograph of a beach, circular umbrellas and rectangular towels repeat across the design. The variety of colors and positions creates visual interest.

Fred Ward (b. 1935), *Aerial, Beach*, c. 1966. Print. Courtesy of the artist. ©2010 Artists Rights Society (ARS), New York/VISCOPY, Australia.

Use of Color

Color, which can play a powerful role within a design (see Chapter 4), is one of the simplest ways to create a sense of unity. Of course, if you covered an entire canvas with a flat coat of a single color, the design might be boring and monotonous. Most likely, you would need to add an interesting texture or a subordinate color. If you used a single blue color to paint a landscape, the work would be unified, but the viewer would not be able to distinguish the trees and mountains from the sky. To create the necessary contrasts, you might add white, black, or gray to create different tints, shades, or tones of blue.

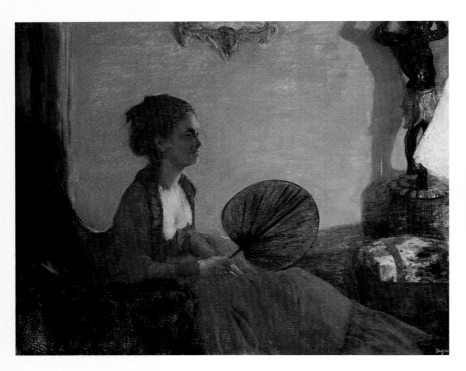

8–12 Edgar Degas spent a great deal of time studying the effects of artificial light, and he often explored this type of light in his paintings. How would you describe the interior space that he depicted here?

Edgar Degas (1834–1917), *Madame Camus*, c. 1869–70. Oil on canvas, 28 ⅝" x 36 ¼" (72.7 x 92.1 cm). Chester Dale Collection. ©1998 The Board of Trustees, National Gallery of Art, Washington, DC.

Discuss it

Look through magazines to find clothing advertisements. How did the designer use color to achieve unity? What did he or she add to produce enough variety to make the design interesting?

8–13 Newcomb College Pottery was part of a college for women. In the early twentieth century, there were few choices for women who wanted to make a living in the field of art. Pottery decoration was one way they could put their art training to use and earn a wage.

Henrietta Bailey (1874–1950), *Vase*, 1916. Designed for Newcomb College Pottery, New Orleans, Louisiana. Painted earthenware, 10" high (25.4 cm); 7 ½" diameter (19.1 cm). Carnegie Museum of Art, Pittsburgh. John Berdan Memorial Fund, 81.53. Photograph ©2009 Carnegie Museum of Art, Pittsburgh, Pennsylvania.

An artist might use analogous colors to retain a strong feeling of unity. Look at the painting of the seated woman by Edgar Degas (fig.8–12), who chose to work with oranges and reds. This dominant group of colors both unifies the work and conveys a feeling of warmth and intimacy. Within the design, subordinate areas of yellow and brown provide areas of contrast.

8–14 In this painting, Rothenberg uses different tones of the same color to create unity. Identify the areas where the red is repeated as both a darker shade and a lighter tint.

Susan Rothenberg (b. 1945), *Dominos—Hot*, 2001–2002. Oil on canvas, 73" x 75" (185.4 x 190.5 cm). Courtesy Sperone Westwater, New York. ©2010 Susan Rothenberg/Artists Rights Society (ARS), New York.

Try it

Create a landscape, still life, or geometric design. Use a single color, plus one or two other colors that contain that single color in their mixture. For example, use red as the main color, and add red-orange and red-violet. Because they all contain red, these colors can be intermixed without endangering the unity. Even if you change the values by adding black and white, the unity will remain.

Surface Quality

Texture or surface quality is an important element of any design (see Chapter 6), and artists can use texture to develop a feeling of unity. For example, a painter might create a dominant surface quality by using similar brushstrokes on all parts of a work. The strokes might be wet, wide, thin, or transparent. Another painter might use a palette knife to make the paint look as though it had been buttered onto the canvas. Look at the work by Cézanne (fig.8–15), and then turn back to view a work by Seurat (fig.4–23) and one by van Gogh (fig.1–9). Note that consistent strokes unify the surface in each of these designs.

A sculptor might unify a work by using a single material. For instance, the rough or smooth quality of that material can impart an overall dominant texture to the piece. Or the sculptor might alter the surface quality of the piece with fingerprints, scratches, tool marks, and indentations. If these alterations cover much of the surface, they also can provide a characteristic that unifies the different parts of the sculpture.

To keep a design from losing visual interest, an artist might slightly vary the surface quality of a piece. A painter who uses similar brushstrokes might include a variety of colors or values. A sculptor or architect might include quiet areas in which the texture is reduced or not apparent. Similar to the use of color or repetition, the dominant surface quality will give each design a feeling of wholeness or harmony—and the added variations will help capture and hold a viewer's attention.

Try it

Create a simple drawing, painting, print, or ceramic piece in which the entire surface is united by a similar texture. For example, you might use only vertical lines to create texture in a drawing, or you might use a single tool to create texture in a clay sculpture. Examine and analyze the texture in your finished piece, in the works by other students, and in the images in this chapter.

8–15 Notice how Cézanne applied the paint in separate strokes. Experts believe that in this painting, Cézanne used a different shade of color every time he put his brush to the canvas. The unity of the work is visible in the consistency and clarity of each brushstroke.

Paul Cézanne (1839–1906), *Maison Maria with a View of Château Noir*, c. 1895–98. Oil on canvas, 25 ⅝" x 31 ⅞" (65 x 81 cm). AP 1982.05. Kimbell Art Museum, Fort Worth, Texas. Photo by Michael Bodycomb. Photo: Kimbell Art Museum, Fort Worth, Texas/Art Resource, New York.

8–16 How has this student created unity of surface quality in his artwork?

Stephen Harris (age 16), *In Human Bondage*, 1996. Mixed media on multisurface, 30" x 40" (76 x 101.6 cm). Lake Highlands High School, Dallas, Texas.

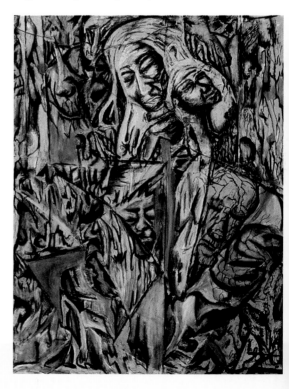

Isamu Noguchi

Perhaps Isamu Noguchi did not choose to be a sculptor, but instead, sculpting "chose him." Born in Los Angeles in 1904 of an American mother and Japanese father, Noguchi spent his early years in Japan, but he returned to the United States at the age of thirteen. When he completed high school and was asked what he wanted to do next, he responded, "Be an artist." He surprised even himself with this answer: Noguchi's only experience making art had been a few years earlier in Japan, where he created a garden, did woodcarving, and studied woodworking.

Having taken a friend's advice to go to medical school, Noguchi had begun premed courses at Columbia University, when (at his mother's suggestion) he wandered into the Leonardo da Vinci Art School. Despite his lack of enthusiasm for sculpting, Noguchi was offered a scholarship by the school's director. After three months of studio work, Noguchi successfully exhibited his art, left medical school, and became a sculptor.

Known best for his sculptures in stone, Noguchi experimented and explored many media and techniques during his long life. He made drawings, practiced brush and ink, became a costume designer, industrial designer, landscape architect (of designs that ranged from intimate gardens to monumental earthworks), stage-set designer, and furniture designer. He sculpted in clay, wood, metal, paper, bamboo, water, and light. Noguchi was so versatile that critics became frustrated trying to explain his style.

In 1961, Noguchi established a studio and living quarters in a former factory building in Queens, New York. In 1981, he bought adjacent land and began design and construction of the Isamu Noguchi Garden Museum, which opened to the public in 1985. Today, the museum maintains a website (www.noguchi.org) that posts information about Noguchi's life and work.

Just before his death in 1988, Noguchi created plans for a 400-acre park in Sapporo, Japan. He was an artist who drew his inspiration from the natural world, particularly Japanese settings. Always thoughtful about the meaning of sculpture, Noguchi desired to make sculpture a part of daily life.

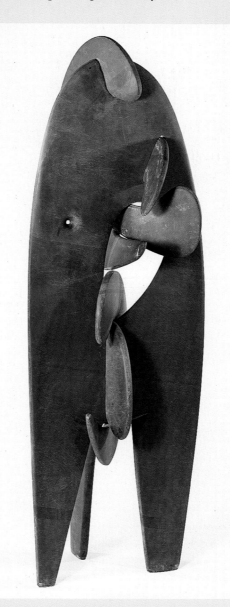

8–17 The unusual title of this work refers to the great skill and patience required to create the single, seamless surface of each interlocking piece of brittle slate.

Isamu Noguchi (1904–88), *Humpty Dumpty*, 1946. Ribbon slate, overall: 59" x 20 ¾" x 17 ½" (149.9 x 52.7 x 44.5 cm); base: 3" x 30" x 30" (7.6 x 76.2 x 76.2 cm). Whitney Museum of American Art, New York, purchase 47.7a-e. ©2010 The Isamu Noguchi Foundation and Garden Museum, New York/Artists Rights Society (ARS), New York.

Another Look at Unity

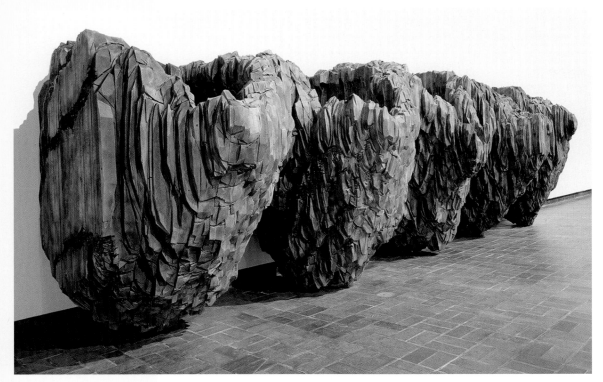

8–18 The elements of this sculpture are very similar, but they are not exactly alike. How has the artist balanced unity and variety here?

Ursula von Rydingsvard, (b. 1942) *krasawica II*, 1998–2001. Cedar, graphite, 72" x 264" x 48" (182.9 x 670.6 x 121.9 cm). ©Ursula von Rydingsvard. Courtesy Galerie Lelong, New York.

8–19 This twirling, dynamic composition keeps our eye moving from one part of the painting to the next. What element of design did the artist use to unify the work?

Melissa Miller (b. 1951), *Salmon Run*, 1984. Oil on linen, 90" x 60" (228.6 x 152.3 cm). Shirley and Thomas J. Davis, Jr. Courtesy of the Lyons Matrix, Austin, Texas.

Note it

Start a clip file of art and graphic-art reproductions. With each reproduction, write a short statement about the unifying element, as well as the elements that create interest through variation. These could be pasted in a notebook, scrapbook, or sketchbook; filed in envelopes; or organized in page protectors in a binder.

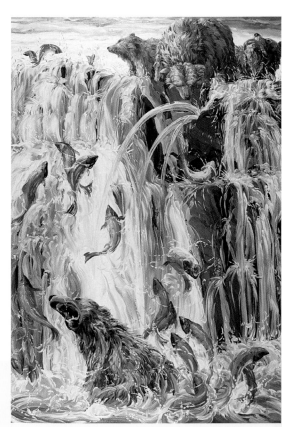

8–20 Compare this sculpture to von Rydingsvard's (fig.8–18). Can you name at least two similar ways in which these artists unified their work?

Jacques Lipchitz (1891–1973), *A Song of the Vowels*, 1932. Bronze, 156" high (396.2 cm). Sculpture Garden, University of California, Los Angeles. Photo by A. W. Porter. ©Estate of Jacques Lipchitz/Licensed by VAGA, New York, NY/ Marlborough Gallery, New York.

8–21 How has this student achieved unity in her work?

Sharon Hess (age 16), *Paperclips*. Watercolor and felt tip, 18" x 24" (45.7 x 61 cm). Montgomery High School, Skillman, New Jersey.

Review Questions

1. Why do artists often try to create unity in their artworks?
2. List four ways to create unity in an artwork.
3. Explain what dominant and subordinate elements are in a design. Name an example of an image in this chapter that has a dominant element. Identify that element.
4. Name an image in this chapter that uses repetition of shape to create unity.
5. Select one image in this chapter that uses an overall surface texture to create unity. Describe the texture.
6. Explain what prompted Käthe Kollwitz to create her series of prints, *The Weavers' Uprising*.
7. With what two countries was Noguchi most closely associated? How did these cultures influence his work?

Career Portfolio
Interview with a Gallery Owner

An art exhibit is generally unified by theme or other similarities. **Bernice Steinbaum** specializes in women artists and artists from different cultural and ethnic backgrounds. She helps build the careers of the artists she represents by making sure their work is seen by the public, and by acting as an agent for the sale of their work. Her gallery is in Miami.

How did you start your art gallery?

Bernice I studied art history; then taught. I was concerned that we were graduating college students with none of them able to get jobs in their chosen area of study. So I told my chairperson, "We have to add some different areas of study to the curriculum. We have to include museum studies, curatorial studies for children's museums," and other things I felt the university was ignoring. She said, "What are you complaining about? Your job pays your rent." That was devastating to me because I did not want to define my life as a way to pay the rent.

So, I said, "Okay, I'm going to open an art gallery." I took the work of artists that I had collected personally, and opened with a group show. I called *The New York Times*, and in my innocence—I would not have the courage now because I know too much—I called an art critic and said, "Listen, I read your writing every week, and it seems to me you should see what I'm about! And make sure you bring your cameraman." Sure

enough, she came, she did bring her cameraman, and she photographed this group exhibition. I got a full page in *The New York Times* art section, and I was in business.

How did you get interested in art?

Bernice I think one becomes obsessed with it. I guess I need a lot of visual stimulation. I think artists make magic, and for the rest of us—who can view their magic, no less get into the rooms where the potions are made—it's quite extraordinary. It gets me a tiny step closer to the magic.

As an art dealer, I often get to go to the studio prior to the rest of the world seeing the work. Occasionally, I get asked my opinion, and I find that very awesome. But I'm just as content to see it before everybody else, to be able to dream about and think about it and talk about it.

What advice would you give to young people who want to own a gallery some day?

Bernice Do not go into this because of money; go into it because of the passion—and that's sincere. I would

Bernice Steinbaum's appreciation for art goes beyond the main gallery where the one-person shows take place. In her private office, shown here, the art on the walls are works of artists that she represents. She thinks of it as her personal museum where the works change regularly depending on what the clients have bought. Photo by Marilyn G. Stewart.

tell them to learn as much art history as they can. It's the discerning eye that makes the difference between good artists and other artists. I would tell them that working as an intern in a gallery during the summer or a Christmas vacation is an absolute must.

I think they have to see a lot of art—that means every show that comes through their town. Find out what the local museum schedule is, and look at their permanent collection. Become a member and hear the artists they're showing speak about their work. If they're very interested in art, they should get an art publication like *Art in America* or *ArtNews*—they're both readable.

And then take the basics in college—Art History 101 and 102—whether they're interested in becoming an art professional or not. We tend to be visual illiterates; we don't know that something we're looking at is good unless we see it in writing. We don't trust our eyes. Sometimes, that trust comes when you've seen enough art.

Studio Experience
Putting It All Together

Task: To create a painting that demonstrates unity and coordinates with other artworks.

Take a look.

Review the following images:
- Fig. 8–6, Ellsworth Kelly, *Blue on White*
- Fig. 8–8, Frank Stella, *Raqqa II*
- Fig. 8–17, Isamu Noguchi, *Humpty Dumpty*

Think about it.

Study the images listed above.
- How is unity created in each artwork?
- Compare and contrast these artworks. Which have similar shapes? Which have similar surface textures? Which are similar in color?
- If you were to arrange these artworks in an exhibit, how would you order them so that there would be a unity or flow to the exhibit? Explain the reasons for your arrangement.

Do it.

1 Select an image in this chapter and determine what the artist did to create unity in the artwork. From another chapter, select an image that goes with or is similar to the first work. Write the title, artist, and medium of each piece, and explain how the two pieces are alike.

2 Create a painting that is similar to the two artworks you selected. Imagine that your painting will be grouped in an exhibit with the two pieces you selected. For example, you might have chosen two works that show a group of people going someplace and include a wealth of details about the location. In a similar style, you could paint friends going shopping or to a ball game. Or, perhaps the overall texture of brushstrokes and use of light in the two works would inspire you to use a similar brush texture.

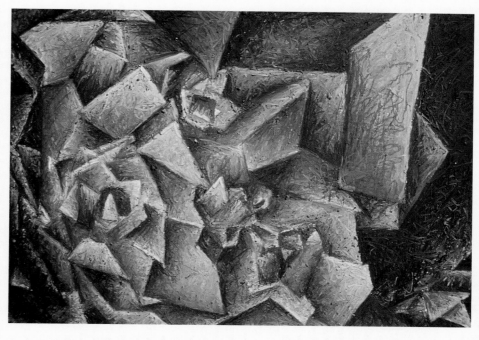

"I used color, texture, and variety to create my self-portrait. To keep the flat shapes from being boring, I overlapped them to stress differences."

Sharon Kim (age 16), *Self-portrait*, 1996. Oil pastel, 15" x 20" (38.1 x 50.8 cm). Plano Senior High School, Plano, Texas.

3 Think about what you will paint. Make several pencil sketches on paper or in your sketchbook. Use the same method to create unity as did the artists whose work you selected.

4 Lightly sketch your design onto a 15" x 20" illustration board.

5 Paint your picture with acrylic paints. After it dries, you may wish to add details with a small brush or a fine marker.

6 When you have completed your art and checked it, display it with copies of the two artworks that you originally selected.

Helpful Hints
- Do not copy your selected artworks, but use them as inspiration to express your own ideas.
- Because acrylic paint will harden brushes if it dries on the bristles, clean your brushes often as you paint. At the end of the painting session, clean the brushes with soap and water, and store them with bristles up.
- Acrylic paints dry very quickly. If your painting style requires blending, slow down the drying time by adding an acrylic retardant.
- If you use brushstrokes that create a good deal of texture and you want the paint to be thick, add acrylic gel to the paint. Use a palette knife to transfer the gel onto your palette, and mix the gel with the paint.
- If desired, use masking tape to create straight edges in your painting.

Check it.
- While working on your painting and after you have completed it, set it up and view it from a distance. Check it for unity: do all the parts seem to go together? Rework the painting if it does not look unified.
- How did you create unity in your composition?
- How well does your work coordinate with the two artworks you selected?
- In what ways is your painting original?

9 Contrast

OUR LIVES ARE FILLED WITH CONTRAST OF ALL KINDS. You probably feel joy at a holiday celebration, but sadness when you see illness or helplessness. In your neighborhood, tall old trees might stand next to small, newly planted ones. In the animal world, the dramatic black and white stripes of a zebra might contrast with the brilliant colorings of a butterfly. Whereas variety describes small differences within a design, *contrast* describes larger differences in the elements of a design.

9–1 In nature, contrast serves a variety of purposes, such as protection, camouflage, and attraction.
Cactus. Photo by J. Gatto.

9–2 How does contrast help lead your eye to the center of interest in this image?
Gertrude Käsebier (1852–1934), *Blessed Art Thou Among Women*, ca. 1900. Platinum print on Japanese paper, 9 ⅜" x 5 ½" (23.5 x 13.9 cm). Gift of Hermine M. Turner. The Museum
of Modern Art, New York. Digital image ©The Museum of Modern Art/Licensed by SCALA/Art Resource, New York.

There are many kinds of contrast. Filmmakers, musicians, authors, and dancers all use contrast in their work. They may use it to add interest, to change the pace, or to develop or underscore a mood. Visual artists also use bold contrasts, which include the contrast of natural with manufactured materials, large with small, dark with light, rough with smooth, shallowness with depth. The contrasts may delight our eyes, set a mood, or make a statement that grabs our attention or even spurs us to action.

9–3 Ken Chu incorporates design contrasts, as well as contrasts in content, in this work of art.

Ken Chu (b. 1953), *I Need Some More Hair Products*, 1988. Acrylic on foamcore, 21" x 25" x 5" (53 x 63.5 x 12.7 cm). Courtesy of the artist.

9–4 This mask displays variety through contrast in texture and materials. What different textures and materials can you find?

Africa (Kuba), *Ngaady a mwaash (mask)*, late 19th–early 20th century. Wood, metal, cotton, and raffia fibers, paint, beads, and cowrie shells, 13 ½" high (34.3 cm). The Baltimore Museum of Art: Gift of Alan Wurtzburger, BMA 1954.145.77

9–5 Gabriel Metsu was a contemporary of fellow Dutch artists Rembrandt van Rijn and Jan Vermeer. Like them, he was fascinated with the effects of light. The contrast of light and shadow, as well as texture, plays an important role in his paintings.

Gabriel Metsu (1629–67), *Woman at Her Toilette*, c. 1658. Oil on panel, 24" x 21 ½" (61 x 54.6 cm). Norton Simon Foundation, Pasadena, California.

Contrasting Materials

When an artist or designer combines two or more distinct materials within a single design, he or she is using contrast. Look at the armchair in fig. 9–7. The soft, thick fabric cushion is quite different from the rigid glass that forms the back and "legs." Furniture designers might combine metal, fabric, wood, and plastic to create contrast in their products. Architects often use steel, brick, concrete, wood, and glass. In the art classroom, you might choose to use paint and sand or balsa wood and cotton. The texture, color, and weight of the materials provide the desired contrast.

9–6 The small, individual sun-dried bricks of these ancient Native American dwellings contrast with the massive cliffs into which they are built.
Cliff Palace, Mesa Verde National Park, Colorado, about 1100. Photo by H. Ronan.

9–7 When this chair was exhibited in 1939 along with an accompanying glass table and sidebar, the ensemble was praised by critics for its "comfort, convenience, and delights." The public, however, found the glass furniture too heavy and fragile.
Pittsburgh Plate Glass Company (founded 1883), *Armchair*, c. 1939. Glass, metal, and fabric, 29 ¼" x 23 ¼" x 22 ¾" (74.3 x 59.1 x 57.8 cm). Carnegie Museum of Art, Pittsburgh, Pennsylvania; Dupay Fund 83.78.2. Photograph ©2009 Carnegie Museum of Art, Pittsburgh, Pennsylvania.

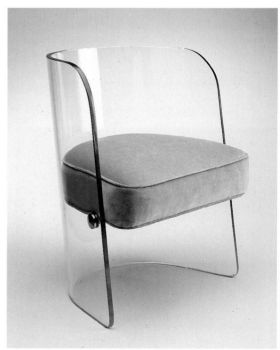

Try it

Use fabric scraps or found objects to create a collage or sculpture in which you vary the textures, shapes, and colors. Approach the project in one of two ways: either think of what you want to make, and then gather the necessary materials; or, gather interesting materials, and let them "tell" you what to make.

Another way to contrast materials is to combine those from nature with those made by humans. Contrast might be shown by an arrangement of fresh flowers in a glass vase, or a photograph of telephone wires intermingled with tree branches. Even a statue designed for a park or garden displays a contrast between the manufactured object and its natural setting.

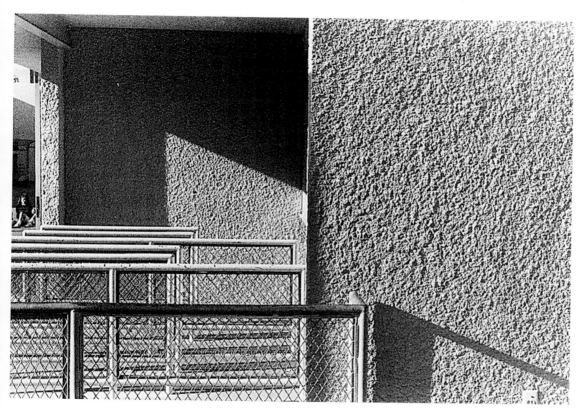

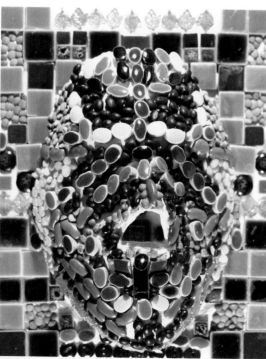

9–8 This photograph captures the contrast in materials on the exterior of a school building. The rough expanse of the stucco wall contrasts with the smooth, regular parts of the fence and railing. How did the photographer make use of the afternoon light to exaggerate this effect?

Stucco walls with railings. Photo by J. Selleck.

9–9 What three pairs of contrasting words might describe this student work?

Derek Tremblay (age 17), *Derek's Face,* 1998. Beans and tiles, 6" x 7" (15.2 x 17.8 cm). Whittier Technical School, Haverhill, Massachusetts.

Line Contrasts

Lines are one of the basic elements of design (see Chapter 1). Combining different types of lines—short, bold lines with long, spidery ones or horizontal lines with vertical ones—within a single design is one way to achieve contrast. Look at Leonardo da Vinci's study of a young girl's face (fig.9–10). The artist combined loose, curving lines with tightly drawn diagonals. He also created a contrast between the closeness of the lines at the center of interest and the openness of those farther from the subject's face.

Another way to achieve contrast with lines is by using different media, such as bold strokes of magic marker with lighter strokes of pastel crayon, or smooth gray pencil lines with textured lines of charcoal. In *Sneakers* (fig.9–11), the student artist used thin black lines of pen and ink over large washes of ink. You've probably seen this popular combination in many children's-book illustrations.

9–10 Throughout the centuries, the great masters often used relatively few lines in the creation of sketches, which focused their attention on a particular design problem that they were trying to solve. What design problem do you think Leonardo da Vinci was exploring in this drawing?

Leonardo da Vinci (1452–1519), *Study of the Head of the Angel, for the Madonna of the Rocks.* c. 1483. Silverpoint drawing, 7 ¼" x 6 ½" (19.1 x 16.5 cm). Biblioteca Reale, Turin, Italy. Photo: Alinari/ Art Resource, New York.

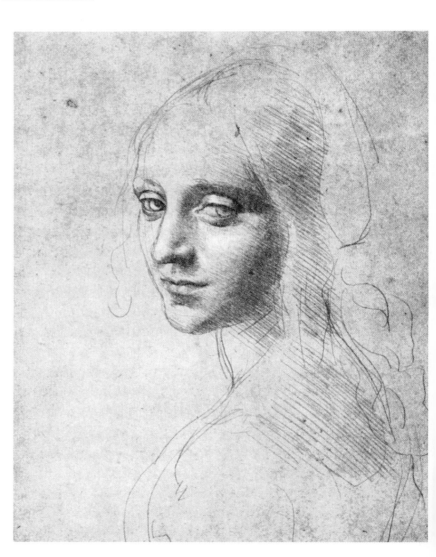

9–11 How has this student used line to create a contrast between the foreground and background?
Lauren DiColli (age 18). *Sneakers*, 1997. Pen and ink, 19" x 21" (48 x 53 cm). Haverford High School, Havertown, Pennsylvania.

9–12 The consistency of line quality throughout this work heightens the contrast between the blue and orange paint.
Sue Williams (b. 1954), *Mom's Foot Blue and Orange*, 1997. Oil and synthetic polymer paint on canvas, 8' 2" x 9' (248.9 x 274.3 cm). Carlos and Alison Spear Gómez Fund, Marcia Riklis Fund, and an anonymous fund. The Museum of Modern Art, New York. Digital Image ©The Museum of Modern Art/Licensed by SCALA/ Art Resource, New York.

Using Shape, Form, and Size

Shape and form offer artists many opportunities for contrast. For instance, they might contrast rounded shapes with angular ones, or complex organic forms with simple geometric ones.

9–13 What contrasts in shape can you find in this work?

Mbuti (Zaire), *Bark cloth,* early-mid 20th century. Ground gardenia seed on bark-cloth, 31" x 21" (78.7 x 53.3 cm). Courtesy of the Tambaran Gallery. Photo by Abby Remer, 1997.

9–14 The New York School refers to a group of New York artists who were important in directing the course of modern art from the 1940s to the 1960s. This image appeared on the catalog cover to an exhibition of some of their art. Can you describe the humor in the poster? How does the contrast of the rounded tube tops and the angular bodies of the buildings make the design more interesting? How would the design change if realistic building tops had been used?

Louis Danziger (b. 1923), *The First Generation, New York School,* 1965. As seen on the catalogue cover for the New York School exhibition at the Los Angeles County Museum of Art, June 16–August 1, 1965. Los Angeles County Museum of Art, Los Angeles. Digital Image ©2009 Museum Associates/LACMA/Art Resource, New York.

William Baziotes · Hans Hofmann · Richard Pousette-Dart
Willem De Kooning · Franz Kline · Ad Reinhardt
Arshile Gorky · Robert Motherwell · Mark Rothko
Adolph Gottlieb · Barnett Newman · Clyfford Still
Philip Guston · Jackson Pollock · Bradley Walker Tomlin

New York School

Artists might also combine shapes or forms of different sizes to create contrast within a design. Larger shapes generally seem to move forward (see Chapter 5) and may also appear heavier and more stationary. Smaller forms usually appear lighter and more free to move about. Look at the student painting (fig.9–15). There are several images of two girls that repeat in a variety of sizes. The largest forms appear solid and well anchored to their positions. The smallest figures seem to be caught in mid-motion.

9–15 This student artist actually gives the viewer a false sense of security in this strange space she has created. Notice how the larger, more securely placed figures are actually about to walk off the edge of the "stage."
Melissa A. Chung (age 16), *Untitled*, 1997. Mixed media collage of photographs, metal, and computer chips, 8 ¾" x 11 ¾" (22 x 30 cm). Montgomery High School, Skillman, New Jersey.

9–16 What contrasting forms did the designer use in this server?
Thomas P. Muir (b. 1956), *Espresso Server*, 1991. Sterling silver, nickel, and aluminum; formed, fabricated, cast, and oxidized, 10 ½" x 3 ¼" x 5 ¾" (26.7 x 8.3 x 14.6 cm). White House collection of American crafts, Washington, DC. Photo by John Bigelow Taylor.

Contrasting Dark and Light

You can find examples of dark and light contrasts all around you. Glance out a window to study the interaction of light and shade. On a sunny afternoon, look for interesting shadows created by bright light as it passes through a fence or under a pier or deck.

Whether working with natural or artificial light, artists over the centuries have been interested in the effects of dark and light. They have used the contrast to create dramatic designs, frightening moods, sharply modeled forms, or a sense of space and depth. To experiment with dark and light contrasts, artists can choose from many materials, from traditional ink or charcoal to neon or fluorescent light—even laser beams!

Special infrared negatives are what Minor White used to create the mysterious contrasts in his photograph (fig.9–18). Because infrared film records heat, the warmth absorbed by the sky makes it appear dark in the photograph. The warmth reflected by the tree leaves gives them a ghostly white glow in the image.

9–17 This silkscreen is meant to celebrate the lives of Asian-American women living in New York's Chinatown. How does the artist use contrast to help emphasize the purpose of this piece?

Tomie Arai (b. 1949), *Chinatown*, 1990. Silkscreen construction and mixed media, 22" x 40" (55.9 x 101.6 cm). Courtesy of the New Museum of Contemporary Art, New York, and the artist. Photo by Fred Scruton.

9–18 Here, the photographer captures a contrast that is not visible to the naked eye. Minor White used an infrared technique to show variations in heat and cold.

Minor White (1908–76), *Toolshed in Cemetery*, from Rural Cathedrals Sequence, 1955. Gelatin silver print (from an infrared negative). Reproduction courtesy of the Minor White Archive, Princeton University. ©1982 by the trustees of Princeton University. All rights reserved.

9–19 If you stood in this landscape, what might you experience? How did Rembrandt use contrast to communicate the physical sensations of this scene?

Rembrandt Harmensz van Rijn (1606–69), *Landscape with Three Trees*, 1643. Etching. Musée Condé, Chantilly, France. Photo: Bridgeman-Giraudon/Art Resource, New York.

Try it

From an old magazine, cut out a large black-and-white photograph of a face. Use a brush and india ink to go over the dark and medium-dark tones in the photo. Then use white poster paint to cover the light areas. This sharp reduction to extreme white and extreme black dramatizes the contrasts of lights with darks.

Rosa Bonheur

In a time when societal roles and expectations were much more rigid than today, Realist painter Rosa Bonheur challenged assumptions and won international admiration. She was born in Bordeaux, France, in 1822, and her parents, both artists, encouraged her to draw and paint.

Because of her father's artistic instruction, Rosa Bonheur became skilled at producing landscapes and historical and genre scenes. She then began an independent focus on her lifelong passion: serious, large-scale animal studies.

Bonheur's ideas about portraying animals were quite a departure from the typical domestic scenes of traditional women artists. To achieve a complete knowledge of animal forms, she spent time observing and sketching at stockyards, fields, and slaughterhouses, even dissecting carcasses to learn anatomy firsthand. She obtained legal permission to dress in men's clothing (in France, for a woman to wear men's clothing was illegal) so that she could move comfortably about the rough areas where she frequently worked.

Wearing her hair in an "unladylike" short style, Bonheur made a deliberate decision to avoid marriage, and, by so doing, she avoided losing her independence to take on domestic duties. This contributed to Bonheur's freedom to work, and she confidently followed her own clear path to success. She became financially self-sufficient through sales of her work, and was eventually able to purchase a large estate. On its grounds, she kept many animals that she studied and sketched.

Bonheur died in 1899, having established a body of artworks of animals, both wild and domesticated, and filled with the power and drama of outdoor settings. She had achieved a sense of energy and spirit through her masterful use of light and her attention to composition and detail.

The most well-known public acknowledgment of Bonheur's popularity came in 1864, when the Empress Eugénie presented Bonheur with the Cross of the Legion of Honor, proclaiming that females are as capable of genius as males. Bonheur was the first woman to be presented with the award, the highest honor of the French government.

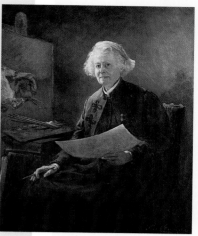

Elizabeth Anna Klumpke (1856–1942), *Rosa Bonheur*, 1898. Oil on canvas, 46 ⅛" x 38 ⅝" (117.2 x 98 cm). The Metropolitan Museum of Art. Gift of the artist in memory of Rosa Bonheur, 1922. (22.222) Image ©The Metropolitan Museum of Art/Art Resource, New York.

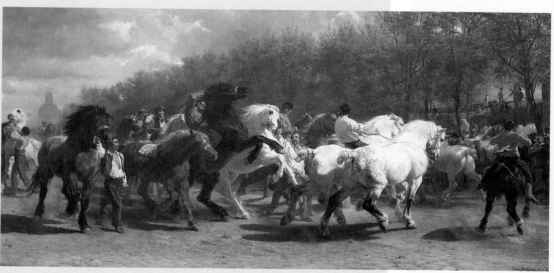

9–20 How did Bonheur use contrast to direct our attention?

Rosa Bonheur (1822–99), *The Horse Fair*, 1855. Metropolitan Museum of Art, New York. Gift of Cornelius Vanderbilt. 1887. (87.25). Image ©The Metropolitan Museum of Art/Art Resource, New York.

Color Contrasts

Color contrasts present many opportunities for artists. They might place warm colors next to cool colors, or bold, vibrant colors next to soft, muted ones. By placing complementary colors side by side, artists can create a powerful effect (see Chapter 4). In the student painting (fig.9–21), the red-violet road and blue of the city create a striking contrast with the yellow-orange of the sky and waterway.

9–21 Carefully analyze the use of complementary colors in the details of this painting.
Craig Marier (age 18), *Blue City*, 1996. Acrylic, 24" x 24" (61 x 61 cm). Bartlett High School, Webster, Massachusetts.

9–22 Why do you think the artist chose to use contrasting colors here?
George Segal (1924–2000), *Woman in Coffee Shop*, 1983. Plaster, metal, wood and glass, 96" x 67" x 48" (243.8 x 170.2 x 121.9 cm). Frederick R. Weisman Art Foundation, Los Angeles Art. ©The George and Helen Segal Foundation/Licensed by VAGA, New York.

Try it

Place a bright red circle on a green background, and gaze at it steadily for at least thirty seconds. Then look away at a white or gray wall (or ceiling). The colors should reverse so that a green circle appears to be on a red background. This visual phenonomenon is called *afterimage.*

Artists also can achieve contrast in a design by limiting their use of color or by choosing colors that are unexpected or unnatural. Look at George Segal's *Woman in Coffee Shop* (fig.9–22). Notice that the plaster figure of the woman is pure white. The background, table, and chair are solid black and red. This simple but strong color scheme creates an unusual contrast between the figure and her surroundings. Why do you think the artist decided not to paint the woman in realistic colors? How would a more naturalistic treatment alter the impact of the design?

9–23 Notice how the artist contrasts bright, simple areas of colors—green, blue, red, and pink—with the paler, more detailed flesh and hair.
Alice Neel (1900–84), *The Family*, 1980. Oil on canvas, 58" x 40" (147.3 x 101.6 cm). Robert Miller Gallery, New York.

Try it

Find a color reproduction of a painting you like. Focus on small sections of the work until you locate an area that by itself could be a well-designed nonobjective painting. What color contrasts exist in this small section? You may wish to use these contrasts in a painting of your own.

9–24 The obvious contrast here is purple with orange. What other color contrasts did the artist use?
Paul Klee (1879–1940), *Der Bote des Herbstes (grün/violette Stufung mit orange Akzent) [The Harbinger of Autumn (green/violet gradation with orange accent])*, 1922. Watercolor, 9 ⁹⁄₁₆" x 12 ⅜" (24.3 x 31.4 cm). Yale University Art Gallery. Gift of Collection Société Anonyme. ©2010 Artists Rights Society (ARS), New York/VG Bild-Kunst, Bonn.

Contrasting Textures

By using texture contrasts, an artist can often add interest to a design or strengthen a message. To show the horror of war, for example, a painter might contrast the rough, textured areas of a battlefield or barbed wire to the smoothness and vulnerability of the flesh of a soldier's face. In an abstract design, the painter might contrast thick strokes of paint with delicate washes.

Textural contrast is one of the most important elements in the unusual projects of the artists Christo and Jeanne-Claude. In *Surrounded Islands* (fig.9–27), Christo and Jeanne-Claude used millions of square feet of pink polypropylene fabric to surround a group of eleven islands in Biscayne Bay, Florida. The fabric floated between the islands and the sea and contrasted with the natural colors and textures of both. What similar project could your class plan for a site in or near your community?

Heavily textured surfaces must be balanced by areas of lesser texture to achieve balance within a design (see Chapter 6). Look at the photograph of the famed Alhambra, in Granada, Spain (fig.9–25). The architects combined intricately carved stucco and flowing water with smooth columns of stone and colorful glazed tiles. The contrasting textures combine to create a luxurious and peaceful palace that has stood for more than 600 years.

9–25 Built environments often display textural contrast to engage the interest of the visitor. Are there locations in your community where this is the case?
Court of the Lions, Alhambra, 1354–91. Granada, Spain.

9–26 What type of contrast besides texture is present in this photograph?
Allison Dinner (age 17), *Untitled*, 1997. Print, 5" x 7" (12.7 x 17.8 cm). Notre Dame Academy, Worcester, Massachusetts.

9–27 Christo and Jeanne-Claude's artwork temporarily changes the appearance of natural or human-built environments.
Christo (b. 1935) and Jeanne-Claude (1935–2009), *Surrounded Islands, Biscayne Bay, Greater Miami, Florida*, 1980–83. 6 ½ million sq. ft. of pink woven polypropylene fabric floating around eleven islands. Photo by Wolfgang Volz. ©Christo, 1983.

Benin plaque

Warrior and Attendants

African works of art usually have a specific purpose that goes far beyond decoration. Notice the nail holes along the top and bottom edges of the Benin plaque. Could the holes be a clue to its purpose? When looking at artworks from centuries past, we can sometimes piece together clues that suggest a way of life that included the use of the artworks. We have information about hundreds of similar plaques from the Benin culture of Nigeria. Their story is one of artisans, kings, and tragedy.

Portuguese explorers began documenting Benin culture as early as 1485. The city palaces, ruled by an *oba* (divine king), were decorated with fine works by highly skilled artisans. These craftworkers belonged to guilds that dated from the late thirteenth century. The artisans learned complex techniques of bronze casting from the neighboring Ife culture, but they also crafted other materials, including ivory, wood, and beads. Along with the famous plaques, there are animals, figures, altars, masks, jewelry and other accessories, fly whisks and fans, and furniture.

The Benin culture did not have a written language when this richly textured plaque was created. Only the *oba* could commission brass or bronze works, and plaques such as this one were created to record the life and ceremonies of the *oba*. These metal "documents" were nailed to walls and posts in the palace courtyards.

Benin artists used size to show importance. The central figure pictured is a warrior chief who carries a spear and waves a fanlike sword (called an *eben*). He is the largest—therefore, the most important—of the people portrayed. At the base of his necklace are leopard teeth, which suggest his strength and cunning. Beside the chief are two attendants (one playing a flutelike instrument) and two warriors. The warriors carry shields and wear cowries on their helmets. They also wear leopard-tooth necklaces and bells that function as communication devices. River leaves appear in the background and on the fabric of the warriors' clothing. Can you locate the animal faces in the sculpture? What might they symbolize?

The Benin kingdom lasted for more than five centuries, and was at its peak from the fifteenth to the nineteenth century. A British expedition in 1897 destroyed Benin's capital city, and looted the artworks from its palace.

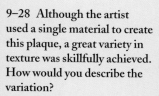

9–28 Although the artist used a single material to create this plaque, a great variety in texture was skillfully achieved. How would you describe the variation?

Africa (Benin Kingdom, Nigeria), *Palace Plaque of a War Chief, Warrior and Attendants,* 17th century. Brass, 14 ¾" x 15 ½" (37.5 x 39.4 cm). The Nelson-Atkins Museum of Art, Kansas City, Missouri. Purchase: William Rockhill Nelson Trust, 58-3. Photograph by Jamison Miller.

Contrasts of Time and Style

Artists and architects also achieve contrast by combining objects or images from different times within a design. Have you ever walked along a street and noticed a new building next to an old one? A sleek modern glass addition to the Louvre Museum in Paris (fig.9–30) contrasts sharply with the classical style of the main buildings. The combination forces the viewer's eye to make constant comparisons between the two dramatically different styles.

An artist may sometimes choose to use a style or technique that dislocates the viewer momentarily or transports the viewer to a different time or world. Look carefully at the watercolor by Masami Teraoka (fig.9–29). At first glance, this seems to be a Japanese painting from the past. But a closer look finds a man holding flippers and a video camera, and a woman struggling to hold on to a samurai sword. The traditional style of the work is in sharp contrast to the modern subject depicted. What do you think that the artist might be saying about how modern times affect past traditions?

9–29 Artists often employ contrast when depicting a humorous or ironic subject.

Masami Teraoka (b. 1936), *Hanauma Bay Series/Video Rental II*, 1982. Watercolor on paper, 28 ¾" x 40 ⅝" (73 x 103 cm). Courtesy of the artist.

9–30 The architect of this glass pyramid, which forms an addition to the world-famous Louvre, chose a minimal, modern style that contrasts sharply with the older, ornate sections of the building. Do you like this contrast? Why or why not?

I. M. Pei (b. 1917), *Louvre Pyramid*, 1988. Paris, France.

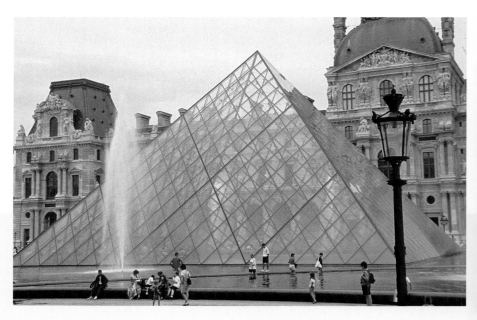

Contrasting Ideas

You have seen the variety of visual contrasts that can occur in art. There is another type of contrast that is less definite, but often stronger, than the contrasts in the work of art itself. It is contrast of ideas that your mind creates.

When you view a work of art, you often compare or contrast it to things you know or have experienced. For example, looking at a realistic painting of a landscape may remind you of a similar scene that you have actually observed. As a result, you can easily understand and accept the artist's interpretation.

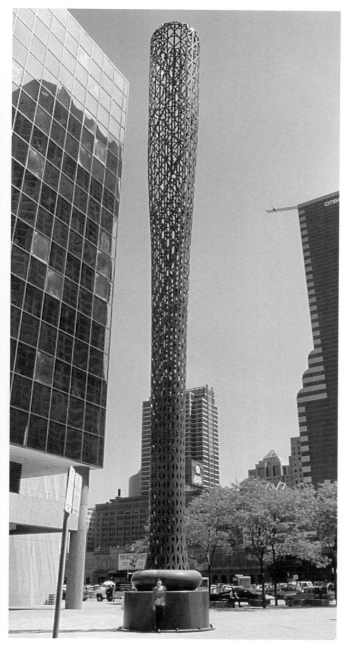

An abstract landscape consisting of simple vertical strokes for trees and splotches of green for leaves might cause you to contrast it to ordinary trees and leaves. This contrast in your mind encourages you to examine the artwork more closely to try to understand the artist's intent.

Artists might use styles, techniques, or concepts that dislocate the viewer for a moment. For example, the giant wire-frame baseball bat (fig. 9–31) forces you to compare it with a common baseball bat. Although you will notice an obvious contrast in size, you might also consider material, texture, and purpose. In the work, Oldenburg and van Bruggen prompt you to examine the familiar world, as well as the artwork itself.

9–31 Claes Oldenburg has created many giant sculptures, including a clothespin and a lipstick. For the city of Chicago—home of the Chicago Cubs and White Sox baseball teams—he and Coosje van Bruggen created a giant, open-form metal baseball bat.
Claes Oldenburg (b. 1929) and Coosje van Bruggen (1942–2009), *Batcolumn*, 1977. Steel and aluminum painted with polyurethane enamel, 96' 8" high (29.5 m). Harold Washington Social Security Center, Chicago. Courtesy of the artist.

Another Look at Contrast

9–32 Artist Ed Ruscha often uses words in his drawings and paintings. Here, he created a contrast in the viewer's mind between the image of a sunset and the word *end*. What other type of contrast can you find in his design?

Edward Ruscha (b. 1937), *End,* 1983. Oil on canvas, 36" x 40" (91.4 x 101.6 cm). San Diego Museum of Art. Gift of the Frederick R. Weisman Art Foundation, Los Angeles. Courtesy of the artist.

9–33 Notice that strong, vivid images often do not display much contrast in value. Can you find other examples of strong, vivid images in this book? What types of contrast did the artists of these works use?

Norval Morrisseau (1931–2007), *Shaman and Disciples*, 1979. Acrylic on canvas, 71" x 83 ¼" (180.5 x 211.5 cm). Purchase 1979. 1979.34.7. McMichael Canadian Art Collection, Kleinburg, Ontario, Canada.

9–34 This work presents formal contrast in terms of color, shape and size, and dark and light. It also presents a conceptual contrast: the idea of silent speech.

Rivane Neuenschwander (b. 1967), Zé *Carioca no. 4, A Volta de Zé (José) Carioca (1960)*. Synthetic polymer paint and ink on printed paper. Each: 6 ¼" x 4" (15.9 x 10.2 cm). Fund for the Twenty-First Century. (100.2005.a-m.vw1) The Museum of Modern Art, New York. Digital Image ©The Museum of Modern Art/Licensed by SCALA/Art Resource, New York.

9–35 What kinds of contrast did the student artist use in this image?

Gabriel Burian-Mohr (age 17), *Untitled*, 1995. Computer graphic, 8 ½" x 11" (21.6 x 27.9 cm). Los Angeles County High School for the Arts, Los Angeles, California.

Review Questions

1. What is contrast?
2. Why do artists create contrasts in their work?
3. List six broad categories of what visual artists often contrast in their art.
4. What are some ways to create color contrasts?
5. What special photographic process did Minor White use in *Toolshed in Cemetery* (fig.9–18) to create high contrasts?
6. What subjects was Rosa Bonheur passionate about painting?
7. Why were plaques such as the one in fig.9–28 created by the Benin artists? Describe three different textures on this plaque.

Career Portfolio

Interview with a Product Designer

Designer **Lyn Godley** has to balance the contrast between a product's function and its artistic element. Godley studied art before entering Product Design, drawn to the concept of merging creativity with people's everyday lives. She received a Master's degree from the University of Wisconsin-Madison and has had her own design firm since 1982. She also teaches Product Design at both Kutztown University and Parsons The New School for Design.

How would you describe your career?

Product Design, which used to be called Industrial Design, can encompass anything from a watch, to a new interface between technology gadgets, to biodegradable picnic ware. The goal is to design responsibly, in ways that address the needs of the user, the setting, and the environment. I now specialize primarily on lighting design.

What do you study to become a product designer?

In a typical Product Design program, you will learn drawing skills, both by hand and computer-aided, and 3-D modeling techniques, and take courses about materials and manufacturing processes. You must learn how to do research and have an interest in how people use objects. In addition to drawing, writing skills are important, as it is critical that you be able to communicate your ideas both visually and verbally.

How do you go about designing a product?

I have to really think about where and how it will be used. I draw up quick sketches, review them with the client, and conduct research to determine the appropriate materials and processes, technology, pricing, and installation resolutions.

Tell me about the lighting you design.

The choice for specific technology is dependent on each project. I designed a permanent lighting display at an art center that needed to reflect the creativity that goes on inside the building, be energy efficient, and not interfere with the building's historical landmark status. We used LEDs that could be programmed to change in color and sequence.

Does it bother you that people won't know your name when they see your products?

I have always enjoyed the ability to observe people viewing or using my work without them knowing I did it. Product Design is more about the relationship between the product and the user, not me and the user.

Lyn Godley, *Elizabeth's Chandelier*. This image was designed to play with the contrast of the traditional shape and iconography of a chandelier with contemporary technology. Digital photographic images of traditional crystal chandeliers were inserted into 55 acrylic tubes and lit with compact florescent bulbs. The chandelier images are also linked to actual crystals hung from each tube. The contrast between old and new, our desire for traditional and historical objects and our readiness to accept imitations of the real thing creates a provoking design.

Elizabeth's Chandelier

Studio Experience
Pop Art Sculpture

Task: To demonstrate a contrast in size by sketching a common object, enlarging the sketch, and making it into a sculpture using cardboard and acrylic paint.

Take a look. Review the following images:
- Fig. 9–22, George Segal, *Woman in Coffee Shop*
- Fig. 9–31, Claes Oldenburg and Coosje van Bruggen, *Batcolumn*

Think about it.
- What are the similarities and differences between the sculptures listed above? What makes an artwork Pop Art?
- How is the depiction of Segal's *Woman in Coffee Shop* different from its real-life equivalent?
- What materials were used in these sculptures? Does the type of material affect the shape or form of the subject? Does the material enhance or detract from the sculpture?

Do it.

1 Select a common, simple object, and draw several sketches of it, showing it from different angles. This will help you determine the shape and size of your sculpture.

2 Before starting your 3-D cardboard sculpture, practice by making a small mock-up with oak-tag board or other stiff paper. Visualize your finished object; then imagine it flattened out. How would you reassemble it as a 3-D object? Bend, fold, and score the paper to get the form you desire, lightly holding sections together with masking tape. When you're satisfied, you can take apart the mock-up and use the flattened paper as a guide for cutting out the final cardboard version.

3 Decide on the final, larger-than-actual size of your sculpture. Use a utility knife and metal ruler or straightedge to cut the cardboard sections. Be sure to use a cutting board.

4 Use masking tape, duct tape, or a hot-glue gun to join the cardboard sections into a form.

5 Hold the newspaper as though you were reading it, and tear strips 2" to 3" wide. Consider the size of your sculpture and estimate and tear enough strips to last for one class period. Once your hands are sticky with glue, it is difficult to stop and tear more strips.

6 Pour a mixture of glue and water into a plastic bowl, and, with one hand, dip a single strip of newspaper into the mixture. Pull the strip from the mixture and slide it between the first and second fingers of your other hand to wipe off the extra glue. Apply two to three layers of newspaper strips to your cardboard form, alternating the direction of the layers.

7 To dry the form and let air circulate around it, place it on an empty bowl or a block of wood.

8 For a stronger sculpture, repeat steps 6 and 7 as needed, alternating between newspaper and brown paper towels torn into patches.

9 Paint the form with one coat of white acrylic paint.

10 Either freehand or with the aid of an opaque projector, draw the details of your object onto the sculpture form. Paint your form. Depending on the object, add details and embellishments with materials such as yarn, felt, or cotton batting. Give your sculpture a final coat of acrylic medium.

Helpful Hints
- For round forms, cover an inflated balloon with the glue-and-paper mixture. Use rolled newspaper to make a cylindrical form.
- To change the surface and contour of your sculpture, tape wadded and folded newspaper to the cardboard.
- If mimicking a product—such as a box of cereal—that requires letters, you may use a lettering stencil.

Check it.
- What were your reasons for selecting the particular sketch that you used for the sculpture?
- What problems, if any, did you have constructing your sculpture?
- What elements make your sculpture Pop Art?
- How does your sculpture successfully represent Pop Art artists' ideas about media, advertising images, and our culture?

"Unlike painting, drawing, or sculpture alone, creating a gigantic piece of pie became a combination of each of these media forms. I also had an opportunity to understand the challenge faced by Pop artists: the creation of something so diverse from everyday life that its appearance would provoke the viewer to examine the world around them in a new way."
Jeffrey Michael Shanahan (age 18), *Pie,* 1997. Airbrush, papier-mâché, cloth, and cotton batting, 18 ½" x 26" x 17" (47 x 66 x 43.2 cm). Holy Name Central Catholic Junior Senior High School, Worcester, Massachusetts.

10 Emphasis

EMPHASIS IS THE SIGNIFICANCE, OR IMPORTANCE, that you give to something. In your life, you might feel that a certain friend, family member, or personal goal is very important. But did you feel the same way last year? Five years ago? Throughout your life, you're met with changing ideas and situations. You identify them, sort them out, and give them different levels of importance, or emphasis. The factors that are significant to you could be rather insignificant to others. And, as you grow and change, each factor might remain just as important, gain importance, or lose its emphasis in your life.

10–1 Many parts of plants are emphasized through color, shape, line, or other characteristics. This emphasis likely evolved to attract insects to help with pollination.
Orchid. Photo by J. A. Gatto.

10–2 Salcedo's work memorializes people who have died due to violence in her native Colombia. She uses furniture and other domestic objects, which she combines with concrete. How might Salcedo's use of emphasis relate to the concepts of loss and memory?
Doris Salcedo (b. 1958), *Untitled*, 1995. Wood, cement, steel, cloth, and leather, 7' 9" x 41" x 19" (236.2 x 104.1 x 48.3 cm). The Norman and Rosita Winston Foundation, Inc. Fund and purchase. (4.1996) The Museum of Modern Art, New York. Digital Image ©The Museum of Modern Art/Licensed by SCALA/Art Resource, New York.

Artists also sort out the various ideas and elements that make up the subject matter of their work. Composers, choreographers, and writers each have ways of developing a main idea, theme, or center of interest. They have to answer questions such as, "What is my work about?" or "What am I trying to say?" Visual artists may simply choose to emphasize a single aspect of a design, but they must also decide *how* to emphasize it. They usually choose from a variety of methods to achieve emphasis, which include relying on a single element of design, simplifying the overall composition, and using special placement.

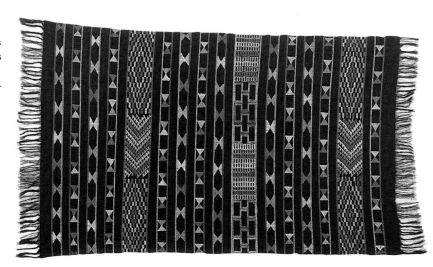

10–3 Artists often focus on specific design elements in their work. Igbo weavers are well-known for their emphasis on color and geometric shape.

Africa, Igbo culture, Nigeria, *Woman's Shawl.* Cotton 55" x 35" (139.7 x 88.9 cm). Virginia Museum of Fine Arts, Richmond. Gift of A. Thompson Ellwanger, in memory of Dr. and Mrs. George W. Sadler and Henrietta Sadler Kinman Photo: Katherine Wetzel ©Virginia Museum of Fine Arts.

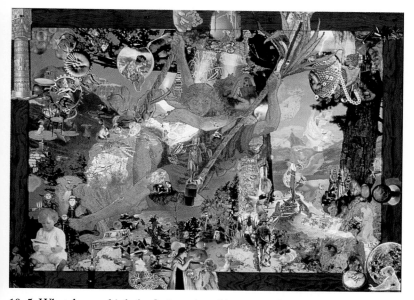

10–4 This feathered headdress was created to be part of a ceremony that involves dance and music. What aspects of the headdress might the maker have tried to emphasize when making the piece? Keep in mind that it is meant to work in unison with the dancing and music.

Native American Dancer. Photo by J. A. Gatto.

10–5 What do you think the designer is seeking to emphasize in this work?

Jess (Jess Collins) (1923–2004), *Midday Forfit: Fainting Spell II*, 1971. Magazine pages, jigsaw-puzzle pieces, tapestry, lithographic mural, wood, and straight pin, 50" x 70" x 1 ¾" (127 x 177.8 x 4.5 cm). Museum of Contemporary Art, Chicago, restricted gift of MCA Collectors Group, Men's Council and Woman's Board; Kundstadter Bequest Fund in honor of Sigmund Kunstader, and the National Endowment for the Arts Purchase Grant Photography. ©Museum of Contemporary Art, Chicago.

Emphasizing One Element of Design: Line, or Shape and Form

Part of your experience in art has been—and will continue to be—the exploration and manipulation of the elements of design: line, shape and form, value, color, space, and texture. Unlike many other areas of knowledge, art has no set rules or formulas for using these elements. Instead, visual artists must experiment with them to develop a clear importance within their designs. If they don't, their works will fail to communicate a main idea or theme.

Emphasis of one particular element can help an artist organize a design and establish a focal point for the viewer. Look at the photograph of the Vietnam Veterans Memorial Wall (fig.10–6), designed by Maya Ying Lin. Her simple but powerful design emphasizes the converging lines of the wall, as well as the engraved lines that record the names of those who died. Compare the memorial to the drawing by Ellsworth Kelly (fig.10–8). Here too, the artist used a simple design; each leaf repeats a similar shape. The overall effect is one of gracefulness and quiet.

10–6 This memorial emphasizes line in its design. The lines in the granite and the walk beside it keep our attention focused on the many rows of names that themselves form lines on the polished granite.
Maya Ying Lin (b. 1959), *Vietnam Veterans Memorial Wall*, 1982. Black polished granite 493' long (150 m). Washington, DC. Photo by Robert Hersh.

Try it

Select three natural forms, such as a shell, a leaf, and a rock, and observe the elements of design in each object. Although subtle variations of line, form, value, color, and texture are evident, one element will usually seem to dominate. Write notes of your observations, explaining what element is dominant and why you think so. Then make a sketch of each object.

Distorting or exaggerating shapes and forms is another way to achieve emphasis. For example, an artist might create a **caricature**, a depiction that emphasizes a distinguishing feature of a subject, such as a strong chin or large eyes. An artist might also create unusual or bizarre shapes or forms to achieve emphasis. The sculpture by Alberto Giacometti (fig.10–7) emphasizes fragile form. A simplified body with elongated arms and legs gives the piece an eerie, dreamlike quality. Giacometti began creating a series of sculptures, of which *Walking Male* is a part, in Europe about the time that World War II ended. Possibly, the figures reflect the fear and helplessness that many people felt during and after the war.

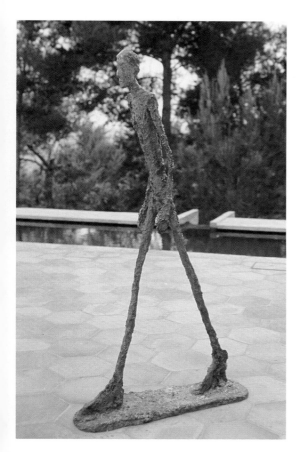

10–7 What other images in the chapter have an unusual or exaggerated form?
Alberto Giacometti (1901–66), *Walking Male*, 1960. Bronze, 37 ½" x 11 ¹⁄₁₆" x 9 ⅞" (95 x 28 x 25 cm). Fondation Maeght, Saint Paul-de-Vence, France. Erich Lessing/Art Resource, New York. ©2010 Artists Rights Society (ARS), New York/ ADAGP/FAAG, Paris.

10–8 What do you think the artist might have been trying to capture in this simple sketch from nature?
Ellsworth Kelly (b. 1923), *Briar*, 1963. Graphite pencil on paper, Sheet: 22 ⅜" x 28 ½" (56.8 x 72.4 cm). Whitney Museum of American Art, New York; 65.42 Purchase with funds from the Neysa McMein Purchase Award, 1965. EK P 23.63

Emphasizing One Element of Design: Value, Color, Space, or Texture

Placing light values next to dark values is a common way to create contrast within a composition (see Chapter 3), and artists often make the center of interest the area of greatest contrast. Look at *Portrait Study of a Man* (fig.10–9), in which Géricault, a famous early-nineteenth-century French painter, used dramatic lights and darks to emphasize the expression on his subject's face. This emphasis of dark values often conveys moods of gloom, mystery, drama, or threat, whereas a composition with predominantly light values tends to produce opposite effects. Today, the TV, film, and advertising industries still rely on the use of light and dark to create dramatic moods and eye-catching compositions.

10–9 How does the use of value in this portrait influence our impression of the sitter and his state of mind?
Théodore Géricault (1791–1824), *Portrait Study of a Man*, c. 1818–19. Oil on canvas, 18 ⅜" x 15 ⅛" (46.7 x 38.4 cm), J. Paul Getty Museum, Los Angeles, California. 85.PA.407.

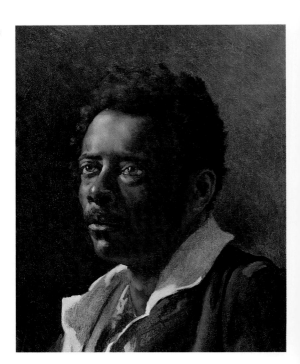

10–10 During the 900s, the Chinese invented the fine white ceramic known as *porcelain*. Today, these treasures are collected and preserved by museums worldwide.
China (Ming dynasty). *Bowl*, 1506–22. Porcelain, 6 ⅜" diameter (16.2 cm), San Antonio Museum of Art, San Antonio, Texas.

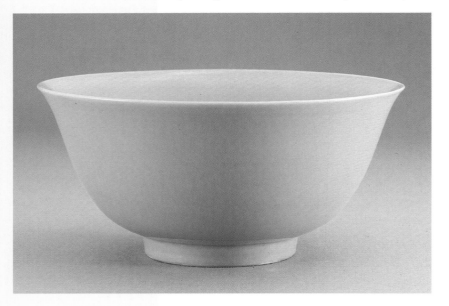

Try it

Explore the use of various traditional or experimental art media and materials by depicting one subject in three different media. Which elements of design do you find yourself emphasizing? Do you see a preference evolving for one element of design over another in your art? If so, describe how you use it within your designs.

The designer of the Chinese porcelain bowl (fig.10–10) emphasized its simple yet perfect form with a pure yellow glaze. Made in the 1500s during the Ming dynasty, the piece is a fine example of the elegance and perfection that are features of much Chinese and Japanese design. The color yellow symbolized the Chinese emperor, who was equated with the powerful and life-giving sun.

Compare the design of the yellow bowl to the images of the glass forms (fig.10–12) and the woven basket (fig.10–11). How does each work emphasize a different element of design? Notice that the chosen element in each design seems well matched to the form. How would the sculpture with glass objects be different if the artist had decided to emphasize multiple colors? Why might that have changed the sculpture's main point or center of interest?

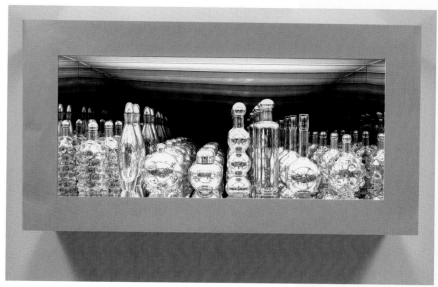

10–11 American artist Martin Puryear says that he is "a builder, not a maker." In the 1960s, he spent two years in Sierra Leone, West Africa. While there, he encountered designs that were quite different from those of a modern industrial society. Many of his sculptures are based on forms and materials that West Africans use in their traditional crafts and buildings.

Martin Puryear (b. 1941), *The Charm of Subsistence*, 1989. Rattan and gumwood, 84 ¼" x 66 ½" x 10 ½" (214.9 x 168.9 x 26.7 cm). Saint Louis Art Museum. Funds given by the Shoenburg Foundation, Inc. (105:1989). ©Martin Puryear.

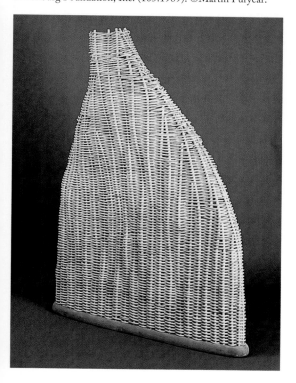

10–12 In this sculpture, the artist emphasizes space by manipulating it. He uses mirrors to create what appears to be infinite depth.

Josiah McElheny (b. 1966), *Modernity circa 1952, Mirrored and Reflected Infinitely*, 2004. Mirrored glass case with hand-blown mirrored glass objects. 18 ½" x 56 ½" x 30 ½" (47 x 143.5 x 77.5 cm). Milwaukee Art Museum, Milwaukee, WI. Gift of Contemporary Art Society M2004.359. Courtesy Donald Young Gallery, Chicago.

Note it

The next time you walk down a street, determine which building or structure dominates the skyline and what one element of design is emphasized. Make a list of visually dominant structures in your community and describe the design elements in each.

Using Simplicity

We are not comfortable with haphazard or disordered arrangements, so we generally appreciate visual order in a design. One way to achieve order and to clarify the center of interest is to keep a design simple. Because simplicity allows the viewer to quickly see the artist's main idea or point, it almost always contributes to emphasis.

In cartoons and comics, artists often simplify the bodies and faces of their characters. They may choose to place emphasis on only the eyes and mouth so that viewers can easily figure out a character's feelings or personality. Look at the expressions on the faces of Wallace and Gromit (fig.10–14). How can you tell what the characters are thinking in this scene?

You've probably noticed that shapes and forms also gain importance when they are set off against plain, uncluttered backgrounds. If a background is more dominant or detailed than the center of interest, the main subject may be difficult to find. Look at the watercolor painting by Wang Yani (fig.10–15), who included small, dark ovals to represent a pebbly surface. However, she left blank the area around the two birds. To frame the main subject, she painted the large rock and leaves without great detail.

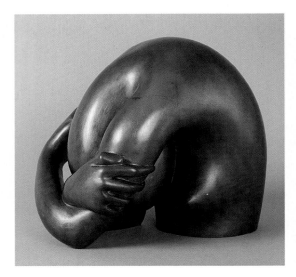

10–13 Conveying an idea with great simplicity is quite difficult. Why do you think this is so?
Hugo Robus (1885–1964), *Figure in Grief*, 1952. Bronze (from edition of 6), 12" high (30.5 cm). Columbus Museum of Art, Ohio. Gift of Hugo Robus Jr. in memory of his father. 1968.006

10–14 Would these characters be more or less effective if their creator had put a great deal of detail into their faces and bodies? Why?
Nick Park (b. 1958), *Wallace and Gromit* ™—*A Close Shave*, 1995. ©Wallace & Gromit Ltd/Aardman Animations Ltd 1995.

Wang Yani

At a very young age, Chinese artist Wang Yani became famous for her work. She was born in 1975, and lived in an environment that included the beauty of mist-shrouded mountains, green hills, ancient temples, and the clear Chiajiang River. Surrounded by nature, Yani was keenly observant, and she showed both a gifted memory and a lively imagination.

Yani watched her father, a painter, as he worked, and he provided her with art materials as soon as she could use a pencil and charcoal stick. At the age of two, she scribbled, as most children do, but then she became serious about her picture-making. Before the age of three, she surprised her father by asking if she might paint.

Her father decided not to influence her with formal art training, and instead he gave her the opportunity to paint as often as she liked. She painted birds, animals, houses, the sun, and children. Pictures flowed from her as a kind of language, and her father encouraged her strong, broad strokes.

Yani loved animals, and she became fascinated while watching the monkeys at the Nanning Zoo. The three-year-old artist

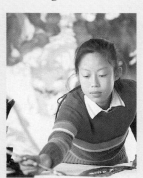

began to paint her impressions of the playful monkeys she had seen. Over the next few years, she painted hundreds of monkey scenes. News of Yani's talent began to spread.

10–15 Asian painters frequently leave areas of their work blank. They achieve a delicate balance between negative and positive space and make it clear where we should focus our attention.
Wang Yani (age 13), *A Happy Episode*, 1988. 19" x 26" (48.3 x 66 cm). Photo by Zheng Zhensun.

When she was four, exhibits of her work were held in Beijing, Shanghai, and Guangzhou. One of her monkey pictures was issued as a Chinese postage stamp.

To many of her paintings, Yani adds an inscription, words that make a statement, such as the one on her painting *Animals' Autumn*: "Autumn seems to be a withering season for trees, but the animals are happy." She also adds her red artist's seal, which varies in size and shape, to each completed work.

By the age of sixteen, Yani had painted more than ten thousand pictures. Solo exhibitions of her work have been held in Japan, Hong Kong, Germany, Great Britain, and the United States.

Style

Wang Yani works in the traditional method of Chinese painting: her finished works are similar to those that have been created by Chinese artists for hundreds of years. Although each painter who uses this method may have a distinctive aspect to his or her compositions, the group as a whole works in a similar *style*—the characteristics that distinguish the work of an individual or group of artists.

Style may be defined by the general subject matter, method of composition, choice of colors, or even types of materials. Compare the portrait by Géricault (fig.10–9) with the group portrait by Alice Neel (fig.9–23). Describe each style of painting. How would you compare the two styles of painting? How would you describe your own style?

Using Placement and Grouping

In Western culture, we read from left to right and top to bottom. The significance of this eye movement from upper left to lower right permits artists and designers to create emphasis through placement. For example, many Western visual artists place the center of interest on the right side of a composition. The viewer's eyes will start "reading" the composition at the left and be drawn across to the right. Also, magazine and newspaper layout artists generally place the more expensive and important ads on the right-hand pages.

This concept of ideal locations for placement of subject matter has been an important part of design since ancient Greece. Look at fig.10–16. Along with the importance of right-hand placement, three other areas are ideal for achieving emphasis. When you place the center of interest at or near one of these four locations, your subject matter will receive added emphasis. Your design also will have a strong asymmetrical composition.

Another way in which artists can achieve emphasis is by grouping many shapes or forms. The collected objects or figures visually attract one another and easily become the dominant point or center of interest. In such designs, the entire group is usually viewed as one entity. The closer the forms are to one another, the stronger their attraction and emphasis will be.

10–16 In this diagram illustrating the rule of thirds, ideal positions are shown for an artwork's center of interest. Notice that the four positions are slightly removed from the center of the picture plane. When an object or figure is placed in the exact center, what occurs is an undesired bull's-eye effect which causes the viewer to ignore all other parts of the design.

10–17 In this image, the rows of soil move the viewer's eye to the abandoned farmhouse. Notice that the photographer located the building in one of the ideal center-of-interest positions. Dorothea Lange (1895–1965), *Tractored Out*, c. 1938. Silver print. Library of Congress, Prints and Photographs Division. [LC USF34 18281 C].

Discuss it

At home, select five packages from commonly used products, or find ads that have images of packages. Bring your selections to class, and discuss the art elements emphasized in each package. Do you think the designs are effective in helping to sell each product? What suggestions for improvement might you make if you were the graphic designer in charge of designing these packages?

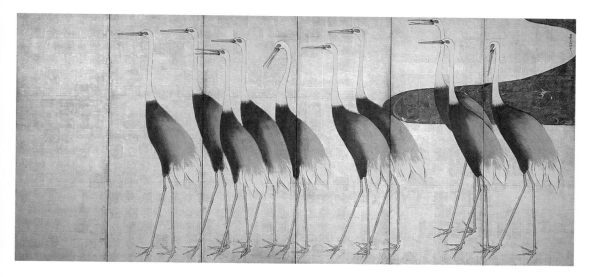

10–18 What traits in these birds did the artist choose to emphasize by grouping them in this way?
Ogata Korin (1658–1716), Cranes, 17th–18th century. Ink, color, and gold on paper, 65 ⅜" x 146" (166 x 371 cm). Freer Gallery of Art, Smithsonian Institution, Washington, DC. Purchase, F1956.20.

10–19 How has this student created a strong center of interest in his work?
Jeremy Emerson (age 18), Time, 1993. Pen and ink, 10" x 7 ½" (25.4 x 19 cm). Plano Senior High School, Plano, Texas.

10–20 The placement of the hand is crucial to this poster's success. The wiping action of the hand is meant to erase the words, yet the message must still be easy to read.
Milton Ackoff (b. 1915), Wipe Out Discrimination, 1949. Offset lithograph, printed in color, 43 ⅞" x 32 ¾" (116.8 x 83.8 cm). Gift of the Congress of Industrial Organizations. (103.1968) The Museum of Modern Art, New York. Digital Image ©The Museum of Modern Art/Licensed by SCALA/ Art Resource, New York.

Emphasis Through Isolation

When one object or figure is separated or removed from others, it becomes isolated. To achieve isolation in a design, an artist or designer might place the main subject against an absolutely plain background. This method of creating emphasis, which is closely related to the use of simplicity and placement, is commonly used in two-dimensional designs such as photographs, drawings, and advertisements. Look at the painting by John Chalapatas (fig.10–21), in which the artist used a red background to dramatically isolate the foreground subject (the skeleton). Some sculptors also use isolation. The casual quality of John Ahearn's two neighborhood girls (fig.10–23) recalls a snapshot taken against a wall or other plain background.

Sculptors and architects are also concerned with placement or location. Because some sculptors intend their works to be seen "in the round" (from many different viewpoints), emphasis by isolation is important. Have you ever noticed that sculptures in museums and galleries are frequently placed on a base or pedestal? This helps separate the piece from its surroundings and allows the viewer to move around it easily.

Architects must always consider the relationship between a planned structure and its surroundings. A building can sometimes be viewed from several sides—or perhaps just one side. Whenever possible, architects use available land around their buildings to help unify the feeling of the space and to emphasize their designs. Often, however, the future of a building and its environment is beyond the control of the architect. Over time, nearby buildings may be torn down, thereby exposing sides never meant to be seen; or new structures may become overpowering neighbors. Such changes can dramatically alter the original emphasis of the structure.

10–21 This student has used emphasis through isolation in his painting. Are there other ways he has used emphasis?

John Chalapatas (age 18), *Untitled*, 1997. Oil pastels, 18" x 24" (45.7 x 61 cm). Oakmont Regional High School, Ashburnham, Massachusetts.

10–22 Many of the Classical structures that once crowded this hilltop in Athens, Greece are no longer standing. Although pollution and tourists threaten the fragile building's well-being, the Parthenon continues to display emphasis through its isolation high atop the Acropolis.

View from the Mouseion. Acropolis, Athens, Greece. SEF/ Art Resource, New York.

Discuss it

Look through the images in this and other art books. How do the works of certain artists or designers consistently emphasize the same elements of design? Who are some of your favorite artists? What aspect of their style helps you identify their work?

John Ahearn

Janelle and Audrey

10–23 How does isolation help us better focus on the girls? What would happen if there were a background?

John Ahearn (b. 1951), *Janelle and Audrey*, 1983. Acrylic on plaster, 32" x 32" x 9" (81.3 x 81.3 x 22.9 cm). Courtesy of Alexander and Bonin, New York. © D. James Dee, 1991.

Artist John Ahearn believes in connecting artworks to real life. Can you think of a better way to create a powerful connection than by using plaster casts made from real, live people? When the artist paints his cast sculptures, he takes great care to achieve a likeness of each person.

Throughout the 1980s, Ahearn often worked with a partner, artist Rigoberto Torres. Together they created many such sculptures, portraying their neighbors in the South Bronx of New York. They sometimes set up their artmaking on the sidewalk, where people would wait for their turn to "become" a sculpture. Ahearn and Torres would pass art materials through the windows of Ahearn's rented ground-floor rooms.

When he learned of plaster casting in 1979, Ahearn was an alternative-arts journalist for a Manhattan artists' collaborative. A friend was repairing some plaster life casts for the American Museum of Natural History, and Ahearn became fascinated with the process and began experimenting. He developed his own working style, creating sculptures from plaster casts of people he knew. After his twin brother commented that Ahearn's artwork was "too safe," the artist moved to the Bronx, where he met high-school student Rigoberto Torres. Torres was enthusiastic about learning the casting process and offered to help Ahearn.

The artists found people in the inner city who were willing to be models. First, they coated their models with a gel so that the plaster could be removed after it hardened.

The models put straws into their nostrils so that they could breathe throughout the procedure. Ahearn and Torres then wrapped the parts of the bodies to be cast, completely encasing them in wet plaster bandages. Later, they carefully removed the hard plaster, which they would use as a mold. After pouring plaster into this mold, the artists had a sculptural form that they then painted. For any models who wished, Ahearn made a cast of their face for them to keep.

Ahearn has described himself as "an itinerant portrait painter." By representing everyday "slices of life," Ahearn and Torres have brought art to the community in a new way. They have immortalized common people in artworks, thereby enabling people to see themselves and art in a positive and meaningful way.

Ahearn reconstructs some of his sculptures in fiberglass in order to make them freestanding. He has cast some of his works in bronze, for outdoor display. His sculptures appear throughout the South Bronx—in people's homes, in public spaces, and in galleries.

Using Size and Repetition

One way to achieve contrast is to combine shapes or forms of different sizes (see Chapter 9). Size can also create emphasis within a design. You're probably familiar with ads in which products are emphasized by being bigger—and therefore more important—than other, similar products around them. Contemporary architects design increasingly taller skyscrapers to tower above city skylines; and certain visual artists, including Christo and Jeanne-Claude (fig.9–27) and James Turrell (fig.10-24), enjoy working on projects of gargantuan size.

What these artists and designers are doing is emphasizing scale in their designs. *Scale* is the relative size of a figure or object. For example, a house is larger in scale than a desk. Scale also describes objects and figures that are depicted much larger or smaller than life-size. For instance, the sculptor of the Statue of Liberty greatly increased the scale of the human figure. Sculptors Doris Salcedo (fig.10–2), Giacometti (fig.10–7) and Claes Oldenburg (fig.9–31) have also exaggerated scale in their works in order to create attention-getting designs.

An artwork also displays emphasis if it includes repetition of objects or figures—regardless of their size or scale. When many forms appear on a picture plane or in a three-dimensional sculpture, the emphasis of the forms is reinforced. An image of a crowded beach, for example, offers greater emphasis when dozens of people are bunched together than when only five or six are shown. The concept of a jungle or dense forest is more impressive when many trees, rather than just a few, are depicted. In general, more repetition of a shape, form, or color creates more emphasis in a design.

10–24 In this work in progress, Turrell has emphasized space and light, as well as size, by coordinating its open areas with the passing effects of the sun, moon, and stars.

James Turrell (b. 1943), *Aerial Photograph of Roden Crater*, 1983. ©James Turrell, courtesy PaceWildenstein, New York.

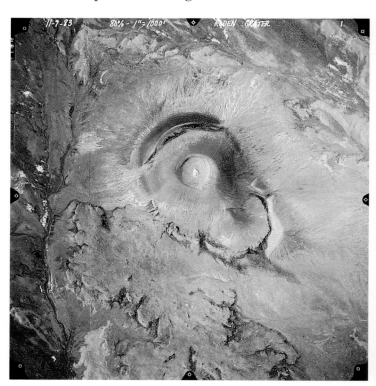

10–25 Many layers of symbolism can be found in this work. In one layer, Cole represents black or African laborers in domestic situations. A second layer is the portrayal of African tribes, shown by mask-like stamped "faces" of the irons. A third level of meaning is signified by the similarity of the iron shapes to a slave ship's layout. Would you say that the principle of emphasis through repetition has been successfully used by Cole?

Willie Cole (b. 1959), *Domestic ID IV*, 1992. Iron scorches and pencil on paper in window frame, 34" x 32" x 2" (86.4 x 81.3 x 5.1 cm). Courtesy Alexander and Bonin, New York.

10–26 Repetition often provides the viewer with clues about what is important in a work. In this quilt, what imagery is emphasized?

Maria Teokotai and others, *Ina and the Shark,* c. 1990. Tivaevae (ceremonial quilt, Cook Islands), 101" x 97 ⅛" (257 x 247 cm). Museum of New Zealand (Te Papa Tongarewa), Wellington.

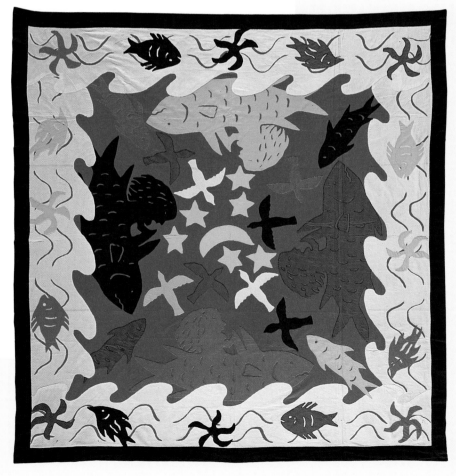

Another Look at Emphasis

10–27 The artist has clearly chosen the hand in the center of the composition as her focal point. She has used more than one element of design to create emphasis. Which one is most significant?

Joy Feasley (b. 1966), *Wooley Bear Says "Ouch"*, 2004. Silkscreen on arches 88 paper, 1/20, 15" x 18" (38.1 x 45.7 cm). 2004-182-1(3) Philadelphia Museum of Art, Philadelphia. Photo: The Philadelphia Museum of Art/Art Resource, New York.

10–28 This is a portrait of a very powerful fifteenth-century Italian nobleman. How did the artist emphasize the nobleman's importance?

Piero della Francesca (1410/20–92), *Portrait of Federico da Montefeltro, Duke of Urbino*, 1465–70. Tempera on wood, 18" x 13" (47 x 33 cm). Uffizi, Florence, Italy. Scala/Art Resource, New York.

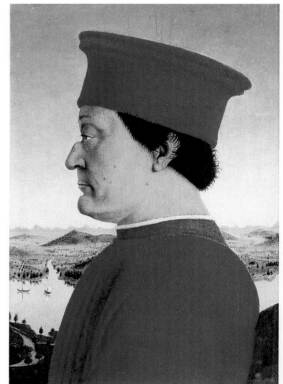

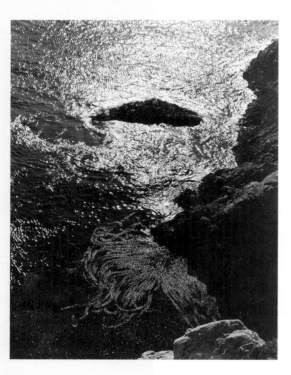

10–29 What elements of design has the photographer emphasized in this work?

Edward Weston (1886–1958), *Kelp, China Cove, Point Lobos*, 1940. Gelatin silver print, 9 ½" x 7 ½" (24.3 x 19.3 cm). Edward Weston Archive. 81.270.109 ©1981 Center for Creative Photography, Arizona Board of Regents.

10–30 Converging lines can emphasize the center of interest in a design. In this work, the wall on the right and the review stand at left lead our eyes to the focal point of the work, the speeding bicycles.

Antonio Ruíz (1897–1964), *Bicycle Race,* 1938. Oil on canvas, 13 ⅛" x 17" (33.3 x 43.2 cm). Purchased with the Nebinger Fund, 1949 (1949-24-1). Philadelphia Museum of Art, Philadelphia. Photo: Philadelphia Museum of Art/ Art Resource, New York.

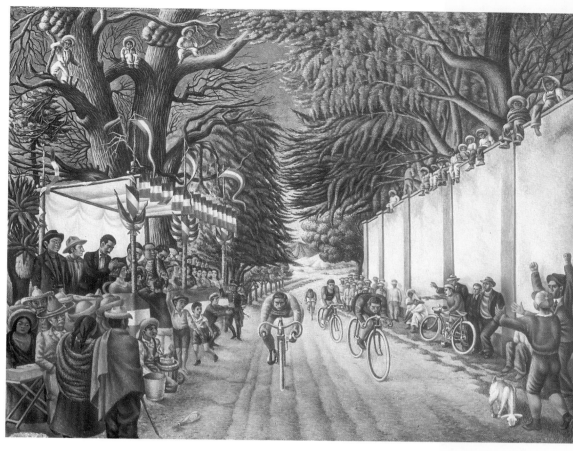

10–31 How has this student used repetition of form to create emphasis in this work?

Jorge Medrano (age 18), *Repetitive,* 1998. Styrofoam, 30" x 20" x 15" (76 x 50.8 x 38 cm). James W. Robinson, Jr. Secondary School, Fairfax, Virginia.

Review Questions

1. What does scale refer to in art?
2. What is a caricature?
3. List at least five ways to create emphasis in a design.
4. Why do architects often leave open areas of land around their structures?
5. Select one image from this chapter and explain what the artist emphasized and how he or she created this emphasis.
6. Name a Chinese art prodigy known for her paintings of animals, especially monkeys. How did she emphasize her main subject in the illustration in this book?
7. Describe the process that John Ahearn uses to create his realistic three-dimensional portraits.

Career Portfolio
Interview with a Photojournalist

Photo ©Barbara Hakim.

Capturing images from the world of possibilities around her, **Dorothy Littell Greco** works with emphasis every time she frames and shoots a photograph. Whether on assignment or pursuing her own ideas, her aim is to compose a shot that makes a statement, tells a story, or records an event. Born in 1960 in Franklin, New Jersey, Dorothy lives in Boston, Massachusetts.

How do you describe your career or your type of art?

Dorothy I make still photographs which appear in newspapers, magazines, books, and corporate publications. I work in an editorial/reportage style, which means my images are naturalistic, rather than ones that are conceived and executed in a studio.

How did you enter into this type of work?

Dorothy As a child as young as five or six, I can remember taking my Kodak camera with me on vacations. As a teenager, I began to get more serious about photography. I taught myself using my dad's old camera and took a course at night school my senior year. For two years, I worked as the high-school yearbook photographer, which influenced my decision to study photography in college. I have a B.S. degree in journalism, with my concentration in photography.

Describe what your working day is like.

Dorothy Since I am self-employed, no two days are the same. Some days, I get a phone call at noon from a newspaper asking me to do an assignment at two. I spend some days in the darkroom printing, or at my light table, editing slides. I rarely have more than one assignment per day, and generally each shoot takes me three to four hours.

If I have to make the photograph inside, I may have to take several cases of lighting equipment with me. Occasionally, I hire an assistant to help me carry my gear and set up lights. I may also be asked to fly to a location and spend several days or weeks making photographs for a client. Since the sun is so important to my work, I often get started about an hour before sunrise and continue shooting until just after dark. At midday, when the sun is at its peak, I caption my film, eat, and rest.

I have photographed presidents, princes, and refugees. I've sat courtside during the NBA Championship and shot the World Series. I've also waited for hours, sometimes even days, in a fire station, a hospital, and a courtroom for something

anything—to happen so that I could make a photo. Every day brings new challenges, and I can no longer imagine having a "normal" job.

How would you describe your creative process?

Dorothy Normally I go into a shoot with some ideas about how I want to make an image. Sometimes it is very specific, and sometimes very general. When I actually arrive, the light may be poor, or my subject might inform me that I have only ten minutes to get the photo. My equipment has to be an extension of my body so I don't have to think about the mechanics. Then I just try and let the situation unfold, responding as best I can, working as quickly as possible.

Each time I have an assignment, I make an attempt to gain my subject's trust and to give something back to them. When this happens, both of us know it, and it's tremendously rewarding. It's also very satisfying artistically to enter a situation with a few vague ideas, to emerge an hour later with exposed film, and then to see the image in the paper or magazine a short time later.

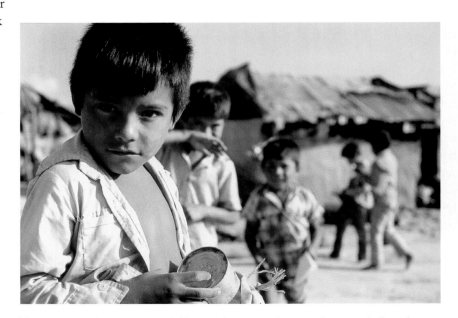

These resourceful Salvadoran children tied rags together to make soccer balls and used cans as makeshift toys. This photograph was taken with a 35mm SLR camera and a wide-angle lens. It was shot late in the afternoon as the sun began to set.

Dorothy Greco, *Mesa Grande Refugee Camp.* Photo courtesy of the artist.

204

Studio Experience
Emphasis in a Photomontage

Task: To create a photomontage that emphasizes one center of interest.

Take a look. Review the following images:
- Fig.10–5, Jess, *Midday Forfit: Feignting Spell II*
- Fig.10–27, Joy Feasley, *wooley bear says "ouch"* from the Philadelphia Invitational Portfolio 2004
- Fig.5–4, Yvonne Jacquette, *Dark Basilica by Logan Circle, Philadelphia*

Think about it.
- What is the main focal point of each image listed in **Take a look**? How has each artist emphasized the center of interest? In each image, what object is near the center of the layout? Were contrast of color or value used to emphasize the focal point? Which lines lead to the center of interest? What other means of creating emphasis were used?
- Compare the location of the center of interest in each image to fig.10–16. Which image has a center-of-interest position that is shown in the diagram?
- Look through magazines for an advertisement that combines several photographs. How did the advertising artist group or join photographs to emphasize a section of the layout? Locate the focal point. Is it close to the center of the ad? How did the artist use contrasts of value, color, texture, and shape to emphasize the center of interest? Did the artist use line to emphasize the focal point? Discuss any other means used to create emphasis in the ad.

Do it.
1 To create a photomontage in which you emphasize one center of interest, first look through old picture magazines and cut out five to ten photographs of objects, people, and interesting textures and colors. As you

"The importance of the balance of darks and lights is apparent in this piece, and was easily created by picking up the dark and light shapes and placing them where they were appropriate."

Leah Ruth Penniman (age 17), *Eclectic*, 1997. Magazine collage and mixed media, 12" x 18" (30.5 x 45.7 cm). Oakmont Regional High School, Ashburnham, Massachusetts.

search for photographs, start to develop a theme or subject for your montage. Store the cutouts in an envelope.

2 Try arranging the cutouts in various ways. Experiment by joining subjects that you normally would not find together.

3 Think about how you can emphasize your subject and meaning. Try grouping or overlapping your cutouts to create one center of interest. You can arrange them on different background colors, values, and textures to create contrasts so that they will stand out. Consider moving the center of interest to one of the four points shown in the diagram on page 196. You might add lines cut from strips of magazine photographs to lead to your center of interest and make it more noticeable.

4 Check your arrangement of cutouts for just one important center of interest. If it has more than one, rearrange the cutouts, perhaps by removing some or by grouping them closer together to form a focal point.

5 When you are satisfied with the emphasis in your montage, glue your cutouts to the posterboard.

6 Prop up your artwork on an easel or wall, step back, and check it with another student or your teacher. Answer the questions in **Check it**.

Helpful Hint
Carefully trim the magazine photographs to the edge of the image without leaving an outline or bits of background around the contours. Then the cutout photographs will seem less like pieces of cut paper.

Check it.
- Describe your photomontage. What did you emphasize? What is your focal point or center of interest? Does your montage have just one focal point?
- Which of the following did you use to emphasize the center of interest?
 — Contrast of values, colors, or textures?
 — Line?
 — An off-center or on-center location?
 — A larger scale or size of the focal point, in relation to the other parts of the design?
 Did you use any other means to create emphasis?
- Consider the craftsmanship of your artwork. Did you trim the cutouts close to the edge of the images? Are your photographs glued neatly? Are these points important for the effectiveness of your work?

11 Pattern

Key Vocabulary

pattern

motif

planned pattern

half-drop design

random pattern

PATTERN APPLIES TO A VARIETY OF HUMAN ACTIVITIES. Patterns are used for cutting out and assembling clothing. Flight patterns direct the movements of airplanes. Behavior patterns indicate how people act in certain situations. A visual *pattern* is the repetition of one or more elements, such as the stripes on a raccoon's tail, the repeated shapes of the waves in an ocean, and the alternating colors in a field of flowers.

11–1 Views from an escalator can bring architectural designs in focus as in this linear overhead structure. *Shopping Center Overhead Design.* Photo by J. Selleck.

11–2 Seen from above, landscape patterns produce unique effects. Occupants of this biplane view the colorful area patterns of flower fields at Carlsbad Ranch, north of San Diego, California. *Biplane over flower fields. Los Angeles Times.* Photo by Con Keyes.

Pattern can add variety to sculpted surfaces or help create contrast in a photograph or painting. Like texture, pattern can also reinforce or highlight shapes and forms. To capture the viewer's attention, an artist might create a strong and colorful pattern of large shapes. To produce a more reserved or refined effect, the artist might choose a subtle, muted pattern of small or close-knit elements. In general, pattern has two main functions in art and design: it helps organize or unify an area or object, and it provides visual enrichment and interest. Look at the quilt (fig.11–3) and the pot (fig.11–4). How would their impact be altered if these works did not have patterns?

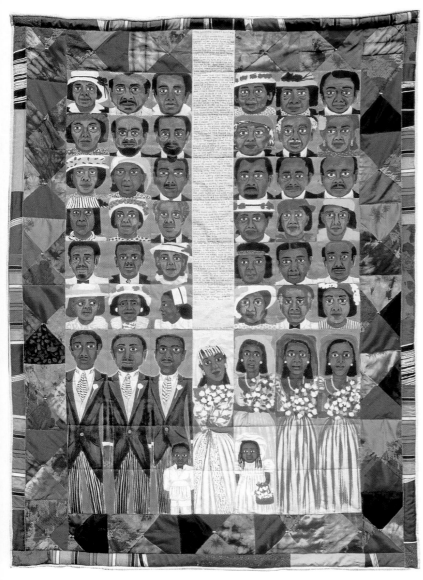

11–3 What different patterns can you see in this quilt? Notice that there are small sections of pattern within the large, overall patterns in the design.

Faith Ringgold (b. 1930), *The Wedding*, 1986. Series: *Lover's Trilogy #1*. Acrylic on canvas, 77 ½" x 58" (196.9 x 147.3 cm). Phillip Morris Co. collection. ©Faith Ringgold, 1986.

11–4 All cultures use pattern for decoration. There seems to be a natural human delight in surface pattern.
Native American pot. Photo by A. W. Porter.

Patterns in Nature

Many patterns are commonly found in nature. You probably can identify quite a few animals by their patterns alone: a leopard by its spots, a tiger by its stripes, or a peacock by its plumage. These natural patterns may camouflage an animal or help it to attract a mate. Other patterns in nature are broader, such as a cloud-filled sky or the ripples of a wheat field. Still other patterns—such as those in pine cones, wood grain, and hundreds of flower species—are more intricate, and intriguing patterns are evident in cross-sections of trees, fruits, and vegetables.

11–5 Some patterns in nature are temporary because they are created by momentary weather conditions. What are some other such patterns?

Wheat field scene. Photo by J. Scott.

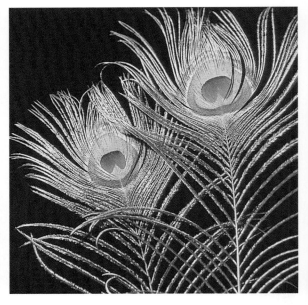

11–6 Peacocks, with their characteristic iridescent green and blue feathers, originated in Asia. The brilliant feathers are found on male birds and are used to attract females during courtship.

Two peacock feathers, terminal "eye" portion. Photo by J. Scott.

Note it

Search for patterns in one small section of a park or other landscape near your home or school. You will find that even rocks, grassy areas, exposed earth, and tree bark have patterned qualities. Sketch the patterns that you discover, or photograph some of the natural patterns that you find most appealing.

Every pattern—whether natural or manufactured—involves the repeated placement of a basic unit, called a ***motif***. In one pattern, a motif may be a simple dot, a line, a square, or a squiggle. In another pattern, it may be a complex shape or form with an intricate texture or bold color.

The motifs in nature's patterns are a rich resource and great inspiration for designers and artists. Many of the motifs in fabric, weavings, and everyday objects have been borrowed or adapted from the patterns in plants and animals. Artists sometimes even use actual plant materials to press into clay or to print designs on paper. Careful observation of patterns in nature will help you transfer those impressions to your own creative work.

11–8 Compare the pattern on this vase to the real peacock feathers in fig.11–6.
Louis Comfort Tiffany (1848–1933), Peacock Vase, 1892–96. Favrile glass, 14 ⅛" x 11 ½" (35.9 x 29.5 cm). Gift of H. O. Havemeyer, 1896 (96.17.10). The Metropolitan Museum of Art, New York. Image ©The Metropolitan Museum of Art/ Art Resource, New York.

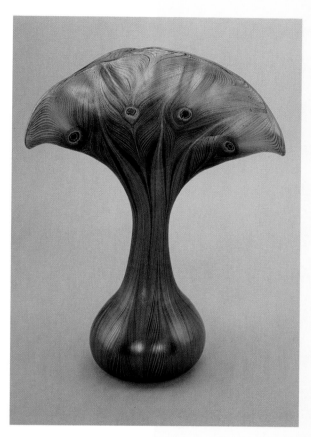

11–7 The patterning that occurs in wood is a constant presence not only in nature, but also in our built environment. Consider how patterning in wood paneling, tables, and bowls makes these objects appealing to the eye.
Wood pattern, Monster face, from the *Driftwood* series. Photo by J. Scott.

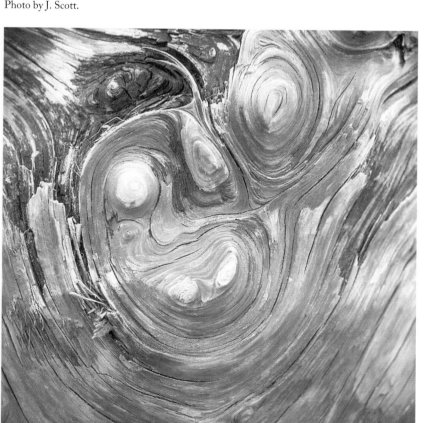

Discuss it

Discuss with classmates the patterns in the local landscape and the sensations you get from them. Do certain patterns reflect the growth of a form? Do some patterns serve as protection? How do the patterns enhance the forms? What patterns in other areas of nature are similar to the ones that you have found?

Patterns in Manufactured Designs

Most people like to bring variety and interest to their surroundings by adding decoration. Pattern, an important aspect of the decorative things that we buy and make, is in the fabric of a pillow, the design of a rug or blanket, or the way that objects are displayed on a shelf. Consumers often plan their purchases so that patterns will work well together.

Graphic artists, landscape architects, filmmakers, and fashion designers all use pattern. In fact, this list could include the manufacturers and designers of almost any product. To create effective patterns in their work, these visual artists must juggle the elements of design. The patterns that they create may be subdued and subtly integrated with the object. Or they may be bold and invigorating, like the pattern in the Navajo blanket (fig.11–11).

Sometimes the material determines the pattern. Have you ever watched a mason fit bricks together to build a wall? Or a craftsperson bend reeds to form a basket? If so, you've witnessed the growth of pattern from material. Different materials lend themselves to specific patterns, whether they are stacked, folded, tied, or even combined with other materials. The materials available to today's artists are highly diverse, ranging from palm fronds to plywood, and paper to plastic.

11–9 Look carefully at your school or home surroundings. What manufactured pattern can you find that you hadn't noticed in the past?

Stone wall. Photo by A. W. Porter.

11–10 The artist of this vase combined pattern and texture to create an unusual surface.

Doyle Lane (20th century), *Ceramic pot.* 8 ½" tall (21.6 cm), 6" diameter (15.2 cm). Collection of Shirl and Albert W. Porter. Photo by A. W. Porter.

Try it

Experiment with various materials to discover possibilities for attractive patterns. How can you modify certain materials to produce additional or unusual patterns? Which materials can you combine to create a pattern? Design a small object—such as a bowl, vase, or basket—whose pattern is determined by its materials.

Navajo Beeldleí

This chief's blanket was made for wearing, and would drape to move with the body. Its simple beauty comes from a balanced arrangement of design elements. The striped pattern with diamond shapes is typical of blankets created by Navajo women in the mid-nineteenth century.

Weaving is affected by the availability of fibers and dyes to the artisan. In the case of the Navajo—who were originally nomadic—a combination of factors led to favorable conditions for weavers, who became renowned for their brightly woven fabrics with strong patterns.

The Navajo who came to the southwestern United States by 1500 were skilled basket weavers. The neighboring Pueblo were textile weavers who grew cotton for fiber as early as 700 CE. In 1540, the Spanish began to colonize the area, bringing sheep and European-style treadle looms.

The Pueblo likely taught the Navajo to weave cloth on upright looms. The Pueblo, Navajo, and Spanish exchanged certain techniques, designs, and materials. For example, when the Spanish brought sheep to the region, the Navajo began shepherding. They wove fine-wool blankets that were worn as clothing, as well as used for sleeping or for covering walls or floors. Leaders wore striped blankets as an indication of their status.

The Navajo originally adopted both dyes and decorative patterns from the Pueblo. Later, at trading posts, they obtained European pigments to add to their natural

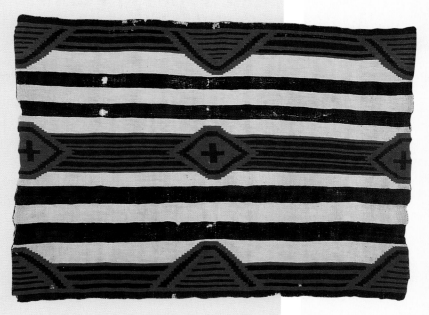

11–11 Notice how this design makes use of diagonals to break the horizontal repetition. What other devices were used to avoid monotony?

Navajo Beeldleí (Chief's blanket), 1870–75. Handspun wool and raveled yarn, 49 ¼" x 71 ⅝" (125 x 181.9 cm). Collected by Douglas D. Graham at Zuni during his term as first U.S. Indian Agent (1880–85). Presented by his nieces. National Museum of the American Indian, Smithsonian Institution, Washington, DC.

plant dyes from sage, indigo, and walnut. Until Spanish settlers came to the area, the Navajo had no good source for the color red. At first, the Navajo unraveled Spanish bayeta cloth to acquire red fibers. Later, they used commercially available aniline dyes.

Through the early twentieth century, the colors and patterns used by Navajo weavers became increasingly complex. Today, many Navajo women produce handwoven textiles specifically as art objects. Frank Stella and Jasper Johns, contemporary male artists, have been powerfully influenced by the work of these women.

Note it

Explore indoor and outdoor environments to find patterns. Look for obvious, broad, large patterns, such as those on the sides of buildings. Then look more closely for smaller patterns, such as those in pavement, bicycle stands, and landscaping. Note how patterns create rich surface appearances and help us identify forms.

Basic Types of Planned Patterns

Whether produced by nature or manufactured by people, most visual patterns fall into a category called *planned pattern*. A planned pattern is a precise, regular repetition of motifs. Its overall design is consistent and cohesive, and examples may be seen in clothing, wrapping paper, jewelry, architectural surfaces, *and* in nature. To achieve contrast and balance within a design, artists might pair a small planned pattern with a large, plain area. Some designers also might combine two patterns. However, not all patterns work well together. For instance, bold patterns or patterns whose motifs are of similar size and dominance will often clash.

When you create planned patterns, give careful consideration to materials, the motifs, and the way you repeat the motifs. Will you place the motifs in a row or in a grid pattern? Will you stagger them or alternate them with other motifs? Will the patterns radiate from a central point, or will they occur in bands and borders?

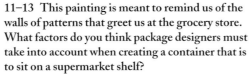

11–12 What words would you use to describe the patterns in this fabric?
Indonesian Batik, 1995. Photo by T. Fiorelli.

11–13 This painting is meant to remind us of the walls of patterns that greet us at the grocery store. What factors do you think package designers must take into account when creating a container that is to sit on a supermarket shelf?

Andy Warhol (1928–1987), *Green Coca-Cola Bottles*, 1962. Synthetic polymer, silkscreen ink and graphite on canvas. Overall (Canvas): 82 ⅜" x 57" (209.2 x 144.8 cm); framed: 83 ¾" x 58 ⅝" x 2" (212.7 x 148.9 x 5.1 cm). Whitney Museum of American Art, New York. Purchased with funds from the Friends of the Whitney Museum of American Art. 68.25 ©2010 The Andy Warhol Foundation for the Visual Arts, Inc./Artists Rights Society (ARS), New York; The Coca-Cola Company™. All rights reserved.

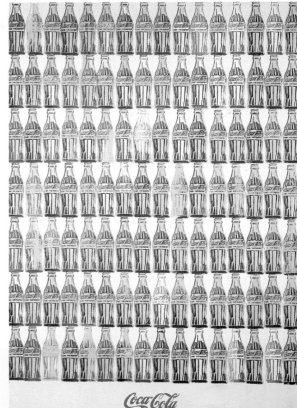

Rows

The simplest pattern is achieved by repeating the motif in a single row or along several similar rows or columns. You've most likely encountered this kind of pattern in supermarkets and stores, where bottles are arranged in rows and boxes are aligned on shelves. Plowed fields, rows of flowers, and beaded necklaces are other examples of these simple planned patterns. Look at fig.11–14, in which the artist creates pattern through rows of sculptures.

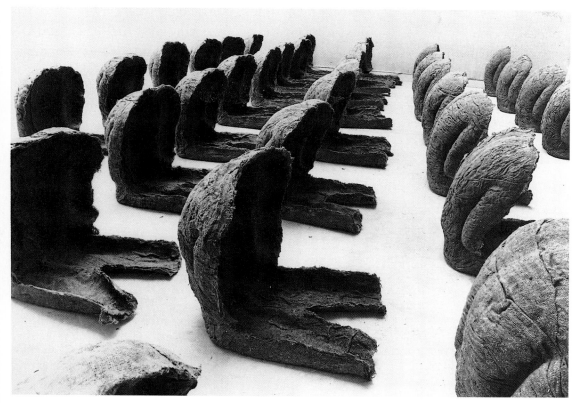

11–14 Notice the rows formed by the individual sculptures. Why might the artist have placed them this way?
Magdalena Abakanowicz (b. 1930), *Backs* series. 1976–80. Burlap and resin, 3 different sizes: 24" x 19 ⅝" x 21 ⅝" (61 x 50 x 55 cm), 27 ¼" x 22" x 26" (69 x 56 x 66 cm), 28 ¼" x 23 ¼" x 27 ¼" (72 x 59 x 69 cm). ©Magdalena Abakanowicz/Licensed by VAGA, New York/Marlborough Gallery, New York.

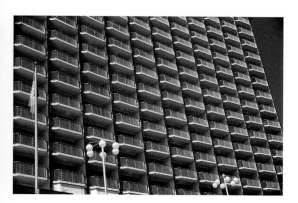

11–15 Architecture abounds in planned patterns, as is evident in banks of windows or ribbons of concrete that adorn the façades of buildings.
Apartment building. Photo by J. Selleck.

Try it

Look for small, intriguing objects, both natural and manufactured, to use as printable motifs. Choose one or two to create a simple pattern design for wallpaper, wrapping paper, or fabric. Ink the object and press it onto a sheet of heavy paper. You might reverse the motif to produce mirror-image patterns; or cut a motif into segments, and use both the whole and the parts to form a planned pattern.

Grids

A grid pattern is formed by intersecting vertical and horizontal lines or shapes. Similar to rows, the motifs in a grid pattern are usually spaced at equal or roughly equal intervals. You can find grid patterns in checkerboards, automobile grills, waffles, and honeycombs. Intersecting streets in many cities have been designed to form a grid, and most contemporary architecture also utilizes a grid structure. An overall grid pattern provides equal emphasis throughout a design.

Although you may think of grids as being arranged up and down, they also may be diagonal or circular. Notice the grid pattern at the top of the lighthouse (fig.11–17) and in the glass sculpture (fig.11–18). The lines of a geodesic dome and the intersecting longitude and latitude lines on a globe are other grid patterns: the lines that make up these grids cover a sphere.

11–16 The uniform grid pattern of a Japanese window screen diffuses light.
Japanese window screen. Photo by A. W. Porter.

11–17 Crisscrossing structural strips encase a light-house beacon. Note that the open-grid pattern has the opposite purpose of the compact grid of the Japanese screen (fig.11–16).
Lighthouse. Photo by A.W. Porter.

Try it

Mark out a series of points 1" apart both vertically and horizontally on a sheet of paper. Then draw lines connecting these points to form a grid. This simple construction is itself an example of a grid pattern. Use it as the basis for developing a more complex grid pattern by adding repeated shapes, colors, or a combination of elements.

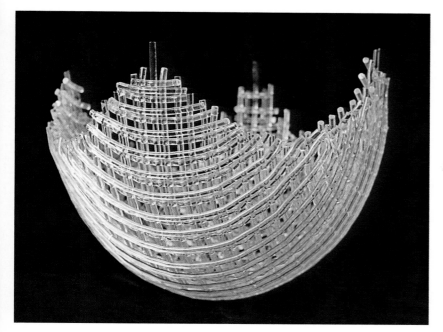

11–18 Artist Bruce Freund uses fused glass rods to create a curved-grid form.

Bruce Freund (b. 1953), *Glass piece*, 1988. 16" x 16" x 16" (40.6 x 40.6 x 40.6 cm). Courtesy of the artist, from his collection. Photo by B. Freund.

Try it

Use paper, cardboard, toothpicks, or balsa wood to build a three-dimensional form with a gridlike structure. You'll find that simple grids give physical and visual strength to a design. To make your design more complicated or unusual, you may wish to overlap different grid patterns or add strong colors and textures.

11–19 Though her sculpture is based on the grid, artist Jackie Winsor provides variation in spacing and tilted grid lines to bring an organic quality to this work.

Jackie Winsor (b. 1941), *Bound Grid*, 1971–72. Wood and twine, 84" x 84" x 8" (213.3 x 213.3 x 20.3 cm). Fonds Nationale d'Art Contemporain, Paris (formerly CNAC). Art ©Jackie Winsor. Image courtesy of the Paula Cooper Gallery, New York.

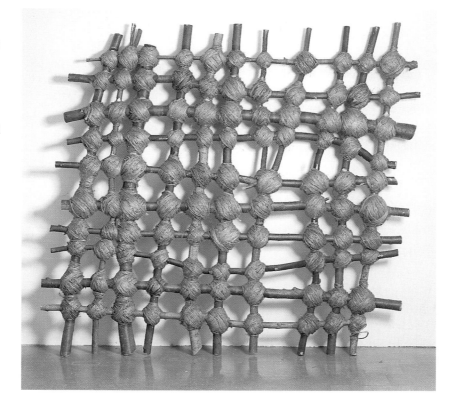

Half-Drop Designs

Designs made simply of linear or grid patterns can be rigid and monotonous. To make a more complicated or interesting design, an artist might manipulate the placement of motifs within a pattern. A *half-drop design* lowers each row of motifs half the height of the row above it. It also can stagger the rows so that they are no longer in perfect alignment. A half-drop design creates a pattern that seems to have a wavy movement. The scales on a fish and the leaves of an artichoke are examples of half-drop designs found in nature.

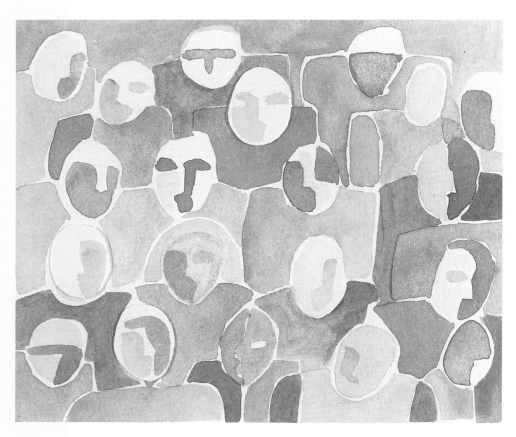

11-20 What pattern is created by the seating design of a stadium or theater? This painting utilizes a predominantly half-drop design, but notice where the pattern is varied. Why might the artist have chosen to do this?

Diana Ong (b. 1940), *Spectators*, 1994. Watercolor, 6" x 7 ½" (15.2 x 19.1 cm). ©Superstock.

Try it

Use inked pieces of sponge or carved erasers to create a half-drop or alternating pattern.

11–21 The half-drop pattern is complex. Can you think of some other instances in nature where it occurs?

Artichoke. Photo by T. Fiorelli.

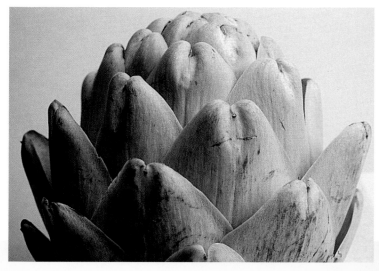

Alternating Patterns

Alternating patterns are similar to half-drop designs, but they are much less rigid. An alternating pattern is not limited to equally spaced rows of similar elements. The space between rows may change, or each row may contain a different number of motifs. The motifs themselves may vary in shape, size, color, and so on. An alternating pattern also may use a linear or grid design that combines two different motifs. In each case, however, this planned pattern requires a system of organization that is logical and consistent.

Look at the graphic design in the Andri poster (fig.11–22), which combines two alternating patterns. The top half contains a red-and-white cloud motif on a black background. The rows of clouds get thinner and closer together as they approach the horizon line. At the center is a triangular group of trees. Each row contains a different number of trees, and the trees themselves vary in color and size.

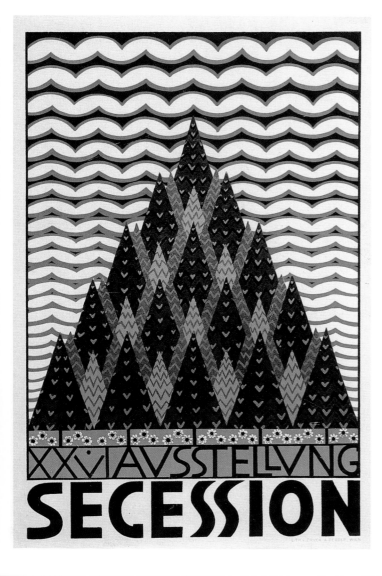

11–22 This poster, designed in Austria in 1906, announces the twenty-sixth exhibition (*Ausstellung*) of the secession movement in Vienna. This movement, formed at the very end of the 1800s by a group of forward-looking Viennese artists, wanted to breathe new life and modern thinking into all art forms.
Ferdinand Andri (1871–1956), *XXVI Ausstellung Secession Exhibition*, 1906. Courtesy of the Vereinigung Bildender Küntsler Wiener Secession, Vienna.

Radial Patterns

A radial pattern, like radial balance (see Chapter 7), is based on a branching out from a central point. Star shapes, asterisks, wheel spokes, and many fireworks are examples of radial patterns. The motifs of a radial pattern not only extend outward from the center, but they also usually occur at regularly spaced intervals. Radial patterns are generally active and structurally strong. Some even have an explosive quality. They speed up our eye movement as we trace the motifs that move outward, inward, or around the pattern.

Radial patterns give artists the opportunity to convey dynamic movement and contrast. Small, bursting patterns may be contrasted with large, slowly accelerating radial designs. Radial patterns of similar size also may be combined to create an overall tie-dye pattern. In Roszak's *Star Burst* (fig.11–24), the radiating lines might depict an explosion, the end of the world, or deep space.

11–23 Many flowers and plants display radial patterns. In this cactus, the pattern allows a maximum amount of surface area for absorbing water. *Silversword cactus.* Photo by J. Scott.

Try it

Make a series of drawings from objects or surfaces that have definite radial patterns. Use several of these studies to develop your own finished design.

11–24 Note how the artist used value contrast to increase the energy of the radial pattern used in this image.
Theodore Roszak (1907–1981), *Star Burst*, 1954. Pen and black ink, and brush and colored ink on paper, Sheet (Irregular): 43 ½" x 80 ⅝" (110.5 x 204.8 cm). Whitney Museum of American Art, New York. Gift of Mrs. Theodore Roszak 83.33.10 ©Estate of Theodore Roszak/Licensed by VAGA, New York.

Michelangelo Buonarroti

Known as one of the most talented artists of all time, Michelangelo was an Italian sculptor, painter, poet, and architect who lived from 1475 to 1564. From an early age, he was devoted to the study and practice of art.

Michelangelo spent innumerable hours learning about the human body, not only by drawing from live models and studying early Greek and Roman statuary, but also by dissecting bodies. His reputation as "the greatest sculptor in Italy" was earned at the age of twenty-nine by his marble carving of *David*.

Michelangelo was also highly skilled at drawing and painting, and completed many works of biblical scenes. He was a master of *fresco*, a technique of painting with pigment on walls of wet plaster. By commission to Pope Julius II, he painted the ceiling of the

11–25a Oval, or elliptical, shapes were considered undesirable by architects and planners in Michelangelo's time. His use of the oval as a basis for the pavement pattern design was a powerful artistic statement.
Michelangelo (1475–1564), *Campidoglio*, 1538–64. Plan, Rome. Engraving by Dupérac.

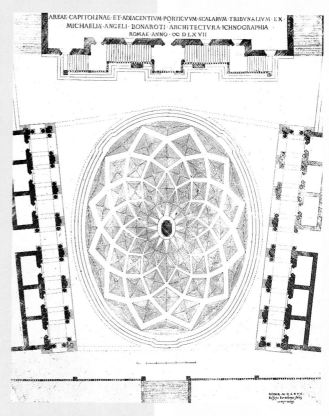

enormous Sistine Chapel, a monumental work that took him four years to accomplish. During the project, he spent so many hours working overhead that his body became accustomed to that position; as a result, in order to read a letter, he held it over his head!

In the last thirty years of his life, Michelangelo spent most of his time working on architectural plans. He was commissioned in 1537 by Pope Paul III to redesign the Campidoglio in Rome, a hilltop area that included two palaces. The position of the existing palaces, which are placed at an angle, posed a challenge. Michelangelo's design included a third building to add an unconventional trapezoidal symmetry to the plaza.

Best known for the monumental forms of his sculptures and paintings, Michelangelo so successfully designed buildings and urban spaces that his work on the Campidoglio has been hailed as one of the most significant efforts in the history of urban planning. The Campidoglio is an excellent example of how an artist especially known for an emphasis on one element or principle of design (form) will often stretch creativity and genius in another direction (pattern) in order to solve a specific visual or design problem.

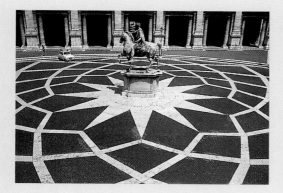

11–25 The radial pattern of the pavement unifies the buildings in this hilltop plaza by creating a cohesive space. What other function does the pattern serve?
Michelangelo (1475–1564), *Campidoglio*, 1538–64. Pavement, Rome.

Borders and Bands

Another way to add pattern is to enrich a surface with a decorative border or band. Since the Renaissance, sports teams have identified themselves by adding bands of color to their uniforms and flag. Household items, cars, planes, and pottery are some of the many other items also decorated in this way.

11–26 Architects often use decorative bands to relieve large expanses of plain wall surface or to help define and divide space.
Carved architectural detail. Photo by A. W. Porter.

11–27 How would you explain the way the border of this plate works both to stop the eye and to keep it moving?
Dedham Pottery, *Plate*, c. 1900–28. 10" diameter (25.6 cm). Courtesy of the Dedham Historical Society, Dedham, Massachusetts. Photography by FFPhoto.com.

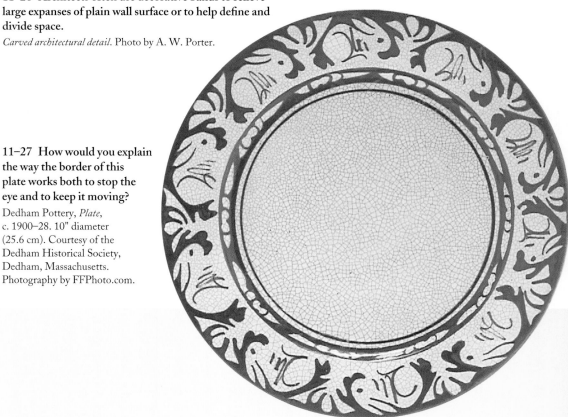

Artists and designers frequently use borders and bands to emphasize the edge of a form or to highlight a particular area. Architects might design a patterned border to run along the top edge of a wall. A potter might create bands of indentations in a clay bowl or use glazes to add a border to a ceramic plate. Look in your closet: most likely, you have a shirt or sweater whose neck or sleeves are decorated to add emphasis to the design.

Borders and bands can make a composition visually stronger. They may add a color, shape, or texture that will add contrast and increase interest. They also can lend elegance and individuality to a design. In some ways, adding a decorative border or band is similar to underlining a word for emphasis. If you were designing the side panels of a racing car, what kinds of lines and colors would you suggest?

11–28 What pattern device was used in this title page? Why would a book designer want to make a title page particularly inviting to the eye?
Bruce Rogers (1870–1957), Title page from *Fra Luca de Pacioli*, by Stanley Morison. 12 ½" x 8 ¼" (31.8 x 21 cm). The Grolier Club, New York, 1933.

11-29 How has a decorative band been used on this work? How would the appearance of the vase change if the band were removed?
Candice Cuchetti (age 18), *Nature Quest*, 2008. Red earthenware clay, sgraffito, 10 ½" x 8 ½" (26.7 x 21.6 cm). New Smyrna Beach High School, New Smyrna Beach, Florida.

FRA·LUCA
DE·PACIOLI
O^F·BORGO·S
SEPOLCRO
B^Y·STANLEY
MORISON
THE·GRO·
LIER·CLUB
NEW·YORK
MCMXXXII

Random Patterns

Sometimes, patterns just happen. Have you ever noticed a pattern of crisscrossed footprints in mud or sand? Or one produced by a spilled or splattered liquid? A pattern created by chance or without an orderly organization is called a ***random pattern***. Aging wall surfaces are good places to discover random patterns; many artists have been inspired by the interesting effects of weathered wood, peeling paint, and faded signs.

Random patterns usually have nonuniform surfaces and asymmetrical compositions, and they may also contain irregular or unusual elements. These conditions often make random patterns more expressive and visually exciting than planned patterns. The lack of a rigid plan often contributes a feeling of wildness or energy to the design. In the student painting (fig.11–33), a random pattern was achieved with ink and charcoal.

11–30 Close inspection of nature's forms can reveal intriguing patterns like these random clusters of ice on twigs.

Ice-covered shrub twigs. Photo by J. Scott.

Try it

Look at patterns in your environment to find a mixture of random and planned patterns. Make one or two designs in which you use both types. One possibility is to combine carefully drawn and spaced line arrangements with splattered or randomly applied paint or ink.

11–31 Notice that random patterns can have a wildness that is not present in even the most energetic radial patterns.

Lines of light. Photo by A. W. Porter.

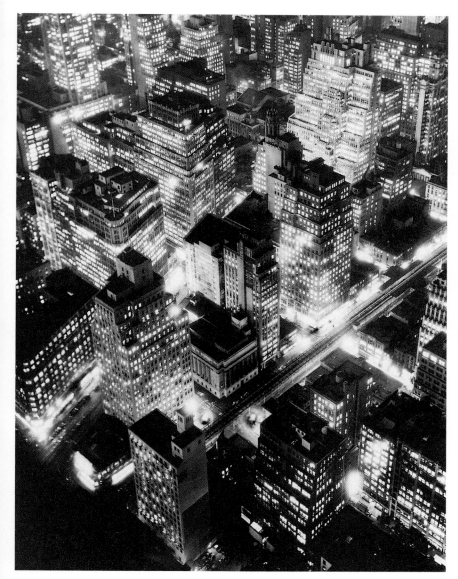

11–32 In what ways does this image show random patterning?

Berenice Abbott (1898–1991), *Nightview, New York, 1932*. Gelatin silver print. ©Berenice Abbott/ Commerce Graphics Ltd., Inc.

11-33 The random placement of paint in this work gives it a feeling of liveliness. The viewer's eyes are in constant motion.

Kenny Holmes (age 18), *Untitled #7*, 1998. Ink and charcoal, 20 ½" x 7" (52 x 18 cm). James W. Robinson, Jr. Secondary School, Fairfax, Virginia.

Another Look at Pattern

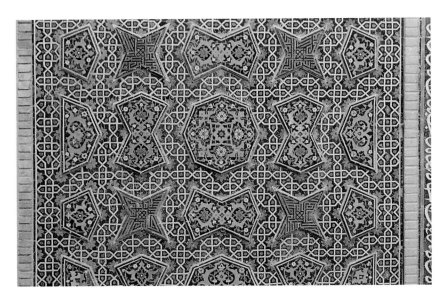

11–34 Because Muslims are forbidden to include figures in their religious art, Muslim artists over the centuries developed a style that incorporates magnificently intricate patterns.
Ceramic tile wall, c. 1500. From the Friday Mosque, Isfahan, Persia (Iran).

11–35 In early medieval times, manuscript artists were masters of densely packed, intricate patterns. Note that the decorative border in fig.11–28 was derived from the Celtic tradition of interwoven pattern found in the *Book of Kells*.
Ireland. *Book of Kells*. TCD MS 58 fol 188r (the opening page of Luke's gospel). The Board of Trinity College, Dublin, Ireland.

11-36 Pattern is sometimes colorful and bold; but in some instances, it is quiet and understated. Think of a familiar outdoor space. What kind of patterning does it have?

Simon Rodia (1875–1965), *Watts Tower*, detail. Photo by A. W. Porter.

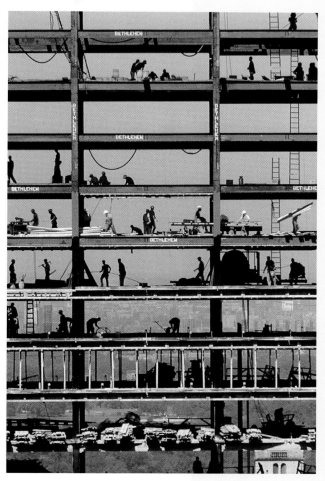

11-37 A photographer can spot patterns that many of us might miss. How did the artist frame this image in order to emphasize pattern?

Lee Lockwood (b. 1932), *New York Hilton Hotel Under Construction*, 1962. Print. ©Lee Lockwood/Time Inc.

Review Questions

1. What is visual pattern?
2. Give an example of a manufactured and a natural pattern.
3. What are two main functions of pattern?
4. List six basic types of planned patterns. Draw a small example of each.
5. What is a random pattern?
6. Explain how other cultures have influenced Navajo blanket weaving.
7. What type of pattern did Michelangelo use in his design for the Campidoglio pavement in Rome?

Career Portfolio
Interview with a Fabric Designer

Pattern is an essential principle of fabric design, which is based on repeated images. **Wesley Mancini** discovered his flair for fabric design while studying art education at the Philadelphia College of Art. He went on to obtain a master's degree in fiber from Cranbrook Academy of Art. He now has twenty-two people working for his company in Charlotte, North Carolina.

As a fabric designer, what is your specialty?

Wesley Woven fabrics for the home, primarily for upholstery and interiors. We've been expanding into bedding—bedspreads, dust ruffles, and pillow shams. Once we got into printed fabric, that market expanded into tabletops (table linens, place mats, napkins) and shower curtains, as well as printed upholstery and draperies.

What does upholstery include?

Wesley Primarily sofas and chairs. However, the fabrics can be used for drapery or whatever an interior decorator would like to use them for. I've seen the fabrics used as apparel for vests, or the top part of boots, eyeglass cases—basically anywhere that a textile can be used, even lampshades.

What is the difference between print design and woven design?

Wesley They are very different sensibilities. Just because you're a good woven designer doesn't necessarily mean you're a good print designer.

With the print designs, the art is the most important thing. You have to be able to paint with techniques. A painted design is printed on fabric in much the same way that pictures are printed on paper.

Woven designs include the structure of the fabric itself. There is a lot of linear thinking, figuring out constructions and weaves, so it is mathematical. You're designing the elements, making the yarns, dyeing them, deciding the sizes, and then figuring out the structure and how they are all going to fit together. The art department paints the art, and a styling department assigns different weaves to each of those colors. They also determine what yarns are going to be woven and the number of yarns per inch in the horizontal direction, as well as the vertical direction. The editing department scans the art into a computer and puts in the number of yarns, vertically and horizontally.

What advice would you give to someone interested in this field?

Wesley Go out and see what is selling in stores. See what colors are selling. See what kinds of designs are out there. If you want to go into apparel, that would be a different kind of design than if you were picking upholstery. I would pick schools that are known for that particular thing. You don't have to be a fabric designer: you can be a fiber artist and make one-of-a-kind pieces.

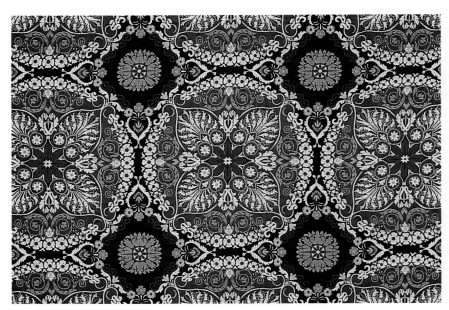

For fabric design to work, a pattern must hold together when repeated throughout the cloth. A fabric artist first draws the design in rough pencil, and then paints the section to be repeated. That section is scanned into a computer, where it is copied, rotated, and mirrored to make the whole image. Many different color schemes may be applied to one design. Can you find the triangular pattern within the fabric?

Wesley Mancini. *Fabric design with markings and color guide.* Courtesy of the artist. Photo by T. Fiorelli.

Studio Experience
Pattern Prints

Task: To draw natural patterns, carve one as a linoleum-block print, and then print several patterns with repeat schemes.

Take a look. Review the following photographs of nature images:
• Fig. 11–6, *Peacock feathers*
• Fig. 11–21, *Artichoke*
• Fig. 11–23, *Silversword cactus*

Then review these illustrations of human-made patterns:
• Fig. 11–3, Faith Ringgold, *The Wedding: Lover's Quilt No. 1*
• Fig. 11–34, *Ceramic tile wall* from Friday Mosque
• Fig. 11–37, Lee Lockwood, *New York Hilton Hotel Under Construction*

Think about it.
• Study the nature photographs listed above. Note that the focus in each is on the zoomed-in pattern of the natural object. In each image, what element created the pattern?
• Study the human-made patterns, and identify several of the motifs in each pattern. Notice how some motifs have been joined together to form a larger unit that is repeated. How do the motifs vary from row to row in each pattern?

Do it.

1 On drawing paper, make several pencil drawings of patterns found in nature.

2 Select a portion of one drawing as the design for your linoleum-block print. Later, you will print this many times as a motif. Transfer your pencil drawing to the linoleum block: place your drawing facedown on the linoleum, and rub over the back of the paper with the side of a pencil or the back of a spoon. Your print will be the reverse of your carved print block.

3 Use linoleum cutters to carve away the areas of your design that will be the

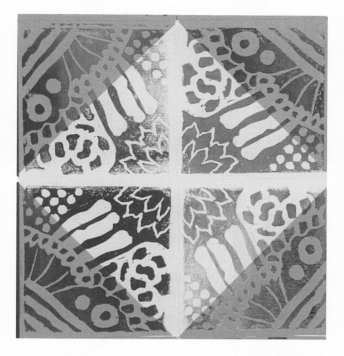

"Complementary color systems of paints and colored paper were followed during the printing process. For instance, warm-colored paints were printed on cool-colored papers, and then cool-colored paints were printed on warm-colored papers. I also looked at artwork made by quilt makers to influence the way I arranged the finished prints."

Erica Wallin (age 16), *Butterfly Wing Quilt*, 1998, detail. Linoleum print on colored paper, 17" x 17 ½" (43.2 x 44.5 cm). Clarkstown High School North, New City, New York.

color of the paper. Do not carve too deeply. Always keep hands behind the blade. If bench hooks or C-clamps are available, use them to hold the linoleum in place.

4 Make a proof print by inking the block with water-soluble ink and printing it on paper.

5 Pull the paper from the block. Study your print to decide if you want to cut away any more of the linoleum. Using your block as a motif, print repeated patterns on larger sheets of paper. Try different types of repeated patterns. Print your block in grid, half-drop, radial, and random patterns. Experiment by turning the block in different directions, leaving varying amounts of space between the prints, and using several colors.

6 Mount your two favorite patterns on colored paper or cardboard.

7 *Option:* To produce an effect similar to the student work on this page, vary your block prints by using different colors of ink and paper. Then, cut the prints in half diagonally and reassemble the blocks.

Helpful Hints
• To get an idea of what your print will look like before you ink the block, make a rubbing by placing a piece of thin paper over the block and rubbing the paper with the flat edge of a pencil lead.
• Each time you ink your block, set it on a clean page of a recycled magazine or telephone book. This will keep your work surface free of wet ink.

Check it.
• What type of repeat scheme did you use in each pattern?
• Consider the craftsmanship of your artwork:
 — Did you ink and print your block correctly?
 — Did you put too little or too much ink on your block?
 — Did you apply enough pressure to create an even, sharp print? Does this matter in your pattern?
 — Are there any stray spots of ink on your paper? If so, does this interfere with the effectiveness of the pattern? Do they accidentally add to the success of your design?
• What do you like best about the two patterns?
• What might you do differently the next time you create a similar piece of art?

Movement and Rhythm

WHEN YOU WALK ACROSS A ROOM, you display simple movement. A figure skater's performance is a more complex movement. In design, artists achieve a variety of effects through the use of movement. Movement can create a path for the viewer's eyes to follow across a composition. It can also set a mood or convey a feeling. In some designs, such as mobiles, actual movement is present. In others, such as a photo of a horse jumping over a fence, movement is recorded by the work.

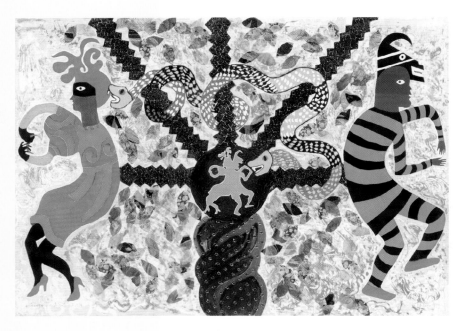

12–1 The artist creates movement and rhythm by using both repetition and contrast. Point out examples of each.
Miriam Schapiro (b. 1923), *Adam and Eve*, 1990. Color etching, collage, fabric, 30.5" x 40" (77.5 x 101.6 cm). Copyright Miriam Shapiro. Courtesy of Flomenhaft Gallery.

12–2 Notice how curving and diagonal lines provide a feeling of motion. Artists frequently use these devices to add movement to a composition. In the case of this sculpture, the blue circular forms actually do move.
Jerome Kirk (b. 1923), *Avion*, 1986. Painted aluminum and stainless steel, 312" x 300" x 120" (792.5 x 762 x 304.8 cm). Irvine, California. Courtesy of the artist. Photo by J. Selleck.

Visual rhythm, similar to rhythm in music and dance, is closely related to movement. It may be produced by repeating one or several units of a design, such as a triangular shape or the color green. These motifs are depicted in a certain order or pattern, which creates a rhythm. Artists and designers can choose from a variety of visual rhythms, including regular, flowing, or alternating. Compare the images on these two pages. How would you describe the different movements or rhythms that you see?

12–3 Gehry's rhythmic design is particularly fitting for a concert hall. In what ways does this building's design reflect the music that is performed inside?

Frank Gehry (b. 1929), *Walt Disney Concert Hall*. Walt Disney Concert Hall. Photo ©John Edward Linden/ Arcaid/Corbis.

12–4 Movement in nature is often rhythmic.
Birds in flight, North Carolina. Photo by N. W. Bedau.

12–5 In 1988, *Tin Toy* became the first completely computerized animated film to win an Oscar from the Motion Picture Academy of Arts and Sciences. Why might the artist have included the long black diagonal shadow lines in this computer-generated image from *Tin Toy*? How do the lines help move your eye through the scene?

From *Tin Toy*. ©1988 PIXAR.

Actual Movement

Certain works of art, such as motorized sculptures, actually move and change over time. Their form at any given moment may be different from the form they represented seconds before. Gravity may produce or begin the action in some constructions, whereas air currents or wind may move or change others. Art that includes actively moving parts is called *kinetic art*. Some pieces of kinetic art move rapidly; others change almost imperceptibly. The movement may be programmed, or it may need to be started manually.

12–6 Mobiles are constructed to be highly sensitive to changes in air currents. The frequent motion of a mobile provides a constantly changing work of art.

Julio Le Parc (b. 1928), *Continual Mobile, Continual Light*, 1963. Painted wood, aluminum, and nylon threads, 63" x 63" x 8 ¼" (160 x 160 x 21 cm). Tate Gallery, London. Photo: Tate Gallery, London/Art Resource, New York. ©2010 Artists Rights Society (ARS), New York/ADAGP, Paris.

12–7 A photograph of an artwork that has actual movement is limiting. One of the most essential characteristics of the work of art cannot be captured by the camera.

Bruce Nauman (b. 1941), *Double Poke in the Eye*, 1985. Edition of 40. Neon, 24" x 35" x 6 ½" (61 x 88.9 x 16.5 cm). Collection of the New Museum of Contemporary Art, New York. ©2010 Bruce Nauman/Artists Rights Society (ARS), New York.

Other works of art display actual physical movement without changing position. Flashing lights, continuously moving water, and the use of video monitors and TV screens are all ways of incorporating action into a design. The colored neon lights in Nauman's sculpture (fig.12–7) blink on and off repeatedly to create a hypnotizing effect, whereas the flow of water creates the movement in Bernini's sculpture (fig.12–8). To produce constant change and motion, Bernini and other Baroque sculptors often designed enormous, elaborate fountains, combining carved marble with flowing and spraying water.

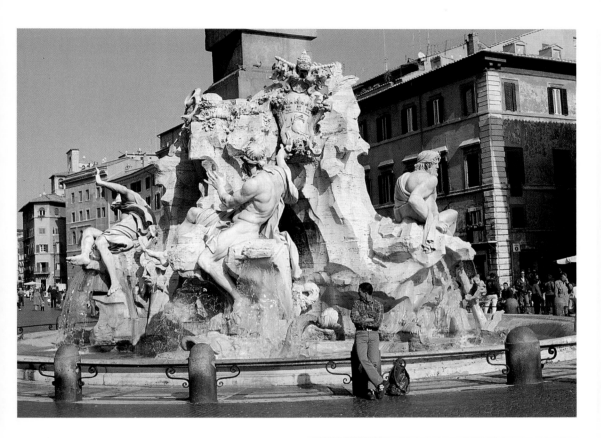

12–8 The sculptor Gianlorenzo Bernini took into account the sound that splashing water would make in this fountain. He calculated its mechanics so that the sound would be highly pleasing. The sound adds to the feeling of constant movement that is a trademark of this famous Roman landmark.

Gianlorenzo Bernini (1598–1680), *Fountain of the Four Rivers*, 1648–51. Travertine and marble. Piazza Navona, Rome. Photo by J. Selleck.

Try it

Use shapes or forms of different sizes to construct a simple mobile. Consider how the kinds of shapes will affect both the compositional and the actual movement and rhythm. Create first those elements that will hang at the bottom of the mobile, and vary the lengths of wire or string.

Recorded Action

One of the marvelous qualities of vision is the ability to shift our eyes to follow action. We can see a speeding car off to the left and follow it as it zooms to the right. If we couldn't follow the movement of the car, we would see only a blur. This kind of image is like a moving image captured by film or videotape. However, the images in paintings and photographs don't move—and even several sequential photographs or drawings cannot display fluid action—but they can record movement or freeze a moment of action.

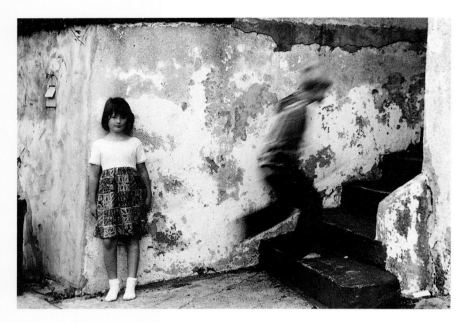

12–9 How does the photographer use contrast in values to emphasize the change from stillness to motion in this image?

Akiko DaSilva (age 18), *Untitled,* 1996. Print. Los Angeles County High School for the Arts, Los Angeles, California.

12–10 A 1/100,000-second strobe flashed every 1/100 second to make this extraordinary image.

Dr. Harold E. Edgerton (1903–90), *Densmore Shute Bends the Shaft,* 1938. Print. ©Harold and Esther Edgerton Foundation, 1998. Courtesy of Palm Press, Inc.

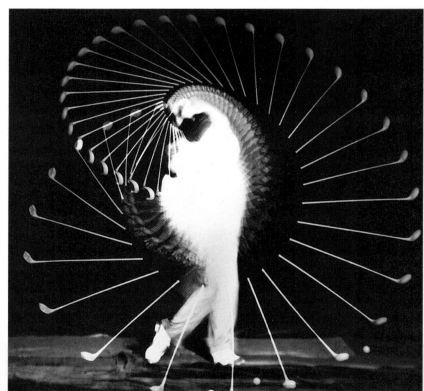

Art records action in various ways. A photograph of a vapor trail etched across the sky indicates an airplane's movement. Compositions that include falling leaves, flapping or curling flags and banners, and spirals of smoke also imply movement. Other designs may exhibit motion through techniques such as blurred images. DaSilva recorded a figure climbing a staircase (fig.12–9). The blurry movement contrasts with the stillness of the girl on the left.

A design also can capture action through the use of multiple images. Look at the photograph of a golfer (fig.12–10), for which the artist used a strobe light to repeatedly stop and record sequential moments of a single motion. Because the multiple images are recorded on one piece of film, they give the sense of continuous fluid movement.

Try it

Draw a model from one angle. Then use a different color or drawing medium to draw the model from another angle. Draw the second pose on top of the first one. Then draw one more pose in another color on top of the first two. How does your drawing suggest movement? What might you add to emphasize movement or change?

12–11 In this partially ruined ancient sculpture, rippling garments capture the movement of a winged figure as she descends from the sky.
Ancient Greece, *The Nike of Samothrace*, 3rd–2nd century BC. Marble, 8' high (2.44 m). Louvre, Paris, France. Photo: Bridgeman-Giraudon/Art Resource, New York.

12–12 The artist has designed this advertisement for maximum effect. The movement of the figures and waves sends a message of fun-filled action.
Tom Purvis (1888–1959), *East Coast by London and North Eastern Railway.* Color lithograph poster, 40" x 50" (101.6 x 127 cm). Inv.: E.935-1927. Victoria and Albert Museum, London, Great Britain. Photo: V & A Images, London/Art Resource, New York.

Compositional Movement

Compositional movement is neither action nor a record of action. It is experienced by comparing the positions of stationary objects or spaces within a design. Although a picket fence cannot move, it definitely conveys movement as it leads your eye from one end of the fence to the other. Compositional movement may be generated by contrast, emphasis, direction lines, shapes and colors, and other devices—and it can occur in both three-dimensional and two-dimensional art.

12–13a,b Multiple images of a three-dimensional artwork can offer some notion of the changes that occur as a viewer walks around it. There is no substitute, however, for experiencing a work of art firsthand.

Allan Houser (1914–94), *Desert Dweller*, 1990. Bronze, edition of 18, 7 ¼" x 8 ½" x 3" (18.4 x 21.6 x 7.6 cm). ©Allan Houser, Inc. Edition of 18. Photos courtesy of Allan Houser Inc.

Compositional Movement in Three-Dimensional Art

When we stand in front of a building or sculpture, our attention is drawn first to any large shape, textured surface, or area of contrasting values. Then we might notice the details of construction. In most three-dimensional art, compositional movement cannot be read or judged from a single point of view. A stationary sculpture will display change or movement as a viewer walks around it. Each new angle of vision often creates a shape or form that greatly contrasts with those seen from other angles. Compare the two views of Houser's *Desert Dweller* (fig.12–13a,b). Much of this sculpture design depends upon the relationship between negative and positive space, yet when the face is viewed frontally the appearance of the piece dramatically changes. The emphasis from this perspective is on the elongation of the face and the relationship of the forms.

Architects can produce movement by creating physical paths or other indicators that lead people to a building's entrance. Look at the photograph of a library (fig.12–15). The entryway juts out and is covered by a large arch and flanked by tall pillars and hedges. The doorway itself is a large opening of contrasting value. All these elements contribute to the compositional movement in the design of one structure. And when several buildings are clustered, movement is increased as a viewer's attention shifts from one structure to another.

12–14 Gothic architects, trying to lead the eyes of worshipers toward God, built the interiors of their cathedrals as tall as possible. These great heights convey a feeling of strong vertical movement. High, narrow windows, ribbed columns, and exterior spires all enhance and strengthen this sense of movement toward heaven.
Salisbury Cathedral, 1220–1380. Salisbury, England. Interior view of nave facing west.

12–15 Generally, an architect gives a visual cue to let us know where to find a building's entrance. Here, the curved arch attracts and holds the eye amidst the many verticals. The eye has a tendency to keep wandering back to the arch, as though the arch were creating a circle around the point of access.
Michael Graves (b. 1934), *San Juan Capistrano Library*, San Juan Capistrano, California, 1983. Photo by J. Selleck.

Compositional Movement in Two-Dimensional Art

To create compositional movement in works such as paintings and photographs, artists manipulate the elements of design. Their goal may be to lead a viewer's eye across a composition or to the center of interest. This ability to control or direct eye movement is essential in two-dimensional art. Without it, a composition would lack unity.

Our eyes tend to move across a picture plane along a path from upper left to lower right. As with three-dimensional art, our attention may be drawn to and pause at large shapes, a textured surface, or an area of contrasting values. Then we begin to examine details. We may notice that other objects or areas have their own set of lesser movements—also determined by lines, shadows, colors, or textures.

Artists and designers sometimes include objects such as arrows to point our attention in a certain direction. Shapes that have a definite front and back (such as cars and animals) prompt us to look in the direction toward which those objects face. In *Beach Blanket* (fig.12–17), the illustrator causes our eyes to move back and forth as we follow the conflicting directions of the many moving characters. Remember that lines of sight (or the gaze of one person toward another) also can create compositional movement.

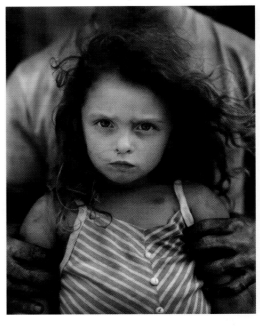

12–16 The blowing curls of the girl's hair and the diagonal lines of her shirt are two examples of compositional movement in this photograph. Can you find others?

Sally Mann (b. 1951), *Holding Virginia*, 1989. Gelatin silver print, 22 ½" x 18 ¼" (57.2 x 46.4 cm). Restricted gift of Robin and Sandy Stuart, 2005.24, The Art Institute of Chicago. Photograph by Robert Lifson. Reproduction, The Art Institute of Chicago.

12–18 An object, such as the apple in the lower right of this painting, placed at the "edge" of the picture plane draws our attention. The viewer's eye is led along the line of apples to the last one at the back of the composition.

Sung W. Lee (age 18), *Apples on Table*, 1997. Mixed media, 24" x 18" (61 x 45.7 cm). West Springfield High School, Springfield, Virginia.

12–17 Notice how the illustrator used color both to keep our eyes focused on the center of interest and to create compositional movement among the figures.

Laurent de Brunhoff (b. 1925), *Beach Blanket*, 1990. Ink and watercolor, 11 ½" x 16" (29 x 40.6 cm). Babar Characters™ and © Laurent de Brunhoff. All Rights Reserved.

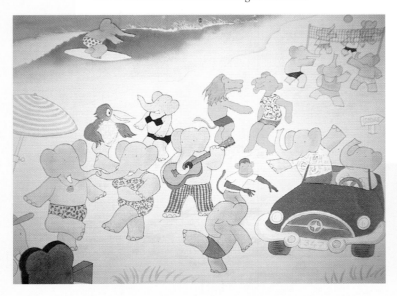

Frans Hals

Banquet of Officers of the Civic Guard of St. George at Haarlem

Imagine that you are a member of a group, such as a soccer team, in the early seventeenth century, and that your team would like a group picture. Because photography has not yet been invented, perhaps you would get together and hire a painter to make your picture. How would your group like to be portrayed? Would you pose in rows—kneeling, seated, and standing—or would you prefer an image of the team gathered in conversation with your coach?

In Holland at the time that Hals created this artwork, associated groups of people were often painted by artists. Such groups could have been men who traveled together on a pilgrimage or were members of a company of archers or riflemen. Dutch group portraits typically presented people posed stiffly in rows, with no sense of life or movement.

Frans Hals had great skill in capturing a likeness, and he became well known for his ability to show the nuances of each person's face. In 1627, he was commissioned to paint this portrait, in which he included diagonal components, most likely in an effort to enliven the work. Although the angled body positions affect the sense of drama in the scene, the overall composition is not considered successful. The figures seem detached from one another, so the efforts to show the group interacting are incomplete.

Nevertheless, the painter's contribution to the history of art was significant. Hals established a legacy as a gifted portrait artist, utterly convincing in his portrayal of each person's characteristics. In addition, he paved the way for more innovative treatments of composition in group portraits.

Discuss it

Study a reproduction of a famous painting. Then discuss the answers to these questions: How does the artist lead the viewer's eye through and around the painting? Is the movement accomplished with line, color, shape, value, or some other device?

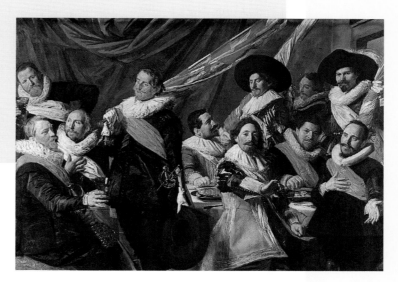

12–19 What gestures and glances contribute to the sense of diagonal movement? What other diagonals are present in the composition?

Frans Hals (1581–1666), *Banquet of Officers of the Civic Guard of St. George at Haarlem,* 1627. Oil on canvas, 5' 10" x 8' 5 ⅜" (2 x 2.6 m). Frans Hals Museum, Haarlem, the Netherlands.

Types of Rhythm

When a musical band starts to play, do you drum your fingers on a table or tap your foot? Do you experience a special feeling when fall comes each year or when school lets out for summer? The repetitious beat of music and the repeated pattern of activities related to seasonal change are both examples of rhythm. So, too, is the continuous crashing of waves on a beach. Rhythm is fundamental to our lives. We are surrounded by it, and we learn to walk, run, dance, talk, and eat in patterns of repetition.

In art, visual rhythm, which is similar to pattern, may be produced by repeating one or more motifs in a recognizable or predictable order. Visual rhythm can be easy to read, or it can be extremely complex. Both artists and designers use rhythm to help organize a composition, and also to create interest, emphasis, or unity. They might vary visual rhythm by changing the size, position, or direction of the repeated motifs and by altering the intervals between them. They might also combine two or more rhythms. In your work, practice and experimentation will help you to determine which rhythms work best in certain situations.

12–20 Visual rhythm in nature is often accompanied by sound rhythm.
Rock and wave action, from "Driftwood Series". Photo by J. Scott.

12–21 This wall sculpture is completely regular in its rhythm. If the work were extended, the addition would be highly predictable.
Donald Judd (1928–94), *Untitled*, 1980. Galvanized steel and red Plexiglas on sides and front, 9" x 40 ¼" x 31" each (22.9 x 102.2 x 78.7). Frederick R. Weisman Art Foundation, Los Angeles. ©VAGA, New York.

Regular

Look at Judd's sculpture (fig.12–21), in which the design repeats a rectangular form, and the space between the forms remains constant. This is an example of regular rhythm. Regular rhythm creates a repeated pattern that is both predictable and continuous. The pattern may be restricted to the borders or edges of a design, or it may cover the entire surface of a building or a sheet of wrapping paper. Note how a photographer captured the regular repetition of rows of seats at a sports arena (fig.12–22).

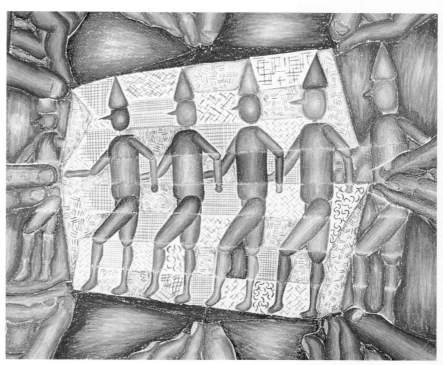

12–22 A series of similar elements placed at a constant interval produces a regular rhythm.
Tennis-court seats. Photo by J. Selleck.

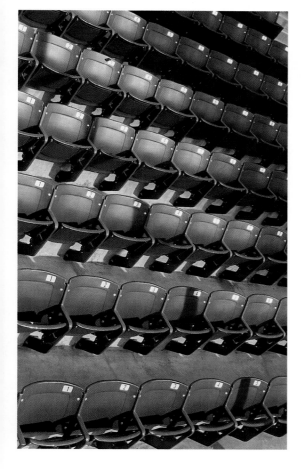

12–23 A regular rhythm is created in this student work by the row of similar marching figures.
Jang Cho (age 18), *Mannequin Center Stage*, 1997. Colored pencil, 11" x 14" (27.9 x 35.6 cm). Lake Highlands High School, Dallas, Texas.

Flowing

Smooth, flowing rhythms seem to unify whole compositions in a peaceful but powerful way. Usually, large movements that sweep across an entire work tie each of the parts together. Some flowing rhythms move along curved, circular, or wavy paths, and may be similar to radial patterns.

In nature, the swirling form of a seashell, smoothly rolling hills, and the winds of a hurricane are all examples of flowing rhythms. In art, flowing rhythm can communicate freedom and grace. Artists and designers commonly employ it in landscapes, figurative designs, and in abstract and nonrepresentational works. Flowing rhythms produce compositional movement along a definite path. In fig. 12-24, the viewer participates in the artwork just by being in the room. The video surrounds the viewers with continuous flowing motion.

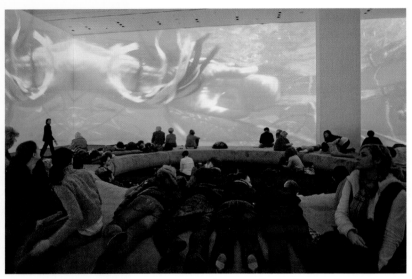

12–24 Rist chooses video/audio installations because "there is room in them for everything." From the title of this installation, can you tell what mood the artist was trying to elicit from the participants?
Pipolotti Rist (b. 1962), *Pour Your Body Out*, 2008.
Multichannel video (color, sound), projector enclosures, circular seating element, carpet, 9619 cubic yards (7354 cubic meters). Digital image ©The Museum of Modern Art/Licensed by SCALA/Art Resource, New York.

Try it

With paint or drawing media, explore patterns that move in flowing rhythms. Plan your composition to include a series of wavy lines so that each line echoes the path of the lines closest to it. Consider how much space to leave between the lines: you might vary the amount to obtain different effects. Allow enough space to add a series of shapes to form a pattern. You could select motifs that emphasize the sense of flowing movement or rhythm, and you could also increase or decrease the size of the units as the pattern advances.

12–25 This design contrasts sharply with the regular rhythms that are typical of architecture.
Don M. Ramos (20th century), *O'Neill guest house*, 1978. Los Angeles, California. Photo by J. Selleck.

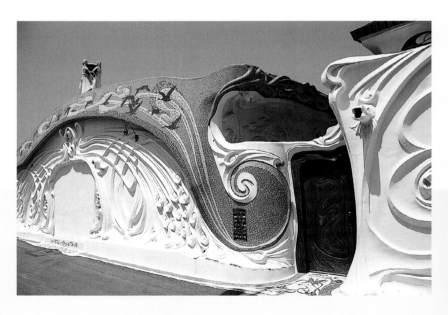

Henri Matisse

Matisse found great joy in creating art, asserting that the purpose of his artwork was to bring pleasure to the viewer. He worked as an artist from 1890 until his death in 1954 at the age of eighty-five. During this time, the art world underwent major changes. Matisse was influenced by movements such as Impressionism and Cubism, yet he held firm to his own path—a steady movement toward extreme simplicity of shape and color. Matisse sculpted as well as drew and painted, concentrating much of his effort on portraying the human form and exploring the use of color.

One of the few artists to achieve fame and popularity within his lifetime, Matisse became known for his outstanding ability to simplify a complex subject, extracting the pure elements of shape, as in *The Snail* (fig.12–26). To create a sense of movement, he would often exaggerate and distort shapes.

Henri Matisse (1869–1954), *Self-portrait,* 1918. Oil on canvas, 25 ½" x 21 ¼" (65 x 54 cm). Courtesy Musée Matisse. Photo by Archives Henri Matisse ©2010 Succession H. Matisse/ARS, New York.

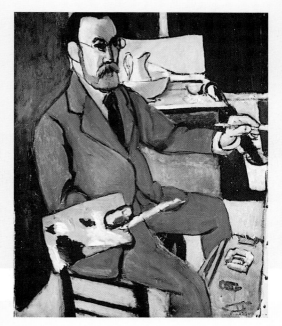

In his final years, Matisse was ill and bedridden. However, he continued to create art, composing powerful abstract collages—*papiers-découpés*—from brightly painted paper cutouts. He was able to work, cutting paper with scissors, from his bed. At first, he used the cutout pieces to plan paintings, but later he made them the actual materials of his artworks. Despite his physical discomfort, Matisse felt that reading poetry and creating art made life worth living.

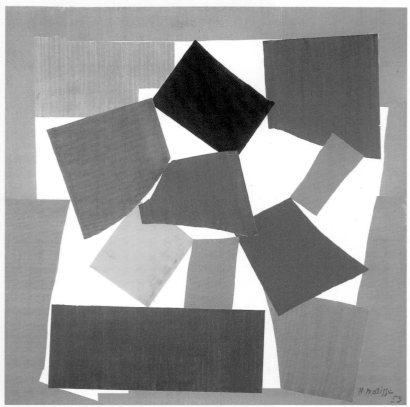

12–26 This work—which can be seen as an exploration of the boundary between abstract and representational art—is one of the last that Matisse completed. How did he include flowing rhythm in this work?

Henri Matisse (1869–1954), *The Snail,* 1953. Gouache on cut and pasted paper, 112 ¾" x 113" (287 x 288 cm). Tate Gallery, London, Great Britain. Photo: Tate Gallery, London/Art Resource, New York. ©2010 Succession H. Matisse/ARS, New York.

Alternating

Regular and flowing rhythms tend to be pleasing because they are predictable and contribute to order and unity. But if rhythms are *too* much the same, they can be monotonous. For example, if all the high-rise buildings in a city were exactly the same height and shape, they would create a dull skyline. Variety is what helps overcome such boredom and can create needed interest in a composition.

By pairing periods of excitement or suspense with moments of quiet and relief, authors of books and directors of movies use alternating rhythm to sustain interest. In design, this type of rhythm might be created with a simple wallpaper pattern that alternates vertical rows of small flowers with vertical stripes. Examine the woodcut (fig.12–27), in which the artist used rows of round apples to create one rhythm, and tall angular sticks to create another. The two work together to provide interest and variety.

12–27 Compare this image with fig.12–22. What rhythmic differences and similarities can you find?
Wayne Thiebaud (b. 1920), *Candied Apples*, 1987. Edition of 200, no. 20. Print 16 ½" x 15" (41.9 x 38.1 cm). Courtesy of the Allan Stone Gallery, New York. ©Wayne Thiebaud/Licensed by VAGA, New York.

12–28 What are the alternating patterns in this work?
Katherine Porter (b. 1941), *Untitled*, 1981. Charcoal, gouache, and crayon on paper, 26 ¼" x 40 ¼" (66.4 x 101.4 cm). Courtesy of the Fogg Art Museum, Harvard University Art Museums. Acquired through the Deknatel Purchase Fund.

Progressive

Like alternating rhythm, ***progressive rhythm*** also brings variety to a composition. A rhythm is progressive when its repeated motifs change in a predictable or regular way. A simple example would be a design in which a shape increases or decreases in size each time it is repeated. A more complex example of progressive rhythm is a pattern in which a motif turns a little or becomes darker each time it is repeated. In the student work (fig.12–29), notice how (in a series of five steps) the car progressively changes into a bird.

12–29 In this composition, the eye of the viewer is rhythmically led from bottom to top where one is inclined to imagine the bird flying out of the picture plane.
Jason Foor (age 18), *Untitled*, 1995. Pencil 24" x 18" (61 x 45.7 cm). Plano Senior High School, Plano, Texas.

12–30 A "shotgun" is a kind of row house built originally by Haitian slaves. Biggers was born in this type of small house in North Carolina. His richly patterned painting combines progressive rhythms.
John Biggers (1924–2001), *Shotguns*, 1987. Acrylic on canvas, 41 ¾" x 32" (106 x 81.3 cm). Private Collection. ©John T. Biggers Estate/Licensed by VAGA, New York.

Unexpected

Although most visual rhythms produce a feeling of orderly interaction between the parts of a design, some artists and designers prefer unpredictable rhythms. These unexpected rhythms might be jerky, irregular, or spontaneous, like those often found in jazz music. They can convey feelings of excitement, confusion, or unfocused power and energy. Unexpected rhythms can also add suspense, tension, and variety to a composition. Such rhythms can be created by irregular spacing and by random changes in the size, color, or shape of repeated motifs.

12–31 Though there is much in this work that is unpredictable, the design is held together by repeating squares.
Jennifer Bartlett (b. 1941), *Rhapsody*, detail, 1975–76. Enamel on steel, each plate 12" x 12" (30.4 x 30.4 cm); overall approximately 7'6" x 153' (228.6 x 4663.4 cm). The Museum of Modern Art, New York. Digital image ©The Museum of Modern Art/Licensed by SCALA/Art Resource, New York. Art ©Jennifer Bartlett. Image courtesy of the Paula Cooper Gallery, New York.

12–32 Murray manipulates several elements of design to create a sense of surprise. However, she also employs some more regular rhythms to offset the unpredictability. Find examples of each.
Elizabeth Murray (1940–2007), *Eleventh, from "The Metropolitan Series"*, 2005. Lithograph on cut-and-pasted paper with felt-tipped pen and watercolor additions. Composition (irreg.): 25 ⅞" x 33" (65.7 x 83.8 cm); sheet: 28" x 35" (71.1 x 88.9 cm). John B. Turner Fund. ©2009 Elizabeth Murray. The Museum of Modern Art, New York. Digital Image ©The Museum of Modern Art/Licensed by SCALA/Art Resource, New York.

Look at the detail from a large wall painting (fig.12–31). The entire work is made up of nine hundred eighty-eight separate squares; only a small sampling is reproduced here. The viewer's gaze moves from one square to another, encountering a variety of repeated motifs, including circles, houses, and trees. Although the squares are orderly, the color, style, and size of the motifs change throughout the composition. No single planned pattern is apparent. The entire work, called *Rhapsody*, can be compared to a piece of music in which notes are played unpredictably—at varying volumes and even by different instruments.

12–33 Compare this painting to fig.12–25. Although both works make use of flowing curves, the ones in this work are not predictable.
Rhythmical grid. Photo by A. W. Porter.

12–34 Ritchie's work addresses his interest in the constant stream of information that bombards us every day. How does his use of movement and rhythm reinforce that concept?
Matthew Ritchie (b. 1960), *The Fast Set*, 2000, installation view, Museum of Contemporary Art, North Miami, Florida, 2000. Photo: Matthew Ritchie. Courtesy Andrea Rosen Gallery.

Try it

Listen to various kinds of music with distinctive beats, such as rock, classical, Caribbean, flamenco, country-western, and lullabies. Experiment with art media to suggest the variety of movements and rhythms in each kind of music. Without depicting any recognizable objects or forms, try only to capture the feeling of the music and convey its journey.

Another Look at Movement and Rhythm

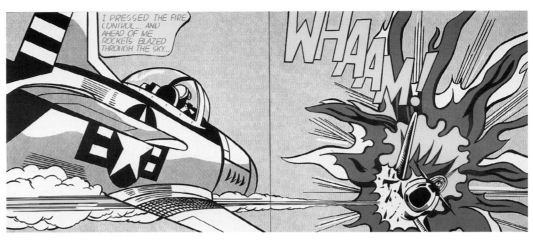

12–35 How did Lichtenstein express action in this painting?

Roy Lichtenstein (1923–97), *Whaam!*, 1963. Magna acrylic and oil on canvas, two canvases, each 68" x 80" (172.7 x 203 cm). Tate Gallery, London, Great Britain. Photo: Tate Gallery, London/Art Resource, New York

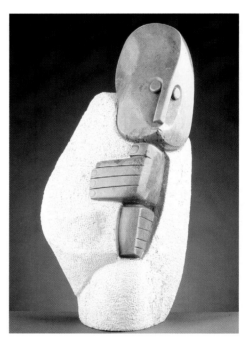

12–37 How is your eye directed to move across the surface of this sculpture?

Phineas Kamangira (20th century), *Elder Wrapped in Blanket*, c. 1990. Chiweshe Serpentine, 36" high (91.4 cm). Courtesy of Ukama Press//Spirits in Stone, Inc. and Mike Spirelli Photography.

12–36 This figure was part of a group that included a now-lost bronze horse running at full gallop. Imagine how the movement in this piece would have been enhanced when the boy was perched on the horse.

Ancient Greece. *Jockey from Artemisium*, 240–200 BCE. Bronze. National Archaeological Museum, Athens. ©Hellenic Ministry of Culture/Archeological Receipts Fund.

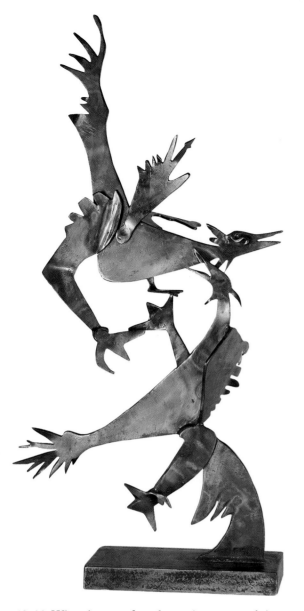

12–39 The artist's use of movement in this print might remind you of natural phenomena like falling snow or rushing water. What other associations can you make?

Jaune Quick-to-See Smith (b. 1940), *An American Breakthrough*, 2007. Color litho & archival inkjet, edition of 30, 25" x 17.5" (63.5 x 44.4 cm). Segura Publishing Co. Tempe, Arizona.

12–38 What element of art plays an important role in supporting the dynamic rhythm of this sculpture?

David Smith (1906–1965), *Cockfight*, 1945. Steel, 45" high (114.5 cm). Saint Louis Museum of Art, Museum Purchase (188:1946). Art ©Estate of David Smith/Licensed by VAGA, New York.

Review Questions

1. What is kinetic art?
2. Give an example of an artwork that actually moves, one that records a real movement, and one that displays effective compositional movement.
3. Why do artists try to create compositional movement within their two-dimensional designs?
4. What are two ways to record or indicate actual movement on a flat surface?
5. List five types of rhythm.
6. Why did Frans Hals paint the *Banquet of Officers of the Civic Guard of St. George at Haarlem*? What type of current images are created for a similar purpose?
7. Despite the influence of various art movements throughout his long life, what remained constant in Matisse's art? With what medium did Matisse create most of his later works?

Career Portfolio

Interview with an Illustrator

Kevin Gillespie has been fascinated by visual storytelling—first in comic books and then in illustrated books—since he was a little boy. Working in paint, pencil, pen and ink, and other media, he creates illustrations for theater posters, greeting cards, and books. He received his artistic training at Boston University and the Massachusetts College of Art, and is a member of the Boston/New England chapter of the Graphic Artists Guild.

How would you define your job?

An illustrator provides images, which enhance ideas. If the illustrator is creating images for a story, as in a children's picture book, he or she is often given a copy of the text of the story to go by. I think that the best illustrators produce pictures that illuminate ideas that the stories suggest, rather than simply describing what the words already explain well enough without any images. Illustrators are different from fine artists in that they tend to use recognizable symbols to get across the messages to a broad audience, whereas fine artists are more free to use personal symbols to express their own ideas about the world and the meanings behind their art can be more hidden.

Did you study art in school?

Yes, I've always loved to draw and paint, and my art teachers have always been encouraging. After high school, I studied Fine Art and Art History in college, and I wanted to be a great painter like Picasso or Rembrandt. When I realized how difficult that would be, I began to study graphic design, industrial design, and illustration, as these seemed to lead to real "careers." I worked for many years in the world of sneaker design before turning more to illustration.

What comes first, the story or the artwork?

Most often, the collaboration begins with the story and the writer works independently from the illustrator. Some of the greatest children's picture books have been created by author/illustrators who do both the writing and the artwork, such as "Where The Wild Things Are" by Maurice Sendak, one of my heroes.

Do you use real-life models to capture gesture and movement?

I have taken many life drawing classes so that I can render people in naturalistic positions without having to look at a model. However, if I'm trying to capture a likeness of someone, I try to have a few photos of him or her to guide me. I use a mirror and hold up my hands and arms for the gestures, or make a facial expression so that I can study where the lines should go. Sometimes I ask my wife or my daughter to pose for me if I'm stuck.

This painting began as a tribute that a neighborhood organization was paying to a woman who had created many wonderful festivals there. The illustrator was asked to create an illustration of how much her work meant to them. Because her festivals generally included a parade along the main street (in this case, Centre Street), he used this as the theme for the picture.

Studio Experience
Action!

Task: To draw an action-sequence comic strip, and then enlarge and paint one frame that demonstrates graphic movement.

Take a look. Review the following images:
- Fig. 12–1, Miriam Schapiro, *Adam and Eve*
- Fig. 12–17, Laurent de Brunhoff, *Beach Blanket*
- Fig. 12–35, Roy Lichtenstein, *Whaam!*

Think about it. For each of the images listed above, answer these questions.
- The artist created implied action to indicate that the subject had moved. What word describes this action?
- How did the artist create graphic movement to direct your view through the picture plane? Note any overlapped objects, repeated shapes or colors, and patterns.
- How would you describe the rhythm in the image?

Do it.

1 Look at newspaper comic strips, and note how artists create stories and indicate motion both within a frame and from one frame to the next.

2 From a story or play, select an action sequence to illustrate in three to five frames.

3 Plan your action sequence. Draw each frame several ways. For each frame, think about how you can direct the reader's view through the scene. Try overlapping objects and using directional lines to create movement. Also think about the action of the figures from one frame to the next. How will the subject change in each frame?

4 When you have a series of frames that you like, lightly redraw them on drawing paper. Use a ruler to draw the edges of the frames.

5 Use a black felt-tip marker to draw over your lines. Sign your name to the last frame.

6 Select one frame to make into a painting. Choose a frame that has good visual movement through its composition. You might want to modify your drawing to emphasize the movement.

7 Enlarge your frame, and lightly redraw in pencil onto a canvas board or a gessoed panel.

8 Paint your picture with acrylic paints.

Helpful Hints
- See the activity in Chapter 7 (page 153) for directions on how to enlarge your drawing.
- To create sharp straight lines or edges of shapes on your acrylic painting, put masking tape down along the line; paint; and remove the tape.
- Clean brushes thoroughly with soap and water at the end of each painting session. Even a little acrylic paint left in a brush will stiffen the bristles.

Check it.
- In your comic strip, did you create an implied action from one frame to the next?
- Describe the graphic movement through the composition of your large painting. How would you describe the rhythm?
- What do you like best about the comic strip?
- What do you like best about the painting?
- What did you learn in this project?
- What might you do differently the next time you create a similar piece of art?

Other Studio Projects

Using a camcorder, digital video camera, or digital camera, create your own animated action sequence. Break down an action (such as a person walking or throwing an object) into a series of smaller movements. Draw each movement (by hand or digitally). Scan hand-drawn images and save them as jpg-image files. Use a digital movie-making program to organize, edit, and animate the action sequence.

Jon Williams (age 16), *Zarm's Way*, 1998. Acrylic and colored pencil, 16" x 20" (40.6 x 50.8 cm). Asheville High School, Asheville, North Carolina.

Guide to Artists

A

Magdalena Abakanowicz (b. 1930, Poland). mahg-de-lay-nah ah-bah-kah-noe-vits

Berenice Abbott (1898–1991, US). ber-a-nees ab-bet

Milton Ackoff (b. 1915, US). ak-off

Ansel Adams (1902–84, US). an-sull ad-ams

John Ahearn (b. 1951, US). ay-hern

Josef Albers (1888–1976, Germany–US). yo-zef ahl-bers

Peter Alexander (b. 1939, US). alek-zand-er

Anna Alma-Tadema (c. 1865–1943, England). al-muh-tad-uh-muh

Ferdinand Andri (1871–1956, Austria). ahn-dree

Nemesio Antúnez (1918–93, Chile). nay-mayz-yo ahn-too-nes

Richard Anuszkiewicz (b. 1930, US). a-noo-skay-vich

Karel Appel (1921–2006, The Netherlands). kar-el ah-pel

Tomie Arai (b. 1949, US). toe-mee-a uh-rye

Anna Atkins (1799–1871, England) at-kinz

John James Audubon (1785–1851, US). aw-deh-bahn

B

Henrietta Bailey (1874–1950, US). bay-ley

Jennifer Bartlett (b. 1941, US). bart-let

Baule (Ivory Coast). bau-lay

Welton Becket (1902–69, US). well-tun bek-et

Vanessa Bell (1879–1961, England). bell

Gianlorenzo Bernini (1598–1680, Italy). jahn-low-rens-oh bair-nee-nee

John Biggers (1924–2001, US). big-urz

Rosa Bonheur (1822–99, France). rosa bon-err

Fernando Botero (b. 1932, Colombia). fair-nahn-doh boh-tay-roh

Hans Van De Bovenkamp (b. 1938, The Netherlands). honz vahn day boh-ven-kahmp

Georges Braque (1882–1963, France). zjorzj brahk

Colleen Browning (1929–2003, Ireland-US). brown-ing

Coosje van Bruggen (1942–2009, The Netherlands–US). koh-shah vahn brew-gen

Pieter Brueghel the Elder (c. 1525–69, The Netherlands). peet-er brew-gul

Laurent de Brunhoff (b. 1925, France). lor-enn da broon-hoff

C

Gustave Caillebotte (1848–94, France). goo-stahv kai-ee-bot

Alexander Calder (1898–1976, US). call-der

Canaletto (1697–1768, Italy). can-ah-let-toe

Ken Carlson (b. 1945, US). carl-sen

Vija Celmins (b. 1939, Latvia–US). vee-yah sel-minz

Paul Cézanne (1839–1906, France). say-zahn

Marc Chagall (1887–1985, Russia-France). mark sha-gahl

Jean-Baptiste-Siméon Chardin (1699–1779, France). zhahn-bat-teest-see-may-ohn shar-dan

Georgio de Chirico (1888–1978, Italy). jor-jyoh day key-ree-coh

Dorte Christjansen (b. 1943, Danish-US). door-teh krist-jan-sen

Christo (b. 1935, Bulgaria). kriss-toe

Ken Chu (b. 1953, Hong Kong–US). choo

Frederic Edwin Church (1826–1900, US). cherch

Chuck Close (b. 1940, US). klohs

Henry Cobb (b. 1859–1931, US). cob

Willie Cole (b. 1959, US). kole

Jess Collins (1923–2004, US). cahl-inz

Douglas Crockwell (1904–68, US). krok-well

Imogen Cunningham (1883–1976, US). im-a-jean cun-ning-ham

D

Salvador Dali (1904–89, Spain). sahl-vah-door dah-lee

Louis Danziger (b. 1923, US). dan-tsig-er

Edgar Degas (1834–1917, France). ed-gahr day-gah

Willem de Kooning (1904–1997, The Netherlands–US). vil-em deh-koon-ing

Charles Demuth (1883–1935, US). day-mooth

Desiderio da Settignano (1429/30–1464, florentine). dez-eh-der-ee-oh da set-tee-yahn-oh

Laddie John Dill (b. 1943, US). lad-ee jon dil

James Doolin (1932–2002, US). dool-en

Aaron Douglas (1899–1979, US). dug-les

Arthur Dove (1880–1946, US). duv

Albrecht Dürer (1471–1528, Germany). ahl-brecht dur-er

E

Thomas Eakins (1844–1916, US). ay-kins

Carol Eckert (b. 1945, US). ek-urt

Harold E. Edgerton (1903–90, US). ej-er-ten

Alexandre-Gustave Eiffel (1832–1923, France). al-ex-andr-goo-stahv ee-fel

Alfred Eisenstaedt (1898–1995, Poland–US). eye-zen-shhtat

M. C. Escher (1898–1972, The Netherlands). esh-er

Richard Estes (b. 1932, US). ess-teez

F

Joy Feasley (b. 1966, US). feez-lee

Lyonel Feininger (1871–1956, US). fie-ning-ur

John Ferren (1905–70, US). feh-ren

John Forbes (b. 1946, US). forbz

Jean-Honoré Fragonard (1732–1806, France). zhahn-oh-no-reh fra-go-narh

Piero della Francesca (1410/20–92, Italy). pyay-roh del-lah fran-ches-kah

Helen Frankenthaler (b. 1928, US). frank-en-thal-er

Bruce Freund (b. 1953, US). froint

G

Antoni Gaudí (1852–1916, Spain). an-toh-nee gow-dee

Frank O. Gehry (b. 1929, US). geh-ree

Théodore Géricault (1791–1824, France). tay-oh-dor zhay-ree-koh

Alberto Giacometti (1901–66, Italy). al-bair-toe zhah-co-met-ee

Sylvia Glass (20th century, US). glass

Vincent van Gogh (1853–1890, The Netherlands). vin-sent vahn go

Glenna Goodacre (b. 1939, US). good-ake-er

Michael Graves (b. 1934, US). grayvz

Jonathan Green (20th century, US). green

Charles Sumner Greene (1868–1957, US). green

Henry Mather Greene (1870–1954, US). green

Juan Gris (1887–1927, Spain/active in France). wahn grees

Walter Gropius (1883–1969, Germany). grow-pee-us

Cai Guo-Qiang (b. 1957, China). tseye gwoah chee-ong

Alexander Guthrie (b. 1920, US). guth-ree

H

Ekaku Hakuin (1685–1768, Japan). ay-kah-koo ha-koo-in

Frans Hals (1581–1666, The Netherlands). frahns hahls

Duane Hanson (1926–96, US). dwane han-son

Michael Hayden (b. 1943, Canada). hay-den

Dame Barbara Hepworth (1903–75, England). hep-werth

Arturo Herrera (b. 1959, Venezuela). ar-tur-ro er-ray-rah

David Hockney (b. 1937, England). hawk-nee

Allan Houser (1914–94, Chiricahua/Apache/US). how-zer

I

Igbo culture (Nigeria, Africa). eeg-bo

Robert Indiana (b. 1928, US). indee-an-a

Torii Ippo (b. 1930, Japan). tory ippo

Irian Jaya (Lake Sentani, New Guinea). eer-ee-in jie-yah (lake sen-tah-nee, noo ghin-ee)

Robert Irwin (b. 1928, US). er-win

J

Yvonne Jacquette (b. 1934, US). ee-von jak-et

Jeanne-Claude (1935–2009, France). zhahn-kload

Yale Joel (1919–2006, US). jole

Gwen John (1876–1939, Wales). jon

Philip Johnson (1906–2005, US). jon-sehn

William H. Johnson (1901–70, US). jon-sehn

Donald Judd (1928–94, US). jud

K

Frida Kahlo (1910–54, Mexico). free-dah kah-low

Phineas Kamangira (20th century, Zimbabwe). fin-ee-ess ka-man-gee-ra

Wassily Kandinsky (1866–1944, Russia). vahs-i-lee kan-dins-key

Anish Kapoor (b. 1954, India–England). ah-neesh kah-poor

Karajá tribe. Amazon. (Araguaia River, Mato Grosso, Brazil). ka-ra-ha (are-uh-gwy-uh, mah-too gross-oo)

Gertrude Käsebier (1852–1934, US). ger-trood kay-zah-beer

Alex Katz (b. 1927, US). catz

Ellsworth Kelly (b. 1923, US). elz-wurth kell-ee

William Kentridge (b. 1955, South Africa). kent-rij

André Kertész (1894–1985, Hungary–US). ahn-dray ker-tesh

Jerome Kirk (b. 1923, US). jeh-rome kurk

Paul Klee (1879–1940, Switzerland). clay

Elizabeth Anna Klumpke (1856–1942, US). klom-key

Stephen Knapp (b. 1947, US). nap

Käthe Kollwitz (1867–1945, Germany). kay-teh kahl-vits

Ogata Korin (1658–1716, Japan). oh-gah-tah core-een

Kuba (Africa). koo-ba

Shiro Kuramata (1934–91, Japan). shee-roe koo-rah-mah-tah

L

Doyle Lane (20th century, US). lane

Dorothea Lange (1895–1965, US). dor-uh-thee-uh lang

Georges de La Tour (1593–1652, France). zjorzj de la toor

Jacob Lawrence (1917–2000, US). lor-ense

Dinh Q. Lê (b. 1968, Vietnam). din q. leh

Le Corbusier (1887–1965, France/Switzerland). luh kaw-bu-see-ay

Leonardo Da Vinci (1452–1519, Italy). lay-oh-nar-doh dah vin-chee

Julio Le Parc (b. 1928, Argentina-France). hule-yoh leh park

Marilyn Ann Levine (1935–2005, Canada–US). leh-veen

Roy Lichtenstein (1923–97, US). lick-ten-stine

Maya Ying Lin (b. 1959, US). my-uh ying lin

Jacques Lipchitz (1891–1973, Lithuania–France). zjahk leep-sheets

Lee Lockwood (b. 1932, US). lok-wood

M

Charles Rennie Mackintosh (1868–1928, Scotland). ren-ee mak-in-tosh

René Magritte (1898–1967, Belgium). ren-ay mah-greet

Sylvia Plimack Mangold (b. 1938, US). plim-ick man-gold

Sally Mann (b. 1951, US). man

Andrea Mantegna (1431–1506, Italy). ahn-dray-ah man-ten-ya

Maori (New Zealand). may-or-ee

Maria Martinez (1881–1980, US). ma-ree-ah mar-tee-nes

Masaccio (1401–1428, Italy). ma-zaht-choh

Henri Matisse (1869–1954, France). ahn-ree mah-teece

Roberto Matta (1911–2002, Chile). may-tah

Josiah McElheny (b. 1966, US). jo-zeye-ah mak-el-hen-nee

Julie Mehretu (b. 1970, Ethiopia-US). merit-two

Mayan (200 BCE–500 CE, Mexico). my-en

Mbuti (Zaire). mm-boo-tee

Richard Meier (b. 1934, US). my-er

Gabriel Metsu (1629–67, The Netherlands). gah-bree-el met-sue

Michelangelo (1475–1564, Italy). mee-kel-an-jay-loh

Melissa Miller (b. 1951, US). mill-er

Clark Mills (1815–83, US). milz

Ming dynasty (14th–17th cent., China). ming

Minoan (Palaikastro). mih-no-in

Joan Miró (1893–1983, Spain). joe-on mee-roh

Moche culture (Peru) mo-shay

Joan Mitchell (1926–92, US). mich-ell

Piet Mondrian (1872–1944, The Netherlands). pate mohn-dree-ahn

Claude Monet (1840–1926, France). kload moh-nay

Henry Moore (1898–1986, England). more

Thomas Moran (1837–1926, US). me-ran

Georgio Morandi (1890–1964, Italy). jor-jyoh moh-ran-dee

Berthe Morisot (1841–95, France). bairt moh-ree-zoh

Norval Morrisseau (1933–2007, Canada). nor-vahl moh-ree-soh

Philip Moulthrop (b. 1947, US). mowl-thrup

Thomas P. Muir (b. 1956, US). mure

Peter Müller-Munk (1904–67, Germany). mew-ler-monk

Elizabeth Murray (1940–2007, US). mur-ee

'Abd Allah Musawwir (active mid-16th century, Bukhara, Persia). ab-da ah-lah muh-sa weer

N

Nasca (Peru, 100–700 CE). nass-kuh

Bruce Nauman (b. 1941, US). naw-men

Alice Neel (1900–84, US). neel

Rivane Neuenschwander (b. 1967, Brazil). ree-van-eh noy-en-schwan-duh

Louise Nevelson (1899–1988, Russia–US). nev-ul-sun

Arnold Newman (1918–2008, US). new-men

Nodena culture (Late Mississippian culture, US) noe-dee-nah

Isamu Noguchi (1904–88, Japan–US). ees-sah-moo noh-goo-chee

O

Georgia O'Keeffe (1887–1986, US) jor-jah o-kefe

Claes Oldenburg (b. 1929, Sweden–US). klahss old-en-berg

Diana Ong (b. 1940, China-US). ong

Meret Oppenheim (1913–85, Germany). meh-ray ahp-uhn-hym

P

Nam June Paik (1932–2006, Korea). nahm joon peak

Jorge Pardo (b. 1963, Cuba-US). hor-hay par-doh

Nick Park (b. 1958, England). park

I. M. Pei (b. 1917, China–US). pay

Raymond Pettibon (b. 1957, US). petty-bohn

Judy Pfaff (b. 1946, England–US). faf

Ellen Phelan (b. 1943, US). fay-lin

Pablo Picasso (1881–1973 Spain/active in France). pah-blo pee-kahs-oh

Albert Porter (1923–2009, US). port-er

James A. Porter (1905–71, US). port-er

Katherine Porter (b. 1941, US). port-er

John Portman (b. 1924, US). port-man

Tom Purvis (1888–1959, Great Britain). pur-viss

Martin Puryear (b. 1941, US). per-yeer

Q

Qing dynasty (18th century, China). king

R

Don M. Ramos (20th century, US). ray-mohs

Anthony Ravielli (1910–97, US). rah-vee-el-ee

Man Ray (1890–1976, US). ray

Rembrandt van Rijn (1606–69, The Netherlands). rem-brant van rhine

Viljo Revell (1910–64, finland). vil-ee-o reh-vell

Faith Ringgold (b. 1930, US). ring-gold

Pipolotti Rist (b. 1962, Switzerland). pip-ah-law-dee rist

Matthew Ritchie (b. 1960, England). rich-ee

José de Rivera (1904–1985, US). ho-say da ree-vay-rah

Hugo Robus (1885–1964, US). roe-buss

Simon Rodia (1875–1965, Italy–US). roh-dee-ah

Bruce Rogers (1870–1957, US). raw-jerz

Richard Rogers (b. 1933, Great Britain). rawj-erz

Theodore Roszak (1907–81, US). thee-ah-door ro-shak

Susan Rothenberg (b. 1945, USA). rawth-en-berg

Antonio Ruíz (1897–1964, Mexico). roo-eez

Edward Ruscha (b. 1937, US). roo-shay

Ursula von Rydingsvard, (b. 1942, Germany). er-sa-lah vohn reye-dings-vard

S

Kay Sage (1898–1963, US). saje

Augustus Saint-Gaudens (1848–1907, Ireland-US). aw-gus-tus saint-gawd-unz

Doris Salcedo (b. 1958, Colombia). sal-see-doh

John Singer Sargent (1856–1925, US). sar-jent

Miriam Schapiro (b. 1923, Canada-US). mee-ree-um sha-peer-oh

Egon Schiele (1890–1918, Austria). ay-gon she-luh

Emil Schulthess (1913–96, Switzerland). shul-tess

George Segal (1924–2000, US). see-gul

Senufo/Baule (Cote d'Ivoire, Africa). sehn-noo-fo

Georges Seurat (1859–91, France). zjorzj suh-rah

Ben Shahn (1898–1969, Lithuania–US). shan

Toshusai Sharaku (active 1794–95, Japan). toh-shu-sah-ee shah-rah-kew

Alan Siegal (1913–78, US). see-gul

David Smith (1906–65, US). smith

Jaune Quick-To-See Smith (b. 1940, Salish Cree Shoshone/US). zjhohn kwik to see smith

Nonomura Sotatsu (1576–1643, Japan). soh-taht-soo

Frank Stella (b. 1936, US). stell-a

Varvara Stepanova (1894–1958, Russia). var-var-ah ste-pah-no-vah

Clyfford Still (1904–80, US). still

T

Nomathemba Tana (b. 1953, South Africa). no-mah-tam-bah tahna

Paul Tanqueray (1905–91, Great Britain). tonk-eh-ray

Sir John Tenniel (1820–1914, England). ten-ee-ul

Maria Teokotai tay-oh-kah-tai

Masami Teraoka (b. 1936, Japan/active in US). ma-sa-mee te-ra-oh-kah

Wayne Thiebaud (b. 1920, US). tee-bow

Louis Comfort Tiffany (1848–1933, US). tiff-ah-nee

Tintoretto (1518–94, Italy). teen-toe-ret-toe

Norman Kelly Tjampijinpa (b. 1938, Australia). jam-pee-jin-paw

Tlingit, Yakutat (Alaska). tlin-get yah-kuh-tat

Niklaus Troxler (b. 1947, Switzerland). nee-klos troks-ler

Tubuai (Austral Islands). too-bwa-ee (oss-trul eye-lands)

William Tucker (b. 1935, England-Canada). tuk-er

James Turrell (b. 1943, US). tur-el

Kent Twitchell (b. 1942, US). twit-shell

V

Victor Vasarely (1908–97, Hungary–France). va-sah-rell-ee

Jan Vermeer (1632–75, The Netherlands). yahn fare-meer

Daniele da Volterra (Daniele Ricciarelli) (1509–66, Italy). dan-yell-ay da vahl-tare-ah

W

Fred Ward (b. 1935, US). ward

Andy Warhol (1928–87, US). war-hall

Weegee (Arthur Fellig) (1899–1968, Poland–US). wee-jee (fel-ig)

Edward Weston (1886–1958, US). west-en

James Abbott McNeill Whistler (1834–1903, US-England). hwis-ler

Minor White (1908–76, US). wite

Sue Williams (b. 1954, US). will-yums

Ellis Wilson (1899–1977, US). wil-sen

Fred Wilson (b. 1954, US). will-suhn

Jackie Winsor (b. 1941, US). win-zer

Tyrus Wong (b. 1910, China–US). tie-rus wong

Grant Wood (1892–1942, US). wood

Frank Lloyd Wright (1867–1959, US). rite

Andrew Wyeth (b. 1917, US). why-eth

Y

Kumi Yamashita (b. 1968, Japan–US). koo-me ya-ma-shee-ta

Wang Yani (b. 1975, China). ya-nee

Z

Zapotec (pre-Columbian, 200–900 CE). zah-puh-tek

Wei Zhujing, (16th century, China). way zjoo-jing

Glossary

abstract art Art that emphasizes design, or whose basic character has little visual reference to real or natural things. *(abstracto)*

analogous colors Hues that are next to each other on the color wheel and have a single color in common. For example, yellow-green, yellow, and yellow-orange are analogous colors. *(colores análogos)*

approximate symmetry The organization of the parts of a composition such that each side of a vertical axis contains similar, but not identical, shapes or forms. *(simetría)*

asymmetrical balance The organization of the parts of a composition such that the sides of a vertical axis are visually equal without being identical. *(asimétrico)*

base The foundation or support of an object. The rest of the object is built on top of the base. In a rope and yarn basket or a coiled clay pot, the base is formed by winding the rope or clay in a circle until it forms a flat surface. *(base)*

calligraphy Precise, elegant handwriting or lettering done by hand. The word "calligraphic" is sometimes used to describe a line in an artwork that has the flowing elegance of calligraphy. *(caligrafía)*

caricature A depiction that exaggerates features or characteristics of a subject to an unnatural, ridiculous, or absurd degree. *(caricatura)*

center of interest The area of an artwork toward which the eye is directed; the visual focal point of the work. *(foco de atención)*

color harmony Combinations of color—such as complementary or analogous colors—that can be defined by their positions on the color wheel. Particular color harmonies may be used to achieve specific effects. *(armonía cromática)*

complementary colors Any two colors that are opposite each other on the color wheel. *(complementarios)*

composition The arrangement of elements such as line, value, and form within an artwork; principles of design are considered in order to achieve a successful composition. *(composición)*

compositional movement A path that the viewer's gaze is directed to follow because of the arrangement of elements in an artwork. *(movimiento composicional)*

constructed sculpture Sculpture that is not carved or modeled but is created by combining materials like wire, metal, cardboard, wood, or found objects. First used by Picasso in the early twentieth century. *(escultura ensamblada)*

contour lines Lines that describe a shape of a figure or an object and also include interior detail. These lines can vary in thickness. *(líneas de perfil)*

contrast A principle of design that refers to differences in elements such as color, texture, value, and shape. Contrasts usually add excitement, drama, and interest to artworks. *(contraste)*

cool colors The hues that range from yellow-green to violet on the color wheel. *(colores fríos)*

core The material used to form the basic shape of an object. In a coiled rope and yarn basket, the core is the rope. *(material bàsico)*

crosshatchings Closely-spaced, parallel lines that overlap at angles to each other. Cross hatching is used primarily in drawing and printmaking to create areas of shading. *(sombreado de líneas entrecruzadas)*

Cubism An early twentieth-century movement led by Pablo Picasso and Georges Braque. The artists used small squares or cubes to represent their subjects. Objects are often shown from several different points of view at once, which flattens three-dimensional space. Cubist paintings are often monochromatic and sometimes contain elements of collage. *(Cubismo)*

dominance A concept that one primary element attracts more attention than anything else in a composition. The dominant element is usually a focal point in the composition. *(dominio)*

dynamic Constantly changing or moving; in a state of imbalance or tension. *(dinámico)*

eber A fanlike sword in Benin culture. *(eber)*

fire To bake a ceramic object in a kiln. Firing pottery at a high temperature causes it to harden permanently. *(cocer)*

form An element of design that is three-dimensional and encloses volume. *(forma)*

fresco A technique of painting in which pigments suspended in water are applied to a thin layer of wet plaster so that the plaster absorbs the color and the painting becomes part of the wall. *(fresco)*

geometric shape A shape—such as a triangle or rectangle—that can be defined precisely by mathematical coordinates and measurements. *(figura geométrica)*

gesture line An energetic type of line that catches the movements and gestures of an active figure. *(línea gestual)*

half-drop design A specific kind of row pattern with the vertical orientation of each row evenly spaced to half the height of its preceding row, and with a shifted horizontal position. *(diseño de semidescenso)*

high-keyed Describing colors or values that are light tints, created by the use of white, such as in pastel colors. *(tono alto)*

hue The name of a color, determined by its position in the spectrum. *(matiz/tono/color)*

implied line A suggested line—one that was not actually drawn or incorporated—in a work of art. *(línea implícita)*

implied texture The perceived surface quality in an artwork. *(textura implícita)*

intensity The strength, brightness, or purity of a color. Changing a color's value will also change its intensity. *(intensidad)*

intermediate colors Colors created by mixing equal amounts of primary colors with their neighboring secondary colors. For example, mixing yellow (a primary color) with orange (a secondary color) creates the intermediate color yellow-orange. *(color intermedio)*

iwan A vaulted opening with an arched portal. *(iwan)*

kinetic art Three-dimensional sculpture that contains moving parts. *(escultura cinética)*

linear perspective The technique by which artists create the illusion of depth on a flat surface. All parallel lines of projection converge at the vanishing point, and associated objects are rendered smaller the farther from the viewer they are intended to seem. *(perspectiva lineal)*

line of sight A type of implied line from a figure's eyes to a viewed object, directing the attention of the viewer of a design from one part of it to another. *(línea de la vista)*

line personality The general characteristics of a line, such as its direction, movement, quality, or weight. *(personalidad de la línea)*

low-keyed Describing colors or values that are dark tints, usually created by the use of black or gray. *(tono bajo)*

monochromatic Of only one color. A monochromatic painting uses a single hue, plus black and white. The use of lights and darks creates contrast in the work. Most drawings are monochromatic because they use only one color of ink or lead. *(monocromático)*

motif The two- or three-dimensional unit that is repeated to form a pattern. *(motivo)*

negative space The areas of an artwork not occupied by subject matter, but which contribute to the composition. In two-dimensional art, the negative space is usually the background. *(espacio negativa)*

neutral Having no easily seen hue. White, gray, and black are neutrals. *(color neutro)*

nonrepresentational art Art that has no recognizable subject matter, that does not depict real or natural things in any way. Also called nonobjective art. *(arte no representativo)*

oba A divine king in Benin culture. *(oba)*

one-point perspective Linear perspective used in combination with a single vanishing point. Used to show three-dimensional objects on a two-dimensional surface. *(perspectiva de un punto)*

organic shape A shape that is free-form or irregular; the opposite of geometric shape. *(figura orgánica)*

outline A line that defines the outer edge of a silhouette, or the line made by the edges of an object. *(contorno)*

papiers collés A French term meaning "glued-on papers." The Cubists used this technique, the beginning of collage, when they attached items like newspaper clippings to their paintings. *(papiers collés)*

papiers découpés Abstract collage, from the French term meaning "cut-out papers." *(papiers découpés)*

pattern A principle of design in which the repetition of elements or combination of elements forms a recognizable organization. *(patrón)*

perspective An artist's representation of a three-dimensional world on a two-dimensional surface. *(perspectiva)*

photomontage A composition formed of several pictures, usually pasted together. *(montage)*

picture plane The flat surface of a composition. *(superficie pictória)*

pigment The coloring material used in making painting and drawing media, dyes, inks, and toners. Pigments may be natural (made from earth or plants) or made from laboratory-prepared chemicals. *(pigmento)*

planned pattern The consistent, orderly repetition of motifs, whether found in nature or created by an artist. Planned patterns include row, grid, half-drop, radial, alternating, and border. *(patrón planeado)*

positive space The areas containing the subject matter in an artwork; the objects depicted, as opposed to the background or space around those objects. *(espacio positivo)*

primary colors In subtractive color theory, such as when mixing pigments, the hues—red, yellow, and blue—from which all other colors are made. *(color primario)*

progressive rhythm A pattern in which each series of motifs incorporates a predictable change. *(ritmo progresivo)*

radial balance A composition that is based on a circle, with the design radiating from a central point. *(equilibrio radial)*

random pattern The repetition of an element or elements in an inconsistent or unplanned way. *(patrón aleatorio)*

real texture The actual surface quality of an artwork. *(textura real)*

scale The relative size of a figure or object, compared to others of its kind, its environment, or humans. *(escala)*

scoring Scratching grooves or lines into surfaces of clay pieces that will be joined together. Scoring helps the pieces of clay to bond during the firing process. *(marca)*

secondary colors Colors produced by mixing equal amounts of any two primary colors. The secondary colors are violet (red mixed with blue), orange (red mixed with yellow), and green (blue mixed with yellow). *(color secundario)*

shade A darker value of a hue, created by adding black or a darker complementary color to the original hue. *(sombra)*

shape An element of design that is two-dimensional and encloses area. *(figura)*

sketch line A quick line that captures the appearance of an object or the impression of a place. *(línea de bosquejo)*

slip Clay thinned with water to create a thick liquid. Slip is used on scored areas to bind pieces of clay together. *(barbotina)*

spectrum The complete range of color that is present in white light. The spectrum colors are visible when light is refracted through a prism. *(espectro cromático)*

split complementary A color plus the two hues next to that color's complement. For example, blue forms a split complementary with yellow-orange and red-orange. *(color complementario dividido)*

static Showing no movement or action. *(estático)*

structural lines Lines that hold a design together. *(líneas estructurales)*

style The distinctive character contained in the artworks of an individual, a group of artists, a period of time, an entire society, or a geographical location. *(estilo)*

subordinate Anything that is of lesser importance than the dominant element in an artwork. *(subordinado)*

surface A plane that can be described in terms of two dimensions: height and width. A surface has no depth. *(superficie)*

symmetrical balance The organization of the parts of a composition such that each side of a vertical axis mirrors the other. *(equilibrio simétrico)*

texture An artwork's actual or implied surface quality, such as rough, smooth, or soft. *(textura)*

thrown pottery Ceramic objects made by forming clay on the spinning disc of a potter's wheel, producing a symmetrical round form. *(cerámica a torno)*

tint A lighter value of a hue, created by adding white to the original hue. *(matiz)*

tone A less intense value of a hue, created by adding gray to the original hue. *(tono)*

tortillon A small stump of tightly rolled paper, pointed at one end, used to blend pencil, charcoal, and pastel. *(difumino)*

triadic harmony A combination of three equally-spaced hues on the color wheel. Examples are red, yellow, and blue, or blue-green, red-violet, and yellow-orange. *(tríada cromática)*

two-point perspective A way to show three-dimensional objects on a two-dimensional surface, using two widely-set vanishing points and two sets of converging lines to represent forms. These forms are seen from an angle and have two receding sides. *(perspectiva de dos puntos)*

unity The sense of oneness or wholeness in a work of art. *(unidad)*

vacuum forming A method of shaping a plastic sheet over a solid relief pattern. The plastic is heated until it is pliable and when a vacuum is created under the form, the plastic is drawn down onto the pattern like a skin. *(moldeado al vacío)*

value An element of design that refers to the lightness or darkness of grays and colors. *(valor)*

value contrast Dark and light values placed close together. Black in proximity to white creates the greatest value contrast. *(contraste de valor)*

vanishing point In a composition featuring linear perspective, that spot on the horizon toward which parallel lines appear to converge and at which they seem to disappear. *(punto de fuga)*

visual rhythm The result of pattern combined with implied movement. Elements or motifs are combined to create a series of regular pauses (stops and starts) for the viewer's eyes, similar to the way a drumbeat creates a series of pauses for the listener's ears. *(ritmo visual)*

warm colors The hues that range from yellow to red-violet on the color wheel. *(colores cálidos)*

wedge To homogenize a ball of clay by repeatedly cutting it with a wire and pounding it together until it is fully blended. This process removes bubbles that could cause a piece of pottery to crack in the kiln. *(acuñar)*

wrap A material used to cover another material. In a rope and yarn basket, the yarn that is wound around the rope is the wrap. *(envoltura)*

Bibliography

Albers, Josef. *Interaction of Color*. New Haven: Yale University Press, 1994.

Alekzander, Terri. Ed. *Fresh Ideas in Brochure Design*. Cincinnati: North Light Books, 1997.

Arnheim, Rudolf. *Art and Visual Perception: A Psychology of the Creative Eye*. Berkeley: University of California Press, 1997.

Berryman, Gregg. *Notes on Graphic Design and Visual Communication*. Rev. ed. Menlo Park, CA: Crisp Publications, Inc., 1990.

Birks, Tony. *The Complete Potter's Companion*. Rev. ed. Boston: Bulfinch Press Book, Little Brown and Company, 1998.

Billcliffe, Roger. *Charles Rennie Mackintosh: Textile Designs*. San Francisco: Pomegranate Artbooks, 1993.

Birren, Faber. *Color and Human Response: Aspects of Light and Color Bearing on the Reactions of Living Things and the Welfare of Human Beings*. New York: John Wiley and Sons, 1984.

Bourges, Jean. *Color Bytes*. Worcester, MA: Davis Publications, Inc., 1997.

Brommer, Gerald, and Gatto, Joseph A. *Careers in Art*. Worcester, MA: Davis Publications, Inc., 1999.

Carter, Rob. *Typographic Specimens: The Great Typefaces*. New York: John Wiley and Sons, 1997.

Carter, Rob; Day, Ben; and Miller, A. Ed. *Typographic Design: Form and Communication*. 2nd ed. New York: John Wiley and Sons, 1997.

Ching, Frank D. *Architecture: Form, Space, and Order*. 2nd ed. New York: John Wiley and Sons, 1996.

Dormer, Peter. *The New Ceramics Trends and Traditions*. 2nd ed. New York: Thames and Hudson, 1994.

Edwards, Betty. *Drawing on the Right Side of the Brain*. Rev. ed. New York: The Putnam Publishing Group, 1989.

Eidelberg, Martin. *Designed For Delight: Alternative Aspects of Twentieth Century Decorative Arts*. New York: Abbeville Press, and Paris: flammarion, in Association with Montreal Museum of Decorative Arts, 1997.

English, Marc. *Designing Identities, Graphic Design as a Business Strategy*. Gloucester, MA: Rockport Publishers, 1997.

Ernst, Bruno. *The Magic Mirror of M.C. Escher (Taschen Series)*. New York: Taschen America, 1995.

Fichner-Rathus, Lois. *Understanding Art*. 5th ed. Englewood Cliffs, NJ: Prentice Hall, 1997.

Gatta, Kevin; Lange, Gusty; and Lyons, Marylin. *Foundations of Graphic Design*. Worcester, MA: Davis Publications, Inc., 1991.

Gilbert, Rita. *Living With Art*, 5th ed. New York: McGraw-Hill, 1997.

Hale, Nathan Cabot. *Abstraction in Art and Nature*. New York: Dover Publications, 1993.

Heller, Steven. *Graphic Style from Victorian to Post-Modern*. New York: Harry N. Abrams, Inc. Publishers, 1994.

Itten, Johannes. *The Art of Color: The Subjective Experience and Objective Rationale of Color*. New York: John Wiley and Sons, 1974.

Itten, Johannes. *Design and Form: The Basic Course at the Bauhaus and Later*. Rev. ed. New York: John Wiley and Sons, 1997.

Itten, Johannes, Birren, Faber. Ed. *The Elements of Color: A Treatise on the Color System by Johannes Itten*. New York: John Wiley and Sons, 1985.

Lauer, David A. *Design Basics*, 4th ed. Fort Worth: Harcourt Brace College Publishers, 1994.

Lucie-Smith, Edward. *The Thames and Hudson Dictionary of Art Terms*. New York: Thames and Hudson, 1988.

Martin, Diana and Haller, Lynn. *Graphic Design, Inspirations and Innovations 2*. Cincinnati: North Light Books, 1997.

McCloud, Scott. *Understanding Comics: The Invisible Art*. New York: HarperCollins, 1994.

McLuhan, Marshall. *Understanding Media: Extensions of Man*. Cambridge: MIT Press, 1994.

Meggs, Phillip B. *History of Graphic Design*. 2nd ed. New York: John Wiley and Sons, 1992.

Miller, Anastatia R. and Brown, Jared M. *What Logos Do and How They Do It*. Gloucester, MA: Rockport Publishers, 1997.

Montague, John. *Basic Perspective Drawing*. 3rd ed. New York: John Wiley and Sons, 1998.

Murphy, Pat, and Dunham, Judith. Ed. *By Nature's Design: An Exploratorium Book*. San Francisco: Chronicle Books, 1993.

Parola, Rene. *Optical Art: Theory and Practice*. New York: Dover Publications, 1996.

Pina, Leslie. *Alexander Girard Designs for Herman Miller*. Atglen, PA: Schiffer Publishing Ltd, 1998.

Preble, Duane; Preble, Sarah; and Frank, Patrick. *Artforms: An Introduction to the Visual Arts*. 6th ed. New York: Addison Wesley Longman, 1999.

Read, Herbert, and Stangos, Nikos. *The Thames and Hudson Dictionary of Art and Artists*. 2nd ed. London: Thames and Hudson, 1994.

Richer, Paul, and Hale, Robert B. Ed. *Artistic Anatomy*. New York: Watson-Guptill Publishers, 1986.

Roberts, Marie MacDonnell. *The Artist's Design: Probing the Hidden Order*. Walnut Creek, CA: Fradema Press, 1993.

Roukes, Nicholas. *Art Synectics*. Worcester, MA: Davis Publications, Inc., 1984.

Roukes, Nicholas. *Design Synectics*. Worcester, MA: Davis Publications, Inc., 1988.

Sarnoff, Bob. *Cartoons & Comics*. Worcester, MA: Davis Publications, Inc., 1989.

Sawahata, Lesa. *Building Great Designs with Paper*. Gloucester, MA: Rockport Publishers, Inc., 1998.

Sayre, Henry M. *A World of Art*. 2nd ed. Englewood Cliffs, NJ: Prentice Hall, 1996.

Schwartzman, Arnold. *Designage: The Art of Decorative Sign*. San Francisco: Chronicle Books, 1998.

Shadrin, Richard L. *Design & Drawing*. Worcester, MA: Davis Publications, Inc., 1992.

Sparke, Penny. *A Century of Design: Design Pioneers of the 20th Century*. Hauppauge, NY: Barrons, 1998.

Stoops, Jack, and Samuelson, Jerry. *Design Dialogue*. Worcester, MA: Davis Publications, Inc., 1990.

Supon Design Group. *Visual Impact*. Washington, D.C.: Design Editions, a Division of Supon Design Group, 1998.

Tambini, Michael. *The Look of the Century*. New York: DK Publishing Inc., 1996.

Young, Doyald. *Logotypes and Letterforms*. Berkeley: Design Press/McGraw-Hill, 1993.

Zelanski, Paul. *Design Principles and Problems*. 2nd ed. Fort Worth: Harcourt Brace College Publishers, 1995.

Zelanski, Paul, and Fischer, Mary Pat. *The Art of Seeing*. 4th ed. Englewood Cliffs, NJ: Prentice Hall, 1998.

Acknowledgments

A book of this kind would be impossible without the generous participation of students, teachers, artists, photographers, companies, galleries, and museums.

The primary authors, Joseph Gatto, Albert Porter, and Jack Selleck are deeply appreciative to have been able to include all of the artists and their work in this book. We wish to to extend a special thanks to the following artists and agents: Loudvic Akopyan, Jennifer Bartlett, John Biggers, Christo and Jeanne Claude, Hans Van De Bovenkamp, Lois Danziger, Laddie John Dill, Dan Douke, John Forbes, Tobias Frere-Jones, Bruce Freund, David Furman, Frank O. Gehry, Sylvia Glass, Glenna Goodacre, Dorothy Littell Greco, Alexander J. Guthrie, Kenneth B. Haas III, Maren Hassinger, Ilisha Helfman, Allan Houser, Clarissa Hudson, Susie Kim, Jerome Kirk, David Lai, Alexander Lavrentiev, Franlyn J. Liegel, Wesley Mancini, Gene Mater, Adam Meckler, Claes Oldenburg, José Pérez, Christopher Polentz, James Porto, Ray Prado, Richard Putney, Oliver Radford, Anthony Ravielli, Anna Riley-Hiscox, Paula Robbins, Jeanne Rosen, Edward Ruscha, Jesús Soto, Berenice Steinbaum, Mesami Teraoka, Niklaus Troxler, James Turrell, Kent Twitchell, Fred Ward, Tyrus Wong, Victor Hugo Zayas.

Thanks must also go to the staffs of museums and galleries who were especially helpful in providing artwork from their collections: Amon Carter Museum, Anthony d'Offay Gallery, Bonny Doon Art Glass, Holly Solomon Gallery, The J. Paul Getty Museum, Jack S. Blanton Museum of Art of The University of Texas at Austin, Kimbell Art Museum, Marisa Del Re Gallery, Inc., Nelson-Atkins Museum of Art, Norton-Simon Museum of Art, Paula Cooper Gallery, Robert Miller Gallery, San Diego Museum of Art, Steinbaum Krauss Gallery, Tambaran Gallery, and Vereinigung bildender Künstler Wiener Secession.

A special thank you to Nora Halpern-Brougher, Mary Ellen Powell, and the Frederick R. Weisman Art Foundation; Christine Normile and the Sherry Frumkin Gallery; and Anna Ganahl and the Art Center College of Design, Pasadena, California.

We also wish to thank the teachers who shared their expertise and submitted examples of their student artwork. Special thanks to the following teachers: Barbara Levine, Clarkstown High School, New City, NY; Sallye Mahan-Cox, James W. Robinson, Jr. Secondary School, Fairfax, VA; Kaye Passmore, Notre Dame Academy, Worcester, MA; Richard Shilale, Holy Name Central Catholic Junior Senior High School, Worcester, MA.

Thank you to the companies, corporations, and associations who graciously assisted in providing materials for the book: Anne Kohs and Associates, Inc., Frank O. Gehry and Associates, *Los Angeles Times Syndicate*, M. Knoedler and Company, Inc., Mary Zlot and Associates, the Meckler Corporation, North Carolina Zoological Park, Pei Cobb Freed and Partners, Pixar, Portland Public Services Building, Public Information Office of the Jet Propulsion Laboratory at the California Institute of Technology in association with the National Aeronautics and Space Administration, United Airlines, Vitra Inc. Diane Pritchett and South Coast Metro Alliance, Costa Mesa, California.

A special thank you to John Scott for his excellent photographs that significantly helped to reinforce design concepts. Thanks to Susan Quinn, Geri Thigpen, and Shirl Porter for typing parts of the manuscript and for their insightful suggestions. Thank you also to Gerald Brommer for his helpful advice.

The authors are also grateful for the cooperation and dedication of the Davis Publications staff under the leadership of editor Helen Ronan.

Hopefully, the efforts of all of us will aid students in developing a greater understanding and appreciation of design and its importance in their lives.

Index